PHOTOGRAPHING
PEOPLE

PHOTOGRAPHING
PEOPLE

Consulting Editor Jack Schofield

How to take successful pictures
of your friends, family and others around you.

HAMLYN

London · New York · Sydney · Toronto

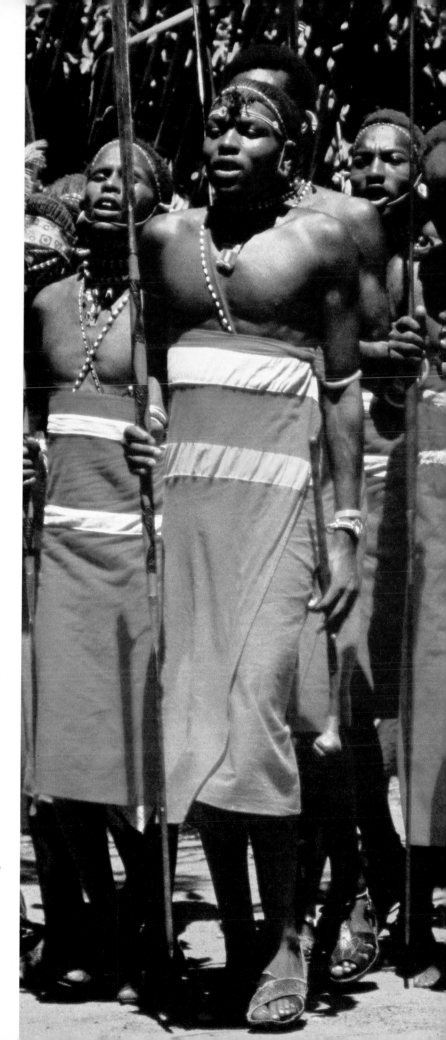

Consultants: John Garrett, Neville Maude, Tina
Rogers
Editors: Christopher Angeloglou, Jack Schofield
Art Director: Carol Collins
Book Editor: Caroline Ollard
Copy Editors: Mundy Ellis, Joselyn Morton,
Suzanne Walker

Contributing Editors: John Bell, Michael Busselle,
Ed Buziak, Anne Conway, Robert Cundy, Tony
Duffy, Mundy Ellis, John Evans, Alison Foster,
John Goldblatt, Tom Hustler, Robin Laurance,
Kevin MacDonnell, Leo Mason, Reg Mason, Don
Morley, Peter O'Rourke, Jack Schofield, Stephanie
Thompson, Alison Trapmore, Douglas Young

Published 1982 by The Hamlyn Publishing Group
Limited
London · New York · Sydney · Toronto
Astronaut House, Hounslow Road, Feltham,
Middlesex

Designed and produced for
The Hamlyn Publishing Group Limited
by Eaglemoss Publications Limited
First published in *You and Your Camera*
Copyright © 1982 by Eaglemoss Publications
Limited

ISBN 0 600 38473 X
Printed by Artes Gráficas Toledo, S.A. Spain
D.L. TO: 607-82

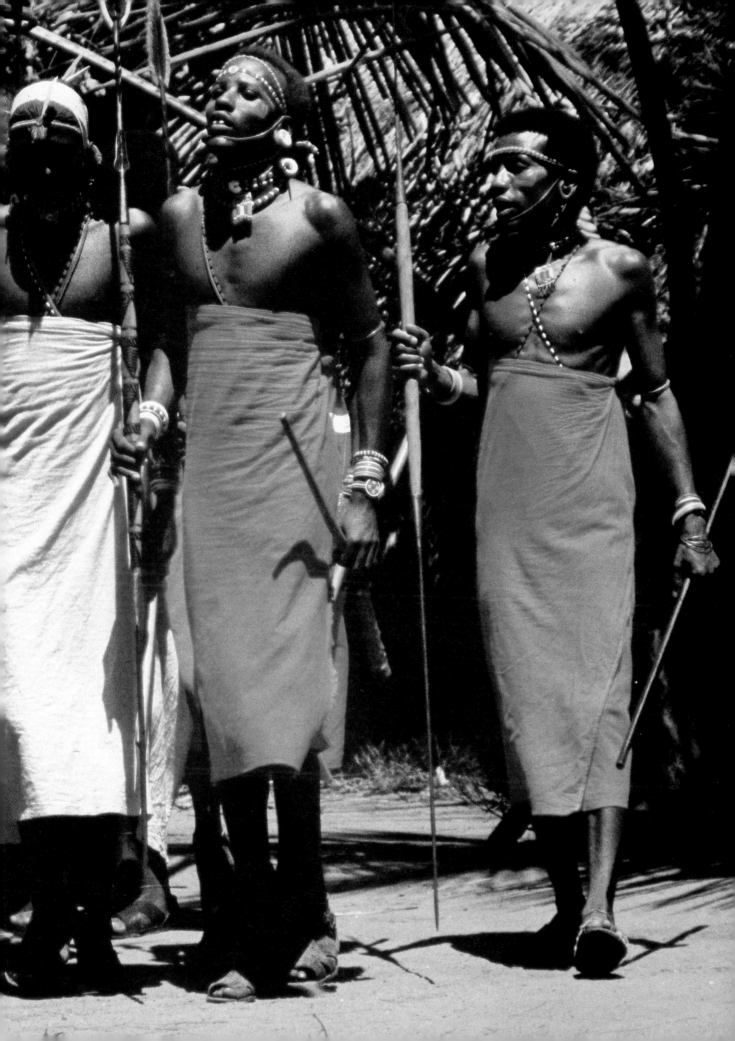

CONTENTS

9 Introduction

Taking successful portraits
10 How to choose your approach
14 The semi-aware photograph
20 The planned portrait
24 Using natural daylight
30 Formal portraits on location
34 Formal portraits: how to light them
38 Double portraits
42 Taking your own picture
44 The appeal of candid photography

Lighting for better pictures
50 Solving your metering problems
56 Metering difficult subjects
60 Using one flash gun
62 Using two or more flash guns
66 People by candlelight

Babies, toddlers and school children
70 Photographing your children
74 Moments in a baby's life
80 Photographing toddlers
86 Photographing schoolchildren
90 Children at play

Nude and glamour photography
96 Photographing girls
102 Your first nude photographs
108 The nude indoors
120 The nude outdoors
124 A different approach
130 Romantic glamour photography

Makeup, posing and fashion
134 The secrets of model makeup
140 Taking fashion pictures
146 A basic posing guide

Groups and occasions
156 The successful planned group
162 Photographing candid groups
168 Parades and processions
174 Parties and celebrations
178 Pictures of a wedding

The travelling camera
184 Taking your camera on holiday
190 On the beach
196 Winter holidays
202 Photographing peoples of the world

Capturing movement
208 Dance in pictures
212 Photographing winter sports
218 Ice skating
222 Pitch sports
228 Athletics meetings
232 Indoor sports

236 Glossary

238 Index

INTRODUCTION

There are many ways to photograph people, from the realism of a formal portrait to the dreamy romanticism of David Hamilton or the revealing candid shots of Cartier Bresson. The photographer's personality, sense of composition and technical know-how all play a part in achieving these different results.

Photographing people presents a unique challenge: the subject's degree of awareness of the photographer can make all the difference to the picture. The book opens with the three basic approaches: the aware, semi-aware and candid. Each approach requires varying equipment and techniques; posing a subject means the photographer can completely control the set-up, whereas he needs the ability to adapt to prevailing conditions when taking a candid shot.

Lighting is another key element. Unflattering shadows and colour casts are common problems which need solving. Helpful comparative shots and diagrams of lighting set-ups show you how to use all types of natural and artificial lighting to create the effects you want.

Techniques for photographing children—a most rewarding activity for the parent with a camera—are fully explained. Nude and glamour photography, groups and weddings, holidays and foreign travel are also covered, as well as sporting events and photographing people on the move. Creative suggestions are combined with practical advice and over 340 inspiring photographs from top professionals to help you take successful photographs of people in any situation.

How to choose your approach

People can be the most rewarding and the most difficult of subjects to photograph. The problem is less a technical one of which camera to use or what lighting is best, than the more elusive one of making your picture reveal something of the character or the way of life of the people that you are portraying. A good photograph will tell you more about the subject than just what he looks like: it may show what he does for a living (by including the tools of his trade) or it may capture a particular expression which typifies his personality.

Many people, however, feel awkward in front of a camera, and the photographer himself may feel hesitant. It is wise, therefore, to examine the different ways to approach the subject and decide which way best suits photographer and subject. If, for example, both are shy, there will be less strain all round if the subject is unaware he is being photographed: he will behave naturally and the photographer can take his time.

There are three basic approaches to photographing people:

1 Fully aware. Here the subject is totally aware he is being photographed and cooperates with the photographer to achieve a planned picture. The photographer is in complete control.

2 Semi–aware. The subject knows the photographer is present but is absorbed in something else and not sure of the precise moment the picture is taken.

3 Unaware. The subject does not know he is being photographed.

Later on each approach is explored in detail. But first you should familiarize yourself with the general principles of each, decide which is best for a given situation and for the effect you want.

Fully aware pictures

If you chose the direct approach you should think of the session as a combined effort. Convey this at the start and you will encourage your subjects to become active participants instead of passive and self-conscious models. Whether you choose a plain studio-like background or take your subject out on location depends on the style of picture you are after. Decide before you start what you want to say. You could take a head and shoulders of John Smith the man, or take him with a violin under his arm as John Smith, the musician.

Eyes are the natural focus of attention. Notice how the emphasis of a portrait changes when you bring the subject's eyes straight into the camera. When

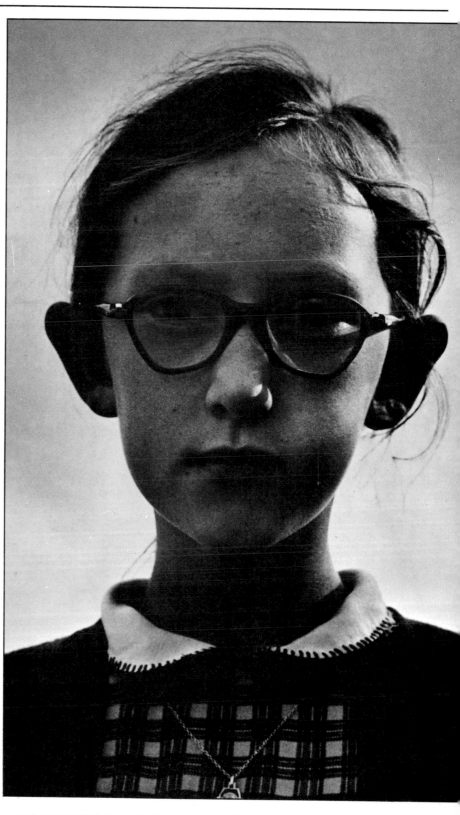

▲ FULLY AWARE: *Dorothy Lange* captures the serious look of a child unembarrassed by the camera. A plain background and one-directional lighting concentrates attention on the face.

▶ UNAWARE: background helps identify two old ladies as members of an Italian village. Frame them with your hands to see how less background tells you less about the subjects. *John Bulmer*

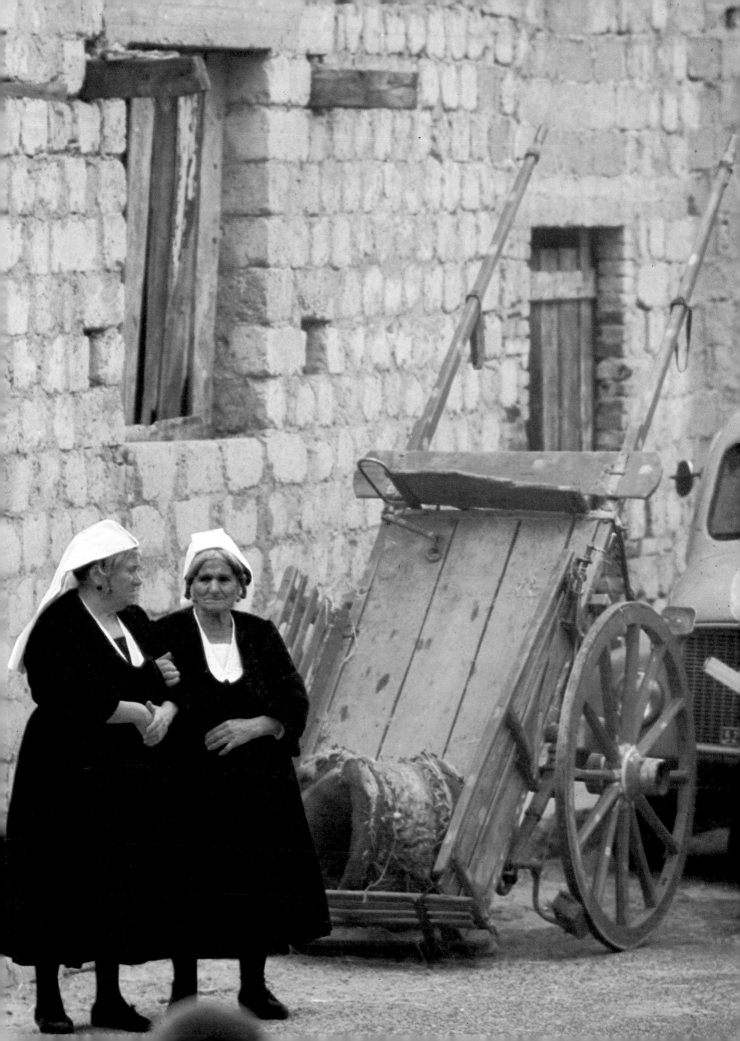

▲ UNAWARE: by using a telephoto lens this group of people remains unaware of the camera. Notice how the lens draws them together. *Robin Laurance*

▲ AWARE: a relaxed family group is created by seating the mother and child, which also gives the father a prop to lean on. *Robin Laurance*

▶ AWARE: back lighting is often better than full sun; the girl laughs at the camera without screwing up her eyes and her hair is appealingly lit. *Michael Busselle*

photographing nudes, a similar change in the direction of the model's eyes can turn a quiet reflective pose into something decidedly erotic.

Group pictures need the most planning and good organization leads to confidence on everybody's part. You will want to find alternatives to the line-up but at the same time you need to see all the faces clearly. Explore different camera angles. Shooting from an elevated position—such as a chair, for example—gives you greater depth so you can bunch your group and still see all the faces. A wide angle lens, with its reduced focal length and greater depth of field, will help to keep faces sharp.

Semi–aware pictures

This approach is particularly successful with people who feel ill at ease in front of the camera. If the subject is doing something—the violinist at rehearsals; a fisherman mending his nets; a child playing with a toy; an aunt knitting—he or she will be more relaxed. And if the sitter is occupied, the photographer does not feel in such a rush to get the picture taken. Use objects around the person to tell you more about him and build up a more interesting picture.

Unaware pictures

If you are taking photographs where your subject is not aware of your presence, then the problem of getting him to look natural does not exist. The main point about candid photography is that the picture is rearranging itself all the time. The skill comes in recognizing the precise moment at which to press the shutter. You lose the control you have in a posed session but you gain completely natural behaviour. In these situations, a telephoto lens comes into its own—it allows you to keep your distance and retain spontaneity.

Let your picture tell a story—about a relationship, a human condition, or an amusing situation—and don't always feel obliged to show faces. A rear view can sometimes tell the story with added poignancy or wit. The important thing is that your pictures evoke a response.

▲ AWARE: the girl is lit from under a glass table by flash diffused through tissue paper. A second flash adds depth to the picture. *Michael Boys*

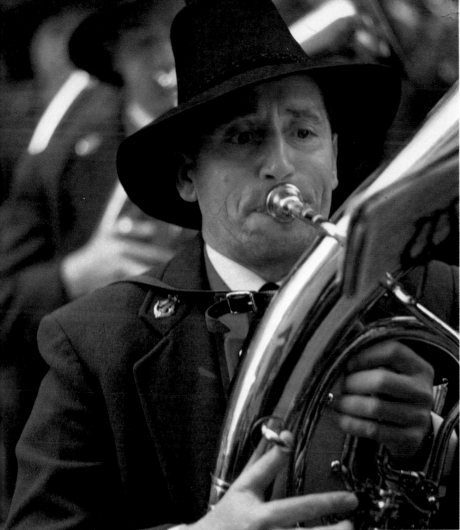

◀ SEMI-AWARE: concentrating on his music, a member of an Austrian brass band is hardly aware of the photographer. *Patrick Thurston*

The semi-aware photograph

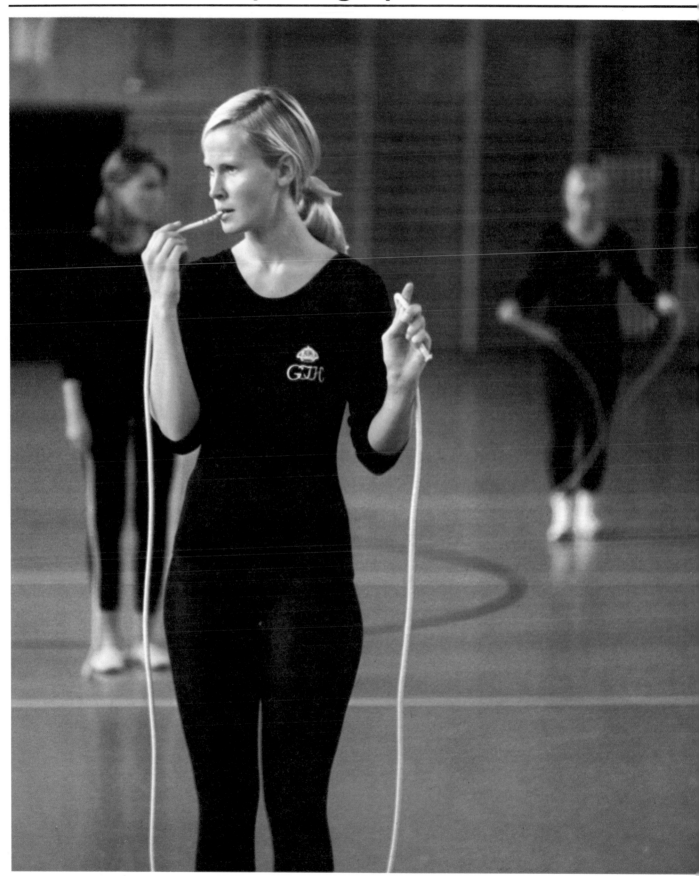

Photographing people can be approached in several ways, ranging from the studied formal pose, where the sitter is totally aware of the camera, to the completely unaware candid picture. Perhaps the easiest one to master is the middle ground between these two extremes—photographing a subject who is only partly aware of the camera because he is concentrating on something else.

People at work or at play are ideal subjects for this method, which allows more control than candid photography yet retains much of the spontaneity of catching a subject unawares. It means, too, that you don't need a studio or even a blank sitting room wall. Nor do you need a knowledge of studio lighting. And, with your subject fully occupied, he is more relaxed and you have the chance to work out the technical details at your own pace and to build a picture on more than just a face, with added interest in it.

Planning the picture

The important thing to remember with this approach is to look first and take the picture later. Identify the strong photogenic elements of your subject and plan and construct the picture in your mind. Ask yourself what you are trying to show. Is a blacksmith best portrayed by a close-up of his face or would including a shoe glowing above the coals add more to the picture? How can you capture the boisterous personality of a market-stall holder?

Think, too, about how you can include objects or activities around the home to tell more about individual members of your family—washing the car, mowing the lawn, or gardening perhaps, or doing the washing up or relaxing with a book. Thinking about photography in this way should give you plenty of ideas for taking pictures of people in everyday occupations.

At this point, let's think for a moment about staging pictures. Some photographers believe that photography should be a pure art and that staging a picture—even an action replay—is wrong. Others believe that it is the final picture that counts and that any means are justified. For the former there is the satisfaction of capturing the

◄ A telephoto lens let the photographer *John Bulmer* observe a gymnasium class from a distance. He gave the girls time to get used to his presence and waited to catch this gently reflective expression.

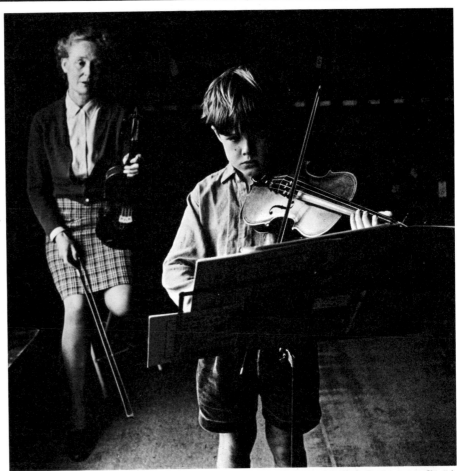

▲ White music sheets reflect light from a window on to this boy's face. Using a wide angle lens, the photographer focused on the pupil and was able to keep the image of the teacher sharp. *John Walmsley*

▼ To portray this family in a confined kitchen, the photographer used a high camera position and a wide angle lens. A higher position would have created unpleasant distortion. *Anthea Sieveking*

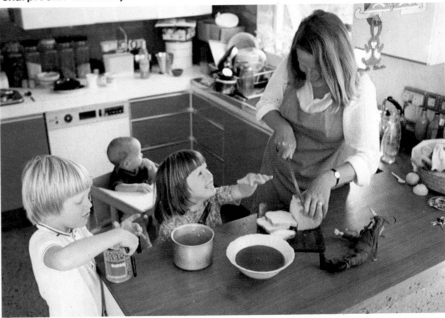

reality of the moment. For the latter there is equal satisfaction in planning and constructing the picture. It is simply a matter of choice and the chances are that you will use both approaches as you go along. Remember, though, that if you do choose to stage your picture your subject is bound to become camera-conscious. Give him time to become absorbed in his occupation again before going any further.

If you choose the 'purist' approach you will need to think ahead and try to foresee how the situation is going to develop. It is like driving. If you are aware that the car in front might brake suddenly, then you will be well prepared to take action. Translate that to photography and you cut the reaction time between the eye registering a picture and your finger pressing the button. And you will have given yourself time to find the best position from which to take the picture.

When you are photographing people who are partly aware of the camera, you will generally be working outside or using available light from a window inside. When working inside, consider the light carefully. It may light the subject's face but not his hands. Try to make sure that the light is even and reposition your subject if necessary. When working outside, don't be afraid to shoot into the light—but remember to adjust your exposure accordingly and always use a lens hood to stop stray light coming in. Use a slow film if there's plenty of light and a faster film—ASA 400, for example—if the light is not very bright.

Foregrounds and backgrounds can be a help or a hindrance. A fussy background which has nothing to do with

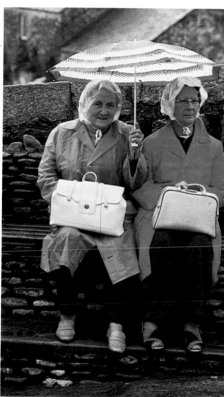

▶ To allow for dim lighting caused by rain and the shade of the umbrella, the photographer opened his aperture half a stop more than was indicated on his exposure meter.
Malcolm Aird

▼ The photographer has carefully composed this picture to include plenty of honey jars and still kept the woman's head sufficiently bold. He has wasted no space above or at the sides of the photograph.
Roland and Sabrina Michaud

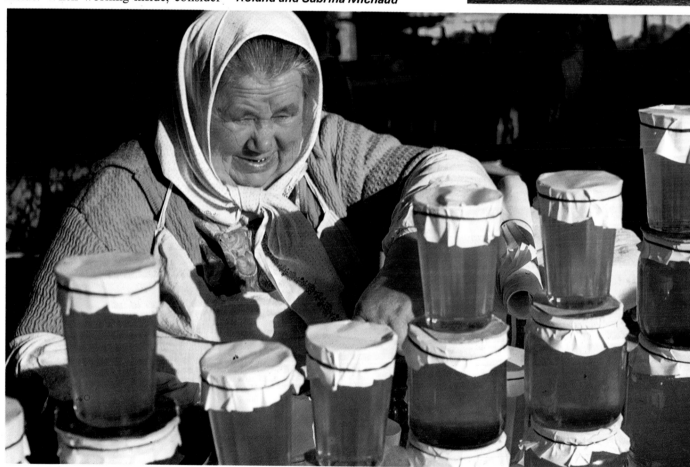

the subject is distracting. Move in close to decrease the depth of field and you will lose the background. A telephoto lens has the same effect and, to a lesser extent, so does changing the aperture setting. The larger the aperture, the shallower the depth of field and your background drifts out of focus.

Conversely, you may want to add foreground or background to your picture, such as tools of a trade or items around a home or an office. The wider the angle of your lens, the greater the depth of field and the sharper the foreground. If you can't change the lens, close the aperture by increasing the f number for a similar result. Foregrounds don't have to be pin-sharp, however. *Suggesting* a row of milk bottles in front of a machine operator at a bottling factory can be as effective as defining them.

You will see, too, how including or excluding foregrounds and backgrounds can change the emphasis of a picture. A wide angle shot of a potter with his wheel in the foreground and examples of his work in the background is first and foremost a picture of a potter. But go in as close as you can to focus on his face, so that it fills the frame, and you have a portrait of a man who happens to be a potter. So decide before you start shooting where you want the emphasis to be. Or you can try it both ways and see which of the two pictures gives the effect you want.

Shutter speeds

Like the choice of lens and aperture, shutter speeds play an important role. Often, of course, your speed will be governed by your choice of aperture. But there will be times when you can select your speed first and take advantage of it. Imagine how the harpist's fingers run up the strings during a concert. As long as the musician's head remains still, you can shoot at a low speed—about 1/30 or 1/15—to blur the fingers and hands and so accentuate the movement.

Finally, consider building up a portrait with a series of pictures, each one concentrating on a different aspect of your subject. It all adds up to a biography in photographs—a few pictures doing the job of many thousands of words.

▶ **Photographing into the sun and using a fast shutter speed to freeze movement, the photographer has avoided flare by pointing the camera down towards the laughing child.** *Malcolm Aird*

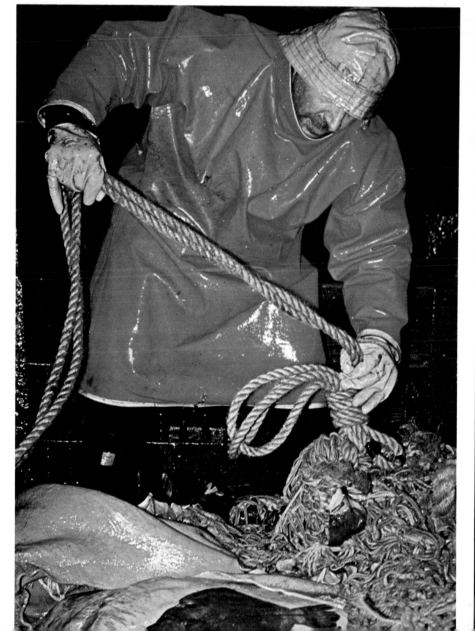

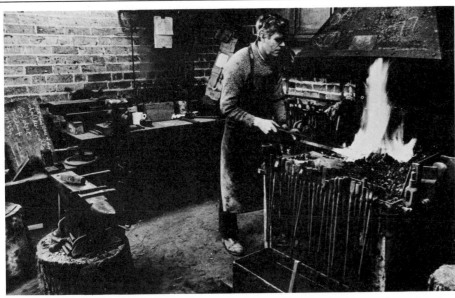

◄ To portray a blacksmith at work, the photographer used three different approaches. First, he used a telephoto lens to blur the background and emphasize the face (far left). Then he chose a slow shutter speed to accentuate arm movement (centre). Finally, he used a wide angle lens to include the man's working environment (left). *Robin Laurance*

▼ Bottom left: in this picture, the photographer has waited until the fisherman's hands were far enough apart to fill the picture frame. *Bryn Campbell*

▼ This picture is a classic action replay where the photographer has asked the craftsman to repeat parts of the process that make the best pictures. *Homer Sykes*

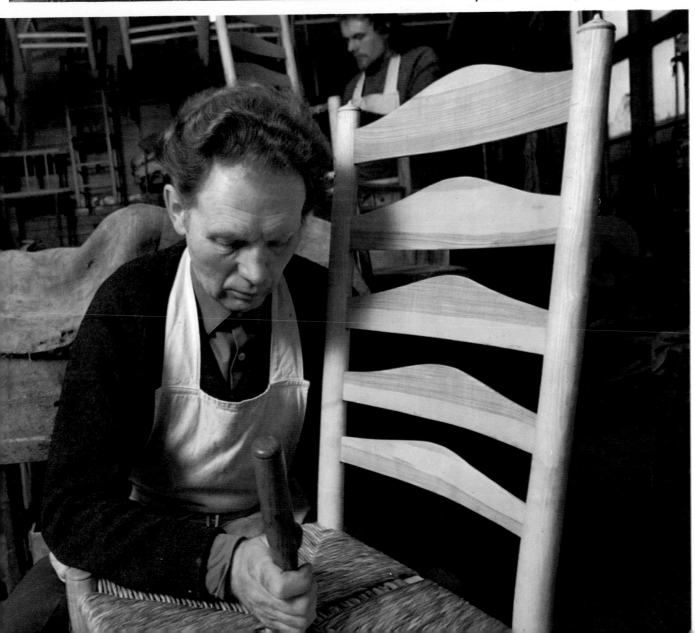

The planned portrait

There is a well-known studio photographer in London who never makes more than three negatives during a formal portrait session. He has such complete control over his equipment and subjects that three shots is all he needs to get the picture he wants.

Control, then, is what distinguishes taking pictures of people who are totally aware of the camera, from other methods. The photographer can tell his subject where to stand or sit, get him to laugh or look thoughtful, choose the position that is best for lighting or including a background—in short, he can manipulate subject and equipment to give him a picture he has already planned in his mind.

Lighting is obviously a key part of this control. The next section discusses the use of natural light for photographing people and further on there is a section on the effects you can achieve with advanced studio lighting.

Putting the subject at ease

The most important aspect of portraiture is to catch the character of the person you are photographing—a difficult task unless the subject is relaxed and comfortable. But the problem is that when people are aware of the camera, they are liable to be awkward and self-conscious.

Part of the skill of portrait photography is to know how to relax the subject. Start with a 15-minute warm-up chat, so that you help your subject to participate in the session. Remember, though, that you are still the director and you must be firm in telling him what you want him to do.

If you are photographing people on the spur of the moment—on holiday, for example, or in the street, when someones face particularly appeals to you—try to put them at ease. Explain what you want to do, ask them about themselves and keep them talking until you see they are relaxed.

But there are times when a relaxed subject will not give you the picture you want. The famous Canadian photographer, Karsh, wanted to capture Winston Churchill's famous pugnacity but, when the time came to take the photograph, he found the statesman contentedly puffing a cigar. Determined to get the picture he had planned, the photographer suddenly snatched the cigar away. Churchill looked furious—and Karsh got his pugnacious picture.

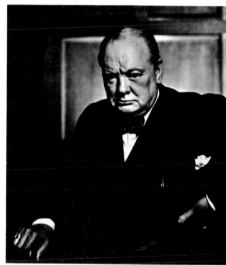

▲ *Karsh's* portrait of Churchill

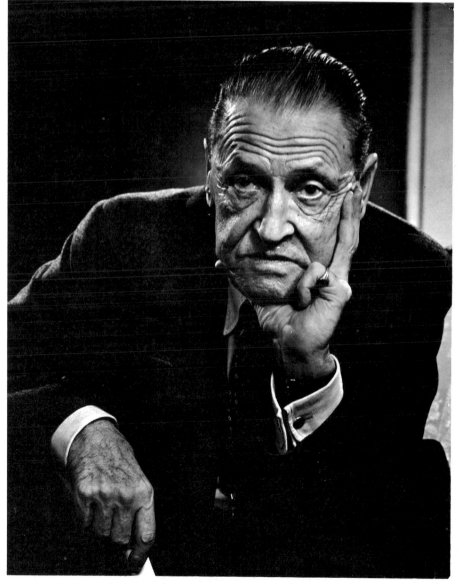

◄ By giving the author Somerset Maugham something to do with his hands, *Karsh* succeeded in relaxing his subject and getting this exceptional portrait. Back lighting appears to bring the subject forwards and prevents shoulders and head disappearing into the background.

► A bank of front lights diffused through tracing paper provided soft mood lighting for this formal studio portrait of the photographer's wife. The hazy border effect was achieved with an opaque vignette filter. *Patrick Lichfield*

Informal poses

You will usually get a more natural looking photograph if you choose a comfortable position for your subject. A forced pose will almost inevitably produce a stilted portrait. Always suggest to your subject what to do with his hands. If you leave them to dangle you will not only have an unhappy model who doesn't know what to do, but your pictures will look awkward.

Avoid having your subject facing straight into the lens. Try turning him away slightly and then bringing the head and eyes back into the lens. Or try a profile (though this does accentuate nose and chin, which may be unflattering to some people). Make the eyes the point of focus but, if one eye is markedly nearer the camera, focus on the bridge of the nose.

Photographing people in their own environment helps them to relax and also shows something of their personality. But background detail can be distracting and many photographers prefer to keep backgrounds to a minimum. It is tempting, for example, to turn an outdoor portrait into a landscape, particularly on holiday. Scenery should in fact form a pleasant but not distracting backcloth. Alternatively, you can lose most of the background by using a wide aperture to give you less depth of field. Indoors, keep to a plain wall (or, if you do not have one, cover a patterned wall with a plain sheet) unless you want the background to say something about your subject.

A tripod is not as essential as many photographers believe it to be. You will certainly need one if your chosen exposure requires a speed of less than 1/60. And if used with a cable release, it gives you the freed to move away from the camera and so break that eye-to-eye tension. Otherwise, using a tripod can be a disadvantage because it makes the session more formal and means the photographer cannot change his camera position quickly.

▲ An artist at work. The colours of his clothes are strong enough to stand out from the surroundings, which act as a pleasing backcloth. *James Carmichael*

◄ The strength of this portrait lies in its vivid colours and careful judgement. A 105mm lens at 3m enabled the photographer to go in close. *Spike Powell*

Distortions

The final results of a portrait session are sometimes disappointing. The photograph may be distorted, either because of a technical error such as the lens you use (see pictures below), or because the camera has picked up an unflattering characteristic—an inclination of the head or a blemish of the skin, perhaps—which is barely noticeable until it is put on film. By altering the angle of view, you will be able to play down its prominence. Watch out, too, for rounded shoulders, stray wisps of hair and untidy folds or creases in clothes.

Formal portraits and lens distortion

For a head-and-shoulders portrait, the subject must fill the frame because having to enlarge a small part of a negative to get head and shoulders only will produce a picture of poorer quality. So the photographer has to make sure that the image on the negative is as large as possible. But going in too close can cause distortion of the features.

The answer is to know your lenses and the distortion they produce, so that you can decide which to use in each case.

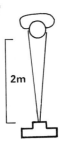

▲ The most practical portrait lens is probably the 135mm. There is no distortion of the features and the photographer does not have to get too close to the subject—an advantage if the sitter is at all self-conscious.

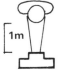

▲ Using a 50mm (standard) lens close enough to the subject to fill the frame produces some distortion on the nose.

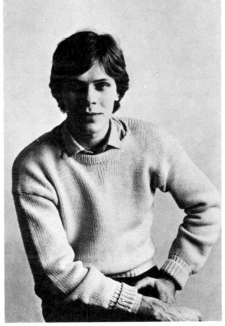

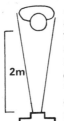

▲ Move the 50mm lens back about 2m (roughly 12 times the distance between nose and ear) and there is no distortion, but the face does not fill the frame. You can enlarge a portion of the picture, but the print will be grainy.

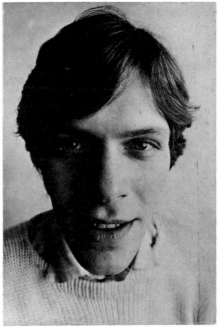

▲ If you try to fill the frame with a wide angle lens the features will become distorted. The closer in you go, the more extensive the distortion.

Using natural daylight

Many of the most successful portraits use natural daylight without any help from expensive studio lighting. Outdoors, daylight allows both photographer and subject considerable freedom of movement for easy, natural photographs. Indoors, the position of your subject is less flexible because you will need to keep him close to a window or open door to make the most of the available light. But the soft quality of diffused natural light more than compensates for the limitations of positioning in the overall effect.

Coping with sunlight

Even outdoors, some care is needed with positioning. As the photographer cannot control the direction of the sun, he must be aware of what positions will produce ugly shadows or screwed-up eyes. If the subject is facing the sun, he will almost invariably squint. But if the photographer turns the subject round so that the camera is facing directly into the sun, the lens may pick up flare and give a flat result. The closer you can get to the subject the more you will fill the frame and so avoid this problem but stray light may still hit the lens. A lens hood will help to cut out this glare. When the sun is high in the sky, glare is less of a problem but then the photographer must take care that the subject's eyes are not thrown into shadow so they look hollow.

Reflected light outdoors

Portraits are usually easier to handle in shaded areas away from strong sunlight. There is normally more reflected light than the human eye is aware of, even underneath a tree or in a shady street. Take a reading on your exposure meter to check the light level out of direct sunlight. Alternatively, you can keep to the gentler light of early morning or late afternoon. In this case, if you are using colour film, open up one stop more than suggested on the film guide (which is generally estimated for bright sunlight).

If part of your subject's face is in shadow and it is not convenient to move him, try reflecting light on to the darker side of his face with a sheet of white cardboard. You may, for example, be shooting indoors with your sub-

▶ In keeping with the American Shaker community's Puritan traditions, the photographer *Chris Schwarz* used only natural daylight without fill-in light for his portrait of a community organizer.

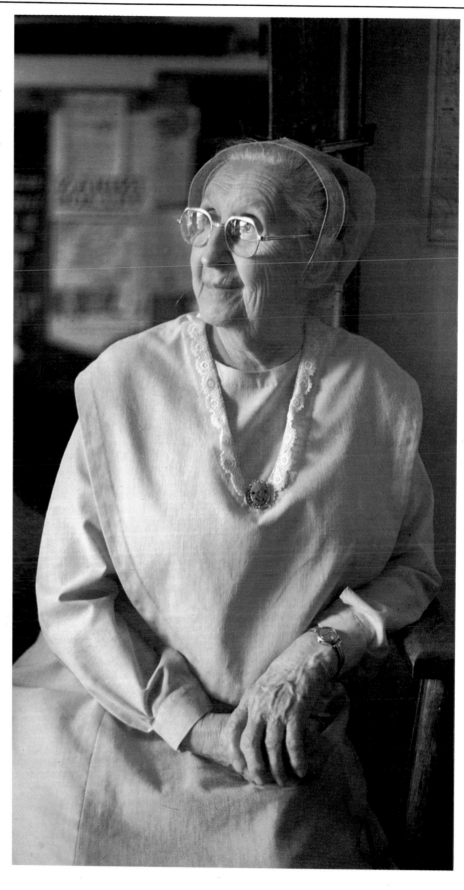

24

ject side-on to a window. Prop up the piece of cardboard on a table (or attach it to an improvised stand such as a standard lamp) so that it is on the shadow side and facing the window. Or you could ask someone to hold up a sheet of newspaper which, despite the black print, reflects light very well.

Using shadows

Sometimes shadows can work in your favour—by hiding such defects as warts, scars and other skin blemishes. In any case, if your subject has any obvious blemishes of this kind, make sure your camera angle does not draw attention to them—unless, of course, you want to emphasize them to make a particular point. A good portrait does not have to be a flattering one. Softening the wrinkles on a middle-aged woman's face may be flattering, but the wrinkles are part of her and tell something more about her.

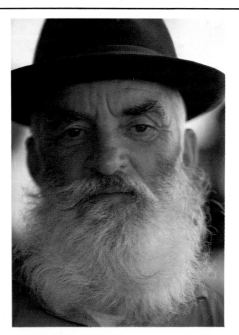

◀ A long lens enabled the photographer to get a really close-up picture of this old man while keeping a comfortable distance away from him. The lens has also thrown a potentially distracting background out of focus. Natural daylight, coming from the side, has caught the detail of his beard and lined face. *John Bulmer*

▼ Here, the photographer has used a 90mm lens (slightly longer than standard) for his close-up of two schoolboys. He was able to stand a comfortable metre or so away from his subjects with the light coming straight on to their faces through a schoolroom window. *John Walmsley*

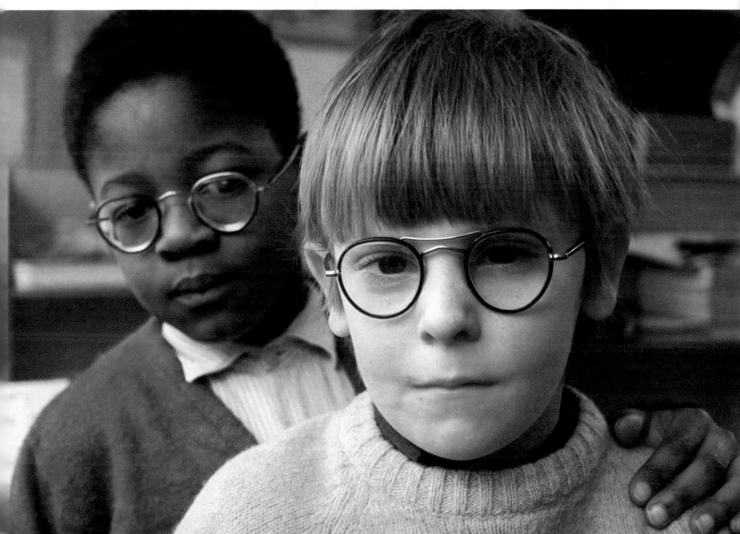

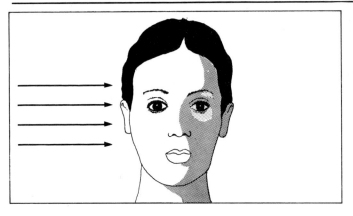

▲ Light coming in from a window on the subject's right has cast ugly pronounced shadows across the left-hand side of the face and neck.

▼ A piece of white board held up on the left of the subject reflects light on to the darker side of the face and eliminates some of the shadows.

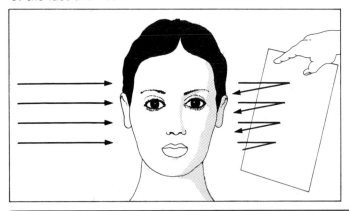

Coping with shadows

One of the main problems in portraiture, whether you are taking pictures out of doors or inside, is that the shadows created by light falling on the contours of the face can make your subject look ugly, ill or even deformed. The best way to understand how shadows are formed is to experiment with them. Get a friend to stand in bright sunlight or near an electric light bulb and notice what happens as the light strikes the face at different angles. See how light at the side causes a shadow of the nose across the cheek, or light from above forms shadows on the eyes or under the chin.

You can often deal with each problem by asking the subject to alter the angle of his head or by moving your own camera position. Or you can fill in the area in shadow by reflecting light to make it less dark.

Try moving the light source closer to your subject to see how distance affects the shadow cast. This will give you an idea how to deal with problems.

Problem: almost everything is wrong. Shadows have blackened the girl's eyes, emphasized smile lines and obscured her forehead, neck and part of her mouth.
Solution: move the light to the front and slightly to the side. Use a white board on the shadow side.

Problem: side light from the girl's left casts a shadow of the nose across her face and leaves her left side in darkness.
Solution: a sheet of white board on the girl's right side would have reflected light on to the shadow side of her face.

◄ Far left: the photographer has not allowed for shadows cast across his subject's face by the light on her right.

◄ Left: when a sheet of newspaper was held up to reflect light back on to the shadow side of her face, he got a more even result —and a picture worth framing.

Problem: hats cast unwanted shadows, particularly if the sun is high in the sky and the hat is a large one.
Solution: remove the hat or use a white board to reflect light up under the chin and on to the face.

Problem: here the photographer has allowed his own shadow to fall across his subject's face and also her body.
Solution: the photographer should have altered his viewpoint or changed his subject's position.

Problem: light from the girl's right has caused heavy shadows on her neck.
Solution: a white board held at an angle on the left would have reflected light under the chin.

A simple studio

While a studio with its sophisticated lighting equipment offers the ultimate in controlled photographic conditions, it is by no means essential for successful portraiture. Even the most modest living room can be turned into an improvised studio with a few simple adaptations to lighting, background and props.

The natural light through a window is often sufficient, particularly if you use faster film—say 400 ASA, which is available in both colour and black and white. If there is not enough light, however, you can supplement it without using more advanced lighting which is fully discussed in later chapters.

One way of providing extra light indoors is to use flash, either pointed directly at the subject or bounced off a light-coloured ceiling or wall. Bounce flash gives a more even distribution of light, handy if you want to include something of the background, while direct flash focuses attention on the subject himself. The problem with flash, however, is that you cannot see the effect it is creating before you release the shutter.

The more satisfactory answer is to substitute photoflood bulbs for normal bulbs in standard or table lamps. These are available from 275 watts upwards and, as a guide, a room about 5m square with light-coloured walls and ceiling and one large window may need only one 275-watt bulb. These bulbs get very hot, so remove lampshades before switching on. And, if you are taking colour slides, use tungsten balanced film.

Curtains at the window can be used to create an effective background by draping them behind the subject and fastening them against the wall. If your curtains or background wall are patterned, however, use a plain sheet which is less distracting.

Start by giving your subject a simple household chair. He can sit on it, lean on it, rest a foot on it or sit back to front on it. A Victorian armchair lends itself to a formal portrait while a kitchen chair creates a casual look.

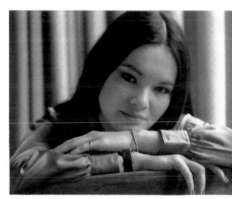

▲ For an atmospheric portrait the photographer used a black stocking over the lens, and 400 ASA film for graininess.

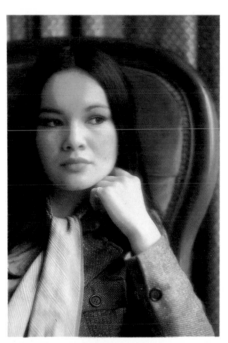

◄ Because she was comfortably seated the subject was able to stay quite still while the photographer took this photograph using a tripod and slow exposure.

► To use his living room as a studio, the photographer tied one curtain back to let in maximum light and positioned his subject close to the window. Because it was a dull day he had to use a slow exposure and a tripod. A helper held a piece of white board to reflect light and no other source of light was used. For some pictures a black stocking stretched tightly over the lens and held with a rubber band helped to diffuse the light.

► Far right: by positioning his subject so that light from the window was reflected back to her shadow side, the photographer was able to use a slow film to give him a good quality print.

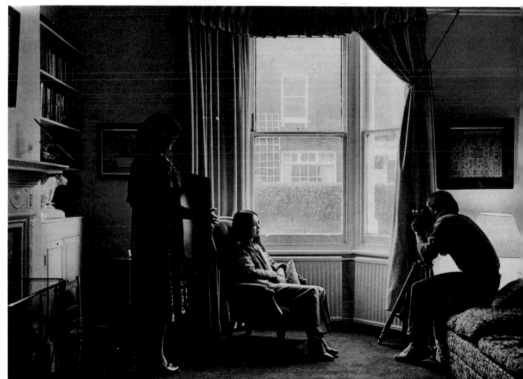

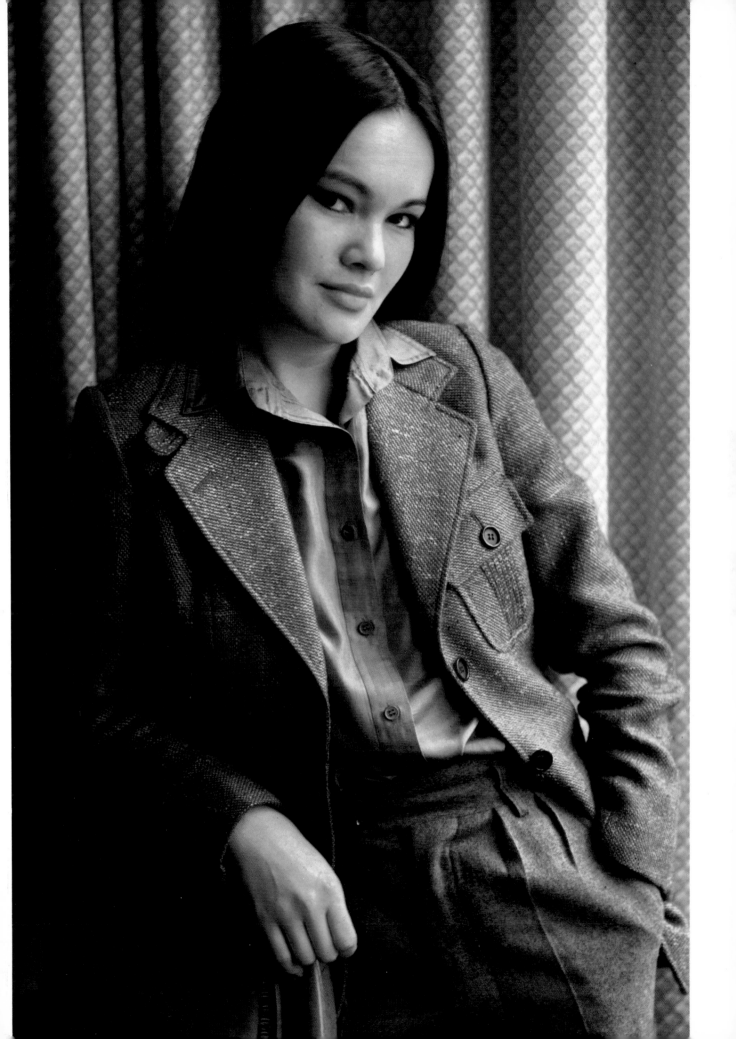

Formal portraits on location

Portraiture is not concerned exclusively with physical likeness. Workmates, friends and family are all subjects where the photographer's aim is to convey the personality of the subject, and this is not wholly dependent on the exact rendering of physical detail. It is easier, for example, to remember Charlie Chaplin's walk, his hat and cane, than it is to remember his face.

Facial expression tells a great deal about a person, and some portraits—normally those taken in a studio, where the photographer has most control—depend solely on expression for their impact. In this first of two articles, however, we deal with the other elements that go into portraiture on location, the first of which is choosing a background.

Choosing a background

To choose a background which expresses character you need to know your subject, which may involve some prior research. Learning about the subject may mean literally gathering information—or it may mean breaking the ice getting to know a stranger.

With friends and family—people you already know—a certain background may seem an obvious choice. However, research should not be neglected: often people have unsuspected interests or hobbies which allow them to be shown in new surroundings or in a new light. Photographing people at home or at work puts them at their ease, and is more of a challenge than photographing in a studio.

You should consider *contrasting* as well as complementary backgrounds. A photograph of an engineer in a workshop may be very effective, for example, but take him out of that workshop and place him against a plain white background holding a spanner: suddenly every spot of grease, the lines on his face and the spanner gain in emphasis. On the other hand, environment may sometimes make the picture. An old lady against a plain background is just an old lady: surrounded by family and mementoes she becomes someone very particular.

The background, or lack of one, is an integral part of a portrait, implying something about the subject's character by its colour, tone and sharpness apart from any specific information it may contain.

Lighting

Lighting on location is the portrait photographer's most difficult technical problem. Often the existing light cannot be controlled, although it can be modi-

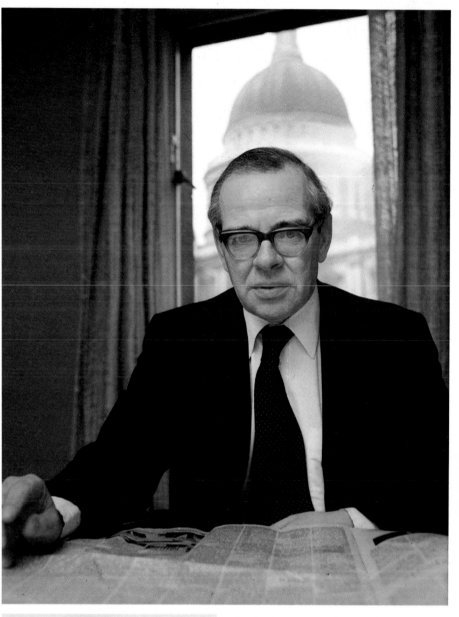

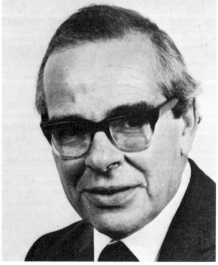

BACKGROUND INFORMATION
A good portrait reveals something of the character of the subject from his expression, but by using a relevant background you can enlarge on this to show more of his way of life.

▲ Max Fisher, Editor of the *Financial Times*. Behind him the familiar dome of St Paul's Cathedral locates the shot firmly in the financial heart of the City of London. In front of him the newspaper he edits is spread out on the desk—unmistakable because of the traditional pink paper. *Roger Perry*

◄ The same subject, photographed for a passport picture. His expression is similar, but without the setting the viewer can deduce little about him.

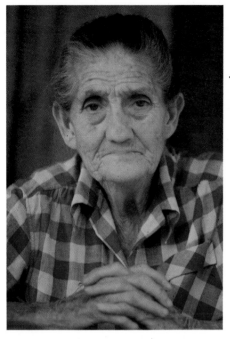

BACKGROUND FOR ATMOSPHERE
▲ *John Bulmer* photographed this old
Apalachian woman for an article on
poverty. Here he concentrated on
her dour expression with an 85mm lens,
leaving the background a blur.

▶ With a 28mm lens showing the family
setting, the woman still dominates
but the picture carries much more
emotional power.

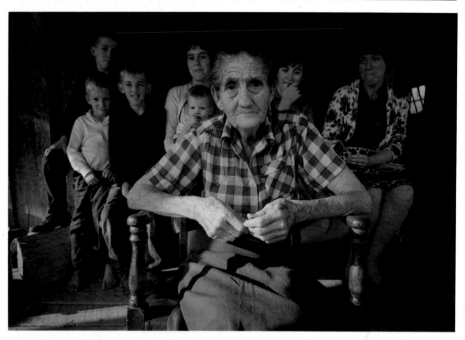

BACKGROUND FOR COMPOSITION
▼ Photographing by low available light at a wide aperture, *Clay Perry*
used the sharply disappearing parallels of this malting house to centre attention
on the figure. The wide angle lens exaggerates the size of the shovel of barley
to complete the story.

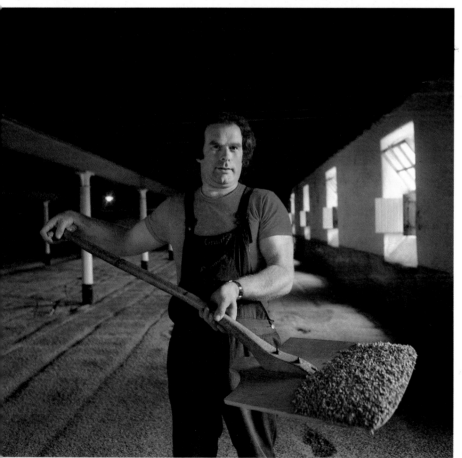

fied with reflectors, diffusing screens
and fill-in lights.

Window light can be ideal, though a
very large expanse of glass is necessary
to light more than one or two people, so
group portraits normally need to be
taken outside. The closer your subject
is to a window, the greater the contrast
between highlight and shadow areas.
You can reduce this contrast by 'filling
in' the darker side by means of a reflec-
tor, or you can move your subject farther
from the window, where the contrast is
less but the light is weaker.

Available light sources cannot be shifted:
the subject must be moved to suit the
light. Consider the way a face appears
to change as the head turns within a
beam of light. With the light behind,
the hair becomes a halo, and a reflector
is needed to give detail on the face. As
the head turns, first the cheekbone and
the tip of the nose are lit, leaving the
eye and the other side of the face in
shadow. Slowly the highlights grow and
the shadows diminish until they are
about half and half across the whole
face—a very dramatic effect in strong
light. With the light threequarters on to
the face, you have the minimum amount
of shadow for a portrait. Lit full on
from over the photographer's shoulder,
the face can appear too flat and the
subject may look dazzled.

Posing your subject

Posing people for a portrait is like arranging a still life: the rules of good composition are the same. Whether you want the subject to look natural or rather dramatized, the picture should work as a whole.

Viewpoint also affects the way the subject is presented. A high viewpoint makes the subject appear smaller and more vulnerable, whereas a low viewpoint exaggerates his stature.

When the light allows, it is often best to ask the subject to sit or stand as he pleases and compose by shifting your own position.

Equipment

In portraiture, a sturdy tripod is a great asset in preventing camera shake and leaving your hands free. Once the composition is set you do not need to look through the viewfinder, which allows you direct contact with your subject as you take the photograph without your face being obscured by the camera. For this you may also need a cable release, preferably one long enough for you to move around freely.

Almost any kind of camera is suitable for portraiture. If you intend to concentrate on the face or head and shoulders, the ideal focal length of the lens is short or medium telephoto (85 to 135mm on a 35mm camera). These lengths allow the photographer to stand back from the subject, and the relatively small depth of field allows the option of putting a background out of focus.

If you want to include a background use a wide angle lens, but these can distort the features of your subject if they are used too close.

With lenses of 135mm and longer you may be forced too far from your subject, and start to lose the rapport on which good portraiture depends.

Whichever lens you choose, always focus on the eyes. If one eye is nearer the camera, focus on the closer eye and stop down to gain depth of field. The eyes attract our attention in a portrait, and if they are out of focus it will lose much of its strength.

Directing your subject

Any directions you give during the portrait session need to be clear, firm and polite. You should have already worked out what effect you want and have organized as much as possible before your subject appears.

Never allow your concern with equipment to interrupt the session. Though exposure readings and minor adjust-

ments to lighting or viewpoint will not disturb the subject, a change or background might. If you spend too much time fiddling with equipment the subject may become bored and self-conscious, and may lose confidence in your ability. Try to set up a rapport with the subject to help him relax and forget the camera.

It usually inspires confidence to explain how you want the portrait to look and to get your subject's co-operation. He may feel less self-conscious and you may have to direct him less.

For example, if you want him to look out of the frame and you have a long shutter release cable, instead of asking him to look away, walk to where you want him to look, talking all the time. He will follow you with his eyes, and the ex-

pression you get in your photograph will be far more meaningful.

Sometimes more drastic measures may be called for. The early English photographer Julia Margaret Cameron used to bully her subjects mercilessly, yet the results remain fresh and direct more than a hundred years later.

It is a useful lesson in portrait photography to put yourself in front of the camera—both in thought and in deed. Photographers in general tend to dislike having their picture taken and it may help to consider why. Ask yourself 'How does my subject see me?' and modify your behaviour accordingly. It is the interaction between subject and photographer that makes the portrait: the camera only records it.

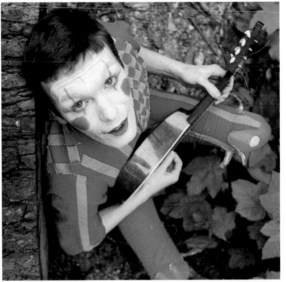

◄ *Laurence Lawry* chose a wood as a background for these portraits of a clown for its magical atmosphere and as a foil for the brightly coloured costume. Using a 28mm lens, Lawry caught the clown unawares to get this relaxed pose.

▼ Even with a standard lens, Lawry likes to emphasize the foreground in his portraits. Though the figure occupies only a small proportion of the picture area, it gains emphasis by contrast with the rough texture of the tree trunk.

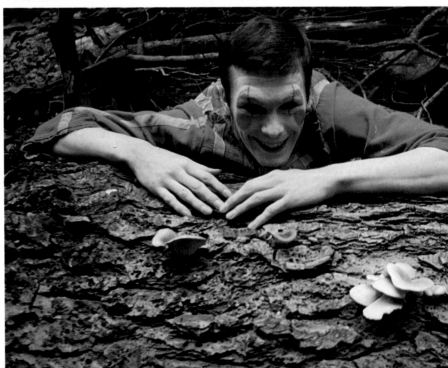

▲ A wide angle lens can distort your subject's features if you use it too close. In many of his wide angle shots, Lawry poses the subject so that something other than the face is closest to the camera so that this is what appears distorted.

▶ Apart from its visual effects, Lawry chooses a wide angle lens so that he can remain close to his subject throughout the session. It also means that he can alter the background composition by using slight changes of camera angle.

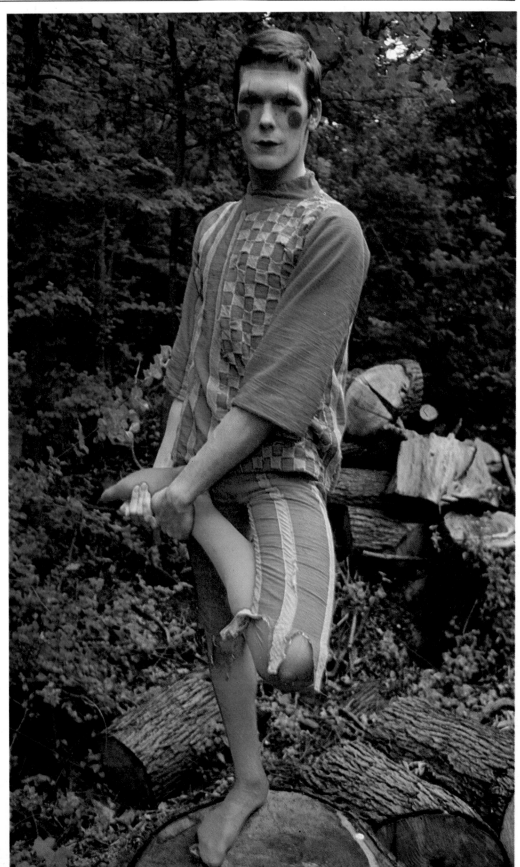

Formal portraits: how to light them

Even out of context—standing in a bare studio—a person reveals a lot about himself just by the way he dresses and by the way he stands. These visual clues help the photographer to get to know his subject, and give ideas for portraying him on film.

A portrait should be more than a record of someone's appearance, it should reveal the character of the sitter. On location the subject's own environment can be used to express this. In the studio it is up to the photographer to reveal character through techniques such as posing and, most importantly, lighting.

Organizing a studio

If you can borrow or hire a studio (perhaps through a photographic club) lights and backgrounds will be made available. If you have to create a temporary studio at home, all you need is a plain background, a camera and tripod, some lights and a few reflectors. The lighting can be either tungsten photofloods or flash, and you can make your own reflectors out of pieces of aluminium foil and white card. If you don't have a plain wall to use as a background, simply pin a large piece of felt or background paper to a wall. In an emergency you can use a plain-coloured sheet to cover up patterned wallpaper.

The important thing is to have your studio set up before the sitter arrives, so that you can immediately turn all your attention to him. Nothing is more boring than waiting around while photographers set up their lights.

▼ *Chris Hill* took this self-portrait to inaugurate his new studio. His 24mm lens gives a vast background, and the single roll of backing paper—enough with a longer lens—becomes humorous.

▲ ▶ Working on location, *Clay Perry* used a barn as a studio for these shots of Jenny Agutter and Alan Badel. He took care to exclude all light other than direct light from the barn door.

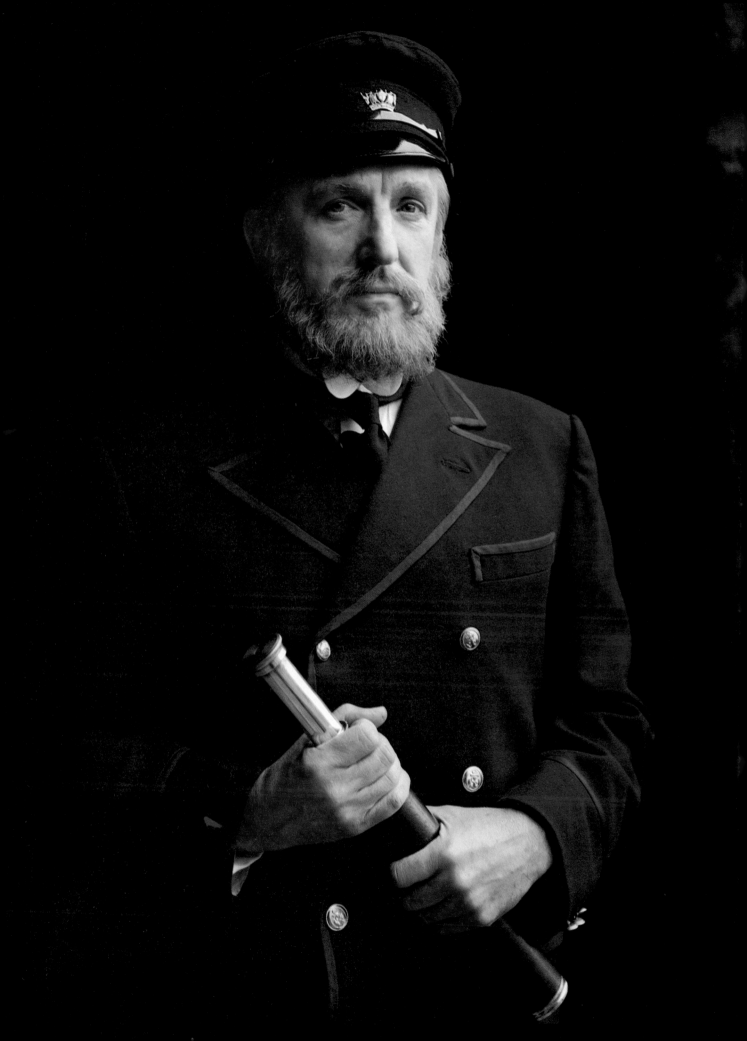

Basic lighting

Always start with a single key light. The choice of a broad, medium or narrow light source will set the mood of the portrait.

Place the key light anywhere on an arc that starts at the camera position and ends up at right angles to, or even slightly behind, the subject. The light should not be lower than the subject's face—a light shining up into a face can look horrific—nor at an angle of more than 60° down on to it, which would give very heavy shadows under the eyes, nose and lips. As the angle between the key light and the camera increases, in any direction, so the highlight areas decrease and the shadows take over, altering the appearance of the subject and the mood of the shot. The larger the shadow area and the more hard-edged it is, the more dramatic the shot and often the more assertive the subject will look.

Large highlights and soft shadow give the portrait a gentler, more romantic feeling.

Once you have positioned the key light, you should then decide whether you need more lights or reflectors. You may not. One effective set-up ('Rembrandt lighting') uses one light to pick out specific detail—perhaps just the top of the face and a hand—allowing the rest of the shot to fall off rapidly into shadow.

The simplest way to supplement your key light is to use a reflector to bounce light into the shadow areas. An extra light, preferably a broad source, can fulfil the same function.

A FOUR-LIGHT SET-UP
Used together, these four studio flash lights make the portrait opposite: none but the key light works on its own.
KEY LIGHT
This broad light source is at an angle of 45° to the model, throwing a deep shadow on one side of her face which helps to emphasise the bone structure.
FILL-IN LIGHT
Bounced from a white reflector placed parallel to the model-to-camera line, the fill-in throws a softer light on the shadow side of the model's face.
HAIR LIGHT
Shining down on the model from above the reflector, this narrow light source highlights the hair, making it stand out against the background.
BACKGROUND LIGHT
A broad, diffused light source, shone directly onto the backing paper kills any background shadows and gives the final picture a lighter feel.

More than one light

Extra lights may be used in many different ways. A broad light source directed into shadow areas may act as a fill-in if a reflector does not give a strong enough effect. But be careful that the fill-in light does not cast its own shadow: noses with two or more shadows make the subject look rather peculiar. If you find your fill-in light causes a shadow, move it farther away or bounce it off a reflector.

An extra light may also be used to provide a highlight. Shining directly downwards it will make the hair on the top of the subject's head shine: placed behind and slightly below the sitter's head it will create a rim of light around the whole head and shoulders. Be careful that this rim light does not shine into the lens,

however, and keep it far enough away from the sitter that he does not become uncomfortable. Placing a rim light too close also makes each hair appear like a wire and creates too dazzling a halo.

Lighting the background

Extra lights can also be used to illuminate the background so that the subject does not seem to loom out of deep shadow. To light the whole background area evenly, keep the background light at a distance and use a broad source.

An unevenly lit background can be used to good effect, however, either by positioning the lightest part of the background behind the part of the subject in deepest shadow, or vice versa.

By combining a background light and a

▼ KEY LIGHT ONLY

▼ HAIR LIGHT ONLY

▲ FILL-IN LIGHT ONLY

▲ BACKGROUND LIGHT ONLY

36

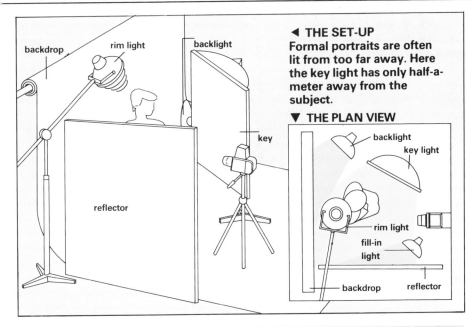

◀ **THE SET-UP**
Formal portraits are often lit from too far away. Here the key light has only half-a-meter away from the subject.

▼ **THE PLAN VIEW**

rim light you can give your portraits an open, airy feel: to do this you will have to allow extra space between the background and the sitter for both lights.

There is no correct number of lights to use for a portrait, but a good rule of thumb is 'the fewer lights the better'. If more than two lights and a reflector are in use, take another look: perhaps you can use the key light to light the background as well.

Flattering

When you decide how to light a face, remember that everyone is a mixture of attractive and less attractive features. Choose which you wish to emphasize and avoid drawing attention to the rest. The simplest way to play down a feature is to pose the sitter so that it does not show.

Shadows emphasize features. Strong oblique lighting, for example, will emphasize lines and wrinkles whereas they tend to disappear under more direct or diffused lighting. In the same way a strong key light to the side of the face makes it appear thinner because the side shadows emphasize the bone structure whereas a broad light from the front makes it seem flatter and rounder. A bald head can be made less obvious by lowering the camera angle, and double chins can be dealt with by raising it. If your subject has both, decide which to play down by means of your camera angle and be careful not to emphasize the other with either strong highlight or heavy shadow. If the subject has a big or a bent nose a profile will only draw attention to it: in this case use a rather longer lens, move the camera back and pose the subject face on in a broad, frontal light.

Help your subject relax

While manipulating the effects of lighting and camera angles, it is tempting to treat the person in front of you like an inanimate object. But he is not, and if you spend too much time on technicalities he will almost certainly become stiff and tense.

Good lighting can do a great deal to bring out character, but if you become too preoccupied with it, your subject will either be a bundle of nerves or so bored that he is no longer worth photographing. Practice lighting techniques on a long suffering friend, observe the effect of lighting at the cinema, on TV, in paintings and photographs. Analyse the effects you like, and come to your portrait session armed with ideas and the know-how to put them into practice.

▲ **FOUR LIGHTS TOGETHER**

Double portraits

Photographing two people together is considerably more challenging than taking a picture of just one person—for a number of reasons. Firstly the composition needs more consideration; secondly the lighting can be more complicated; a third factor is making exposure when both models have good expressions; and yet another consideration is finding a way to establish—or capture—a relationship between the people themselves.

If you are shooting a posed portrait you will be able to control these factors to some extent: for candid shots, however, you simply have to watch and wait until all these elements fall into place.

Composition

Composition in a posed double portrait is largely a question of a happy balance between the two faces within the frame. Even with a three–quarter or full–length photograph it is the subjects' faces to which the eye is first attracted.

The most commonly used method of composition is to arrange the subjects so that their faces fall on a diagonal—one slightly to the left and above the centre of the frame, say, and the other below and to the right. This usually creates a more attractive shape within the picture area than positioning the two faces side by side, though the balance will still give them equal importance—particularly if they are kept on the same plane of focus.

Pictures in which the two faces are side by side can work too, but will need some additional element of composition—using the subjects' hands or arms for example—to avoid a static arrangement.

A degree of overlap, with one head in front of the other, can also work successfully, particularly in a tightly framed picture, creating a more interesting shape.

Composition has a considerable effect on the relationship between the two people in the picture: one of them can be made more dominant simply by having that person's face closer to the camera and therefore larger. Another way to make one face dominate the picture is to have it square on to the camera while the other is angled to show a three–quarter or even a profile view. On the other hand the main subject might look into the camera and the secondary subject be looking towards him or her—a technique often used by wedding photographers to

◄ To give them equal emphasis, *Clay Perry* posed actors Michael York and Simon McCorkindale at the same focusing distance but with their faces on a diagonal line (above) offset by a line of hands.

► The angle of their faces and bodies unifies this couple: hands, arms and shoulders form an intimate circle (above), lending a conspiratorial air. *Homer Sykes*

◄ With mother-and-child portraits, one problem is to prevent either one from dominating the shot entirely. *John Garrett* posed this pair to show the mother's protective role (above) without obscuring the baby. Their eyes are on the same level which emphasizes the difference in the size of their faces—and their reactions to the camera.

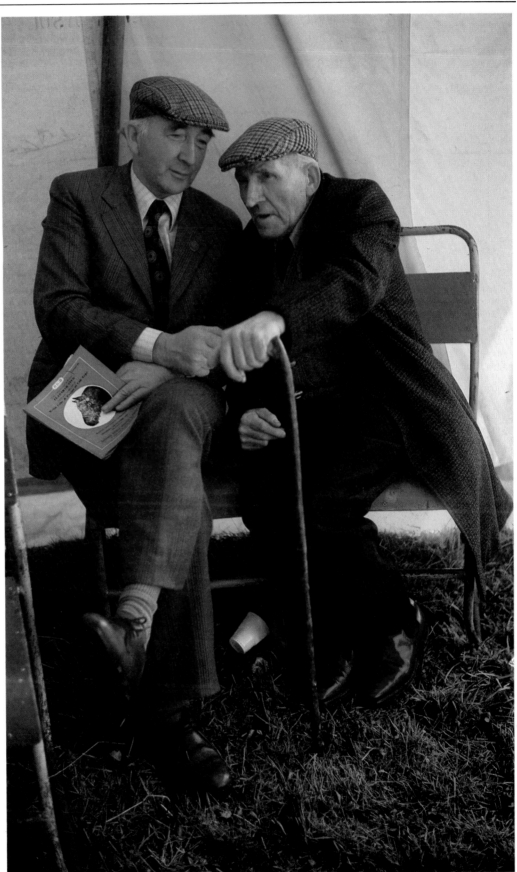

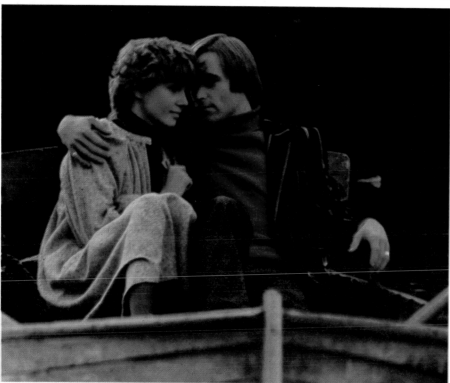

◀ Here the backlighting creates a halo of light around the couple and puts their faces in soft shadow. As well as contributing to the mood of the shot, this also appears to bring the subjects closer together, contrasted against the dark background. *John Garrett*

▶ Background can say a great deal about your subjects. Compare the shot of the couple on the cart with the small section of the picture below. Out of context the figures seem to have little to do with each other: seated together on the cart they reveal their habitual relationship. *John Garrett*

underline the starring role of the happy bride.

Conveying a relationship

It is easy to suggest an affectionate and loving relationship when a bridegroom is looking at his bride—in the right way—and this can be enhanced if he places a protective hand on her shoulder or arm. Any form of physical contact between two subjects will have a strong influence on the apparent relationship between them. A man and a boy standing together without contact could mean very little, but if the man has his arm around the boy's shoulder it immediately implies a family bond. The more intimate the gesture, the more intimate is the implied relationship: pictures of husbands and wives, for example, with their faces in contact can be extremely expressive.

When directing your subjects in this way, however, it is vital that they feel at ease and can relax in the positions you suggest. Some people are quite naturally extrovert and demonstrative, but many are shy of showing physical affection, especially in front of the camera, and nothing looks worse than a picture of this type where the subjects appear to be self–conscious. It is far better to direct your subjects bearing in mind how they behave together naturally rather than attempt to impose anything on them.

The background to your picture is another factor which can influence the apparent relationship of a couple. A plain background will say nothing at all about them, whereas a domestic scene in the background will help to imply a family relationship, and a soft focus woodland scene will add considerably to a portrait of two young lovers.

Lighting

Lighting for two faces can be more difficult to organize than for a single portrait. Bear in mind also that the mood created by lighting can be used to underline the relationship of the couple.

The difficulty is that the effect of directional light on a face changes with the smallest shift in angle, and where two faces are being lit it requires a degree of compromise to ensure a pleasing effect on both, particularly when the relative positions of the two heads are quite different.

The best lighting will allow a fair degree of freedom for the subjects to move their heads and change their positions in relation to one another without the constant need for alteration—and that means a soft and not too directional light. A broad, diffused single source with a fill–in reflector and perhaps a little backlighting will be much more satisfactory than a complex set–up with several lamps. The light from a

north–facing window is ideal for indoor portraits, and outdoor direct sunlight is best avoided in favour of open shade. You should also be aware of the mood that your lighting creates—whether it contributes to the feeling of the picture and the relationship of the couple. It could be quite inappropriate to use sombre, low–key lighting for a portrait of a bride and groom, though this might be ideal for a more formal portrait of two company directors.

Expressions

The last but by no means least of the problems of taking double portraits is to capture two good, characteristic expressions at once. There is no easy answer to this: since there is twice as much chance of a shot being spoiled by one of the subjects frowning or blinking or looking away at the wrong moment, you will need considerable patience. You will probably also find that you need to shoot more frames for a double portrait than for a single one, and you would be wise to, since it is more difficult to watch two faces than one. Rapport with the subjects is even more important than with a single portrait and it is an advantage to have the camera on a tripod so that you do not have to remain glued to the viewfinder. The results will be far better if you can communicate with and watch your subjects directly.

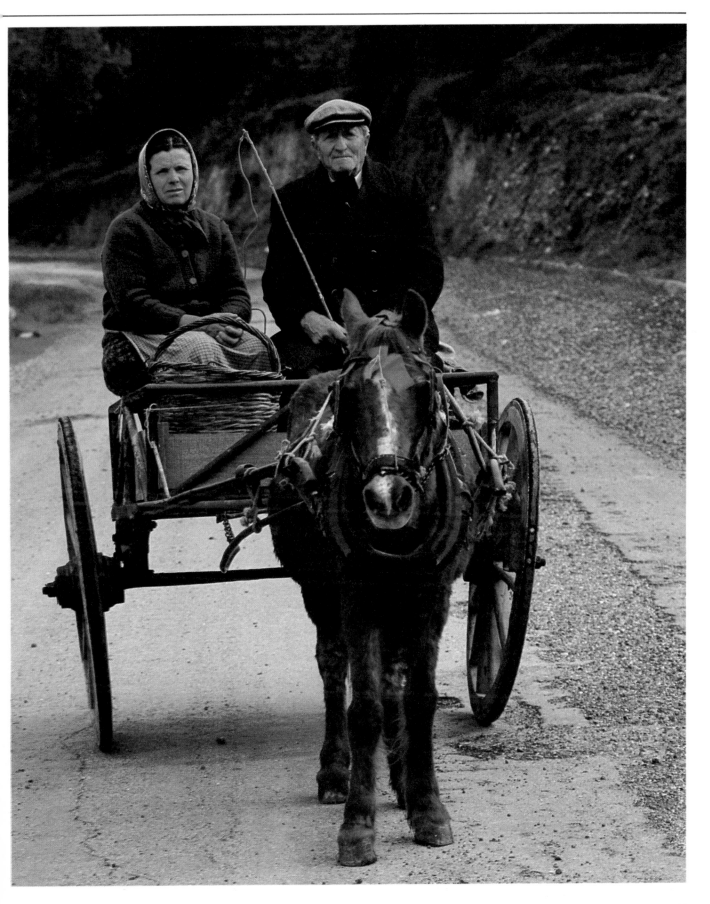

Taking your own picture

▲ How do you see yourself? And how does the camera see you? A group of photographers set up a pavement 'studio' (backcloth, camera and cable release), for passers-by to take their own portraits. *Handsworth Self Portraits*

Many people shy away from taking their own portrait. Don't: it can be great fun. Since you are your own photographer, you have no need to feel self-conscious, and this will show in the pictures. If you need a model you can do the job yourself. If you want to keep a record of yourself, if you want a picture to send to a friend, if you just want to experiment, it is always useful to be able to take your own picture.

Different approaches
There are various ways of setting about self-portraiture ranging from the most elementary to the most complicated.
Holding the camera at arm's length and simply pressing the shutter release gives a spontaneous result. With an SLR you will need a wide angle lens—such as 24mm or 28mm. Hold out your hand at arm's length and focus carefully on it, stopping down to f5·6 or f8 to make sure of a sharp image. Then hold out the camera so that you can see your reflection in the lens. If you hold the camera above you, you can see your whole body foreshortened. The wider the angle of your lens, the more your picture will show distortion.
If you have access to a fish-eye lens, include the whole room or landscape in the background, receding sharply away behind you. A shutter speed of 1/125 will freeze your expression.
If you shoot at 1/60 or slower speeds while holding the camera completely rigid at arm's length, you can spin slowly round. Then you will be panning on

yourself, giving a sharp image of your face with the surroundings completely blurred. But beware of shadows if you try this approach: they should not be too strong since they will change as you move, especially with an overhead light.
A delayed-action time release will give you about ten seconds to position yourself in front of the camera after you set the controls. You will need a firm support for the camera—preferably a tripod—and you will have to prefocus on the point where you will be, so choose a background object to stand up against (such as a tree) or substitute some other object for yourself when focusing the camera. Count out the seconds before the shutter is released so that you are prepared for the exposure, and try to look as relaxed as possible!
A long cable release is very useful for setting up more complicated shots, as it means you have complete control over the timing of the shot. With a cable release you can incorporate movement; you can jump in the air or fling back your head, though you will have to make sure that the camera angle allows for this. In this case the background will be static, but a slow shutter speed will show you—or parts of you, such as your hair—as a blur. You can hide the cable release behind you, or operate a bulb air release with your foot.

Reflections
Mirrors offer limitless possibilities for self-portraiture—particularly if you position them so that they reflect into one another to give infinite reflections extending, apparently, into the distance. You can set up the picture so that it includes the camera or you can hide it. When you set up a shot in a mirror, remember that you will need to see the camera, not your own reflection, to ensure that the camera is seeing you. Once more, you can substitute some object for yourself while you focus the camera. Always focus on the reflection, rather than the surface of the mirror.
It will require a certain amount of experimenting to find the best position for a self-portrait in a mirror, but with a little imagination you can get some very unusual results. Try to think in reverse: it is the light falling on *you* rather than the camera that you see in the mirror that counts, so if there is something obscuring your vision of the light source it means there will be a shadow across your face. On the other hand, if you are using back lighting, your figure will block the light so that it does not reflect into the lens.

Other reflective surfaces—such as glass or shiny metal or even water—will work just as well, providing that you are well lit and the reflecting surface is in shadow. Bear in mind that there will be a colour cast if the reflecting surface is coloured. With sheet glass there will often be a double image, since the image is reflected off both surfaces. This double image is almost impossible to avoid but you can try moving the camera into a central position (with the camera back parallel to the glass), or changing to a longer lens. A polarizing filter will help to cut down the ghosting.
Convex surfaces act like wide angle lenses and take in a good deal of the surroundings, so if there are other people around you, make sure that you want them in the frame.
Distortion adds another element to self-portraiture. Try photographing yourself through glass objects such as bottles or blown glass. Your exposure reading will be affected if the object is thick or coloured, so take your reading from your hand *through* the object. Ripples on water also create interesting patterns, giving the outline of your figure a jagged edge and a textured appearance.

Other ideas
A shadow of yourself is a self-portrait in silhouette. Expose for the surroundings rather than the shadow itself, otherwise you will get an over-exposed picture. Try varying viewpoints—rest the camera on the ground, for example, or point it down a staircase to photograph the shadow cut by each stair. Be careful that the foreground is not too close or it will reproduce as an out-of-focus blur. Avoid this by angling the lens slightly, supported on a lens cap.
Multi-exposures make fascinating self-portraits. This can be done accurately with SLRs that have a system of exposing the film without advancing it, or with large format cameras. If you are taking two shots on one frame, double the ASA speed for metering each shot. If taking three shots on the frame, triple the ASA speed, and so on. (Remember to return the ASA setting to normal after you have finished).
In the darkroom you can make montages, using combinations of old prints of yourself. Thus you can turn one picture into a complete album!
Self-portraiture involves no one but yourself, so let your imagination free. There are no restrictions. You don't need complicated equipment, the locations are up to you—and you will never be short of a model.

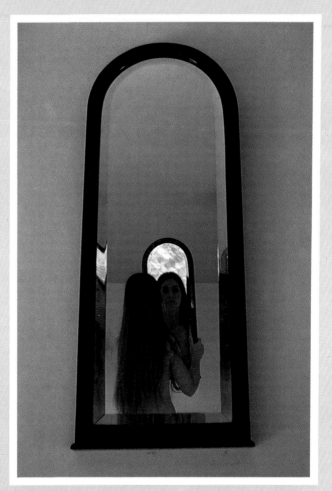

Anne Conway set out to take her own portrait in as many ways as she could. Here are four of her ideas.

▲ A sheet of dull glass abandoned in a garden gave a soft reflection that suited the leafy setting. What caught her eye was the blue reflected sky.

▲ Right: two identical mirrors gave Anne the idea for this two-way self-portrait. With the camera set on a tripod she angled the mirror to frame herself.

▶ The long evening shadows produced this flowing silhouette. She used a wide angle lens, which allowed her to include her own foot in focus.

▼ Strong colour and shape give this shot impact. The self-portrait is a tiny distorted reflection.

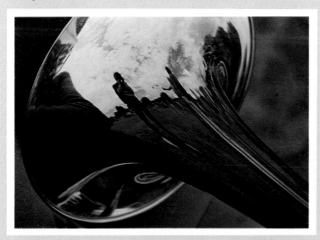

The appeal of candid photography

At no other time is the photographer less in control of what he is photographing than in candid photography. Taking pictures of people who are completely unaware of his presence means he has no way of arranging lights, backgrounds or his subject's position—or of preventing other people from interrupting him. Despite all these difficulties, however, candid photography holds an enormous appeal for amateurs and professionals, because it offers a way of capturing people as they really are with all their emotions and eccentricities on unguarded display.

The quiet approach

The key to candid photography is to be able to mingle anywhere inconspicuously. The most practical camera to use is a 35mm since its small size makes it unobtrusive and it is quiet to operate. It can be loaded with a roll of 20 or 36 exposures, enabling you to take several pictures quickly without having to change film. Since picture content is all-important, forget about grain-free prints (arguably overrated in any case) and use a fairly fast film such as 400 ASA—available in colour and black and white—so that you are not hampered by poor lighting or your subject moving. Keep your distance so that your subject doesn't notice you. This is one of the occasions when a telephoto lens—either a 105mm or a 135mm—is useful for certain types of pictures, but it is by no means essential. In fact, a longer lens can work against a successful picture by pulling the subject out of his environment, while a standard lens gives you scope to include subject and surroundings.
Another alternative is to move in really close with a wide angle lens, which will give your picture a sense of involvement. But try to keep equipment to a minimum to avoid attracting attention.

Asking permission

It is not, as many people seem to believe, illegal to take pictures of people without asking their permission. You can photograph them in any public place, such as the street or park. But this does not prevent photographers feeling that they are intruding at times. In most cases, in fact, the subjects will be less concerned than you imagine and may even be flattered.

Being prepared

While luck plays a considerable part in any successful candid picture, it also has a great deal to do with individual perception. Knowing just how to capture the exact picture you want needs more than technical know-how alone, and only experience will show how expert you are at it. What you *can* do, however, is to be prepared for the moment when the right expression or action presents itself. Try to foresee how a situation is going to develop and how people are going to behave and react.
Whenever possible, get the technical

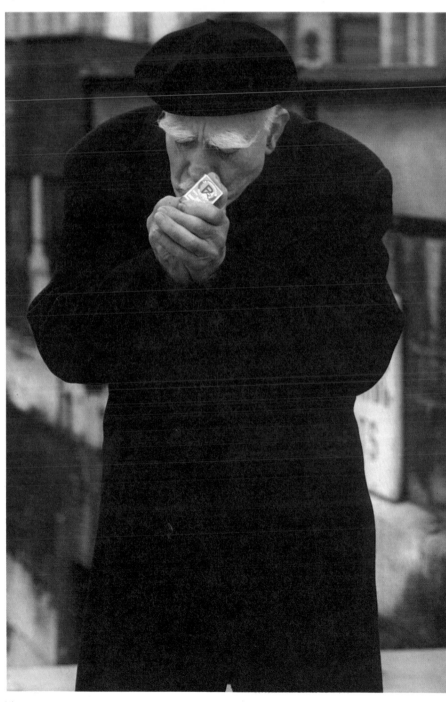

◄ Here, the photographer waited for exactly the right moment—when the old Parisian walking towards him filled the frame.

► A long lens makes it more possible to capture an unguarded moment such as the wistful expression on this old lady's face.
John Bulmer

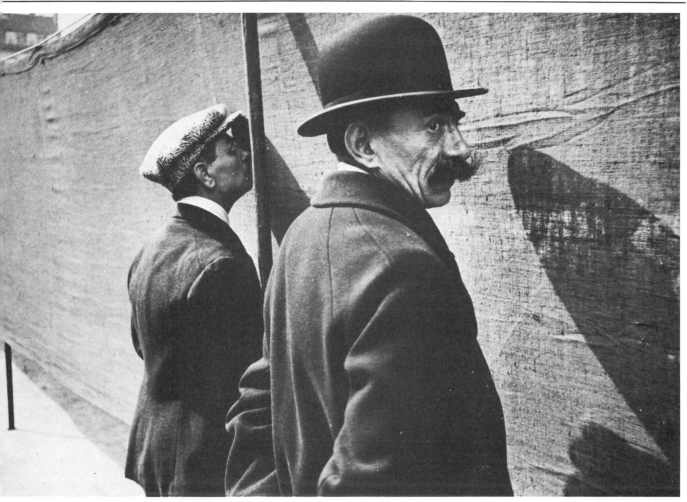

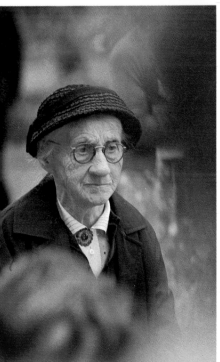

▲ The timeless appeal of candid photography is illustrated by *Henri Cartier-Bresson*'s picture of football spectators taken in 1932 with a Leica and 50mm lens.

▼ A telephoto lens tends to flatten perspective: here, *John Bulmer* gives a sense of depth by including chairs in the foreground to frame his portrait of a young girl.

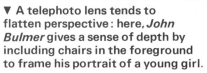

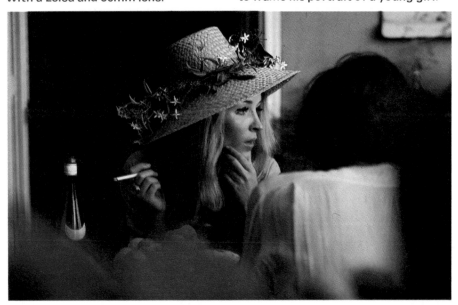

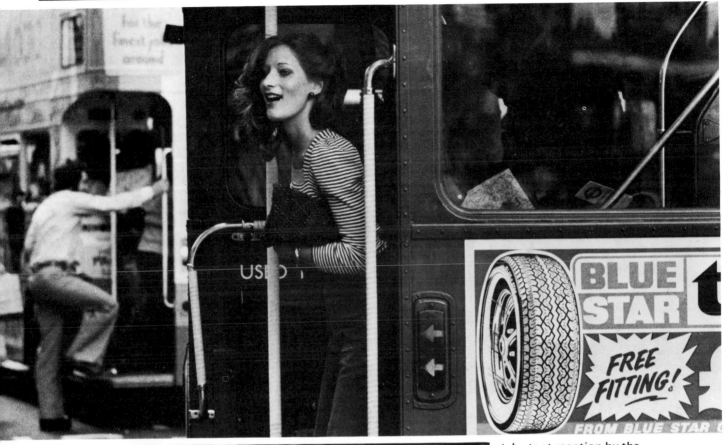

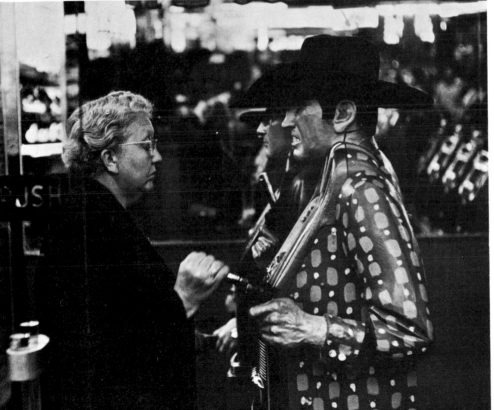

▲ Instant reaction by the photographer caught the vivacity reflected in this girl's face and the shape of her body as she stood ready to jump off the bus. The doorway provides a natural frame. *Herbie Yoshinori Yamaguchi*

◄ Gambling Las Vegas-style is neatly summed up in this candid picture, the ferocious expression of the fruit machine 'gunslinger' contrasting with the bored look of the woman playing two machines at once. *Elliott Erwitt*

► For some photographers, the strength of candid pictures lies in the juxtaposition of things rather than the glimpse of a private moment in a person's life. Here *Thurston Hopkins* instantly recognized the humour of the look-alike chauffeur and poodle in a Rolls-Royce.

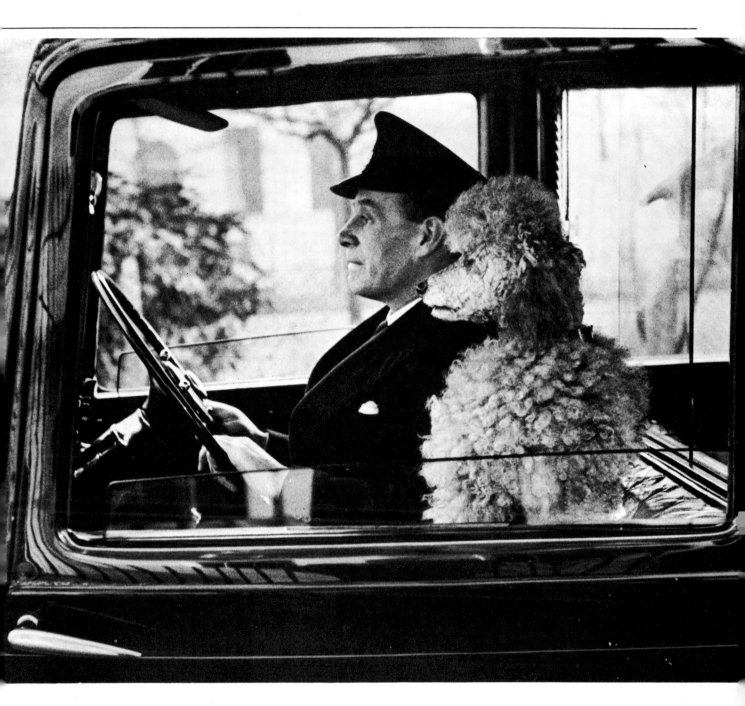

side of things out of the way by setting your shutter speed and aperture well before you are ready to shoot. If necessary estimate your subject's position and set your lens in advance—you should be accurate enough for a slight and speedy adjustment to bring you spot on. If the light is strong enough, set your aperture to a high f number: the greater the depth of field, the greater the margin for focus error. In time, all this should become second nature, so that you can give your full attention to the moment.

Building up a picture
Look for opportunities to build a picture around your subject. By choosing your viewpoint carefully you can create a juxtaposition between your subject and elements of the surroundings to create humour, emphasize a social point or simply create a pleasing composition. An old man sleeping on a bench, for example, will provide a strong contrast against the movement of joggers in a park.
Most important of all, remember that you are not photographing inanimate

objects but living, thinking, feeling human beings. So you should look out for the visible expressions of the emotions—love, hate, sorrow, joy. Since man is a social being, some of the strongest pictures come from capturing these. It could be the love between mother and child or the antagonism between two drivers after a collision or in a traffic jam.

Places to go
Finding places to go for material should present no problem. Henri

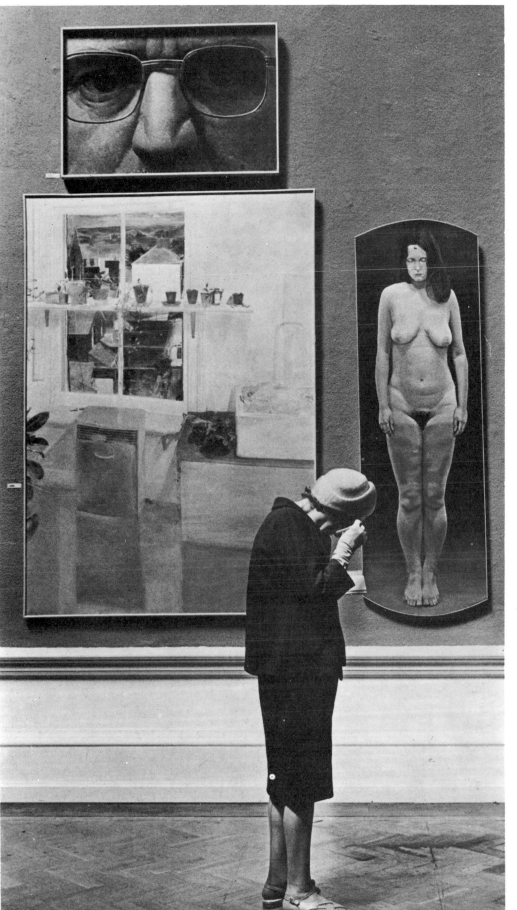

◀ Here, the photographer *Robin Laurance* found his background first and then adjusted his camera for an exposure of 1/60 at f5·6. So he only had a minor focusing adjustment to make when the woman moved into the picture and her downward glance coincided with that of the naked girl.

▲ At slow speeds without a tripod, support the camera.

▶ So engrossed were these two women that the photographer was able to stand right in front, using a wide angle lens to include the painting and put them in context. *Robin Laurance*

Cartier-Bresson, for example, could find a picture outside his front door. For the less expert, however, it is better to start by looking for more easily defined pictures. Take a look at the people at a local exhibition. It does not matter what's on show. Concentrate on the visitors and watch how their faces react to the exhibits. You will have the quizzical and the intense, the admiring and the dismissive. And look even harder and the chances are you will find that telling juxtaposition that turns a snap into a picture.

But you could find the local park most rewarding of all. The joggers, sleepers, riders, gardeners, lovers, dog walkers, and the officials, should provide a host of material. Keep an eye out for silhouettes—lovers against the evening sun, perhaps. Make sure the outlines of the figures are clear, and remember to expose for the sky. Look out, too, for people and their pets—an owner and dog that really *do* look alike perhaps or an old pensioner who feeds the ducks or squirrels every day.

One last suggestion: look at other people's pictures as often as you can. There will be books in the library, and exhibitions of photographs are becoming increasingly popular. Analyse what makes one picture stronger than another and then try to put those elements into your own pictures as often as you can.

Solving your metering problems

If you use a camera with a built-in or TTL meter—and this means most compact and SLR cameras today—you will know that it gets the exposure right most of the time, but not all of the time. It works well in 'average' conditions, and these make up about 90% of picture-taking situations. However, it gives the wrong exposure when the subject is very light or very dark—for example, a snow scene, or a close-up of a black cat—and when the lighting is unusual.

If the light is coming from behind the subject, for example, the subject comes out much too dark.

Camera makers try to solve these problems by adding special controls like the 'backlight control' to over-ride the exposure meter. But they cannot provide a button for every problem case—there are too many of them.

In order to solve these problems you, the photographer, have to know how the camera meter works, so that you know when and how to adjust its reading.

Metering systems

Exposure is worked out according to the light falling on the subject. A hand-held light meter can be used right up close to the subject to measure this amount of light. This is called an incident light reading, and is extremely accurate.

However, all the meters that are built into cameras work by a different method: they are *reflected light* meters. The reflected light meter gives the same result as the incident light meter in two cases:

1) when the reflected light reading is taken from a standard neutral grey test card;

2) when all the tones in the subject, dark or light, would give a standard neutral grey if they were all mixed together.

Incident and reflected light meters all have this in common—they all 'read' a medium grey tone. ALL A METER TELLS YOU IS WHAT EXPOSURE TO GIVE TO GET A MEDIUM GREY TONE ON THE FILM. Therefore if you give the meter a grey tone to read (like the Kodak Test Card) it will give the correct reading. If you point it at anything else, it may not give the correct exposure.

In fact, meters are blind. A meter has no way of knowing if it is being pointed at a grey card, or a black cat, or a patch of blinding-white snow. It cannot tell if the subject is backlit or lit from the

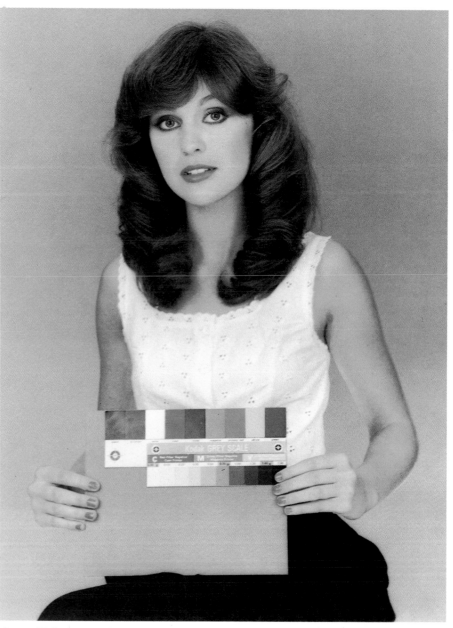

front. Take any reflected-light reading of any subject in any light, and the meter sees, always, the same thing—middle grey!

Metering in practice

Most subjects are, on average, middle grey, which is why camera meters work so well most of the time. But they are not very precise, and it is foolish to follow them all the time. Let's take an analogy from real life.

It may be that, in your town, the average family has 2.4 children. But no *actual* family has 2.4 children. Most have two or three, but some have one child and some have four. Some have five or more children, while others have

▲ When our model is posed against a middle grey background and tones in the picture average out to grey, the TTL meter reading gives the right exposure. The Kodak Neutral Test Card and test patches are thus reproduced correctly.

none at all. You would look very odd if you bought a particular family 2.4 presents, regardless of the actual number of children in the family.

Yet this is what an exposure meter does, in effect. It takes all the light areas of the subject, and all the dark areas, and assumes that, *on average,* the result will be middle grey. In general it is correct, but in particular cases it can be very wrong indeed.

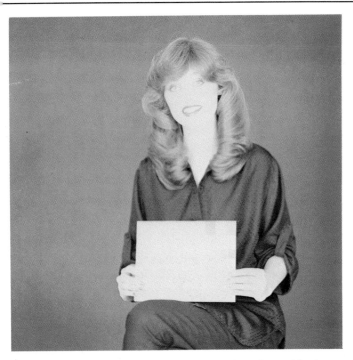

▲ With the model in a black outfit, posed against a black background, the TTL meter 'sees' reflected light. As always, it gives the exposure needed to produce a middle grey tone, so it over-exposes the black to try and make it grey. As you can see from the skin tone and the test cards, this produces too light a picture—the wrong result.

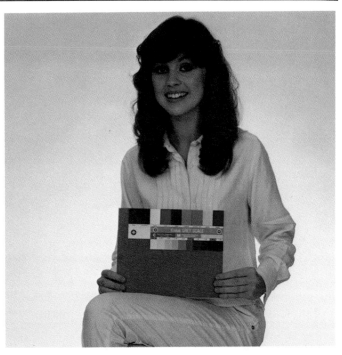

▲ With the model in a white outfit, posed against a white background, the TTL meter 'sees' more light reflected. It gives the exposure needed to produce a middle grey tone, so it under-exposes the white to try and make it grey. As you can see from the skin tone and the test cards, this produces too dark a picture—the wrong result.

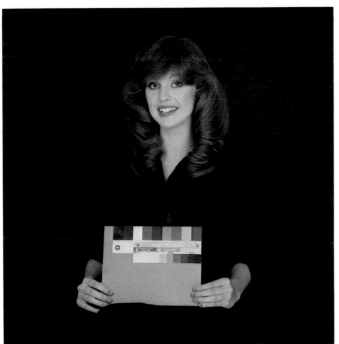

▲ With the black set-up, the lighting is the same and the subject is the same (the girl's face) as for the average-toned picture (left). So the exposure must be the same. An exposure taken at the previous reading (3½ stops less than the TTL meter reading) gives the right result. (The skin tone looks lighter against black but should be the same.)

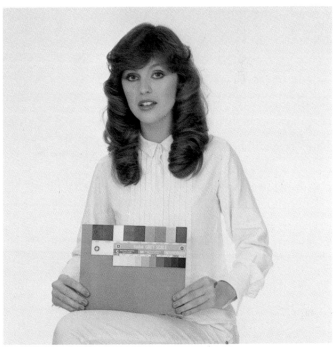

▲ With the white set-up, the lighting and subject (the girl's face) is exactly the same as for the previous two shots. Again, the same exposure must be required, as the above picture confirms. In all three cases, correct exposure can be found by taking a close-up TTL reading from the grey card held by the model, or by an incident light meter reading.

▲ An incident light meter reads (via its receptor) light falling directly on the subject. It is, therefore, unaffected by the tones and colours of the subject that reflect different amounts of light. As always, the meter tells you the exposure to give so a middle grey card held in that light will come out grey.

▲ A reflected light reading (with a hand-held or TTL meter) measures the light reflected off the subject. It tells you the exposure needed to produce a middle grey tone. When the reflected light reading is taken from a standard grey card, as above, this is in effect the same as taking an incident reading.

▲ A reflected light reading can be taken directly from the subject itself, as above. As always, the meter still 'sees' a middle grey tone. It gives the right exposure reading if the various tones of the subject (from black to white) come out, on average, at middle grey tone. If they don't, it doesn't.

For example, if you are photographing a very light subject (a girl in a white suit, against a white background) the meter will tell you the exposure to set on the camera to get a medium grey on the film. This will lead to a *smaller* aperture than is correct, and the picture will come out too dark. If, on the other hand, you are photographing a very dark subject (the same girl in a black suit against a black background), the meter will still tell you the exposure to give to get medium grey. This will lead to a too-light (over-exposed) picture.

The black areas in the subject reflect less light than the white parts did in the previous picture. The camera meter therefore 'sees' less light, and tells you to set a wider aperture to make up for it. The meter, in both cases, is 'integrating to grey', and gets the exposure wrong in both cases.

An experiment to try

This experiment was conducted in a studio. A neutral grey background was selected and the model was asked to wear a white blouse and black trousers, so that the tones of the whole picture were, on average, neutral grey. The pictures were taken at the average reading indicated by the exposure meter. This was the correct exposure—a fact confirmed by taking an incident light reading. The model then changed her clothes and the background was changed. She was then photographed wearing all white against a white back-

ground, then all black against a plain black background.

With the white background, the TTL meter in the camera suggested three stops less exposure than with the grey background. The result was an under-exposed picture (see the previous page). With the black background, the TTL meter suggested three stops *more* exposure, and this resulted in an over-exposed picture.

However, it is obvious that for the three pictures, the exposure must be exactly the same. The subject is the same—although she changed her clothes, her skin colour did not change. Also, the lighting and film were exactly the same. Therefore, the *exposure* should have been exactly the same. This was confirmed by incident light readings, which measure the lighting directly. (These readings are not affected by the tones of the subject.) The pictures reproduced on the previous page taken at the same exposure settings as for the grey background, confirm this.

Incidentally, you can repeat this experiment at home quite simply. Select any small grey subject and take a TTL meter reading from it. Put a piece of white card behind it and check the meter. Replace the white card with a piece of black card and check the meter again. With the same subject in the same lighting, all the exposures ought to be the same. In fact, the TTL meter will give different ones. The different backgrounds influence the meter.

Metering different tones

As mentioned, the TTL meter will give a more or less correct exposure in the vast majority of cases, but in some cases you need to adjust the reading. This is when the tones of the subject do *not* average out to grey. Here is how to handle difficult situations using a TTL meter if you don't have a grey card.

First look for a flesh tone. If there is a light flesh tone in the picture, take a close-up reading from this and open up by one f stop (eg from f11 to f8). An average white skin tone is one stop lighter than middle grey. (For other skin tones, see the table on page 54). Second, if there isn't a skin tone in the picture, hold your own palm in the same lighting as the subject and measure the light reflected from it. Again, skin tones vary but you can compare your own palm to a standard grey test card.

Third, take a close-up reading from a particular part of the subject. If this is the most important tone of the picture and you want it to come out middle grey in the picture, you can use the reading directly. If not, you will have to work out how far the tone you have measured is from neutral grey.

Tone values

It is possible to divide the different tones in any subject, from intense black to pure white, into ten zones (any number could be chosen, but this is convenient). The table on page 54 shows you which tones belong to which zones. Each tone

Step by step to metering nearby subjects

INCIDENT LIGHT READING

▲ With subjects that are nearby, it is convenient to take an incident light reading from the same position as the subject. Thus the light falling on the subject is measured directly. Most people do this by holding the meter vertically and pointing the dome towards the chosen camera position.

GREY CARD READING

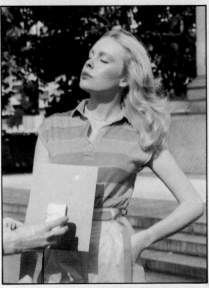

▲ An exposure meter tells you what exposure to give to produce a middle grey tone on the film. An accurate reading is therefore obtained by giving the meter a middle grey tone to read. Above, a Kodak Neutral Test Card is being used. This method works with both hand-held and built-in TTL meters.

TTL METER READING

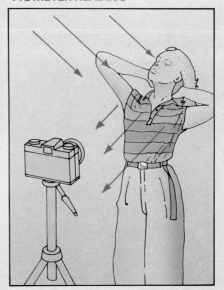

▲ The TTL meter in an SLR camera also tells you what exposure to give to get a middle grey tone. With this average-toned subject and simple, frontal lighting, the built-in meter gives the same exposure reading as incident and grey card methods

TTL METER READING

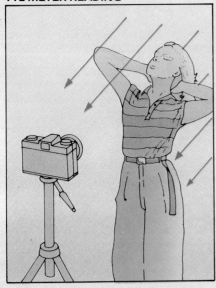

▲ Suppose the photographer and the model change positions. Instead of the sun being behind the photographer it is now behind the model. Instead of frontal lighting, you now have back-lighting. With the sun shining towards the camera, the built-in meter 'sees' a brighter picture and recommends a shorter exposure (smaller aperture).

TTL METER RESULT

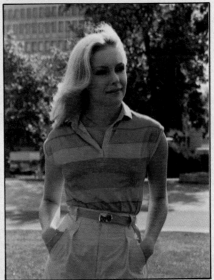

▲ Following the TTL meter reading, as above, gives an under-exposed (too dark) picture of the subject, which is the model's face. From the picture, it is obvious that with backlighting, the model's face is in shadow, and should require more exposure, not less. But the meter has no way of knowing this—all it sees is middle grey.

INCIDENT LIGHT READING

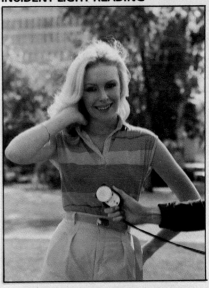

▲ The lighting is just the same as for the previous picture, but the exposure has been set according to an incident light reading. As shown above, the meter is held close up to the main subject to measure the light falling directly on to it, with the receptor pointing towards the camera. Thus it is not fooled by backlighting.

GUIDE FOR CORRECT EXPOSURES

This chart shows you how to obtain very accurate exposures using your camera with TTL metering. These exposures will be more accurate than if you just take a general reading of the subject. The types of subject listed correspond to the 'zones' worked out by Ansel Adams, which are incorporated into some hand-held meters.

HOW TO USE THIS TABLE
Using a TTL meter, measure *only* the *most important part* of the *main centre of interest*. Then look up the type of subject on the chart and make the necessary change so that the *whole* frame will be correctly exposed. This system works for both colour and black and white film, but film does not have enough latitude to record all the tones at once.

TYPE OF SUBJECT	DO ONE OF THESE THREE THINGS		
	CHANGE APERTURE	**CHANGE SHUTTER SPEED**	**CHANGE FILM SPEED SETTING**
	− + f22 f16 f11 f8 f5·6 f4 f2·8 f2 f1·4	faster slower 1/000 1/5000 1/250 1/125 1/60 1/30	25 ASA (dial 50 100 200 400 800 1600)
O. Black	−5 stops eg f2·8 becomes f16	5 speeds faster eg 1/30 becomes 1/1000	ASA x 32 eg 25 ASA becomes 800 ASA
1. Almost black, matt surfaces, black materials, showing no texture. Slightest tone above full black.	−4 stops	4 speeds faster	ASA x 16
2. Deep shadows, black suits, glossy black surfaces, black materials with a hint of texture.	−3 stops	3 speeds faster	ASAx 8
3. Dark grey clothes, blue jeans, deep landscape shadows, poorly lit interiors.	−2 stops	2 speeds faster	ASA x 4
4. African skin tones, dark foliage, dark stone and earth, medium landscape shadows, well lit interiors.	−1 stop	1 speed faster	ASA x 2
5. Asian skin tones, tanned Caucasian skin tones, light earth and foliage, brick and grey stone. Kodak neutral test card (18% reflectance).	no change	no change	no change
6. Caucasian skin tone (white), light coloured flowers, light coloured sand and stone.	+1 stop	1 speed slower	ASA ÷2 (ASA x ½)
7. Snow in sidelighting, light coloured clothes, matt white surfaces, high contrast surfaces, very high contrast subjects	+2 stops	2 speeds slower	ASA ÷4 (ASA x ¼)
8. White materials with delicate textures, white reflective surfaces, highly polished metal, reflecting highlights	+3 stops	3 speeds slower	ASA ÷8 (ASA x 1/8)
9. White, without texture. Glaring white surfaces, eg snow in full sunlight.	+4 stops eg. f16 becomes f4	4 speeds slower eg 1/1000 becomes 1/60	ASA ÷16 (ASA x 1/16) eg. 400 ASA becomes 25 ASA

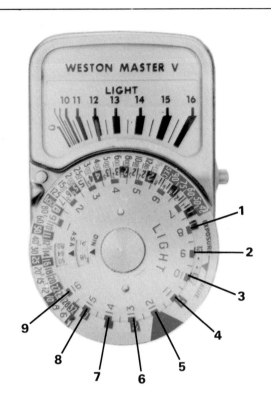

▲ This subject is mostly dark tones, so an average TTL meter reading will not give the correct exposure. Instead, a close-up reading is taken from the important dark tone where detail is required. This zone 5 reading is reduced by two stops to place the dark tone in zone 3. A close-up reading of the white highlight will then show in which zone it will fall (*ie* how many stops lighter it is).

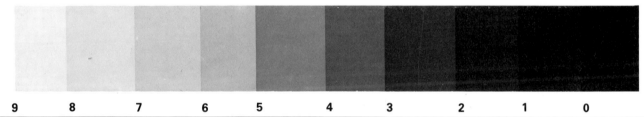

| 9 | 8 | 7 | 6 | 5 | 4 | 3 | 2 | 1 | 0 |

is about one f stop away from the next one.

Suppose you take your close-up TTL meter reading from say, a white wedding dress. The meter tells you the exposure that would reproduce that white as average grey. As you can see from the table, that white dress should be three stops *lighter* than average grey, so the TTL reading must be increased by three stops (*eg* from f11 to f4) when photographing the whole scene. Any average grey tone in the scene will then reproduce—correctly—as average grey. If you take your close-up TTL reading from a dark stone, the meter will tell you the exposure to give to make this stone reproduce as an average grey tone. However, this dark stone should be (from the table) one zone *darker* than average grey, so you must give one stop less exposure for the whole scene. In each case, relate the TTL reading to the middle tone, and adjust

the exposure to make average grey reproduce a grey.

Note that this method only works for close-up readings of particular tones. It does not work for overall or averaging readings.

Limitations

Unfortunately, no film is capable of recording the full range of tones that is present in most everyday subjects. A black and white film has a range of about seven stops, and colour films effectively about four stops—far less latitude. As well as reading an important tone in your picture, check the important highlight and shadow areas too (*eg* those areas in which you want to record detail). If these are outside the film's latitude, you will not be able to record both. You have to choose one or the other.

Any single tone—a grey card, a black cat or white snow—can be placed in any

▲ The Kodak Grey Scale gives a range of ten tones from solid black to pure white. These can be related to the ten zones in the table opposite, and to the one-step divisions on the Weston meter. The U on the scale marks the limit of under-exposure and the O the limit of over-exposure.

zone, but all the other tones will then fall in their related zones according to how much light they reflect. Only *you* can decide which is the most important part of the subject—and this is the part you will want to be correctly exposed. Only *you* can decide whether you want that tone to come out a middle grey tone, or one stop lighter, or one stop darker, or whatever. Your meter is blind—it cannot decide this for you! However, using the table with this article, you will be able to use your built-in TTL exposure meter to decide this yourself.

Metering difficult subjects

Most of the time, exposure metering is a simple matter. With average subjects, one reading—by reflected light (with a camera's built-in meter) or incident light (with a separate hand-held meter)—is sufficient. However, there are times when you need to take more than one reading—when either the subject contrast, or the lighting contrast, is too great for the film to record.

Typical situations like this include—a dark-skinned model in front of a sunlit, white wall; a blonde girl posing in front of a dark hedge; people in a sunlit courtyard seen through an arch or in a dimly lit room with bright sunlight outside; and any portrait with strong backlighting. Even if you never meet these particular situations you are certain to come across others like them when trying to take well-exposed people photographs. In these situations, there are two related problems. First, an exposure meter is designed to read average scenes. With non-average scenes it is unreliable. Second, film can only record detail in a limited range of different brightnesses in the same picture. These scenes may be too contrasty for the film to cope.

Contrasty scenes

In most difficult situations, the easiest solution to a metering problem is to find an average grey tone—a middle grey—and take a close up reading of that. If there is no middle grey tone in the subject (or you are not sure which tone to use), you can measure the light reflected off a standard grey card such as the Kodak Neutral Test Card, when this is held in the same light.

But suppose you are photographing a black horse against a white wall. The grey card reading may be 'correct', but the horse may still be under-exposed and—at the same time—the white wall over-exposed. Neither will be reproduced satisfactorily.

Let's look at this example in more detail. A close-up meter reading of a single tone can be taken using a separate meter, or the TTL meter in an SLR, simply by filling the frame with that tone. So what you do is take two separate meter readings—one of the darkest relevant tone in the picture, and the other of the lightest relevant tone. By a 'relevant tone' is meant one in which you want to record some texture or detail.

In this case, the dark tone is the hide of the black horse, and the light tone is the white wall.

Now suppose the meter gives a reading of 1/125 at f2 for the black horse and 1/125 at f22 for the wall. The lighting brightness range is 8 stops, and this is more than the film can record.

An exposure which captures the detail of the hide will reproduce the wall as blank, washed-out. An exposure which reproduces the fine texture of the wall will reproduce the horse as a black silhouette. You can't have both, assuming standard processing and printing, unless you change the lighting (eg use fill-in flash or a reflector). Instead you have to choose which is the most important tone to record.

▶ **A straight meter reading from this scene would mean that the surfer would be over-exposed, due to the black background. A close-up reading must be taken from the key tone (the surfer) to give the right exposure. *Walter Iooss*.**

▼ **The wide tonal range of this subject is almost too great for the capability of the film. The child is almost a silhouette, as his skin colour is so dark. Extra exposure for that would lead to the brightly coloured toys being over-exposed. *John Garrett*.**

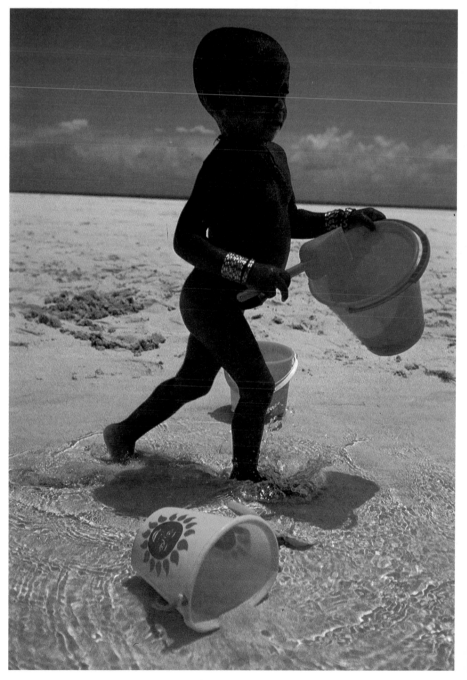

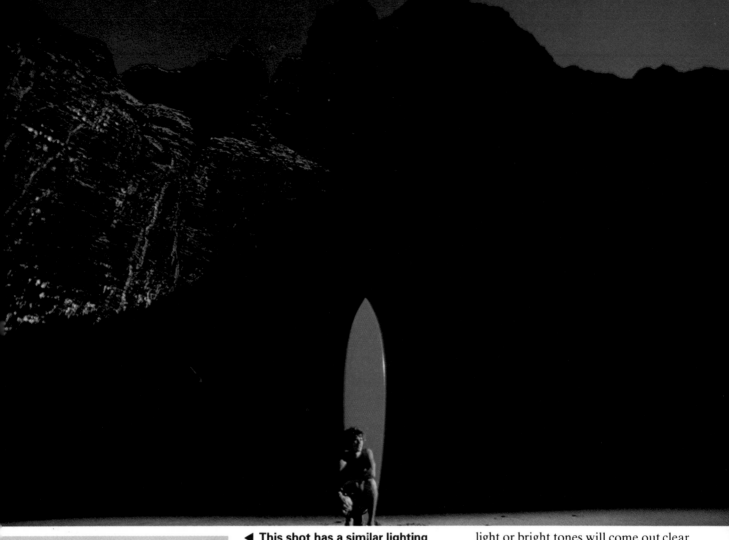

◄ This shot has a similar lighting contrast to the picture of the child opposite. In this case the girl is the key tone and is correctly exposed. As a result, most of the background detail has been lost. *John Garrett*

Brightness range metering

In many cases, the highlight and shadow readings will not be so far apart. Suppose the meter readings were 1/125 at f4 for the horse and 1/125 at f16 for the white wall—a five stop difference. An exposure half-way between these two readings, 1/125 at f8, will certainly record detail in both parts of the subject on all normal negative films.

This is the principle of brightness range metering. You meter the relevant highlight and shadow tones separately, and choose a final exposure midway between the two, (as long as the tones are within the recording capabilities of the film).

Different films vary in their capabilities. As a general rule, black and white film can reproduce a brightness range of about seven stops, colour negative film can reproduce about five stops, and colour slide film only about four stops. Tones outside this range will still be recorded on the film, of course, but they will not normally show detail. Any dark tones or shadow areas will come out solid black in the final picture. Any

light or bright tones will come out clear white.

Let's take another picture as an example. Suppose your picture includes a bright but cloudy sky. Suppose also that at the exposure you have chosen, this is beyond the recording capabilities of the black and white film in use. Then in your picture the clouds will not come out, but the sky will record as an even, white tone.

Most pictures should, in fact, contain *some* areas of solid black and pure white Their presence shows that the capabilities of the film have been used to the full, and full-toned pictures have a sparkle that flat, grey ones lack. However, your metering should ensure that the *important* parts of the subject are correctly reproduced, not shown as solid black or washed-out areas (unless you are trying to produce a silhouette).

Key tone method

Now you can see that contrary to popular opinion, films have little real exposure latitude at all, as long as the best possible print or slide is required. If you over-expose slightly, you lose delicate tonal separation in the highlight areas of the picture. If you under-expose, it is shadow detail which is lost. However, this all depends which areas *you decide* are important in the picture.

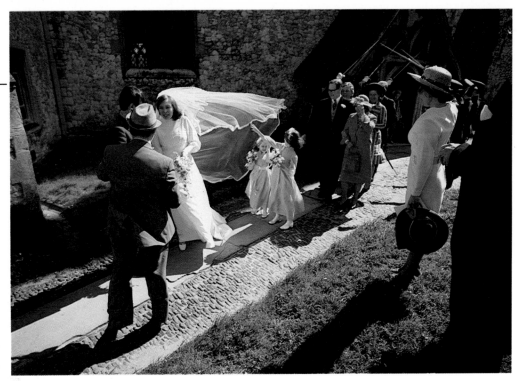

▶ In this scene, the backlighting gives a range of tones that is too great for slide film to record. Some highlights in the bride's dress are 'burned out' to white. Also, the detail in the man's suit (right) has come out solid black. As the picture has important skin tones, the correct exposure is the one which records these. The other details can be sacrificed if necessary. *Per Eide*

For example, suppose your picture includes a pretty girl and a beautiful bright sky. Only you can decide which is the most important part of this picture, and this is how you choose the 'key tone'.

If the key tone is the face of the girl, take your meter reading from this (or from a grey card in the same light), and adjust this middle-grey reading to suit the skin tone of the girl. (For a light, white skin tone, open up by one stop. For a tanned white skin tone, use the meter reading. For an African skin tone, reduce the reading by one stop. (See table on page 54.)

But if you select the exposure to correctly reproduce the skin tone of the girl, the bright sky will be over-exposed. It will come out too light.

In that sense there is no longer a necessarily *correct* exposure, only a range of more or less suitable ones. It depends on the subject, the composition, and the *interpretation* you want. Finally, you are in control.

High key and low key

Pictures that are essentially light in tone are called 'high key' pictures. The subject itself is light, as is the background, and the overall impression should be one of softness and light. But

LIGHT & DARK-TONED SUBJECTS
◀ Apart from the eyes, the tones in this subject are mostly light. A meter reading of the whole subject would thus give the exposure to reproduce it as an average grey tone. You want a *lighter* tone than grey so *open up* by one or two stops to get the desired result. In this picture, the girl's skin is the key tone which must be correct. *Sanders*

this does *not* mean that by over-exposing the picture and desaturating the colours you will automatically get a high key picture.

A true high key picture is correctly exposed—there will almost certainly be some areas of black, even if it is only the pupils of the eyes, and these should be true black, not a washed-out over-exposed grey. The light tones should also be correctly exposed, with no loss of detail.

There are many subject possibilities, but traditionally the high key technique is used for portraits—especially of women with naturally light complexions and blonde hair. It is often used in advertising and in fashion and beauty photography. The advantage, particularly in black and white photography, is that the eyes and mouth are emphasized while skin texture—and blemishes —are virtually eliminated.

The term 'low key' is generally applied to photographs which appear predominantly dark. A true low key shot, however, is not composed entirely of shadowy forms. The overall tone must be dark, but the subject should be lit by a small or concentrated light source which highlights the essential features. The harsh lighting needed is unrelenting and will show up every line and blemish. For this reason low key pictures have often been used for men's portraiture—they are a good way to highlight the characteristics of rugged masculinity. Low key portraits of women can also be successful. They can be used to express an air of mystery or melancholy, but the subject should be dark haired and dressed in fairly dark clothing.

METERING TONES

A meter tells you the correct exposure only when you take a reading from a subject that averages out to grey.

▲ Using a black, a grey and a white card, this test shows how a meter can get exposures wrong.

▲ Black card metered—black reproduces grey, grey reproduces white, white reproduces white.

▲ White card metered—white reproduces grey, grey reproduces black, black reproduces black.

▲ Grey card metered—results correct. The film records the tones as seen by the naked eye.

Using one flash gun

If you own a camera the chances are that you will also own a flash gun. There are many situations where the light is low, and you can't take the portraits you want without one. A single flash gun is more versatile than you may think. All the pictures in this section were taken using just one gun.

An electronic flash gun allows you to take well exposed and very sharp pictures under a wide variety of conditions. The flash itself lasts a very short time (1/1,000-1/50,000 second). This brief duration 'freezes' subject movement and prevents camera shake. The light quality is similar to daylight, so no special films or filters are needed.

Most flash guns have built-in photo cell sensors to give automatic exposure. Power is usually supplied by ordinary batteries. One set will provide a large number of flashes. Some flash units use rechargeable batteries or mains current as well.

Check your camera instructions for correct shutter speed synchronization settings. Most 35mm SLRs cannot be set faster than 1/60 or 1/125.

Using flash

Use a flash gun when the existing light is too dim to allow a suitable hand held exposure. Remember that a flash gun, particularly 'on-camera', gives its own very distinctive light quality. Some flash pictures can be disappointing because the appeal of the subject depended partly on natural light quality. Indirect bounce flash can give more natural results.

Fluorescent or electric lighting can be bright enough to allow hand held shots without flash. Slides shot in this way show a strong colour cast. Using a flash gun ensures that the colours appear normally.

At a party a flash gun gives accurate exposures, captures the action and prevents camera shake—no matter how good the party! An automatic gun is best. For indoor sports a flash gun is almost essential to freeze the rapid movements of the athletes.

Equipment choice

A small manual gun costs little more than a roll of slide film. You have to use a simple calculator table to work out the correct exposure. Larger automatic units have more features but are more expensive. They are much easier and quicker to use, since the built-in sensor gives automatic exposure control. Use of *thyristor* circuits also saves battery power and can cut re-cycling times considerably. Some SLRs can take special automatic flash guns which use the camera's own TTL metering system for exposure control. They set the correct flash sync speed automatically and are called *dedicated* flash guns.

Direct flash—on-camera

On-camera flash is most convenient. It gives predictable, flat lighting with harsh, dark shadows. Light intensity falls off rapidly as distance increases, so backgrounds are under-exposed. This dark effect can be used to suppress a messy background. When a subject has depth, it is difficult to give correct exposure to each part. In a smoky atmosphere light reflects strongly from smoke closest to the camera. Pictures come out flat and with weak colours.

Since the flash gun is close to the camera, light can reflect straight back into the lens. This causes the 'red-eye' effect. Spectacles, windows, mirrors and gloss paint can all cause ugly bright spots and patches in the same way. Avoid having such surfaces facing straight towards the camera.

The best pictures taken with on-camera flash have: unimportant backgrounds; subjects at roughly equal distances from the camera; and reflective surfaces angled away from the lens.

Direct flash—off-camera

Some problems with on-camera flash can be solved by using an extension lead. With a portrait it is usually better to have the light coming from above and to one side. Shadows on the face give roundness and add interest.

When a subject has considerable depth the flash gun can be placed to one side at roughly the same distance from each important part. Exposure is then the same for all areas. Shadows are still harsh, but can be made to fall out of sight by holding the flash gun well above the camera.

Used from below, a flash gun gives a sinister quality to most subjects—try it! With the flash gun to one side, reflections bounce away from the lens. Red eye is avoided by moving the gun just a few centimetres from the camera. Many modern cameras do not have a separate flash sync socket. You need a hot-shoe to 3mm sync socket adapter, before an extension lead can be used with these.

Bounce flash

Some guns have tilting heads, so you can use them on-camera to give *indirect* lighting. Point your flash gun at a ceiling or wall instead of the subject. The large patch of illumination on the ceiling effectively becomes the light source. Shadows are softer and the lighting is even over a reasonable distance.

The reflective surface must be white or grey if you want accurate colours. If there isn't a convenient ceiling or wall, a sheet of white card can be used. Special 'bounce brackets' are made for some bounce-head guns. These hold a small sheet of card to act as an artificial ceiling. For a greater variety of effects you can use a white, silver or gold flash umbrella. Fitting your flash gun and reflector to a stand leaves you free to hand-hold the camera.

Bounce light from a ceiling can be most natural looking. With a portrait, angle the gun to bounce the light midway between camera and sitter. This will give soft shadows on the face with adequate lighting in the eyes and background. If the light bounces directly over the sitter, shadows under the eyes and nose will be too dark. With the flash bounced off a wall or card the effect of window light can be created. The soft shadow quality is perfect for revealing textures and shapes. Reflections in shiny objects are full of interest. Much of the output is lost when flash is bounced. Light is absorbed and reflected uselessly away. The sensor can still be used, for auto exposure control, but it must face the subject. Some guns have a detachable or accessory sensor which can be used on a remote lead.

Set on 'auto', a flash gun could fire at maximum output and still under-expose the subject. To avoid this problem, some flash guns have a 'check light'. You fire the gun by pressing the 'open flash' button, while looking at the control panel. If there is sufficient light for correct exposure the sensor will switch on an LED. If in doubt use manual, which lets you use a wider aperture.

Film and filters

Colour film should be daylight balanced. Any black and white film can be used. Film speed is an important consideration, especially for bounce flash. Light wastage is high so fast film may be needed. At parties you may use both direct and bounce flash, so a high speed film (200 or 400 ASA) and an automatic flashgun make the best combination. For colour slide photography, direct flash is sometimes a little blue. A pale yellow (CC05Y) or skylight (1A) filter removes this cast. Filters can either be fitted over the camera lens or the flash gun.

Direct flash—on-camera

▲ One flash gun mounted on the camera gives little texture or detail, harsh shadows and an unflattering effect. The model here was close to the background (approx 2ft or 2/3 metre), creating a noticeable shadow. To avoid this, position your subject further from the background (approx 9ft or 3 metres).

Direct flash—off-camera

▲ Using one flash gun fixed to a bracket or held slightly to the side and above the camera gives a better result than with the gun on the camera. The result is softer and more flattering. In this shot there is no background shadow as the model had been moved away from the background.

Indirect flash—on-camera

▲ An on-camera flash with a tilting head can be bounced off a ceiling or wall (must be light coloured) for a soft effect. Bounced light reduces the flash reaching the subject, so increase the exposure with manual flash. A rule of thumb for this is to open up by the lens by 2 stops.

Indirect flash—off-camera

▲ The best possible picture that can be taken with one flash gun is when the flash is held away from the camera and a reflector (eg a piece of white card) is placed at the side of the subject to act as a fill in. This produces a natural looking picture. All photographs by *John Evans.*

Using two or more flash guns

Using more than one flash gun opens up a new world of exciting portraits and special effects. Natural or studio style lighting effects can be created. You can lighten backgrounds, and show the colours of your subjects more clearly. Large areas can be successfully lit with a little forethought and care, using a number of flash guns synchronized together. (In certain circumstances it is possible to use one gun flashed a number of times.)

Film choice

Any film can be used, but as with all flash photography, colour film must be daylight balanced.

In many cases exposures will be good approximations at best. Slide film has little tolerance to incorrect exposure. Negative film (colour and black and white) has better latitude, particularly to over-exposure. This material is thus the best choice for complex multi-exposure shots. Aim to slightly over-expose the film. If your calculations are wrong, you'll usually get an acceptable result! Record your exposure data so that successful shots can be repeated and mistakes avoided in the future.

Flash gun power

When using several flash guns together no special guns are needed. However, it could save you money to buy guns of different sizes.

Most lighting sets need a main light. Its job is to provide the quality and basic lighting direction. A 'main light' flash gun is normally the most powerful. Other flash guns are used as background or 'fill-in' lights. These can be less powerful. A typical home studio portrait might need three flash guns, one large and two smaller ones.

Synchronized flash

Synchronizing several guns to fire together is the most convenient way of working. Two ways of doing this are using slave units or a multiple adaptor.
A slave unit is a photo cell which *'sees'* only flash light. It is fitted to a flash gun placed some distance from the camera. The main light flash is connected as usual to the camera via the hot shoe or 3mm socket. When the main flash fires, the slave triggers the remote gun. (There is no significant delay between flashes.) Flash guns may be placed anywhere providing the slave units clearly 'see' one other gun which is firing. Any number of guns can be synchronized in this way. The flash guns can be different models.

▲ To obtain the soft natural effect in this shot, two flash guns were used. The main gun was to the left, and slightly higher than the camera. Fill-in flash on the camera softened the shadows from the main gun. *J Pfaff.*

▶ Three guns were used for this shot. One covered with a green gel lit the background. A large brolly flash at the right-hand side lit the hair and shoulders. A small brolly flash lit the model from the front. *Sanders*

Key words for understanding flash

Synchronization: making sure the flash fires the same time that the shutter fully opens. With multi-flash, it also involves making sure that all the flash guns fire at the same time.
Bounce lighting: reflecting flashlight from a card, ceiling or wall, so light quality is soft and even. Surfaces should be light or white to avoid false colours. On auto, the sensor must face the subject.
Lighting ratio: the relationship between the brightest part of a subject and the darkest. With a colour por-

trait a ratio of 3:1 is best.
Check light or confidence light: device on a larger flash gun which shows when enough light is reflected from the subject to give proper exposure.
Crossed shadows: two or more shadows pointing in opposite directions. Caused by using flash guns of similar power on either side of the camera. Particularly undesirable in a portrait, where having a shadow on both sides of the nose is unpleasant. The remedy is to bring one gun closer to the camera.

Controlling the exposure for fill-in flash

Exposure may be controlled fully automatically if each flash lights a separate area. When flashes overlap, as with main and fill-in guns use the following method to get a 3:1 (main to fill-in) lighting ratio:
1) set main light gun on auto
2) set actual film speed on main gun
3) select suitable aperture
4) set the fill-in gun on manual
5) assume film speed for fill-in gun is 3x actual (*eg* set 400 ASA on the flash for 125 ASA film)
6) position fill-in gun at distance to give 'correct' exposure with 'false' film speed, at selected aperture.
Result: fill-in alone will be one third as bright as main light plus fill-in.

A multiple adaptor can also be used to link up to three flash guns. In this case, the guns must be the same.

The adaptor has three camera-type 3mm sockets and a single 3mm 'plug'. Each gun is connected to a socket via an extension lead. A fourth lead links the adaptor to the camera. Location of the flash guns is limited by the lengths of the leads. Beware of including a lead in the shot!

Many SLR's have both a hot shoe and

a 3mm sync socket. It is sometimes possible to connect one flash gun to each. This produces the simplest method of synchronizing two guns. Check your camera or contact the camera's distributor to see if you can use your camera in this way, or you may cause damage.

Multi-exposure flash

This technique can only be used in a darkened room or outside at night. Put your camera on a tripod and set the shutter to 'B'. Keep the shutter open with a locking cable release. One flash gun can then be fired several times to build up complex lighting effects. Don't touch the camera between flashes: any movement will give you an unwanted multiple image. Remember to close the shutter after the last flash.

Subject approach

Many subjects benefit from multi-flash lighting. A portrait lit with *one gun* has harsh heavy shadows and a dark background. Use a *second gun* to lighten the shadows on the face. This fill-in flash should have about 1/3 the power of the main flash.

The fill-in gun should not create its own strong shadows, so it needs to be quite close to the camera. Keep it about 30cm

from the camera lens or you could get 'red eye.'

You can soften the fill-in light by taping white tissue over the gun or bouncing it from a reflector. A third gun, placed behind the sitter, lightens the background and burns out ugly shadows. The power needed for this gun varies according to the distances involved and the effect wanted. The third gun could, alternatively, be used as a hair or rim light. Placed behind the sitter it is pointed back towards the hair or shoulders. The resulting halo of light clearly separates sitter from background.

Figure studies, groups and formal portraits can all be photographed in a similar way. Synchronized flash is essential.

Multi-exposures: other uses

Night-time exteriors or interiors can be shot by multi exposing or 'painting' with a series of flashes. You can even walk right into the picture area. To fire the gun use the *open flash* button, often marked 'test'.

Both you and the flash gun should be hidden from view behind furniture or in doorways. Exposure can be on auto. Each flash should light one area. Overlapping flashes cause patches of over-

exposure. Try to keep the flash gun pointing roughly in the same directions crossed shadows look ugly.

One gun multi-exposures

You can also multi-expose on a smaller scale at home, though subject choice is limited to still life and other static objects.

Lighting can be built up to resemble synchronized multi-flash, with one gun doing the work of three.

For example, have one flash from the side of the camera to give a main light, bounce it from a reflector for fill-in, and then from the ceiling for a top light. The combinations are endless. Bizarre effects and ghostly multi-images are produced by moving parts of the subject between flashes.

Exposure calculation can be awkward when two flashes light the same area. When using an auto gun, you must alter the film speed setting for each flash to persuade the gun to emit different amounts of light. For a 3:1 (main: fill-in) lighting ratio, set the gun as follows:
1) main flash—increase film speed by $1\frac{1}{2}\times$ (eg set 200 for 125 ASA film).
2) fill in flash—increase film speed by $3\times$ (eg set 400 ASA for 125 ASA film). This will give the correct final result.

Basic plan for 2 flash guns

Main flash
(2 units)

Fill-in flash
above camera
(1 unit)

2+1 = 3 units 1 unit

▲ ▶ Two flashes were used in this shot, illuminating the highlights together. The fill-in lights the shadows (caused by the main flash) alone. It is rare in a portrait for the fill-in light NOT to illuminate the highlights as well as the shadows. Main gun gives 2 units light. Fill-in gives 1 unit light. Total on highlight side is 3(2+1). Total on shadow side is 1. Ratio is 3:1.

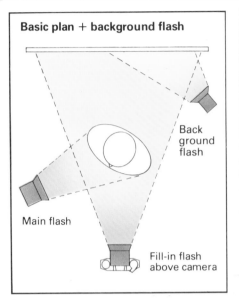

Basic plan + background flash

Back ground flash

Main flash

Fill-in flash above camera

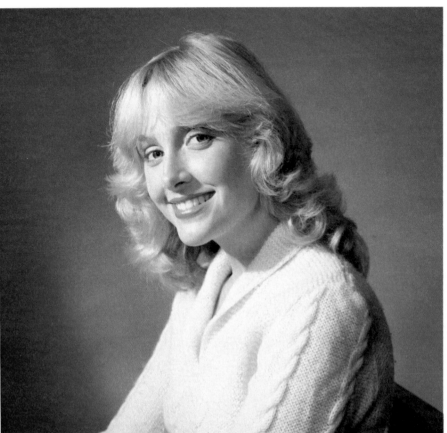

▲ ▶ A third gun can be added to the basic two flash portrait set up. In this shot a third gun was placed behind the model and directed at the background. This flash lightens the background and separates it from the subject giving it more depth. This third gun must be positioned carefully. You must make sure that the gun will not be visible in the photograph.

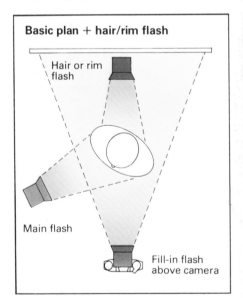

Basic plan + hair/rim flash

Hair or rim flash

Main flash

Fill-in flash above camera

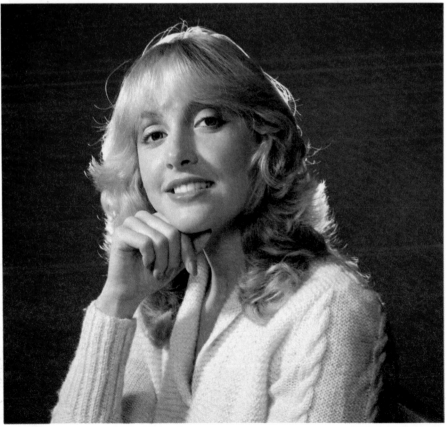

▲ ▶ An alternative way to use the third flash gun is as a hair or rim light. The gun should be in the same position as for the background flash only it should point back towards the hair or shoulders. It creates a ring of light around these areas. The brightness of the effect depends on the power of the gun and the distance it is from the subject. All pictures *J Evans*

People by candlelight

Try taking pictures in a candle-lit restaurant and you are sure to be told that they 'won't come out'. In fact, with modern fast lenses and fast films you can take pictures in any light that is bright enough to see by. That includes candlelight, firelight and other very dim light sources.

The secret is to use a lens with a wide maximum aperture such as f2 or—better still—f1·4, and 400 ASA film. If necessary, the film can be exposed at even higher ASA speeds such as 800 ASA and 1600 ASA, providing the processing is changed to compensate. This means either processing the film yourself and increasing the normal developing time, or finding a laboratory will-ing to do it for you. If you plan to use a laboratory, find one that will 'push process' film before you start shooting.

Shutter speeds and film speed

The point of using fast or uprated film is to get a shutter speed fast enough to avoid camera shake or subject movement. The slowest speed at which most people can hand-hold a camera is 1/30. At speeds below this, many pictures will be blurred because of camera shake. An alternative is to fit the camera to a tripod or another firm support and give a long exposure of several seconds. However, this limits the choice of subject. Pictures may be spoiled by un-sharpness caused by subject movement.

In many low light conditions, however, 400 ASA film will allow an exposure of 1/30 at f2. If this is not sufficient, the film can always be uprated. With the lens at full aperture, each doubling of the ASA speed allows you to halve the shutter speed set. An exposure of 1/8 at f2 with 400 ASA film becomes 1/30 at f2 with 1600 ASA.

The penalty for uprating film is that the picture quality suffers. Graininess increases and sharpness is lost, but the results can still be very acceptable.

All 400 ASA colour films, whether for prints or slides, are meant to be used in daylight. When used with low-light sources such as candles they produce pictures with an overall yellow-orange

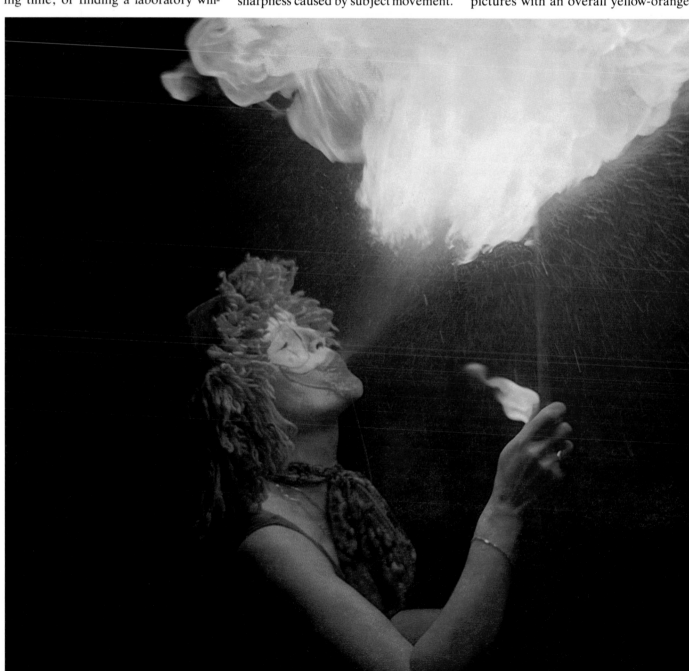

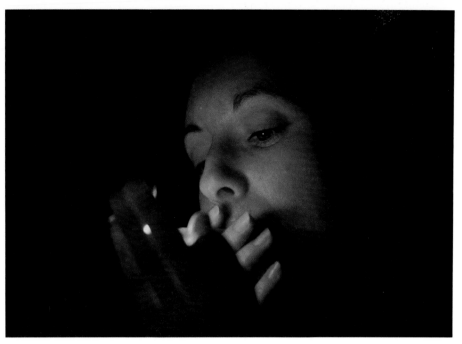

▶ Not all matches give the same light! For this shot of a girl lighting a cigarette, *John Goldblatt* used 400 ASA film and a 105mm lens. He first shot at his widest stop, f2·5, at 1/15. Then he put the camera on a tripod and bracketed at 1/8 at f4. He made a test strip of the film and found it under exposed, so he had the film pushed one stop in the processing. Thus this shot was taken at 1/15 at f2·5 on (effectively) 800 ASA film.

▼ The burning fumes from the fire-eater's mouth give off far more light. *Lawrence Lawry* used 64 ASA film with a 50mm lens. Here, his exposure was 1/30 at f4.

colour cast. However, if you include the light source in the picture, this gives a more attractive and more realistic result than one with 'correct' colour balance. If a picture has obviously been taken by the light of something burning—such as a match, candle or fire—it would look artificial if it had the same colours as an ordinary outdoor picture. It is therefore not necessary to use a filter to 'correct' the colour balance for this type of shot. (In any case, adding a blue colour correction filter would cut down the light and might make hand-held photography impossible.)

Strike a light

The cheapest form of artificial light, a match, can produce some fine pictures. You can photograph someone lighting a cigarette, for example, if you set an exposure of 1/15 at f2 with 400 ASA film. In fact, the exact exposure is not critical. The more exposure you give, the more shadow detail is recorded, but shadow detail is not important here.

Since you will be using the lens at full aperture, you will have a shallow depth of field. If you compose the shot so that the match and the cigarette point directly *towards* the lens, you will not be able to keep both in focus. It is better if the subject turns his head and the cigarette slightly away from the camera so that the match and his cheek are about the same distance from the lens. If the match is cupped in his hands, as it would be outdoors, his hands will acts as a reflector and throw much more light on to the face.

Candles

Though natural and spontaneous pictures can be taken by the light of a match, it does not burn long enough for you to study its effect on the subject's

face. Candles, on the other hand, you can move about as you wish. Whereas with a match you are limited to one light source, with candles you can use as many as you like. They are best placed in proper candlesticks, or bottles if you want an informal effect. To obtain the maximum amount of light, the subject should sit at a table in the corner of a room with light-toned walls. With the candles on the table, one wall acts as a background and one as a reflector. Alternatively, you can place a large sheet of white card just outside the picture area to throw light from the candle back towards the sitter.

If the subject rests his elbows on the table, perhaps with one hand supporting his chin, you can use surprisingly long exposures without any signs of subject movement. An exposure of around 1/4 at f4 or f5·6 will be quite possible with 400 ASA film. (Some of the finest Victorian portraits were taken with exposures of several seconds, so even longer exposures can give good results.) However, you will need a tripod.

The first step is to move the candle about while you watch the effect on the person's face. Generally speaking a broad face will look better with the candle in a high position; lower it for a thin face. Having found the correct position for this main light, use a second candle as a fill-in to soften the shadows. If you have a multi-branch candlestick, increasing the number of candles will allow shorter exposures.

The basic exposure needed for a single candle will probably be the same as for a match because, although the candle flame is brighter, it will be further away from the subject. If you use an exposure meter, either TTL or hand-held, you will need two readings. First take a close-up reading from the face; if you

▲ Though the light in the central area of this photograph was thrown by the candles, *John Garrett* boosted the light level in the rest of the room by turning on the overhead lights. He nevertheless used daylight film for the warm, cosy cast it shows when used with artificial light.

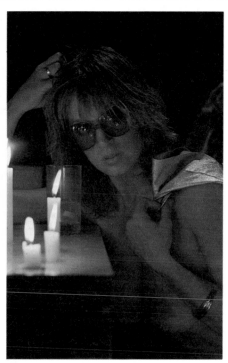

▲ The candles in the picture area here would never have given *John Kelly* the exposure he used—1/15 at f4 on 64 ASA film—without some supplementary lighting. In fact he had filled the room with around 100 candles for a special commission, and their light was increased by several mirrors.

used this exposure the candle flame would be burnt out and the lighting effect would be largely lost. Next, take a reading of the scene including the candle or candles; since the meter will be over-influenced by the bright flame, this exposure would be too little. A compromise is needed, and an exposure midway between the two is likely to be correct. As in all unusual lighting situations, it is wise to bracket by a stop either side, to avoid disappointment.

Table lamps

If you have an old-fashioned oil lamp you can attempt some very atmospheric, nostalgic pictures. The large opaque glass globes cast a soft, diffused light which can be highly flattering. As with the candle, the lamp should be moved about to find the best lighting position. If this proves difficult to manoeuvre, the person being photographed can alter his or her position instead.

The exposure will depend on the distance between the lamp and the subject. Since the light from oil lamps varies so much in power you will need a meter reading. If no meter is available and

the light is bright, try 1/30 at f2. You can also take pictures by paraffin pressure lanterns with mantles. Since these lanterns are much brighter than oil lamps, two or three stops less exposure will probably be enough.

Firelight

Pictures apparently taken by firelight are often faked, since the light produced is not particularly bright and the subject cannot get too close to it because of the heat. At one time the standard technique was to screw up a small quantity of flash powder in a piece of paper, open the camera shutter and toss the paper into the fire. The flash was so bright that quite small apertures could be used.

Nowadays you can get much the same effect by placing a flash bulb or an electronic flash at the end of a long lead on the side of the fire furthest away from the camera.

Try photographing people around a bonfire. First, work out the aperture you need for the flash. Set this aperture, and take a meter reading of the flames to find the shutter speed needed to

record these correctly. At the small aperture required, this may be several seconds. If you take the picture with the shutter set on B, this will normally fire the flash. Then continue to hold the shutter open for the required time exposure. In this way the flash and time exposures can be correctly combined.

To find what stop to use, divide the distance between the flash and the people into the flash gun's Guide Number. (See instruction book). Then open up by one stop, because outside there are no walls or ceiling to reflect light. The result might be an aperture of *eg* f8. It may be that the available light is too dim for your meter to measure at the aperture required for the flash. In this case, take your meter reading at full aperture, and convert the shutter speed to match the chosen aperture. For example, a reading of 1/8 at f2 for the available light converts into an exposure of 2 seconds at f8.

Fireworks

Fireworks outdoors can also provide a source of light but it is usually necessary to add flash to avoid long exposures. Fireworks burn too brightly and too quickly for long exposures—they burn out on the film. However, flash tends to make the result appear artificial. If you have an automatic flash, use the lowest output so as not to drown out the light from the firework.

Creative effects

A match or candle is ideal for creative effects photography, as each is a small, bright light surrounded by a pool of darkness. Cross-screen and star-burst filters will turn a candle into a star. Multiple image prisms can easily turn a single candle into five or more, and different colours can be added too. A moving match or candle will leave an intriguing light-trail. All of these effects show up best with simple subjects and dark backgrounds. By combining effects, unusual pictures can be produced. But even without such special effects, candlelight dinners, fireside scenes, birthday parties, Christmas trees and other low light situations can provide opportunities that electronic flash just cannot match.

▶ Though the girl's clothes reflect a great deal of light, one candle was not powerful enough to light this shot. *Hideki Fujii* subtly matched the colour temperature with tungsten studio lights, using some backlight to make the fabric glow like a lantern.

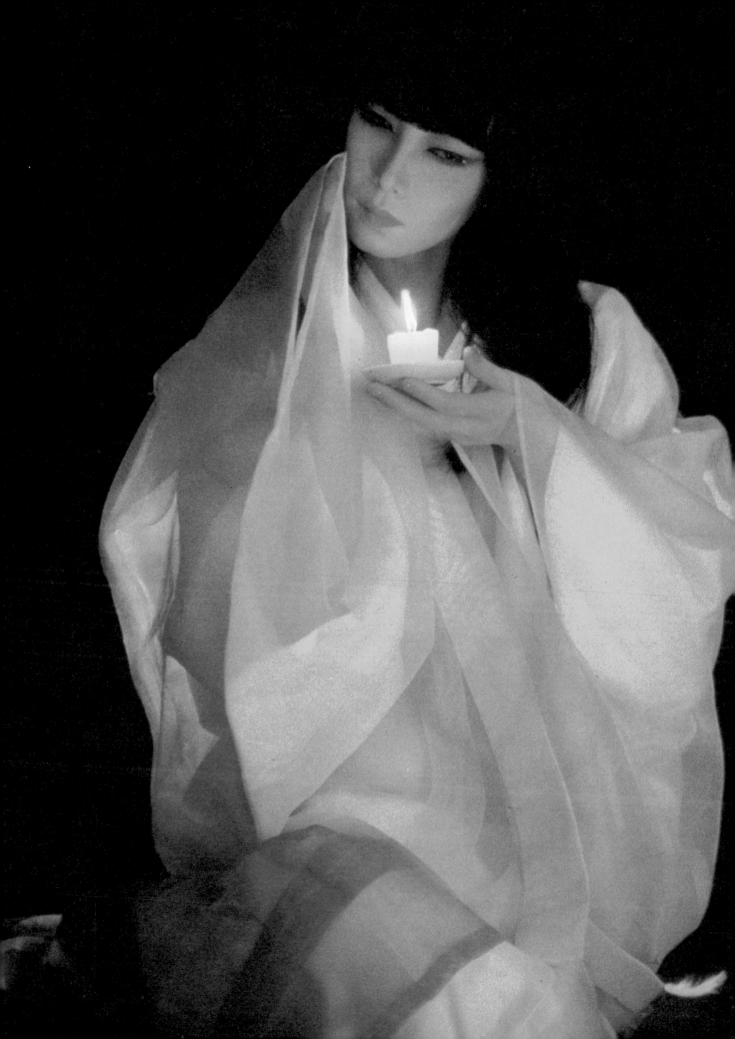

Photographing your children

Photographing your own children is one of the most rewarding pleasures for the parent with a camera. And with a subject as fascinating as a growing family, you can build up just as memorable a record with a compact, cartridge or instant camera as with an expensive SLR.

Between birth and school age a child can never be left alone: one or other parent is with the child at nearly all times and so the photographic opportunities are many. Playing, bathing, eating, dressing—even sleeping—may not seem the most photogenic of activities, but they are what go to make up each day of childhood. For a true record, the parent should not neglect the moments of frustration, irritation and tears: these emotions are as interesting to look back on as all the fun and laughter.

So always keep a camera handy: it is very easy to say to yourself that you will take some pictures tomorrow, when you are less busy, or after a child's bath when he or she looks at his or her best. And so you miss a shot which might never present itself again. Every day your child gets older—one more day passes, never to be repeated—and before you know it another year has gone by.

Your child and the camera

Children are usually fascinated by cameras, but they are often quite camera-shy. They may curl up, hiding their faces behind arms and hands, and the more coaxing you do, the more shy they become. Bribery is one way to get round the problem, though a simpler solution is to make use of whatever reaction presents itself at that moment: if your child hides his head, photograph what you see. It will have its funny side, then and in the future.

Candid shots often say more than shots taken under posed conditions where it can be difficult to bring out the true nature of the child. While friends may not be able to see this, it is important to remember that you are taking the pictures for yourself, for the rest of the family, and for the children themselves when they grow up.

Techniques

The parent photographer has to be alive to every opportunity for a candid shot. Obviously you can't carry a camera round your neck all the time, but you can keep one handy—not in a drawer or in its case but on the sideboard or the mantlepiece. 'Grab-shots' usually make the best child photographs, but they will only be successful if you are familiar with your camera, so that you can take pictures quickly.

If you do not have an automatic exposure camera, it is a good idea to keep the camera pre-set at the correct exposure for normal lighting conditions in your home. Alternatively keep a small flash gun attached to the camera. If you also pre-set the focusing distance at about 1·5m, you will be able to 'grab' pictures quickly without being delayed by technical problems.

As children tend to have boundless energy and cannot sit still for more than a few seconds, you may have to use a fairly fast shutter speed to stop the action. The aperture will have to be correspondingly large and focusing the more accurate. Using a wide aperture has an advantage, however, in that it throws the background out of focus. This is often very helpful in rooms

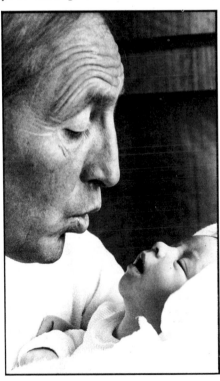

▲ START ON DAY ONE
Helmut Gritscher set out to make a complete photographic record of his son Thomas. He enlisted the help of a friend to take this shot of father and son on the first day.

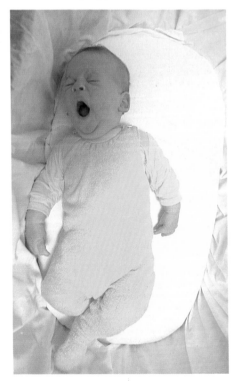

▲ THOSE FIRST EXPRESSIONS
With your subject still immobile, what you must hope for is the odd smile or yawn. *Gritscher* shot this from above with a 21mm lens in daylight filtered through the cot and fill—in flash.

▲ CAPTURING A TODDLER
At this age your first problem is to catch your subject. With Thomas rooted to his chair and concentrating hard, *Gritscher* homed in with a 90mm lens, lighting the shot with bounced flash.

▲ YOUR CHILD'S BEDROOM
By the age of five your child's room already reflects his character, making a telling background. In fact here Thomas is only part of the picture: *Gritscher* composed the shot to show more of his favourite toys than of the boy himself. Bounced flash 'kills' the effect of the bedside lamp.

▼ THOMAS WITH HIS BROTHER
When photographing your children together, wait for the moment which best shows their relationship. Here Thomas, the elder, is absorbed in his game while his younger brother looks on. Fill—in flash supplements the daylight, and the pale tabletop helps to reflect light up into their faces.

▲ ASLEEP IN THE CAR
As toddlers spend much of their lives asleep, use the opportunity to take typical shots. *Gritscher* used a 21mm lens (as Thomas's large feet show) and flash bounced from the car roof.

cluttered with toys and household paraphernalia when there is no time to find a camera angle that puts your subject against a plain background. This also applies out of doors. A garden, for example, will be full of plants and other objects that you may not even notice when you take the shot, but which will inevitably show up on the final print.

One useful technique to remember is to take pictures looking up at or down on your child, which helps to eliminate these unwelcome distracting backgrounds. Carpet, lawns and skies all make excellent foils for your small subject and, in addition, the occasional high viewpoint will reflect the way you normally see him. He will have to look up at you—as he usually has to when you communicate with him.

The right moment

A child's life does not only revolve round his house and garden. There are trips to the shops, journeys by bus, train and car which are seldom regarded as photogenic situations. Cameras tend to be put away as soon as it begins to rain. But what could be more evocative than a picture of a child with his nose pressed to a steamed–up car window and with rain spattering outside? Or a shot of his first ride in a supermarket trolley? There is always a very special quality about 'first time' pictures—the first time your son rode a two–wheeler, caught a fish, rode on an elephant at the zoo—since they are ideal reminders of these occasions.

Even the special occasions which involve careful planning—like birthdays, parties, picnics in the park—can yield unexpected photographs. Surprise is a very positive reaction, and registers very clearly on a child's face. The photographer who can capture real surprise on the face of a child has begun to master the art—and the technicalities—of photographing children.

A photograph which registers some strong emotion in the child has a special poignancy: surprise is one, another is joy. But it is no use manipulating your child's emotions for the benefit of the camera. It will invariably show.

Compiling an album

The family photograph album can be more than just a convenient place to store a random selection of photographs. Instead of sticking the pictures down in the order in which they come back from the processor, you can use the pages to tell a story. For example, a

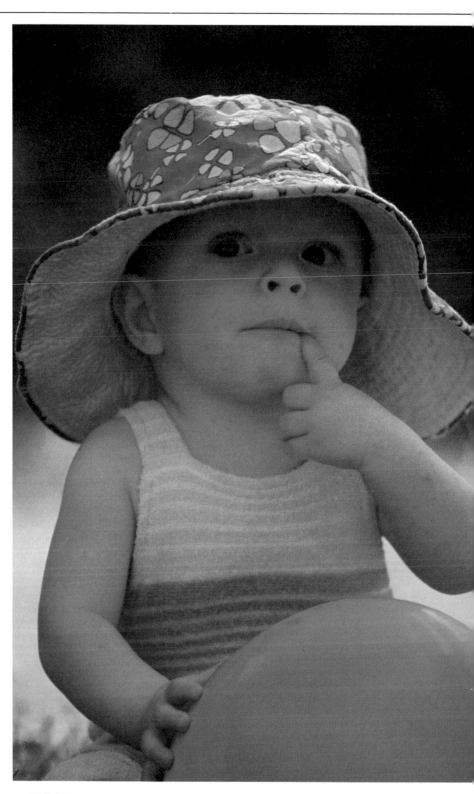

▲ CLOSE–UP SHOTS
With a long lens, *John Garrett* peeked under his son Nicholas' hat and into his thoughts. A shot this close needs care in focusing, and the enveloping hat demands careful exposure, with an eye to the colour of reflected light.

▶ SET–UP SITUATIONS
Although their father set this shot up specially—in the soft shade of a tree and with the cat as a 'prop'—Nicholas and his young brother have by now forgotten the camera. Use a leisurely afternoon to take a series of shots.

series of pictures of one of your children at different ages but doing the same thing—sitting at a desk, perhaps, or riding a rocking horse. Or a group of pictures of different children as they begin to take an interest in the same toys at a particular age, which will illustrate either the similarities or the differences in their approaches to things. One child may have the habit of sucking his finger and another of fiddling with his hair: put these comforting habits together on one page. They are tangible links with the past, a forceful reminder of childhood even when the habit has long been forgotten. Photography can bridge the generation gap, too. Grandchild and grandparent may have 50 years separating them, but look closely at your old family photographs for likenesses and mannerisms that carry through the generations and can be brought out with one click of the shutter.

Family links and likenesses can also be brought out by techniques like multiple exposure or multiple printing from a carefully thought out series of exposures. You can make combination prints from portraits, either linking the features of mother, father and children together or showing the same child at different ages. Similarly, pictures of different children all at the same age can be printed on the same photograph: the result may show likenesses that you could never see when the shots were taken. Without photographs it is all too easy to forget what your children looked like at a certain age.

▶ **SPONTANEOUS PICTURES**
On the spur of the moment, even the professional photographer can miss his framing. But though here he cuts off his hands and feet, *Garrett* still shows the boy's gleeful mood. A slow shutter speed conveys his quick movements.

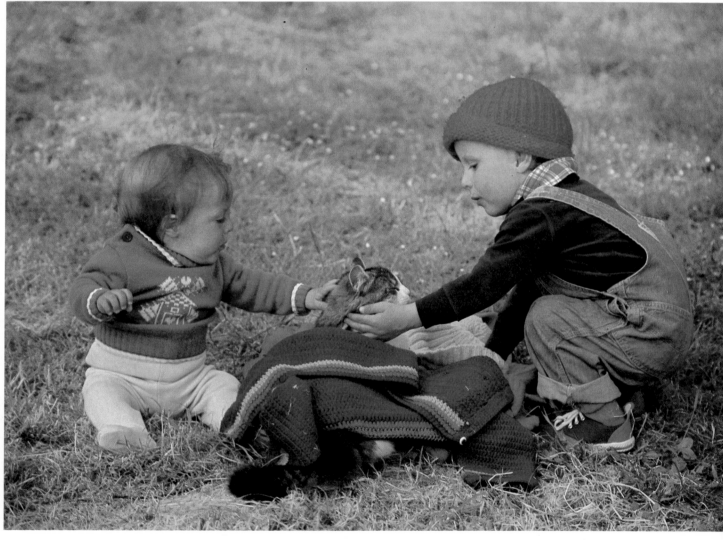

Moments in a baby's life

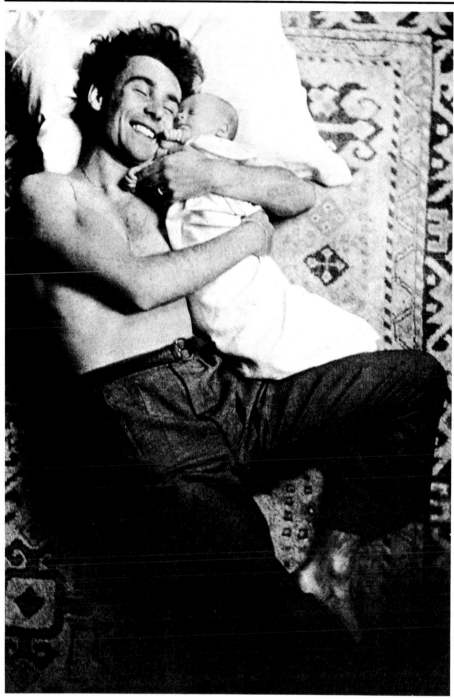

From the fond parents' point of view, a baby's life is full of memorable moments all too soon outgrown. A lively record—especially if the pictures are imaginatively thought out and technically successful—is a rewarding and enduring reminder of your child's earliest days. The most important thing to remember about photographing babies is that *you* must be ready for *them*. Babies cannot deliver smiles on demand or gaze into the viewfinder when you ask them to, so you must have your equipment ready for instant use, be it a light, ready-loaded camera for candid shots or sophisti-

▲ Photographer *Jacques-Henri Lartigue* positioned his son and grandson on a rug on the floor and took this picture looking straight down, capturing the expression of sheer joy on the young father's face.

▶ Highlights and shadows created by light streaming through a tall window at the back of the bed is the key to the elusive quality of this picture. *Elliot Erwitt* himself has described it as a snap, referring to its chance composition and lighting. His skill was in recognizing the exact time to press the button— the moment of eye contact between mother and child.

cated equipment for planned shots. Photographing babies demands the same lack of self-consciousness for which the subjects themselves are famous. Inhibitions on your part will only hinder. Be prepared to clown around, shake rattles, get down on all-fours—anything to catch the baby's attention and that special expression that makes the great photograph. Don't enjoy yourself so much, though, that you forget the rule for all portrait photography—focus on the eyes or, in the case of a three-quarter view, you should focus on the bridge of the nose.

Candid pictures
For candid pictures, a light easy-to-manage 35mm SLR camera is best. But if you haven't an SLR, don't rush out to buy one: it's better to use a camera you know than miss a once-in-a-lifetime shot because you are struggling to master unfamiliar controls. Keep the camera loaded with colour or black and white fast film and set a shutter speed short enough to stop movement —1/125 is ideal.

Planned pictures
For planned pictures have everything ready in advance—and that means not just your camera but lights, background and diversions to entertain the baby. A tripod and cable release are especially useful since they leave one hand free to shake a rattle or wave something to attract the baby's eye towards you and the camera. A helper can do the job but make sure you have only one: too many people could confuse the infant.

Unless babies are asleep or very young, they will only be content and responsive for 10 to 20 minutes. Do not persevere once they have lost interest or when they are tired or hungry. Try

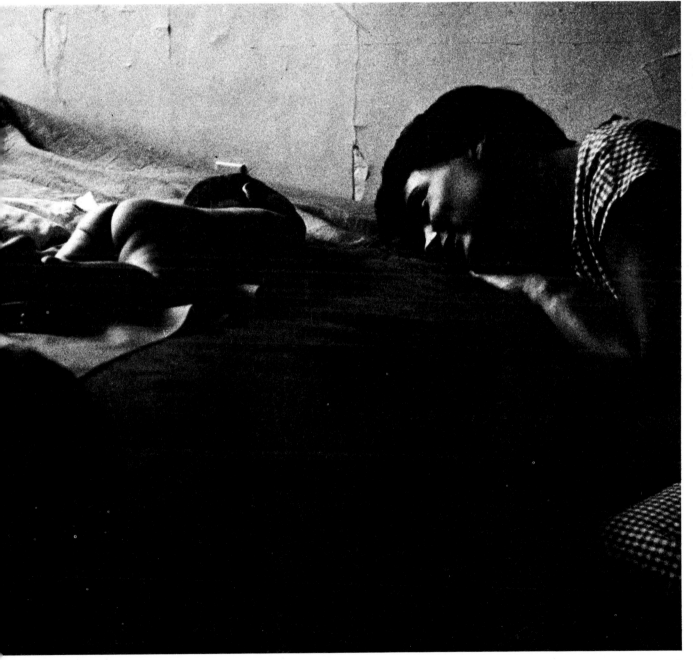

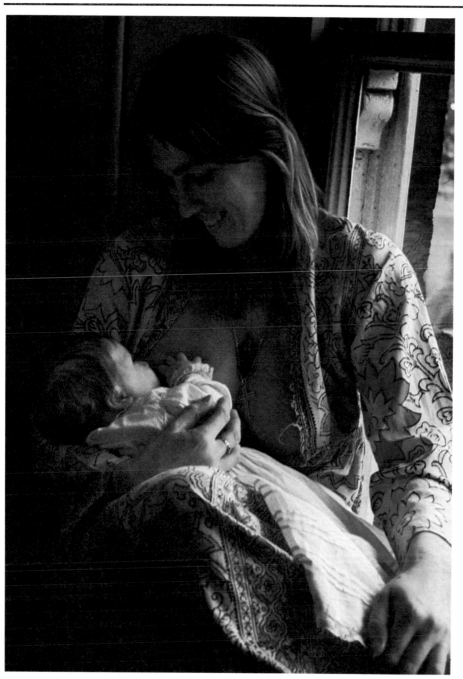

instead to time your sessions in short bursts soon after the baby has been woken, fed, burped, and changed. Take a good selection of photographs during this responsive period.

Close-ups

Close-ups present special problems. Young babies are so small that it is hard to fill the viewfinder with the whole body, let alone a face or hand. If you are using a 35mm SLR, a lens with a focal length between 85 and 105mm is ideal. A standard 50mm lens also gives good results; don't add a close-up supplementary lens as it will give an exaggerated perspective.

Lighting and background

Soft natural lighting is by far the best. Full sunlight produces unhappy screwed-up faces and harsh shadows; flash shots, after the first two or three, fluster the baby. Bright light can often reflect surrounding colours on to the baby. For the same reason, avoid bright backgrounds since the baby's skin may take on the green of the grass or appear lobster red against a red chair. Creams and whites are ideal, or experiment with dark colours. Black and Asian babies are best photographed against light backgrounds but be sure to take your light-meter reading from the baby not the background, otherwise the photograph will be too dark for you to distinguish the baby's features.

When working outdoors, keep to gentle shadows or use bright sunlight as back or side light. Indoors, many professional photographers prefer to work with fast film using available light from a window.

◄ The photographer of this mother and baby picture contrived a deliberately grainy effect to add to the mood. This can be done by under-exposing a fast film and extending the development time.

KEEPING A RECORD
At no other period in their lives do human beings undergo as many changes as during their first year. An alert parent can capture on film a whole series of firsts—the first feed, the first smile—by knowing when and what to look out for and how best to photograph the moment. All babies progress at different rates, however, so don't follow the suggestions too rigidly. Pictures of varying shapes and sizes make an album more interesting.

▲ Top left: a tiny baby like this one-day-old infant won't fill a view-finder alone, so crumpled clothing contributes to this close-up taken with a standard lens on a 35mm camera.
C. Shakespeare Lane
◄ Showing her obvious pleasure, this baby responds to a diversion outside the range of the photograph.
Richard and Sally Greenhill

▲ Dark towelling back-ground provides a pleasant contrast next to the smooth skin of a young baby in an other-wise uncluttered setting.
C. Shakespeare Lane

▼ His face screwed up to reveal the full intensity of his anger and frustra-tion, a baby in a pram provides an expressive chance picture.
Malcolm Aird

UP TO 4 WEEKS
Often red-faced, wrinkled and too small to fill a viewfinder, new-born babies are best photographed with a parent or other adult.
● For a first mother/baby picture, try holding the camera above the subject, perhaps standing on a chair, and looking down as the mother nurses the baby.
● For a first father/baby photo-graph, aim to contrast the fragility of the infant with the father's strong, masculine arms.

4-8 WEEKS
Babies begin to focus and look around but their heads still need to be supported. They may lift their heads if they are talked to softly.
● Lie the baby on his stomach on the floor and take pictures from the front and side at floor level. For a different angle, lie the infant close to the side of a bed and hold the camera just below, looking up.
● Drape a plain sheet over an arm-chair and prop the infant in a comfortable corner.

8-12 WEEKS
Now babies begin to smile and like to be propped up so that they can see what is going on around them. They are more easily entertained by movement and their facial expres-sions are more mobile and varied.
● For a profile of the mother and a full-face portrait of the baby, pose the mother with her back to the camera and the baby draped over her shoulder. If the mother tickles the baby's toes, you may capture an enchanting smile.

► Available light from a window behind gives a soft, natural look to a profile of a mother and new-born baby, the mother carefully supporting the infant's head. *Anthea Sieveking.*

▼ A transparent plastic bath makes bath-time pictures easier since it avoids the need for a high-angle position to include more of the baby and less of the bath. This photograph has been carefully planned with a plain white background, lighting and bath and camera positions pre-arranged. The foreground has only a few props relating to the occasion.

▼ Below right: proving that memorable baby pictures do not have to be traditional happy shots, this once-in-a-lifetime photograph catches an anxious look from an obviously bemused infant. *Anthea Sieveking.*

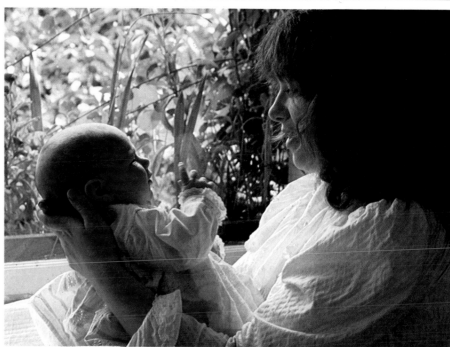

12-16 WEEKS
Babies begin to stretch their legs and can support their heads better when propped up. They also chuckle and gurgle readily. Their attention is easily attracted by noises such as bells and squeakers.
● Have the mother sit out of sight on an armchair, holding the baby up so he looks over the back.
● Photograph the baby stretching his legs in a bouncer hung from a hook above a doorway or pushing himself in a tabletop bouncer.

16-20 WEEKS
Babies become aware of their hands and are fascinated by their own ability to clutch and curl their fingers around objects.
● Photograph the baby clasping a new toy or shaking a rattle. Alternatively, show his tiny fingers clutching an adult finger.
● If you haven't taken a profile of the baby yet, try now. Have the mother hold him high so she is out of sight. Or take a profile of mother and baby facing each other.

20-32 WEEKS
Infants try to sit up unsupported and become aware of their feet. Mirrors fascinate them.
● Try to catch the baby nibbling his toes—perhaps a spot of honey on the toes will encourage him.
● With a helper nearby in case of over-balancing, take a picture of the baby sitting up unsupported.
● Try a shot of the baby catching sight of himself in a mirror. Use natural light and position yourself so your image doesn't appear.

Draping the baby over a shoulder enables the mother to support the infant.
Anthea Sieveking

▶ Far right: by positioning the baby in the shadow of a tree, the photographer not only avoided harsh sunlight but provided a diversion. *Anthea Sieveking.*

▼ Capturing the first moments of life needs careful planning and hospital permission. Take a series of pictures to record events. *Homer Sykes*

 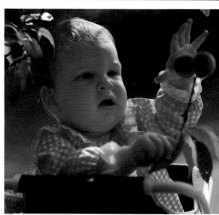

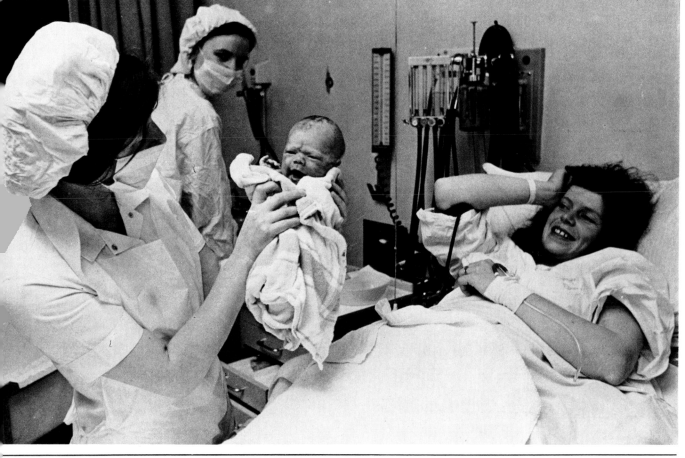

32-36 WEEKS
Babies start to crawl. Their new-found mobility opens up a curious and fascinating world.
● Be prepared to drop what you're doing and grab your loaded camera as the baby discovers noisy saucepan lids, cupboard doors, and countless other novelties.
● For a planned crawling shot, set up all equipment in advance. Place a new toy in the direction you want the baby to crawl and take lots of pictures as he dashes for the toy.

36 WEEKS TO 1 YEAR
Trying to stand is a major preoccupation, particularly if the baby has something like a playpen to hold on to. As the baby is now larger, and fills the viewfinder better, it's a good time for close-ups.
● Take a standing shot using a helper to hold something shiny or noisy just out of range but above the child's head to encourage him to stand. If you have no helper, dangle the object from a stick and work with a tripod and cable release.

1 YEAR
An infant's first birthday, particularly if there's a party, suggests plenty of ideas.
● Blowing out candles on the birthday cake, a picture helped by the fact that all children love flickering lights.
● Take advantage of this age group's lack of inhibitions to get unposed pictures of the baby and guests. Take lots of photographs to catch quickly changing facial expressions.

Photographing toddlers

Between the ages of one and five a baby grows into a communicative person, full of curiosity—a person for whom life is an adventure and the days full of play. It is an age of discovery, and for the discerning photographer it provides a wealth of material. In fact, the young child is a rewarding subject for both the camera enthusiast laden with lenses and the parent with a more modest camera.

Be prepared

Once a child is on the move it takes more than a high-speed shutter and a fast film to capture spontaneous pictures. Opportunities for photographs come and go very quickly so you have to be ready at the right moment. If you have children of your own, keep a loaded camera in a handy place, so that you can record those bizarre situations that only happen once—the 'artist' after an introduction to hand

painting, the uninhibited toddler tackling an over-sized problem. Your aim should be to capture the humour of an incident before there is time for the child to over-act or become camera shy. Always be prepared to take plenty of photographs. This is important with children, partly to make sure of catching their unpredictable expressions and movements and partly to get them accustomed to the camera. The more they see of it, the sooner they lose interest and return to the activities you want to photograph.

Planning a session

Photographic sessions involving other people's children require advance planning. Decide what film you will use—colour or black and white, slides or prints—and think about lighting and location—indoors for formal portrait shots, outdoors for portraits with natural settings and action shots.

▶ Young children are perfect subjects for picture series, particularly if you are on the spot for moments like a baby's first few steps. Here the mother was helping by calling the baby towards her. *Anthea Sieveking* used a motor-drive on her OM 2, but you can get good results from separate exposures with practice and plenty of film. She used Ektachrome 400 film, with the window light reflected naturally from white walls and polished floor.

▼ Diffused lighting is ideal for child portraits. Outside, light from an overcast sky can be supplemented by holding a white reflector close to the subject's face. By shooting close up with a large aperture, the photographer lost background detail, concentrating on the child's face.

Then, when your subject bursts in on the scene, you can concentrate on chatting and creating pictures rather than on photographic techniques.

Have some crisps or sweets handy to tide you over any awkward patches and, if the session never really gets off the ground, give up gracefully. Toddlers cannot hide their off-day feelings as adults can.

You will probably enjoy the game of photography with the toddler as much as he will. A stranger often has a built-in advantage over parent photographers in that the child will almost certainly obey his directions. The familiarity of a parent behind the camera does not always lead to full co-operation.

Lighting

During the daytime in the summer you should be able to take most of your informal photographs, indoors or out-

side, by available light. In dim, wintry conditions you need to use high-speed film; indoor winter photography by available light is often only possible where the window light is boosted with white reflecting surfaces. High-speed films can usually be pushed that little bit further to give acceptable pictures in quite dim lighting. This is done by uprating them to a higher speed. (Information on this is given in film or chemical processing instructions.) However, an increase in film speed means adjusting the processing

times, and so affects an entire film—it cannot be applied to individual frames. (Don't forget to inform the processors of the speed used.)

Lighting for close-up portrait shots is very important. The most effective results with young children are usually achieved with diffused lighting, such as you find outdoors on hazy days or on sunny days in areas of open shade. Virtually shadowless lighting like this can be created indoors using bounced flash.

Keeping the child still

The first birthday usually heralds the age of mobility. This is less of a problem for agile photographers willing to take numerous pictures. It is important to take your camera down to the child's level, but a less tiring approach, and a more economical one, is to enforce a few relatively still

moments on the subject. The easiest way to do this is to sit the child on a low stool or a tricycle, or in a high-sided container such as a shopping basket or a cardboard box. Find a suitable place for the 'seat' before introducing the occupant. The location should be free from clutter and have an uncomplicated, natural background so that the picture is simple and its impact is created by the subject and not the surroundings. The camera should be pre-set and the photographer settled at the toddler's eye level. By the age of two, toddlers are more predictable and less likely to crawl unceremoniously out of the picture in the viewfinder before you have released the shutter. The problem of keeping them still diminishes as they become engrossed in words and conversations and more interested in toys and creative play alone or with others.

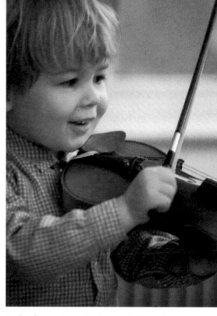

▲ Soft, natural sidelighting from a window was enough for *Michael Boys* to photograph this violinist.

▶ Harsher window light needs more careful composition. *Anthea Sieveking* set up the bricks and waited till the boy was engrossed.

▶ Shooting by low-level available light on Ektachrome 200, *Gary Ede* had to choose between a wide aperture (and the risk of one of the girls being out of focus) and a slow shutter speed (and the risk of an image blurred by subject movement). He chose to shoot at 1/60 sec during a quiet moment of concentration to get an unself-conscious candid picture.

▼ You need not always show your subject's face. This boy, engrossed in his own world, is further isolated by photographing with a high camera angle and a medium telephoto lens.

Close-ups

One of the easiest ways of capturing candid close-ups of young children is to wait until they are busy. A two-year old may happily sit for several minutes fitting shoes on the wrong feet or trying to climb into daddy's boots. An older child will become totally absorbed in painting a picture, a construction toy or water play. During such moments you should have no difficulty in taking expressive close-ups especially if you have a telephoto lens which allows you to keep your distance. If the activity is interesting and colourful, you may want to document it with a series of photographs taken at different angles and shooting distances.

Playgroups

Playgroups or nursery schools offer many opportunities for candid shots. Visits to playgroups should be arranged with the organizers well in advance so that both staff and children are prepared for the distraction. Plan to spend quite some time with the children. The results will probably show a gradual progression from conscious poses—with the children (sometimes delightfully) acting up to the camera—to the intent expressions of youngsters preoccupied in their own affairs. Wherever possible, try to plan the most suitable lighting and backgrounds; if a distracting background is unavoidable, use a wide aperture to blur obtrusive shapes. But remember that the camera lens will distort facial features if you move in too close. A safe, distortion-free distance with a

standard lens is 1·5m. Here again, a long lens, with its narrower depth of field, can help by leaving the background out of focus. Ultimately, the most successful way of obtaining bold close-up expressions when the subject is toddler-sized is by selective enlargement of one part of the picture.

Outside action

There is far more scope for photography outdoors, as children rush around with balls and tricycles, and romp in sand and water; action shots on the swings and roundabouts; candid pictures of make-believe games; studies in contemplation alongside the more exuberant shots.

Action pictures almost always need fast shutter speeds to keep them sharp. Remember that it is easier to prevent blurring if the subject is moving towards or away from the camera, and most difficult when the subject is moving across the field of view. So, if for some reason you have to use slower shutter speeds, concentrate on movements that happen towards or away from the camera.

Accept that dirty hands and faces, dishevelled hair and rumpled clothes are all part of your outdoor pictures. Producing a flannel or comb before you press the button is the surest way to kill spontaneity and will ruin your chances of successful pictures.

▼ Seaside shots can be tricky because of the extra light reflected from the water, so always use a lens hood and expose for the subject. This backlit shot would have been especially difficult because of the girl's dark skin, were it not for light reflected off the sand which helps to bring out her features. *Fiona Nicholls*

◄ Parties are a riot of colour and activity. Outdoor shade gives a soft light which tones down clashing colours and throws no complicating shadows. *Anthea Sieveking*

▼ Showing your child how to use a camera may make him a more helpful subject and provide some interesting candid shots. *John Garrett*

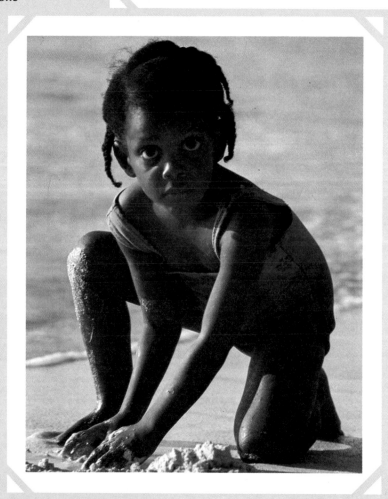

▶ Some of the best portraits are candid shots. Here a high viewpoint and a wide angle lens also give a record of the child's paintings.

▼ A long lens helps with the self-conscious children by keeping the camera at a distance. Try setting up your shot and then calling out as you are about to press the shutter. *Tony Boase*

▼ A big ice cream looks bigger through a wide angle lens, and will usually solve the problem of keeping the subject in one place. The faraway look in this boy's eyes is not sheer enjoyment: *John Watney* had help to attract his attention away from both camera and ice cream sundae before he became completely obscured by it.

Photographing schoolchildren

Starting school is a big adventure for every child around the age of five. It also marks the beginning of a new era for the photographer. His challenge is no longer the smallness of the baby or the unpredictable energies of the toddler. Neither will sticky fingers reach out to grab the camera lens and mar the view. The new problem is the independence of the young schoolchild, who has better things to do than stay at home to be photographed.

As soon as a child gets established at school his interests widen and so do his social activities—friends rather than parents take a leading role. Between the ages of five and 10 there will be fewer 'firsts' for you to photograph and you will have less opportunity to get spontaneous pictures.

Formal portraits

If the child has to wear school uniform for the first time, a dress rehearsal before the first day at school is an excellent opportunity for a portrait.

Lighting: the degree of formality you achieve in a portrait of a five-year-old depends very much on the lighting and the props you have. Although some people use the standard photoflood set-up—modelling light, fill-in and hair light—more and more photographers are using a more modern approach for indoor portraits: very good results with young sitters can be achieved by using either umbrella or bounced flash as the main light source. Both give soft, virtually shadowless lighting which suits a young face. Both also allow the subject a fair degree of mobility, which is an advantage when photographing fidgetty five-year-olds. Flash bounced from a white ceiling is best for pictures of children with glasses as it produces fewer highlights around the eyes.

Composition: though complimentary lighting is the essence of a good portrait, another important consideration is composition—unifying various elements of the picture like colours, shapes and lines, to create a well-balanced result. Even in a portrait of a uniformed five-year-old, shapes and lines can be created with simple props (such as a desk or a chair), and with relaxed poses. Position the child at an angle to the camera—his body should never be square-on like a passport image—and keep his arms and hands in line with his body. If they project towards the camera they will seem oversized and distorted.

During the session, build up confidence by chatting about what you are doing and why. If you make the whole thing interesting and a little scientific you should be able to get good pictures from the toughest of subjects. As you are talking, keep watching and focusing the viewfinder image so that you can shoot an animated expression without delay. A shy child is often more successfully photographed from a distance—for this a long lens is a great advantage. Negative films are the obvious choice for portraiture as they are easily printed and enlarged. Make

▶ For a portrait session with his own children, *Malcolm Aird* loaded his Nikon FE with tungsten balanced film and arranged a simple lighting set-up— a quartz halogen lamp with an umbrella diffuser on one side and a reflector on the other.

▼ For the group portrait he used a 55mm lens, a plain background and a simple grouping. His biggest problem was getting all the children to co-operate at once.

rough contact sheets and work on these, or on the enprints, with L-shaped masks to select the best pictures and framing for selective enlargement.

Home activities

Portraiture need not mean the formal pose, of course, if you have the space and equipment. You can also create scenes with the children as models or actors for a photographic series.

Children, particularly young girls, enjoy dressing up and playing with make-up. Set the scene against a plain background and watch the theatre through the viewfinder as the actors dress themselves in ill-assorted garments. For once you can use clashing colours to add to the drama. The series will be more interesting if you can shoot from different distances and camera angles. Bounce flash and a long extension cable are invaluable for this.

Playing with make-up often involves the use of mirrors. It is not difficult to record both the real and the reflected image in the picture provided you frame the shot with care and focus *either* on the child *or* on the image in the mirror. Having selected the view that gives a good composition, check the background or the mirror image for evidence of the photographer.

Outdoor action pictures

Outdoors, you can get pictures of the children careering around on bicycles or go-carts. A picture series of any such energetic activities calls for fast shutter speeds—1/250 or faster if the film in your camera allows for this—and a photographer with very quick reflexes.

Children with their pets can make attractive subjects. Feeding, grooming and exercising the cat or dog, rabbit or guinea pig, will produce plenty of appealing pictures—especially if you choose close-ups.

Special events at school

As soon as a child goes to school both he and his parents become caught up in the various organized activities that go on there—parties at harvest festival and Christmas, nativity plays and concerts, dancing classes and speech days. Photographing these occasions can be approached in several different ways. Many photographers prefer to avoid flash in these circumstances, and shoot by available light. Often this will mean pushing a fast black and white film to its maximum speed limit (see film or chemical processing instructions).

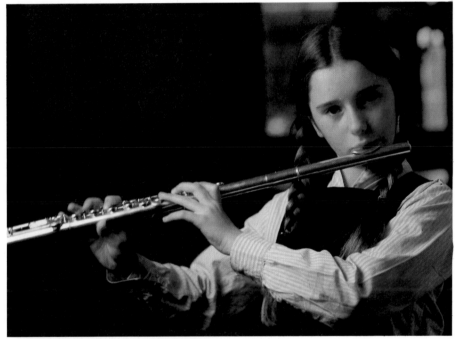

With more time for each child, the individual portraits are more relaxed, particularly where they include a favourite activity. Here *Malcolm Aird* used an 85mm lens.

▲ Top: it would have been uncharacteristic to photograph the boy without his glasses so care had to be taken to avoid reflections from the lamp. Pinpoints of light help to emphasize his eyes.

▲ Here the more complex background is reduced to simple shapes by being out of focus. The photographer had to expose carefully for the face and avoid any spectral reflection from the shiny flute.

◄ An intricate background pattern risks drawing attention from the subject. Here her light hair and shirt create sufficient contrast.

For the photographer who hopes to get school pictures printed in the local paper, however, pushing the film is unlikely to give good enough results. He will need to use black and white film with flash-on-camera to get suitable pictures.

Stage performances are always better photographed at close quarters, preferably from a position on the stage itself. Try to attend the final dress rehearsal for these shots, and supplement them with others taken with an audience on the night itself. But remember that actors—particularly when they are infants—photographed from a distance tend to look lost on a vast stage.

If you are photographing theatricals or parties with colour film for the family album, use blue or electronic flash. The most commonly used film (that is, daylight type) records accurately in daylight or by flash, but does not give a correct colour rendering lit solely by theatre lighting or by candlelight. The pictures tend to show an overall yellow/orange cast.

Some correction for colour balance defects of this kind is automatically made during the machine printing of colour negatives which, in this instance, makes them preferable to transparencies. Carol singing, nativity plays or parties are often excellent material for Christmas cards for friends and relations. Be on the look out before the Christmas rush for any discount printing offers—they are often very good value.

▲ Posed portraits may show off your children to advantage, but it is often snatched, candid shots that reveal more about their real personalities. *Constantine Manos*

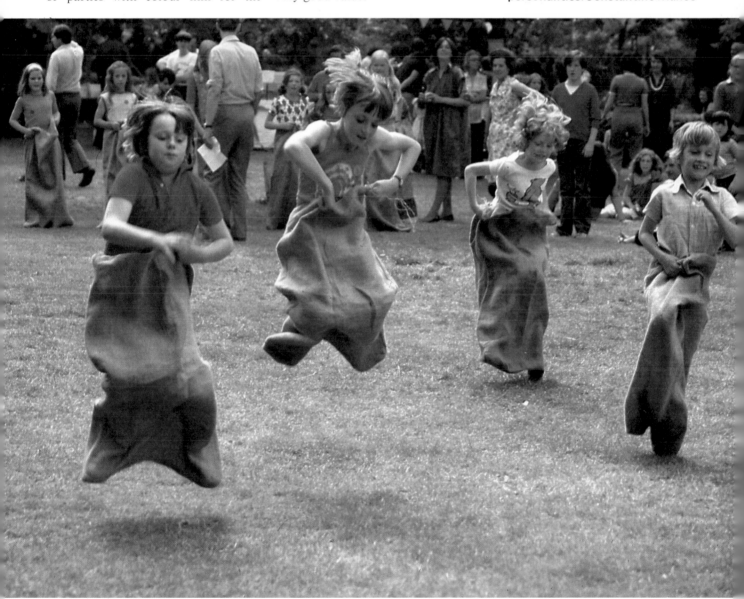

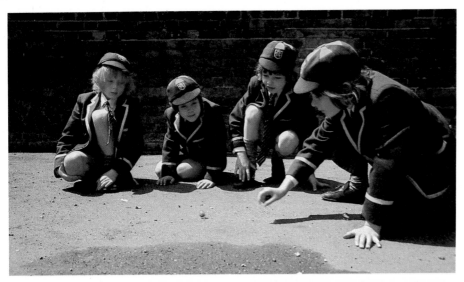

◄ Strong sunlight is not ideal for photographing people, obscuring their expressions with confusing shadows. Here the boys' caps shade their faces from the midday sun, which throws back sufficient light from the ground to show their features. *Clay Perry*

▼ Photographing by daylight and candlelight together, you should anticipate that one will cause some colour distortion. With daylight film (Ektachrome 200) in his Leica, *Michael Hardy* had to balance his light sources carefully: more window light would have drowned the candles, and the warm pink glow on the girl's face would have looked strangely out of place.

▲ As children develop new friendships the playground becomes their private world. Unobserved, *Michael Busselle* had to sacrifice perfect framing to catch these two mid-kick. The plain background helps to emphasize how oblivious the children are to all but each other.

◄ For action shots on a dull day, choose a film that allows you to set very fast exposures. *Anthea Sieveking* was able to set at 1/500, ready for the moment when all four sack-racers were in the air. She kept a pale brown filter on her Olympus OM-2 to get a better rendering of skin tones.

Children at play

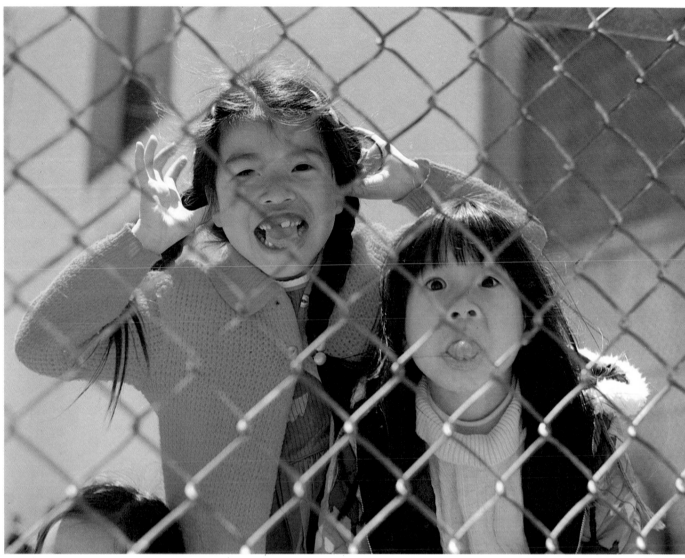

Adults must become 'part of the scenery' to photograph children's spontaneous games. Play is the way in which children learn about the world. They concentrate very hard at it and, like grown-ups, dislike interruptions. The secret of becoming accepted lies in the photographer's attitude and approach.

The golden rule is to make friends at the child's pace. Never be pushy. A friendly, open and unhurried adult, who is genuinely interested in what the child is doing, will be accepted quickly.

Children react to anyone, and especially to a photographer, who takes a sudden interest in what they are doing. The reaction varies according to the age and number of children.

Younger children, especially on their own, can be very shy of a stranger (or even someone familiar) with a camera. Approach them through an adult, perhaps a parent or play leader, and wait until the child talks to you. It is much easier to make friends with a child who has seen someone they trust being friendly with you. Groups of young children, say aged six or less, accept strangers quickly; there always seems to be one individual who wants to make friends with everyone.

It is easier to make the first approach with older or more mature children, if you are prepared to answer innumerable questions. Explain exactly and patiently what you want to do and why. Wait a little longer once the questions have subsided before taking any pictures. Let the child forget the camera; failure to do this encourages the ham actor latent in every small boy or girl.

The most difficult children to deal with are bored 8 to 11 year olds in a group. Produce a camera in front of this lot and there will be a chorus of 'are we going to be on the telly?' and a gallery of funny faces. This is all very well if you want pictures of funny faces but, again, the approach must be to wait.

Some of the group will eventually lose interest in the photographer and start to play. Others will follow but some will hang around wanting attention. Start to walk about when this happens.

If you see a likely picture stop and wait a moment. Focus on the children you want to photograph and turn your back on them. Turning your back prevents the game becoming self-conscious. It also clears a space in front of the subject because any 'hangers-on' will want to stand facing the photographer. Wait another moment, then turn round and take the picture.

This trick works only a few times. After that it becomes a game in which the 'hangers-on' run around guessing who is going to be in the next picture and getting in the way.

Children react to the camera in different ways. Nothing affects their reactions more than the photographer's manner.

◀ Make friends at the child's pace if you want to become part of the child's world. Appear suddenly with a camera and shy children will go quiet or hide. The bolder ones will just start playing the fool. *Pierre Jaunet*

▶ Younger children should be approached through an adult they trust. Talk to the grown-up first so that the children can see you are a friend. *Anthea Sieveking*

▼ Older children can often be approached directly. Sometimes a child will sense what is wanted and 'perform' for the camera. *P Goycolea*

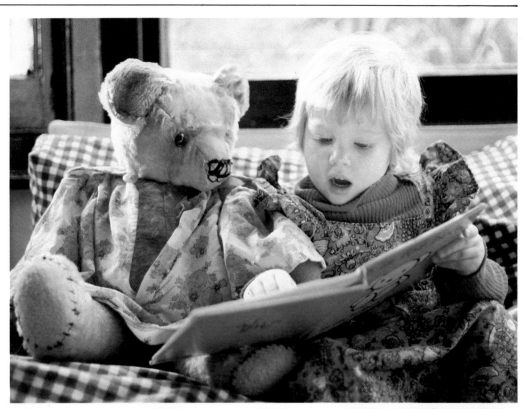

Sometimes it can be an advantage when children play up to the camera. Children of all ages can sense far better than any adult what a photographer wants. If one or more decides to be co-operative you may get every kind of picture that you could possibly imagine. If the children decide not to co-operate, the photographer has two choices: to wait or to take pictures of them playing the fool.

Very small children deal with the camera in a different way. They seem to know exactly when the shutter is about to be released. If they don't like the photographer they will turn away and spoil the picture.

Strangely, 8 to 11 year olds can be the easiest children to photograph. If they are involved in an energetic game of their own making—like swinging on a rope tied to a tree—it is very difficult to distract them.

Finding children

It is not always easy to find places where children can play freely, especially children too young to leave home. Obviously it is an advantage if you have children of your own to photograph: even if they have become bored with being photographed, they are likely to bring friends who have not.

However, many children will be found playing outside at accessible places:

Public parks and gardens are an obvious choice although, at weekends, there are often as many adults as children about the swings and climbing fences.

Play groups cater for children up to school age. Most large towns in the UK have someone who co-ordinates the groups in the area. Contact this organizer who will advise which play groups have the best facilities for photography. Try to find one with an outdoor play space or a room that gets plenty of daylight.

Adventure playgrounds and play schemes are often run by local councils or residents' associations. They cater for school-age children.

School playgrounds are used at specific times. Approach the school head. These are quite difficult places to photograph play. The children are usually self-conscious and want to play fast games that really burn up the energy.

Water is irresistible to children. stand by a large puddle and the first child to

▶ Most children love open water, so head for lakes and canals in the summer. Once they have become absorbed in what they are doing, they won't notice the photographer. *A Howland*

Children often play by themselves. The game may exist only in the child's mind. However, children playing alone seldom have uninteresting expressions.

▲ Swings usually suggest action pictures, but here the isolation of one small boy is emphasized by the apparent stillness of the swing, and the empty landscape behind. *Tom Nebbia*

◀ Far left: children love hanging upside down. Use a medium telephoto and fill the frame for a strong picture. *Catherine Shakespeare Lane*

◀ Left: dressing-up shots are irresistible. Choose a plain background to draw attention to the fabrics, the source of the fun. *Catherine Shakespeare Lane*

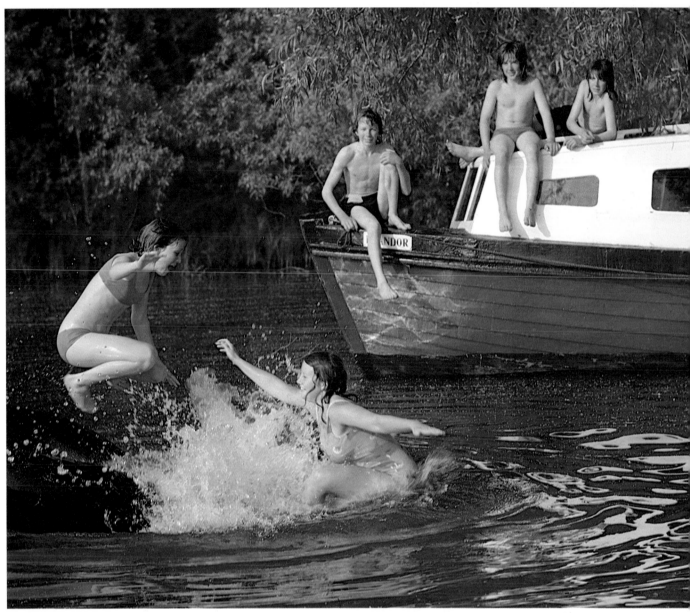

come by is sure to make a splash. Hoses, buckets, streams and any expanse of still water are equally attractive.

Derelict sites and waste ground are hit-and-miss places to find children. If there are games going on watch out for stone throwing and swings made from old tyres and ropes.

Equipment and technique

Lenses. A 35mm SLR with a standard lens is the best all-round equipment once the photographer has become 'part of the scenery'. A short telephoto lens of about 85mm, or perhaps a 135mm, will fill the viewfinder with a child's face. Use one when an individual is deeply engrossed in play. It will emphasize the child's expression and prevent the camera being a distraction. Once the photographer is well accepted it may be possible to use a 35mm lens (anything shorter is too distorting) and to join in the fun. Any grown-up interested enough to do this will be far to busy to feel self-conscious.

Films. Play usually requires shutter speeds of 1/125 or faster to stop movement, which means using medium or fast speed films. Outdoors, on a bright day, choose a film of at least 100 ASA. Use 400 ASA material if the weather is dull or if the game is indoors in fairly good light. If photography happens in poor indoor light then rate 400 ASA film at 800 or even 1600 ASA. If film is uprated in this way, make certain your processor will 'push' the development or you will have to do it yourself.

Backgrounds should be simple or explicit. Let the background say something about the game—for example, that it is in a wood and not a park—otherwise make it plain or out of focus. A telephoto lens has a shallow depth of field; this blurs backgrounds easily but makes rapid, accurate focusing difficult.

A grown-up can make use of their extra height if the background is very confusing. Looking down on a child can make a simple background out of a floor or wall. Don't stand over the subject or the child will appear hopelessly dominated. Never be afraid of kneeling down to the child's level, either to talk or take photographs.

Flash is occasionally a useful accessory.

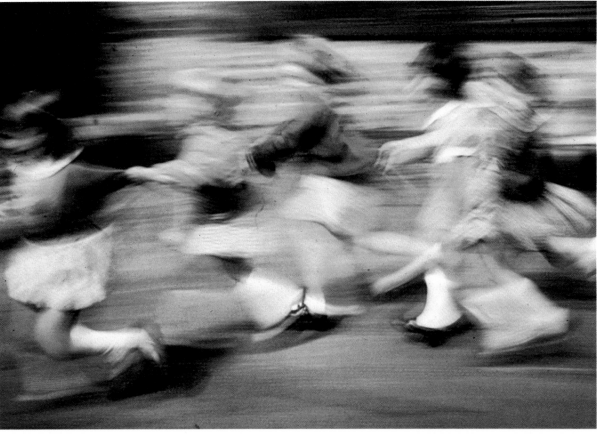

◄ SHARPNESS WORKS
A group of children can be very active, needing a shutter speed of 1/500 to capture the action. Older children can also be more wary of the camera. You need to use a 135mm or longer lens so as not to intrude, and spoil the game.
Patrick Thurston

▲ AND SO DOES BLUR. . .
Often you can capture a sense of motion better by using blur than by freezing it. For this picture of a line of schoolgirls running by, *Richard Tucker* used a long exposure (1/15) while panning.

▼ . . .IF YOU SHOOT QUICKLY!
Children playing will not be interested in posing for the camera. Actions and reactions happen fast, so you have to react quickly to capture them. Using an auto-exposure camera helps. *Ken Schiff*

If the light is bad then use an automatic unit mounted on a flash bracket. Children move too quickly to adjust a manual gun and the bracket makes camera and flash easier to handle. Flash freezes fast, spontaneous play but it destroys atmosphere.

Camera bags should be filled only with strictly necessary equipment. Even an extra lens will feel heavy after a day spent running around with it. Tripods are seldom, if ever, used to photograph children's play because the subject changes too quickly.

Last tip: when necessary, shoot first and estimate the exposure afterwards. Children may repeat a game, but you can never be quite sure what they are about to do.

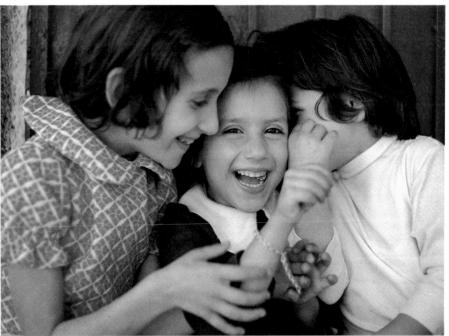

Photographing girls

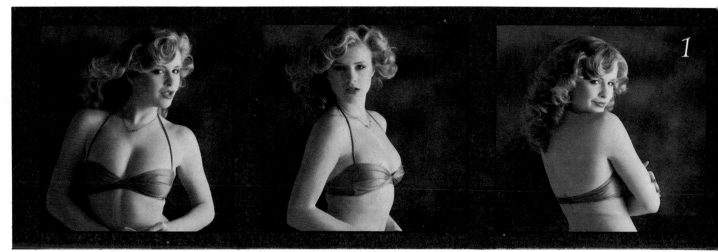

Photographing girls is a huge part of the business of professional photography, and a complete industry has evolved to provide models for photographers and art directors. Every major city has a network of model agencies whose files contain a face and figure for every occasion, and the selection of the right model has become a responsible and demanding job. The girl on all the posters—sipping an aperitif, or eating chocolates—may well have been one of fifty interviewed, many of whom will have been called back for a test session.

For the enthusiast who simply wants to take pictures of an attractive girl, this complicated selection process will seem quite unnecessary. He has only himself to please, not the public at large. Nevertheless the right choice of model determines the success of the session for the amateur as much as for the professional, and a little objective thought beforehand can save a lot of disappointment later. If you belong to a camera club, you may find that studio glamour sessions are periodically organized for the members, and for your first attempt at this type of photography it may be advisable to take advantage of the studio and the professional model they choose. Alternatively you may prefer to choose your own model and organize the setting.

Choosing your model

First of all, you should only ask a girl whom *you* find attractive. This may seem obvious but it is easy to be misled by helpful friends who 'know someone who knows someone who would make a wonderful model.' Whoever you find attractive is your best model. It is not necessary to change your tastes for a photograph: the media condition us to believe that only tall, young, slim blondes are suitable models, even though we may find buxom brunettes more attractive.

For the first few sessions it is wise to choose someone you know fairly well and can be at ease with. Being relaxed is most important for both photographer and model, and though this comes mainly with experience, the beginner can do a great deal to eliminate unnecessary awkwardness.

Clothes and make-up

Your choice of clothes for the model should take account of the mood of the pictures you want to take as well as the model's own preference. Do not encourage her to dress up (or down) in a way which is alien to her. She should feel as natural as possible, since self-consciousness is the most destructive element in this type of picture. Ask her to bring a selection of clothes (a choice of colours is also important when shooting in colour) because often the background and lighting will influence what she wears. It can also be handy to have a small selection of accessories as props—scarves, jewellery or even a hat—which can sometimes add the touch that completes the picture.

Make-up is rather more difficult. It can often contribute to the success of a picture but it can, if used indiscreetly, be a disaster. Too little rather than too much is the best general rule. Slightly tinted powder is useful to kill unwanted shine on the skin, a little mascara adds definition to eye lashes, and a darker shade of lipstick can often

1 *Flirtatious*
For these studio shots, *Martin Riedl* used a simple lighting set-up—one diffused side-light and a reflector—using a wind machine to give more life to his model's hair.

2 *Picture making*
Outdoors, choose locations that contribute to your pictures: framing her in a window gives extra realism to this girl's pose.

◄ One way of finding a model for glamour photography is to join in a camera club session—either in a studio or on location. Though you may forfeit complete control of the model, you will gain valuable practice at working with a professional model at a fraction of the cost.

2

3 Natural

The summer countryside is an ideal background, and less daunting than a studio for an inexperienced model. If possible, choose a hazy day for softer lighting effects. *Michael Busselle* opened up to f2·8 to allow the flowers in front and behind to drop out of focus.

4 Story telling

With a careful choice of props, clothes and background, you can make your pictures tell a story. Here the realistic effect created in the studio is reinforced by natural-looking lighting —electronic flash through a very large diffuser and boosted by a reflector.

5 Humourous

Incongruous settings and props can give your pictures a bizarre humour. Tricky lighting on this beach gave a reading of 1/250 at f8.

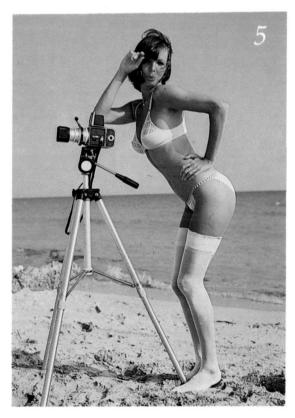

add shape to the mouth—particularly in a full length shot, or when shooting in black and white.

Using make-up to shade the face—such as blusher on the cheek bones—is best avoided unless applied expertly and under controlled lighting conditions. Make-up is discussed more fully in a later section. Make-up can mask any obvious skin blemishes, and when a lot of bare skin is going to be visible it usually looks best if it is brown rather than stark white. There are some rather elaborate tanning products, but a tinted sun oil has a similar effect.

Where to shoot

Your setting may be indoors or outdoors, in natural or artificial light, in a studio or on location. If you are a novice you should make the atmosphere of the location as relaxed as possible. It is usually best, particularly if your model is inexperienced too, to avoid the studio set-up with artificial lighting, because so much effort is needed to make it look natural. Even experienced models and photographers can find this quite daunting.

If, on the other hand, you are happiest when you have complete control over lighting and backgrounds, and are more interested in producing studio pictures, this may suit you best.

Whatever situation you choose, make sure you are organized and can give the impression that you know what you are about. Have your camera loaded, meter set to the right ASA, lighting set up in approximate positions, background in position, and any props you might need, such as a chair or a stool, ready and waiting. If it is your first session it's even worth having a rehearsal with someone other than your model, so that when she arrives *you* are relaxed and in charge of the situation. If you choose a more natural setting—using daylight indoors or outdoors—it is equally important to know exactly where to go and to have a good idea of what you are going to do. If you are shooting outdoors you should know where the sun is going to be at the appointed hour. Will you need a reflector to lighten up the shadows, or maybe fill-in flash? Is there somewhere for your model to change and do her make-up? Would some props be useful —a hammock maybe, or a beach chair? If it is going to be a long session, how about a flask of coffee or some cans of cold beer? The more organized you are, the more you will both enjoy the session.

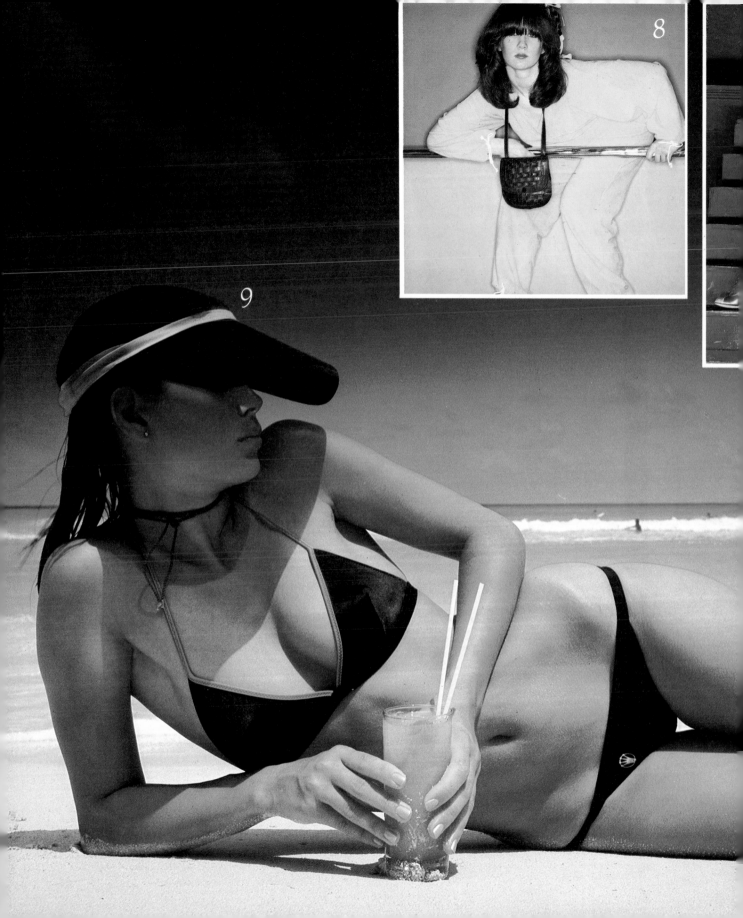

8

9

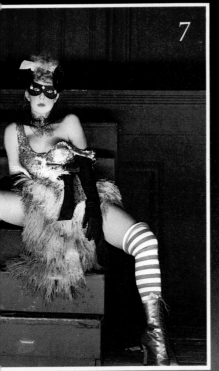

6 Tricks

This picture was shot to be used on its side, cropped to exclude the towel, so that the profile and streaming hair look like a bizarre figurehead. *Tino Tedaldi* used flash close to the lens and exposed six times, each at peak action as the girl flung back her head.

7 Fantasy

Photographing in an old music hall, *James Wedge* used a Contax camera with an 85mm lens and flash directed at the floor for the low, theatrical lighting effect of this picture. He used Ilford FP4 film and hand-coloured the resulting black and white print.

8 Fashion cover

Two sheets of cartridge paper make up this vivid background, the join hidden by the pole. *Howard Kingsnorth* lit the shot with a ring flash around the 150mm lens of his Hasselblad, set at 1/60 and f11.

9 Glamour Girl

Here a graduated filter, normally used to reduce contrast between sky and subject, dramatically darkens the sky. A wide angle lens isolates the model still further by exaggerating the distance to the horizon.

Equipment

All the equipment you use should be familiar to you. Never try out anything new on your first session with a model; it creates a bad impression if you do not seem to know your equipment and it will destroy your confidence if you fumble. A tripod is very useful in this type of photography as the camera can be positioned and left whilst you adjust lighting, take exposure readings and so on. A large reflector, made of card or polystyrene, and something to prop it against are also invaluable, particularly for daylight shots. If you have a camera with interchangeable lenses, a longer lens can be an asset—an 85mm or 105mm on a 35mm camera—as it enables you to work at a distance from

your model rather than crowding her. A longer lens can also improve perspective, particularly when you are shooting close-up portraits, and on location it will help you to subdue any problematical background details by throwing them out of focus.

Directing a model

The best rule about directing a model is —don't. The secret is to establish a situation—by your choice of background, props and clothes—in which the model can forget the camera and be herself. Picture-taking should become almost incidental. If, after the first few shots, you are still having to give precise directions—'move your arm to the right, bend your head, turn your eyes to the left'—then something is wrong and it would be better to stop and start afresh. Organised poses can often look false. The real technique of directing a model is to establish an easy rapport, so that she does what is needed of her own accord. This rapport comes from her confidence in you as a photographer, and the efficiency with which you have organized the session. It also comes from the knowledge that you find her attractive, and the fact that you are both enjoying the session. This is true of professional models too: it is very easy to take bad pictures of top models if you lose their confidence and they begin to feel insecure and even unattractive. The often caricatured patter of the fashion photographer—'super, super...oh, *really* nice'—is not as meaningless as it may sound. It is a way of keeping up the constant communication that is vital between the photographer and his model.

Your first nude photographs

When first you set out to photograph a nude female body, the most daunting problem is likely to be—whose body? There are two main solutions to this, each with its own advantages and potential difficulties.

Photographing a friend

The first and most obvious is simply to ask a friend or someone in your family. Most people, however, feel vulnerable enough in front of a camera even when the end result is only a passport photograph: to be naked as well can only increase their inhibitions, however well they know the photographer. If you want to use a model with no experience, it is entirely up to you to give her the confidence to relax and enjoy the session. If she does not, your photographs will be a dismal failure.

It is crucial that your model has confidence in you as a competent and sensitive photographer. Nothing helps to reassure a model more than the knowledge that the pictures are going to be good—to do her justice—and that you are not simply an incompetent novice trying to take advantage of her. The best way to gain her confidence is to start by shooting some ordinary portraits. If she has seen and liked the results, she will be less likely to be sceptical when you approach her about nude modelling. Even the most devoted wife or girlfriend can find nude modelling an embarrassing experience if she doubts whether you really know what you are doing.

The professional model

You may decide that, for your first nude session at least, it would be helpful to find an experienced model who will already have overcome these initial inhibitions. Camera clubs often organize nude photography sessions for their members, and there are studios which specialize in providing such facilities for amateur photographers. Usually they are arranged on a group basis, several photographers working with one model at the same session. This is far from ideal, but it does at least drastically reduce the cost, and may provide a sensible introduction to basic methods and techniques. The experience and confidence you gain from

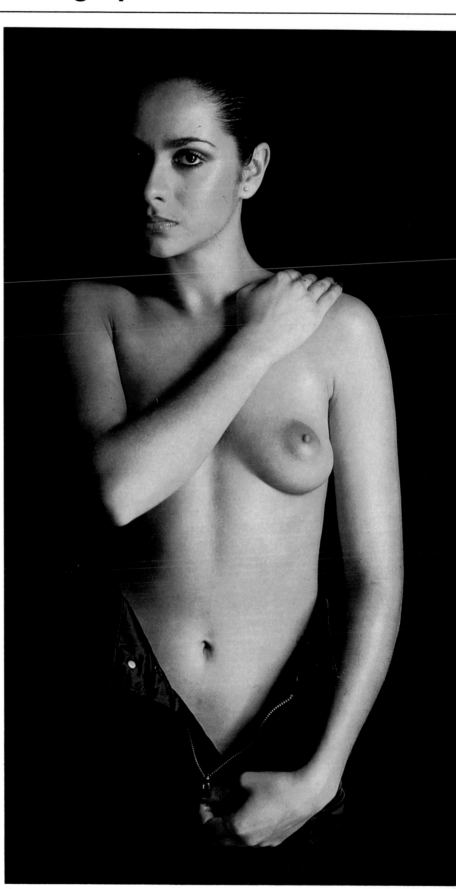

▶ The controlled environment of a studio allows the photographer to concentrate entirely on the model. Here the photographer shut out all the available light so that electronic flash would isolate the figure on a dark background.

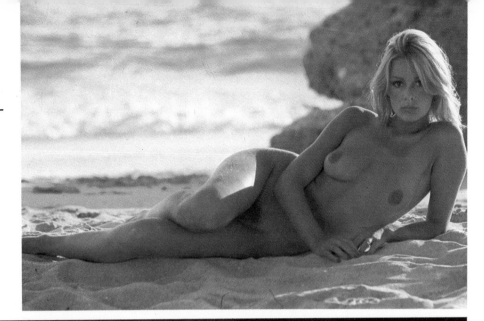

▶ A beach in summer is a natural backdrop for informal nude shots, offering interesting—though often distracting—lighting conditions. With strong backlighting, the pale sand acts as a useful reflector here. *John Kelly*

▼ Photographing at home gives you more time to think out your shots and control the results. This background was chosen to blend with skin tones, leaving careful composition and soft directional lighting to give the shot its sculptured effect. *John Garrett*

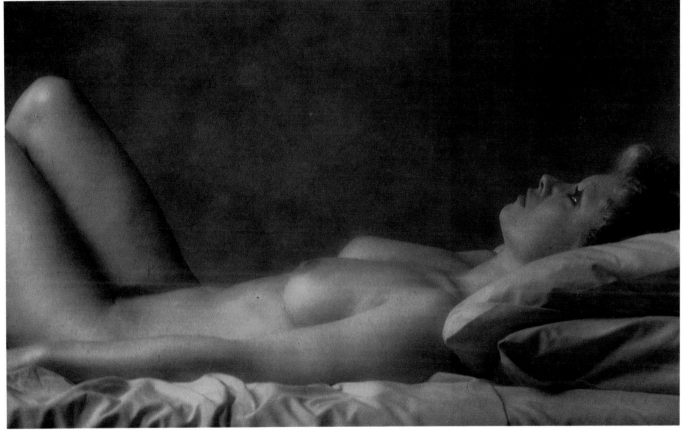

such a group session may make up for less than satisfactory pictures.

Sooner or later you will want a model on an individual basis. This is of course much more expensive, but it means you will have her complete attention and can control the lighting, background and so on entirely to your own taste. The cost might also be justified on the grounds that a good, experienced nude model can indirectly teach you a great deal about this type of work, suggesting pictures in the way she moves her body and encouraging your own creative ideas.

Most major cities have model agencies who will supply index cards of prospective models but remember that by no means all professional models are prepared to do nude work. You should clearly specify what you want when you first approach the agency: remember that fees for nude modelling are 50–100% higher than for normal work. Many photographic magazines carry advertising for models offering their services to amateur photographers; these are unlikely to be full-time professionals but the fees should be considerably lower.

Directing the model

You will doubtless have an idea of the pictures you want to take. You may well wish to create the soft romantic type of image produced by photographers like Sarah Moon and David Hamilton; or the more stark and dramatic pictures of Bill Brandt and Helmut Newton; or even the purely abstract images where the body is used almost as a landscape. Whatever your taste, it is as well to study nude pictures and work out how they were taken before you start your own session. It is a good idea to show your model the type of pictures you wish to produce. This will give her an opportunity to get into the mood of the session and understand how she can help you towards a particular style of picture. This

▼ Finding your model something to do as you photograph her will give your pictures an added—slightly voyeuristic—appeal. This shot was thought out and carefully posed, but you might try letting the model move around quite naturally while you watch through the viewfinder for the best composition. *John Kelly*

▶ A picturesque setting makes the model's pose less crucial as she becomes an element in a larger composition. *Michael Boys* used a Nikon with a 50mm lens and an 81EF filter to give warm tones. He reinforced this effect with a pale orange filter on his Vivitar flashgun: with an aperture of f4 he bounced the flash from a reflector.

does not mean that you should simply try to copy the work of established photographers; but as making a start is the first hurdle, it is better to have some basic idea, albeit unoriginal, to begin with, than simply to hope something will turn up. Once you start shooting and both you and your model become absorbed in the session, you will find that ideas develop.

Background and props

Apart from the model herself there are several other elements to consider. The first is the background. This can be completely plain—a roll of cartridge paper or a wall, for example—or it could be more complex, like the interior of a room or draped curtains, a piece of furniture, or even an outdoor background. Whatever the choice, it is essential that it should be in harmony with the mood you are trying to create. It would, for example, be contradictory to use a fussy detailed background such as trees when you want to produce an abstract nude picture with a simple graphic quality, just as it would be inappropriate to position your model against a harshly lit brick wall for a romantic picture.

You should also consider what props you want to use. You have your model, and behind her your choice of background, but this may not be enough. It can be very difficult, especially for the inexperienced model, to stand or sit and be relaxed without something to act as a foil or to suggest ideas that help her to position her body. Something quite basic like a chair or a stool can be a considerable help, both to your model and to the picture itself. Props can be much more involved than this, of course, and a picture can be so elaborately 'propped' that the model becomes only an element of it. It is very helpful to look through magazines at the advertising photographs and fashion editorials to see just how effectively a simple piece of furniture, a basket of flowers, or a telephone, for example, can provide that extra trigger that makes a picture really work.

▲ The use of props can give pictures a 'storyline' and justify the photographer in experimenting with original poses and effects. *Michael Boys* used a Nikon with a 105mm lens and a magenta filter, with available light supplemented by two white reflectors. The camera was set at 1/60 and f4. Note how the soapy window, as well as telling the story and giving the model something to do, gives a light background against which to pick out the model's silhouette.

▶ Impromptu nude photographs of sunbathers can capture some very relaxed poses, but have one fundamental problem: harsh sunlight seldom leads to good photographs of people because of the confusing, downward shadows it casts. With the model lying on her back, however, the sunlight becomes quite acceptable strong 'front' lighting. Dominant background colour can have a dramatic effect, but check that it does not upset the colour balance— especially in the skin tones.

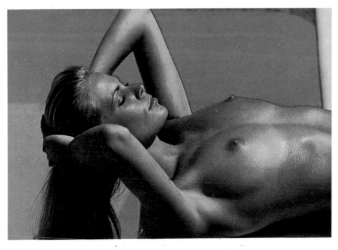

Lighting

A most vital consideration for nude photography is the lighting. There is obviously a choice between daylight and artificial light. If you are shooting indoors or in a studio, a large—preferably north-facing—window is an adequate and pleasant source of light. The soft but directional light from a window shielded from direct sunlight is particularly suitable for nude photography, though it is less easily controlled than studio lighting. When using daylight, indoors or outside, it can be very useful to have one or two large reflectors, about 1x2 metres (they can be card, polystyrene or painted hardboard), which can be propped against a chair or a spare tripod just outside the picture area to reflect light back into the shadow areas. This gives a valuable extra degree of control over the lighting.

Artificial lighting need not be elaborate; two or three lamps with reflectors on tripod-based floor stands will provide a variety of lighting effects with the help of a few simple accessories. You can simulate the large, soft light source of a north-facing window with studio lights. Cover a wooden frame (about 1x2 metres) with tracing paper, and place this between the studio light and the model. It will produce a soft light with good detail, giving shadows with very faint edges. To regulate the softness, vary the distance between the screen and the light source; the farther apart they are, the softer the light will become, so that when the screen is very close to the lamp it will have only a slightly softening effect.

Another method of producing a soft light is to 'bounce' the light from the studio lamps from a white wall or ceiling or, better still, from large reflectors. Naked lights and naked bodies don't go together well: unless you want a dramatic or theatrical effect, some form of diffusion will invariably give a more pleasing result than direct light.

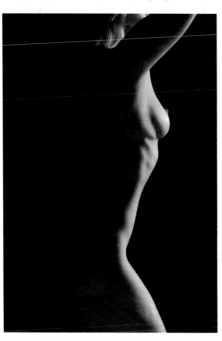

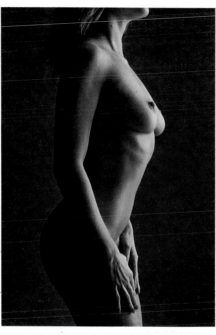

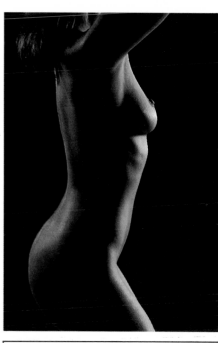

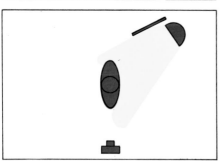

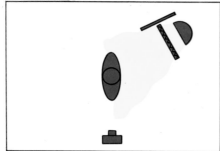

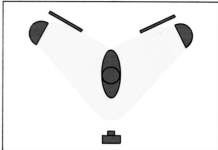

▲ To demonstrate the varying effects of different lighting set-ups, *Michael Busselle* first positioned one hard light to one side of his model (refer to the diagrams for exact positioning). This gave very strong modelling and a rather stark effect, particularly as he posed the figure against a dark background, which was carefully screened from any spilt light.

▲ A diffuser—made from sheets of tracing paper stretched over a frame—was then placed in front of the light to soften the shadows, making the transition from light to dark areas more gradual for a more romantic result. The effect of a diffuser varies with its distance from the light: the further away it is from the light, the greater its effect.

▲ By introducing another light on the opposite side and slightly further away, *Michael Busselle* shows more of the figure. Here he used no diffusers, but continued to screen the background from light to make the figure stand out. In his light-tight studio he used white reflectors as screens: if you have trouble keeping areas dark, absorb stray light with black screens.

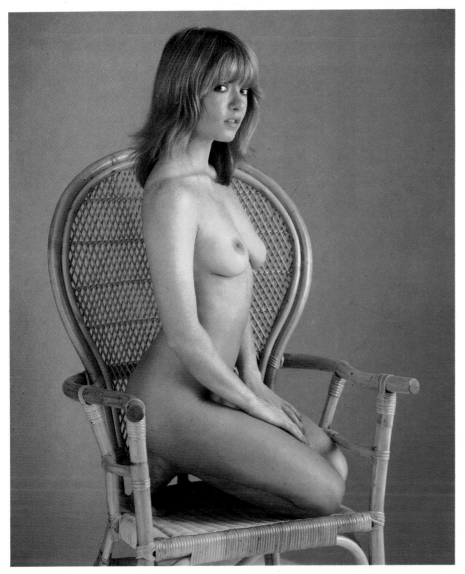

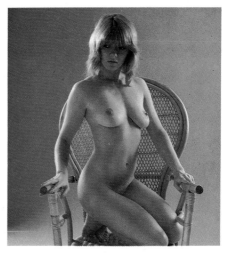

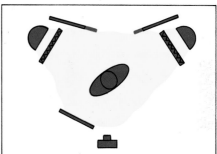

▲ Two diffused lights placed either side of the model and towards the back give a slightly rim-lit look, with a reflector close to one side of the camera to fill in the front shadow area. Two screens were used to maintain a fairly dark background. When dealing with any kind of backlighting like this it is always sensible to use a lens hood to cut down the possibility of flare.

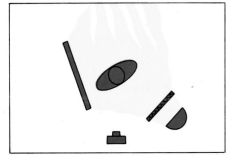

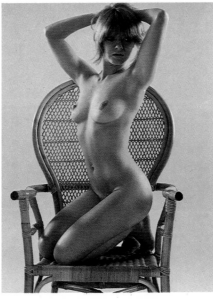

▲ With one diffused light positioned closer to the camera, further in front of the model, the strong modelling effect is lost in favour of a more flattering, blander light. Here a reflector was also used to fill in on the shadow side, and no attempt was made to darken the background so that the overall effect is of balanced, even tones.

◀ The lighting set-up was exactly the same for this picture as for the previous one (top right) — except that the screens were removed. This allowed light to spill directly onto the background, making it reproduce as a much lighter tone. As a result the rim-lighting on the model shows up less clearly. However, both the shape of the model and the chair show up more clearly against the lighter background.

The nude indoors

After choosing a model, the next most important factor in nude or glamour photography is a suitable location. A conventional studio with artificial lighting is very convenient, but at the same time the starkness of the setting and the necessary adjustments to lighting and backgrounds can produce an unrelaxed atmosphere for the inexperienced photographer as well as for his model. The cost of hiring a studio will also tend to hurry the photographer into mistakes. Outdoor locations are less daunting, but bad weather and lighting conditions and the lack of privacy and comfort can produce a new set of problems.

A very satisfactory compromise can be made by organizing your session indoors using daylight. This has a number of advantages—it is private and comfortable; you don't have to worry about the cold; it is more relaxing than a formal studio; and providing you choose a room with a good-sized window, the lighting can be ideal for nude and glamour photography.

Choosing the room

The first consideration must obviously be adequate daylight, either from a large window, French windows or even a skylight. This should be your overriding consideration—other requirements such as backgrounds, props and furniture can be imported into the room. It is a distinct advantage, however, if the room has some appealing characteristic in addition to good light; an interesting shape (sloping ceilings of a garret, for example) or suitable furnishings and décor. These factors can in themselves give you inspiration for your pictures. Even if the décor is suitable, though, a roll of plain background paper can still be an advantage if the background becomes too obtrusive from your chosen camera angle. You may also wish to introduce some extra props such as a house plant or a rug. Always do a reconnaissance beforehand, checking angles in the viewfinder to see what you may need to add or remove.

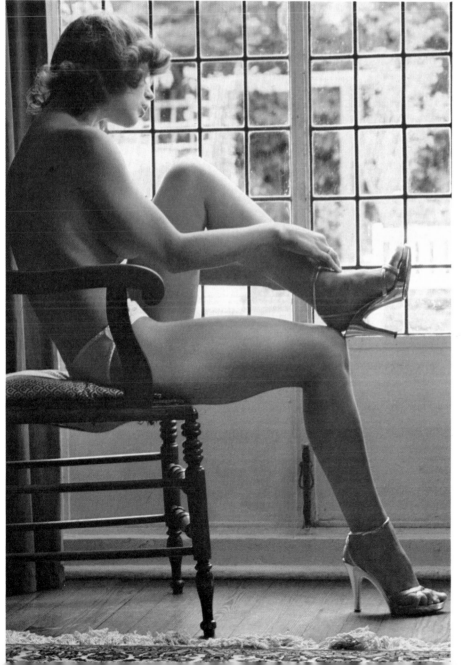

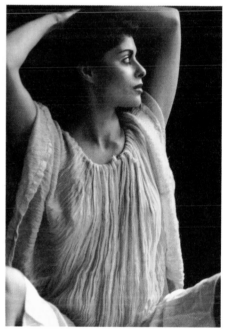

▲ A single window provides a dramatic directional light which can highlight the texture of the model's clothes – as it does here. Have your subject turn her face towards the window for the best effect. *Raul Constancio*

◄ Shooting by daylight with the model against the window, either go for a silhouette, exposing for the outside, or expose for the model and make sure enough light is reflected on to her from inside. *John Garrett*

▶ For indoor glamour shots by daylight a large window is a necessity and some photographers also like to use it as a 'prop'. Shooting into a room through a window, you will need to boost the light inside so that the model is not lost in shadow. *Michael Boys*

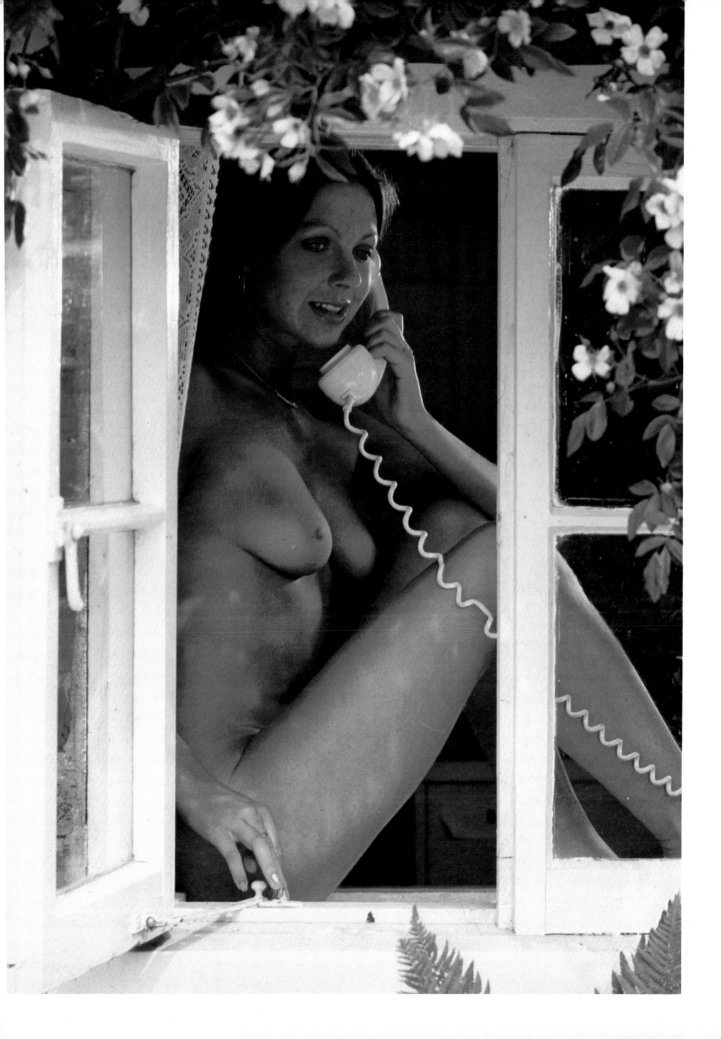

The window

Diffused light from a large window or a skylight not exposed to sunlight is ideal (see page 106). Sunlight through a window *can* produce attractive lighting however, providing the contrast is controlled, and where a softer result is required the sunlight can be diffused by screening the window with tracing paper or even a net curtain. To some extent the position of the window will dictate the possible camera angles and position of the model, so bear this in mind when doing your reconnaissance: the only way to control the direction of the lighting is of course to move the camera and model. With the window behind the camera and the model some distance away but facing towards it, the light will be quite soft and frontal, producing little modelling. If you imagine a line from the camera to the model, the line would be at right angles to the window in this situation. Moving either the model or the camera so that the line from camera to the model

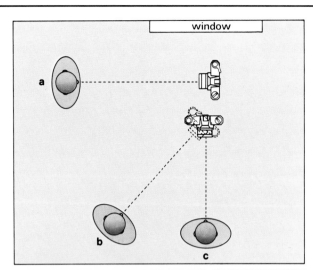

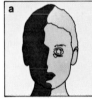 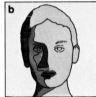 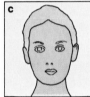

◀ In photography, the term modelling describes the play of light on a subject that creates an impression of form—making a two-dimensional image appear three-dimensional. The angle of light chiefly governs modelling though its quality—diffused or hard—has some effect. The diagram shows strongest modelling with camera and subject near the window. The face is almost cut in half by shadow. Further from the window, with the light at a less acute angle, the shadows are weaker but give more subtle modelling. When the subject faces both light and camera, modelling is at its weakest.

▲ *Michael Busselle* chose a white-washed cottage interior for these shots, taken for a calendar. Here direct light from the window is responsible only for rim lighting the model's face: the rest is softer light reflected from the walls.

▲ Right: moving his model closer to a window (out of shot and to the left of the camera) gave far stronger modelling with darker shadows and more distinct highlights. The window behind has little visible effect.

▶ Moving the model further from the window (this time to the right of the camera) diffuses the effect of the light, giving a softer graduation from light to dark. Note how the blue bed-spread affects the colour of her legs.

110

becomes more parallel to the window will give more shadows, stronger modelling, more pronounced texture, and, of course, higher contrast. Moving the model closer to the window will produce even higher contrast, but less effective modelling.

Controlling the light

The most useful accessory in daylight indoor photography is a large white reflector. The simplest is a 2x1 metre sheet of 25mm-thick white polystyrene. This is very light and rigid, so it can just be propped against a chair or a tripod. By positioning it close to the

model on the opposite side to the window, angled to reflect the daylight, you can exercise considerable control over the contrast and quality of the lighting. For stronger 'fill in' you can use a reflector made out of card covered with silvered paper or fabric, or you can use a mirror. These types of reflector give a harsher, more directional fill-in, so they need to be positioned carefully or they may give an unnatural-looking effect.

For extra control, paint the other side of your reflector black. You can use this to shield the shadow side of your model from reflected light, when you

want a more dramatic effect. This is particularly useful in light-painted rooms, or if the model is lit by more than one window.

Windows in the picture

An attractive window can often be included in the picture—if there is a suitable view outside. However, this can lead to exposure problems. If the scene outside is much brighter than it is indoors, the contrast range will be too great, and it will not be possible to record both correctly. Following a camera's through-the-lens (TTL) meter reading will probably give the correct

▶ The mood of a shot is affected by place, props, light and the attitudes of photographer and model. Adding surprise elements, like the balloon, gives the model something to do and makes a picture different. *Michael Boys*

▼ A large window and lots of space is desirable but not essential. Shooting through a door is one way of making room to move about. *Michael Boys*

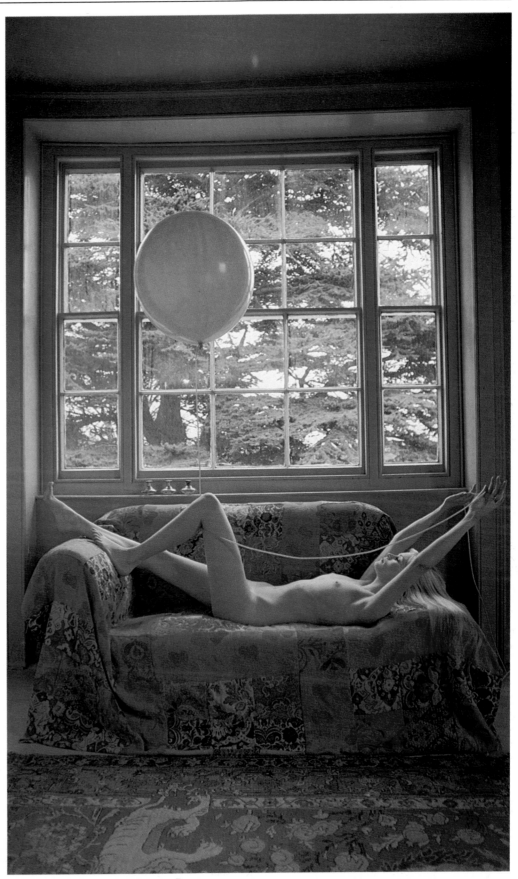

exposure for the outside scene. This will leave the model under-exposed. Unless you want this effect, take your meter reading from close up to the model, excluding the window, so that she is correctly exposed. This will lead to the outdoor view being over-exposed and 'burnt out', of course, but this is often attractive.

The alternative is to use reflectors, or bounced flash, to increase the amount of light falling on the model, and thus to reduce the lighting contrast. Of course, if you make your own prints, it is possible to control the contrast to some extent at the printing stage. For example, you can 'burn in' a window by giving it extra exposure, and you can 'hold back' other areas. This type of dodging is not difficult with black and white, but it is not the ideal solution if you are shooting colour negatives, or slides. With these, always try to get the picture at the shooting stage.

◀ A wide angle lens allows the photographer to work in a confined space. It will exaggerate perspective and make the model appear disproportionate if used at an extreme angle. *Per Eide*

▶ A short telephoto of 80 to 105mm is good indoors. It lets you shoot from a distance without crowding the model. At wider apertures its shallow depth of field throws backgrounds and foregrounds well out of focus. *Michael Boys*

▼ The model was shot in a Romany caravan with a wide angle lens. She does not appear distorted because all of her is about the same distance from the lens. *Caroline Arber*

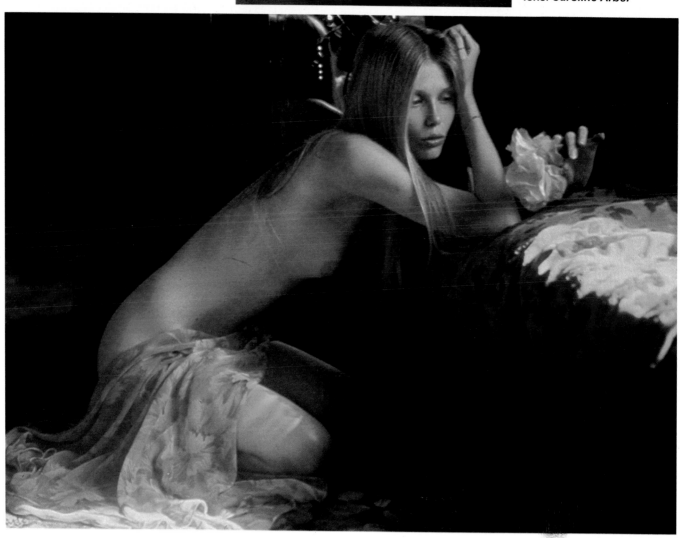

114

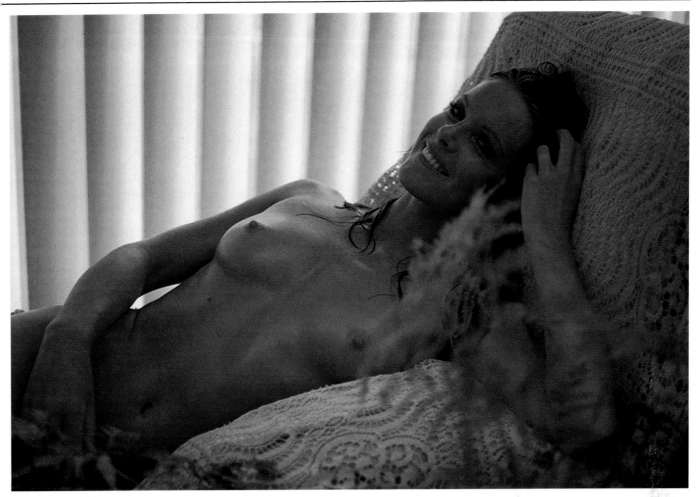

Contrast control

It is not difficult to control contrast at the shooting stage, if you simply take close-up meter readings of the different parts of the scene. In particular, it is helpful to meter both the shadow side and the highlight side of your model. A hand-held meter can be used. If using a built-in meter in an SLR, get close and fill the frame with a suitably-lit area.

Generally, a lighting ratio of about 1:4 will give good results when photographing the nude. That means having two stops difference in exposure between the highlight and shadow areas (usually of the face). If, for example, the highlight side meters as 1/60 at f4, the shadow side should meter as 1/60 at f2, or 1/15 at f4, or an equivalent exposure. If the shadow is darker than this, add reflectors to throw more light into the shadows and meter them again. With this lighting contrast ratio, your pictures will record detail in both highlights and shadows but retain a three-dimensional effect, that is, record effective modelling.

However, a 1:4 ratio is only a useful rule of thumb, not a law which should never be broken. With 'high key' subjects that are pale overall and well lit, a ratio of 1:2 (one stop difference) is often better. With dramatic 'low key' subjects—dark and sidelit—a ratio of 1:6 or even more can be most effective. Shadow detail will not be recorded, but in these cases it is not wanted.

Flashes and floods

Where the lighting ratio is too great to suit the subject, the best solution is to add reflectors—as described earlier. This avoids introducing any extra problems due to the colour or strength of the extra light reaching the subject.

However, interiors are sometimes dimly lit, and you may want to add artificial lighting (flashes or tungsten flood lamps) to window light—or to use these as the main lights.

If you are shooting black and white film, you can often use household lighting or photofloods to fill in the window light. It is usually not a good idea to

try this with colour film, as tungsten light and daylight are different colours. Light from tungsten bulbs is yellow compared to daylight, which can make the picture look unnatural, so you have to use flash instead.

However, it is often possible to use a tungsten light—such as a table lamp— if you include it in the picture. Candles and oil lamps have a similar effect. Although they give an orange-yellow tint on daylight film, the 'pool of warmth' they create adds interest as long as the source of the light is visible.

Flash and daylight can be combined successfully on colour films. Fill-in flash is more difficult because flash lighting tends to be harsh and powerful. It can swamp the picture and destroy the delicate effect of the window light unless you consciously soften the quality and reduce the power.

The major disadvantage of flash is that you cannot *see* the effect it has before you take the picture. To control it, you must therefore use 'lighting ratio' control, choosing the lighting contrast to suit the subject.

Suppose you want the lighting ratio to be 1:4, this means adjusting the flash to give two stops less exposure than the exposure for the highlight side of the subject.

Now suppose the daylight exposure is 1/125 at f8, how should the flash be set? To start with, remember that with a focal-plane shutter camera—which means most SLRs—the *fastest* speed that can be used with flash is 1/60 or 1/100, depending on whether the shutter runs horizontally or vertically. (The 1/90 or 1/100 of a vertical shutter may sometimes be given as a nominal 1/125 on the camera.) Therefore first convert the exposure to one suitable for flash. The 1/125 at f8 would become 1/60 at f11. Now all that remains to do is to set the flash to that it gives two stops less light than this, and it will produce a 1:4 lighting ratio. Thus the flash should be set to give out light suitable for an aperture of f5·6 (two steps less than f11).

With an automatic flash gun, this is simply matter of setting f11 on the camera lens and f5·6 on the gun. An alternative technique which has the same effect is to set a false film speed on the automatic flash gun. For a 1:4 ratio as before, set a film speed which is two stops *faster* than the film that is actually in the camera. Thus if using 100 ASA film, set 400 ASA on the flash gun. If using 400 ASA film, set 1600 ASA (if possible), and so on. In this case you can set the *same* aperture on the flashgun as on the camera lens. But the gun is fooled into giving less light because it thinks you are using a faster film than is really the case.

With a manual gun the calculation is a little more difficult. In this case, use the gun's calculator dial to find the *distance* at which you must place the flash gun. For example, first set the correct film speed, and set the correct aperture on the lens. If this is f11, as in the example above, look at the f5·6 mark (two stops less light) on the calculator dial. Opposite this will be the distance at which you must put the flash gun.

You may be shooting from 2m, and the gun may need to be used from a distance of 4.5m, so you will have to fix the gun on a tripod or prop it, and use a long extension cable to fire it. (As flash becomes one quarter as strong at twice the distance from the subject, a 1:4 ratio generally means having the gun about twice as far from the subject as the camera is placed.) If you have problems getting the right combination of lens aperture and flash aperture setting, remember that you can use *slower* speeds with flash, too. For example, 1/30 or 1/15 can be used instead of 1/60, and 1/30 will double the daylight exposure without increasing the effect of the flash. However, slow speeds can be dangerous: if the model moves you get two outlines instead of one!

There are two other useful alternatives for reducing the strength of a manual flash-gun which also help the light quality. These are to put a couple of folds of fine white handkerchief over the flash tube, or to bounce the light onto your model. (Neither of these techniques reduces the light output with a computer gun, because within the limits of its

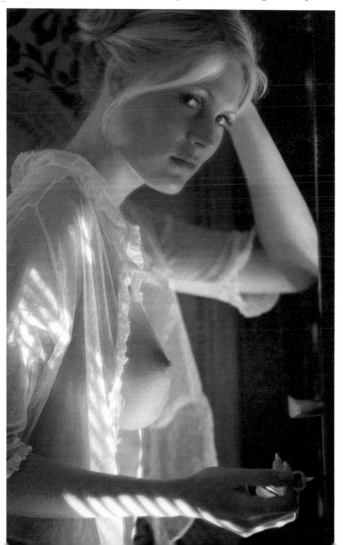

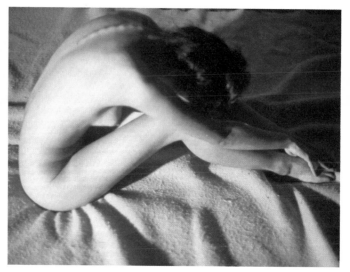

▲ Girl on a bed: *Ashvin Gatha* took this simple shot at home. He made it more interesting by moving his flash-gun off the camera. The sidelighting emphasizes the girl's pose, and brings out the textures and folds of the bedcover.

◀ *Michael Boys* added flash to daylight to create this interesting picture. He used the flash on an extension lead, low down in front of his model, pointing it up to

highlight the girl's breast. He aimed the flash through a slatted blind so it would produce a more natural impression and also add an interesting pattern to the lighting.

▶ This picture was taken in an ordinary living room. A piece of black felt was pinned to the wall to give a plain background. Soft light came from a window. *Stuart Brown* took the shot using a 105mm lens.

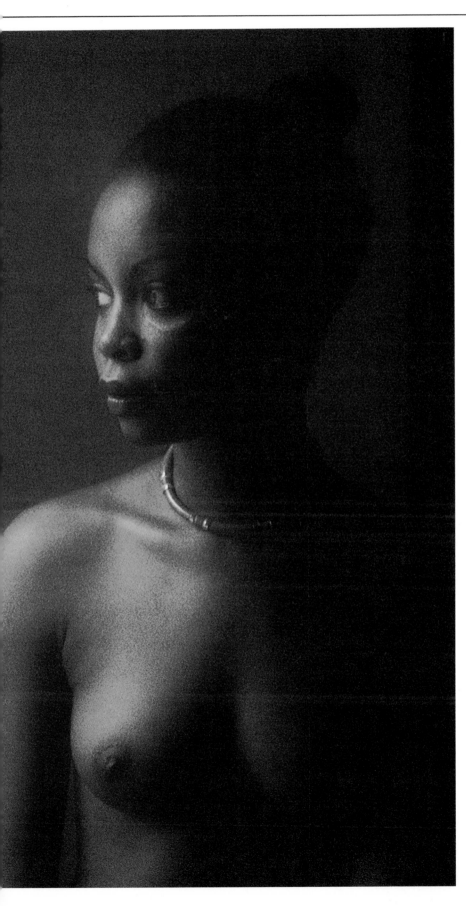

possible power output, the gun simply puts out more light to compensate!) Make sure the handkerchief used, or the surface off which the flash is bounced, is white. If either is coloured, the flash will take on that colour and your model will end up with a colour cast.

With both manual and computer flash guns, using a handkerchief or bouncing the gun's light are useful techniques for softening the light. Flash comes from a small light source—the flash tube—and can be rather harsh for nude photography unless softened in some way.

Location lighting

Both flash and tungsten lighting can be used for indoor nude photography. Both have advantages and disadvantages.

Tungsten lighting is cheap to buy and simple to use, as you can see the effect before you take the picture. The most common lamps are Photofloods. They produce a warm orange cast with daylight balanced film so you need a colour conversion filter (80B). You could use tungsten slide film with an 81A filter instead. Also photofloods burn rather hot, which often makes models uncomfortable, and they do not last very long (A number 1 Photoflood lasts about 3 hours.)

Flash lighting is more expensive and has the disadvantage that you cannot see the lighting effect before you shoot. Also, the effect can be harsh unless the flash is bounced or diffused. The advantages are that flash is very powerful, and both cool and cheap when in use.

Studio flash units offer much the best of both worlds. These are flashes on their own stands, and have built-in tungsten 'modelling lamps' so you can see in advance the lighting effect the flash will have when fired. They are very powerful, so often they are bounced into a white or silvered umbrella. This effectively converts the flash into a large, diffuse light source—which is the best type of artificial light for indoor nude photography.

While professional studio flashes can be very expensive, there are some which are well within the range of the keen amateur. They cost about the same as the average SLR camera.

Soft focus

Soft focus and 'fog' filters are useful indoors for a soft romantic effect: they soften unwanted detail. As they tend to spread the highlights into the

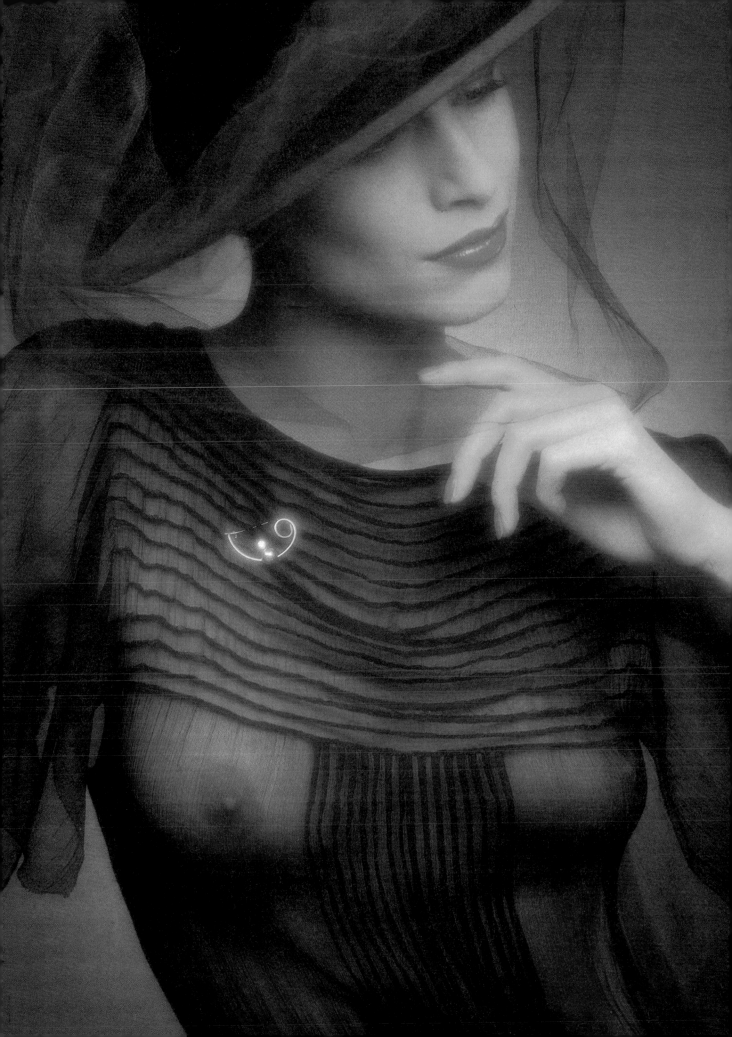

shadow areas, they also help with contrasty lighting. Most filter ranges include several soft focus filters. You can produce your own simply by smearing a UV filter with petroleum jelly (Vaseline), or shooting through clear Cellophane or stretched net materials. Or you can just breath on the lens! Take your time, and try to develop your own ideas creatively. It's fun!

◀ *Sanders* used two brolly flashguns to give a soft light for this studio shot for DeBeer's diamonds. Extra softness came from using a Cokin No 1 soft focus filter over the 180mm lens. The shot was taken with a Mamiya RB67 camera and 120-size Ektachrome 64 film.

▶ *John Garrett* used a soft focus filter, a No 1 Softar, to take the edge off the contrasty lighting. The mottled effect suggests an old oil painting.

▼ This flat, soft effect was produced by breathing on the lens. The grain came from underexposing the film by two stops and 'push processing'.

The nude outdoors

The nude is a subject that the photographer must tackle with confidence, and one of the easiest ways to start is to look beyond the idea of working with one, female, model cooped up in a studio.

Think about replacing the studio with sunshine outdoors or by shooting with available light at home or in any suitable building. Consider that the subject may be mother and baby, husband and wife, friends or even a self-portrait.

There are two big advantages to photographing the nude outdoors (available light has already be considered. It is much easier to persuade people to pose, and the lighting and props are free. Models find it much easier to pose nude outdoors, especially if it is their first session. Many find the atmosphere of a studio, or even a room, too inhibiting to be able to relax.

Locations

Privacy is essential. Neither model nor photographer will be able to concentrate if there is any fear of invasion by any members of the general public.

The simplest location is a secluded garden. If you do not have access to one there are a few that can be hired for a reasonable fee. They are sometimes advertised in photography magazines which have a classified section. Some camera clubs know of such places and use them for group sessions, so club membership may be an answer.

Beaches, especially those with dunes and long grass, and woods offer privacy and varied backgrounds. Open fields are less secluded but it is surprising how empty the countryside can be. Most

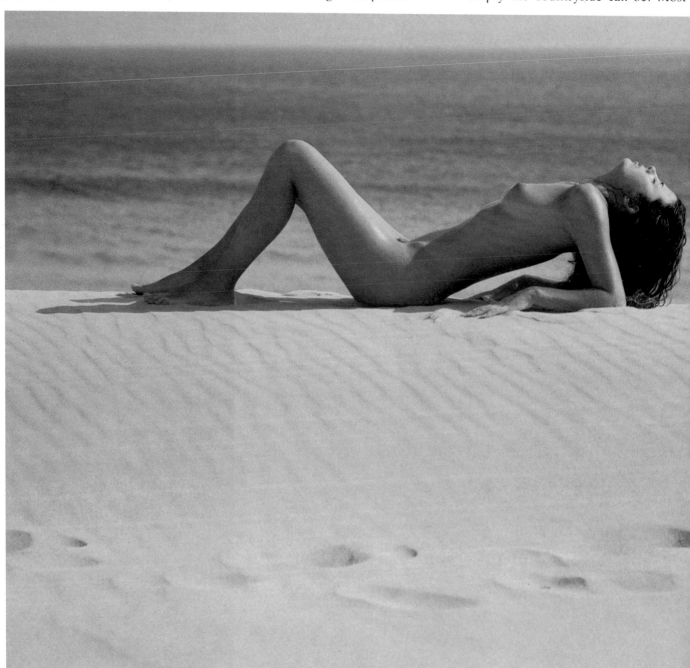

▼ Start simply. A beach is a natural place to start nude photography, especially as nude bathing is allowed in many places. It is also easier for people to pose in the open air than in the confines of a studio. Also the lighting is free! This simple pose is set off by the bands made by the horizon, the top of the dune and the line of steps in the foreground. *H. Blume*

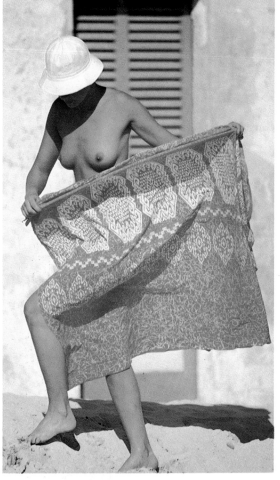

▲ Keep your sense of humour! Nude photography should be an enjoyable experience for both the photographer and the model. Don't take it too seriously, and keep the camera ready for candid shots *Andreas Heumann.*

people do not move very far from their cars, you just have to go a little further. Another way to avoid people is by timing. Beaches and woods that are crowded at weekends will be empty during the week. Places like quarries and derelict industrial land, on the other hand, are vacant during weekends. Many spots, even in fairly well-populated areas, are deserted very early in the morning.

A compromise is to join one of the larger camera clubs and go on a group session. These have the advantage of helping the beginner overcome any initial shyness. They also provide the opportunity to meet one or two models. If you like one of them and feel that you could work well together (this is very important) you can book a private session. You may also be able to book the location.

Lighting and exposure

It is advisable to visit whatever site you choose in advance. Study the sun's effect at different times of day. If you look at several locations make a list of detailed information about each.

Take some reference pictures of a light, neutral coloured object—a fawn raincoat will do. Examine these carefully for any colour cast.

▼ A basic portrait is a good way to start. Try to take pictures that show a feeling for your subject. With nudes you should still pay attention to your model's character. *Lorentz Gullachsen.*

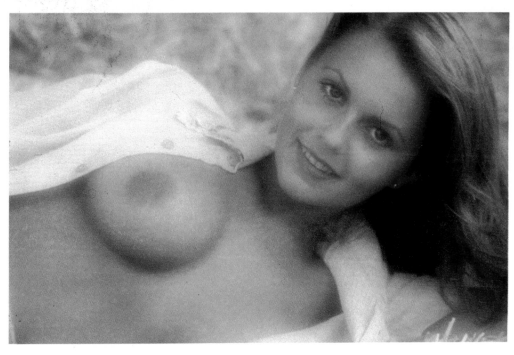

Light not only changes colour during the day, it can also pick up colours from the location. Sunlight passing through trees and reflecting off undergrowth may turn slightly green. It might become slightly blue if reflected off, say, a limestone quarry floor. Should the picture appear to have a cast hold a colour correcting (CC) filter of a complementary colour in front of the print or slide. For example, use a magenta filter to correct a green cast. Hold progressively stronger filters in front of the pictures until the cast disappears.

The rule of thumb is then to reshoot with a CC filter *half* the density of that which made the cast disappear when you held it in front of the picture. For example, if a 10CC magenta filter visually corrected the cast, reshoot with a 5CC magenta over the lens. The colours of the reshoot should then be neutral, assuming that film from the same batch is used and the lighting is the same.

Cold casts like green and blue should always be corrected. They make people look ill. There is no point trying to correct the reds of the sun late in the day. Most people like skin tones that are slightly warm.

Consider using Wratten series (81A, 81B, 81C) or 5CC yellow filters. These make the skin look warmer and more natural. A model who is pale and untanned is likely to look slightly blue even in the brightest sun.

The ideal outdoor lighting for figure work is slightly overcast or hazy sun. It is not too contrasty and the film can accomodate it without the use of fill-in or reflectors. Even when the sun is diffused by cloud its light is still directional. It will affect form and modelling according to the angle between the subject and sun.

A session cannot be cancelled if the sun is too strong. Take a small flash gun to fill-in heavy shadows. Alternatively, work around the location. There may be sand, a white wall, a rock or some other light-toned object to reflect light into the shadows. It has even been known for newspapers to be pinned to a tree or a car moved into position to do the same job.

It is important not to over-expose colour slides, or skin tones will be very pale. Slight under-exposure, perhaps

▶ **Have a clear idea of what kind of results you want before starting work. A dithering photographer will confuse and frustrate the subject. Keep an eye out for the spontaneous when there is a break in the session.** *John Kelly*

one third of a stop, is preferable.

Working with models

Ask your model not to wear constricting clothes for some time before a session. Elastic marks on the skin are distracting. Rings, earrings and all jewellery should be removed. They look very prominent in the absence of other clothes, especially if they glint in the sun.

Most of all beware the uneven sun tan. If you are working with an inexperienced model supply some 'instant sun tan'

lotion available from chemists.

Research a location, decide on some poses in advance, and a first session need be no longer than two or three hours. That is long enough to take a good variety of pictures and to include make-up time. Look after your model's general comfort. You will get more co-operation if you lay on transport and throw in a meal or, at least, coffee.

Posing and composition

Study plenty of photographs beforehand

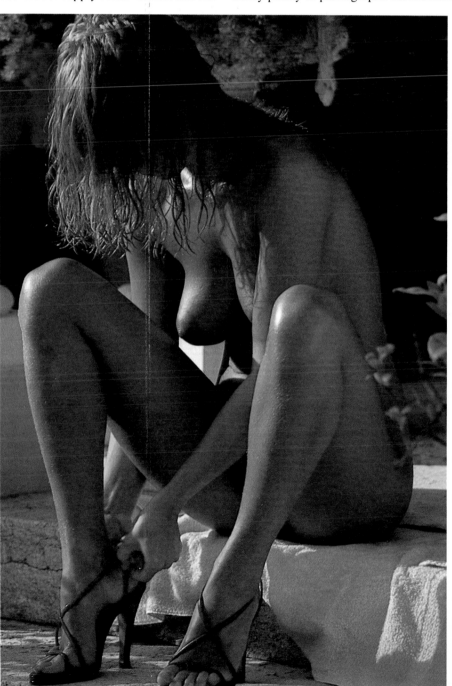

so that you can give positive directions, to the model. This will help to give the model confidence in you.

Amateur models often find it difficult to know where to hold their hands. Use the natural props of the location and suggest ideas like playing with sand, tugging at a branch or leaning on a rock or tree.

Water makes posing much easier if the model is prepared to take a dip. But watch out for goose pimples and keep a towel and wrap or dressing gown handy.

These may sound conventional ideas. However, they are easy to follow and provide excellent experience to build on. Do not expect too much from your first nude photographs. Try to learn lessons that will save time, expense and disappointment in the future.

Film and equipment

A medium speed film, say 125 ASA, will enable the camera to be hand held. This gives more freedom than using a tripod.

A 100mm lens on a 35mm camera (or a 150mm lens with 6x6 equipment) is ideal for full length pictures. It avoids the danger of distortions produced by moving in too close, and enables you to work at a comfortable distance from the model. Progress later to wide angle lenses but, as with everything else, learn to use the basic tools first and gain complete confidence with them.

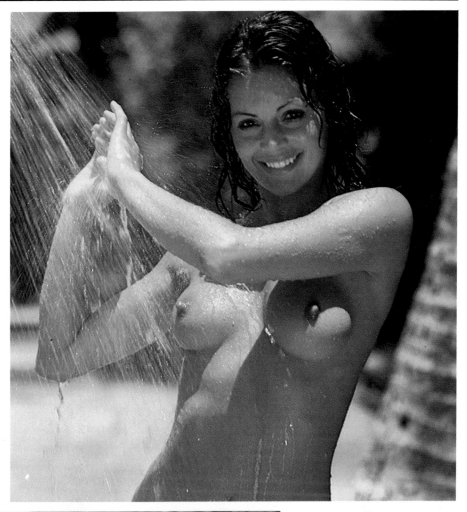

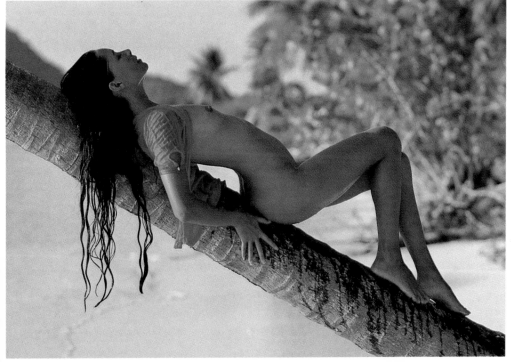

▲ Natural props like water, sand and leaves are always available outdoors. They will help an inexperienced model to relax as well as help the picture to tell a story. *H. Blume*

◄ Research locations well. Note where the sun will be at different times of day. Watch for areas of water or leaves that may reflect light or even give it a colour cast. It is important that skin tones appear natural. Green or blue casts should be corrected. A red cast from the setting sun is usually quite acceptable. Look for large rocks, trees or areas of strong texture which will complement the rounded lines of the human form. *Donald Milne*

A different approach

The majority of photographs are intended as identifiable representations of a particular subject, albeit interpreted and presented in the way a particular photographer sees it. This is especially true of nude and glamour photography where often the purpose of a picture is to project the model's personality as well as her appearance.

At the same time, though, the nude body lends itself to more abstract images, where the identity of the subject becomes far less important than the shapes and tones created in the photograph. The reasons why the human body provides the basis for so many successful abstract photographs is because it possesses qualities which are particularly helpful to the photographic process. The shapes and contours of the body not only vary considerably from one model to another, but also vary dramatically within the same body: the slightest shift in position or change in muscle tension and a completely new 'landscape' is presented to the camera.

There is in fact a great deal of common ground between abstract nude photography and landscape work: like landscape, one aspect of the nude body which makes it particularly photogenic is the way in which different forms of lighting can reveal new and constantly changing images. The texture of skin also gives rise to very effective imagery; whereas conventional nude and glamour photography calls for a degree of flattery, abstract nude photography places no such constraints on the photographer when lighting and composing pictures.

The production of an abstract image involves isolating a specific aspect of the subject so that it is presented and viewed out of context. This can vary in the case of nude photography from a simple depersonalizing of the subject—by merely cropping the head, for example, or not showing the face—to techniques which actually disguise the nature of the subject.

Close—framing and cropping

The first and most obvious of these techniques is the use of tight framing and close—up. By isolating a small area of a body and composing a picture from the shapes and contours within a specific region you can produce images which range from the highly erotic to the highly esoteric. Some very close—up and near—abstract nude photographs can be far more sexual in their impact than the more conventional lip—

▲ Shooting in the studio with a strobe flash (from above and slightly behind the model) *John Garrett* took care to exclude any stray light and keep the background very dark. He under-exposed to lose detail in the shadow areas and diffused the single light source with a glass fibre screen.

◄ Here, using a 45-70mm zoom lens, he aligned the vertical shape of the girl's arm with the side of the frame, emphasizing the contrasting shapes and angles. He bounced his flash from an overhead reflector to create the highlight.

► He took this shot by daylight on location, diffusing the light from the window with netting and exposing at 1/60 and f8.

pouting, chest–thrusting images favoured by popular newspapers.

The work of photographers such as Helmut Newton and Jeanloup Sieff are good examples of abstract nudes which still have a strong erotic appeal. The ability to accentuate the curves of a body and the soft supple quality of skin and hair is much greater when the photographer is aiming for these close–cropped, concentrated images.

Lighting

The effect of light on the nude body can provide virtually limitless photographic effects as if it were a miniature landscape where both the sun and the landscape itself can be moved at will. Although daylight, either indoors or out, can be used most effectively in abstract nude work, the full potential of lighting effects can only be exploited where studio or portable lighting can be fully controlled by the photographer.

It is not necessary to have a great battery of studio lamps; just two or three light sources, either flash or tungsten, with a choice of reflectors

125

and diffusers will suffice for most situations. A spot light can be a help, producing dramatic, high contrast effects, but even these can be achieved with a conventional reflector lamp.

A tripod is invaluable since the slightest change in the position of either the model, the lighting, or the camera will produce quite dramatic changes, and it is therefore advisable to keep the camera, at least, firmly in one place. When working with strongly directional lighting, especially when fairly close–up, it is often preferable to move the model to change the effect rather than the lighting or the camera.

▶ **Using an 81B filter to warm the skin tones,** *John Garrett* **included the girl's hair as a contrasting texture, while retaining abstract impersonality.**

◀ *Mike Busselle's* **model put oil on her skin and then sprayed it with water to accentuate the texture.**

▶ *Bill Brandt* **deliberately reduced real skin texture so the remaining shapes dominate the composition.**

Technique

Good camera technique is vital for this type of work as the impact of such pictures depends to a very large extent on the photographic quality of the image. Where texture is a prominent feature of an image, for example, the picture needs to be as sharp as it can be: the camera must be focused accurately and the correct aperture used to achieve adequate depth of field. When working quite close this often means using the smallest aperture possible, and with tungsten lights or daylight this will mean longer exposures—another good reason for using a firm tripod.

The tonal range and colour quality of this type of image is also of vital importance. There is no point in carefully lighting and composing a picture if the final effect is destroyed by a wrong exposure—causing the highlights to bleach out or go muddy and shadows to lose detail or merge completely. Precise exposure is crucial and it is often preferable to bracket exposures, say ½ stop either side of the reading; you can treat this type of subject as still life, without having to worry about the model's changing expressions.

Camera angles

Another method of abstracting an image with a nude model is by using

unfamiliar and unexpected camera angles. The most commonplace and everyday objects can become almost unrecognizable when viewed from an unfamiliar viewpoint. In this case, too, it is usually easier to move the model rather than the camera.

In most circumstances we look at other people more or less straight on, eye to eye and usually vertical; it is surprising how different and strange a body can look when viewed, for example, from the toes up or from the top of the head. Angles like these are simplicity itself to achieve when you can move your model, especially when you are working close-up and the background is either hidden or cropped out.

Lenses
In conjunction with unusual angles it is also possible to create unfamiliar perspective effects by using either long focus or wide angle lenses. A long lens enables you to work at some distance away and still frame the image tightly. Coupled with a viewpoint along the length of a body, for example, this can create strange juxtapositions of limbs and unexpected effects. A wide angle lens on the other hand enables you to work extremely close, with part of the body in the foreground but still including other areas, with apparently distorted perspective which this creates.

Attention to detail
One thing to remember when shooting pictures which involve isolating small areas of the body and lighting in a way which accentuates skin texture and contours, is to be aware of any blemishes or imperfections, which exist in even the most perfect body. Do not hesitate to use, or ask the model to use, a little make-up to subdue any marks in the picture area. These tend to be exaggerated by the photography and a little care before is better than a spoiled picture afterwards. One universal problem is marks caused by elastic, belts and tight clothing: the only solution for this is time, and it is best to get your model to undress and slip on a loose gown as soon as she arrives, and leave as long an interval as possible before you start shooting.

Skin colour can be a problem when shooting on colour slide film: European skin can sometimes look a little pasty. Careful lighting can to some extent overcome this, and the use of a discreet filter such as a CC 05 Red can also help considerably. Another method is to use a little sun oil, such as Ambre Solaire, rubbed well into the skin, which can produce an attractive sheen and even impart a little colour.

▶ **With his model incongruously placed in a bleak landscape, *Per Eide* added to the visual effect by framing so she appears in the corner of the shot.**

▼ **Using the figure for its shape alone (cover the left side and the subject becomes unrecognizable), *John Garrett* lit the shot from beneath and behind, with a sheet of black velvet above to give the bottle its dark rim.**

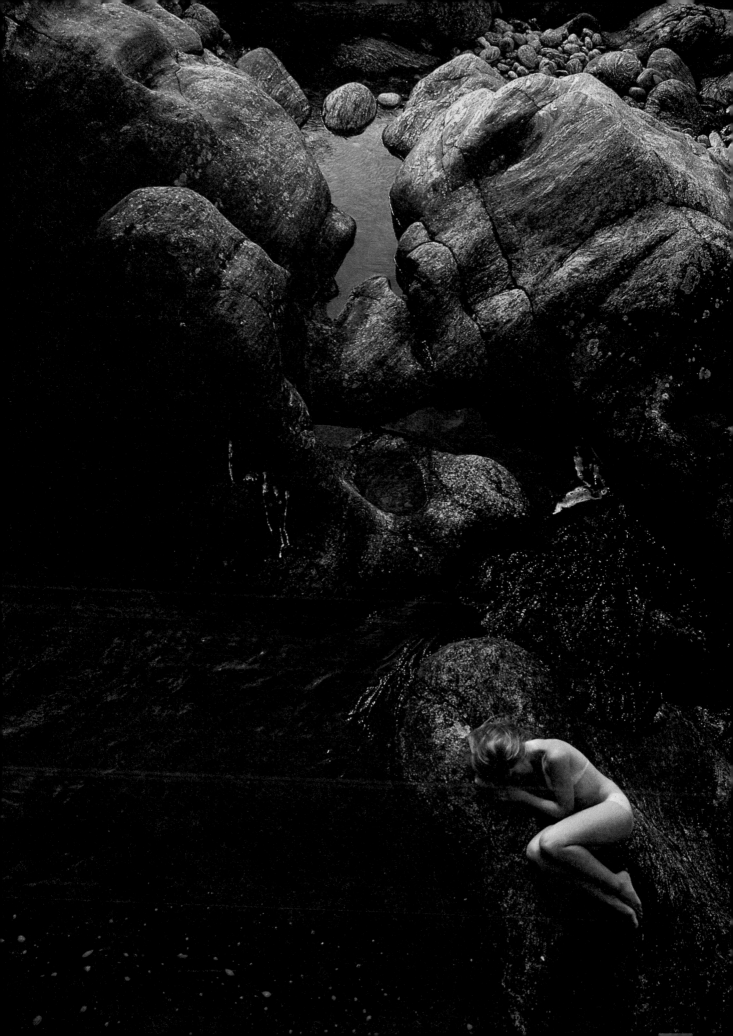

Romantic glamour photography

The essential quality of romantic glamour photography is *softness*. The softness comes from the model, the props, the location, the lighting and the film stock. Introduce a hard note into any one of these basic elements and the effect will be reduced.

Some early photographers deliberately produced soft prints, taking their inspiration from the romantic school of painters such as Turner. The 'pointillist' painters like Seurat formed soft images in their canvases from an accumulation of tiny points of colour. The effect is similar to the grainy pictures of Sarah Moon and Deborah Turbeville—produced by uprating the film and extending the processing ('pushing').

Photography has taken up the theme of romantic pictures of young girls that has been with us for centuries.

The model

Perhaps the leading photographic exponent of romantic glamour—David Hamilton—spends time scanning the countryside of Scandinavia in search of his perfect model. She must be slim, long-haired with a fair complexion and a figure that is not fully developed. He rarely uses professional models because they earn their living by projecting themselves, and are too aware of their own sexuality. This awareness may be enough to break the spell he wishes to cast. His models must appear to be unconscious of their beauty.

But not all photographers can afford to spend time in search of perfection. Every woman is a potential model for this type of photography and it is up to the photographer to find and exploit that potential. It may be in an expression, a pose or a movement. A special grace or gentleness can make any woman a subject for romantic pictures. And one of the greatest tests of the success of the picture is whether it appeals to other women—whether women feel themselves flattered by the image projected.

The model's hairstyle and her makeup should always be natural. No extravagant artificial waves, no red lipstick or nail varnish. Poses should be natural and unforced, but if you feel a striking pose is effective, soften it with the other elements of the pictures. The gentle mood is best suited to simple techniques: a standard lens, straightforward viewpoints and camera angles.

The props

The model's clothes are important. The romantic image is best served by loose

SOFT LIGHT
▲ Diffused window light gives the girl's skin a soft sheen without throwing any harsh shadows.

GRAINY FILM
▶ Fast, large grain film softens the outlines of the figures.
All pictures by David Hamilton

flowing garments with a light texture. Antique stalls and 'flea markets' are the best hunting grounds for clothes like this. Or ask your model to search through her grandmother's wardrobe for lace and silk and chiffon.

Avoid fussiness and overdressing, however. Usually there should be only one dominant colour—apart from the background—and that should be muted. A pink scarf harmonizing with a bowl of pink roses is enough. Props are important in creating the romantic effect. Use a few items to pinpoint colour, or to hint at a story behind the picture. A bunch of dried grasses, a piece of jewellery, shells and pebbles from the seashore, a book of poems, a half-written letter or a pencil sketch can all be used.

The background

Backgrounds are also important. Aim at a basically monochromatic effect, without much dark shadow or strong highlight. Inside, use a white-painted room which will reflect the light from the window, but don't include any strong shafts of sunlight in the picture. Outdoors, avoid harsh sunlight: work in the shade or on overcast days. Apart from the considerations of privacy and the right weather, the texture of the background is the most important element. Imagine a picture of a girl, posed by tall grasses in the late evening

light. Then imagine her posed against a dark fir forest at midday. The first is a romantic image: the second is too 'fussy', with far too much contrast. Woodland settings can work, however. Over-expose for slides like this, and choose your camera position so that the model is backlit. Backlighting works well with backgrounds that include water too. Water is a great friend of the romantic photographer. The sea can give off a pearly light: this combined with backlighting and a reflector will give a diffused quality to the image.

Lighting

A reflector is your most useful piece of lighting equipment. A white sheet, a roll of studio paper or a sheet of polystyrene can all be used in daylight. Direct flash goes against the feeling of romantic photography entirely. It produces sharp outlines and harsh, deep shadows that cut through the soft atmosphere. Only use flash if you are experienced in the techniques of diffusing and bouncing the flash until it gives an almost shadowless light. For this you will need a powerful flash gun, however. Unless you have the right equipment, stick to natural light boosted by reflectors, both indoors and out.

Technique

Filters can be a great help in creating

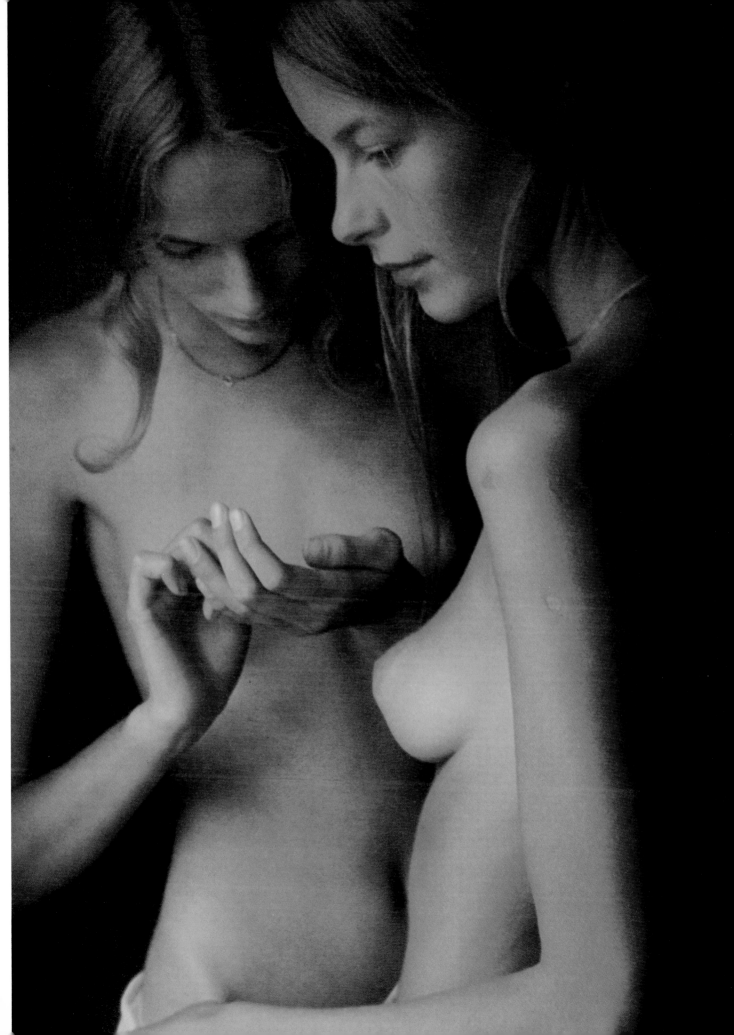

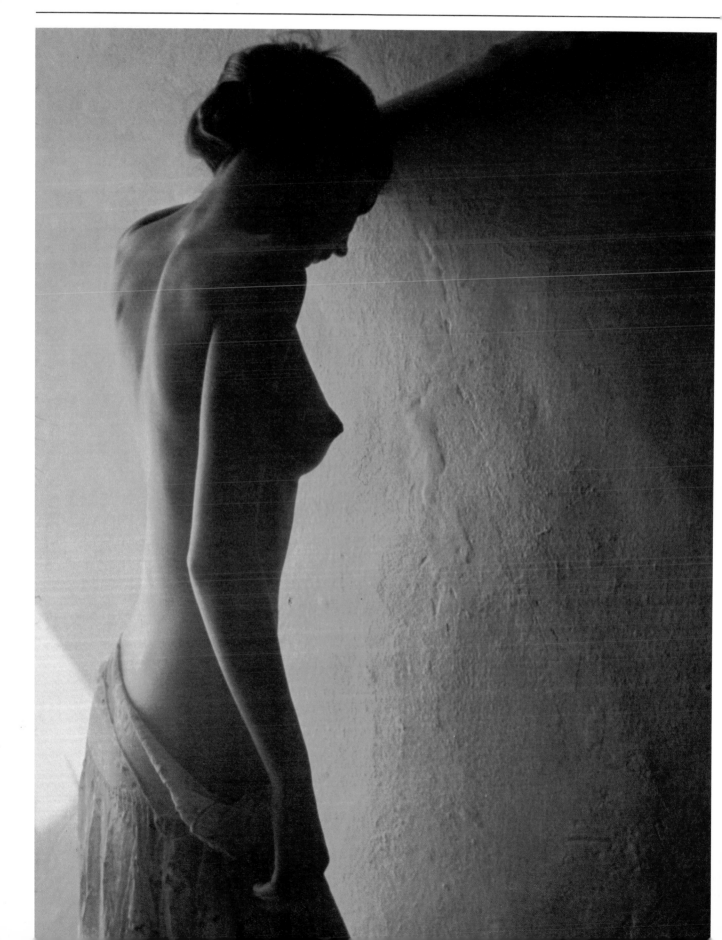

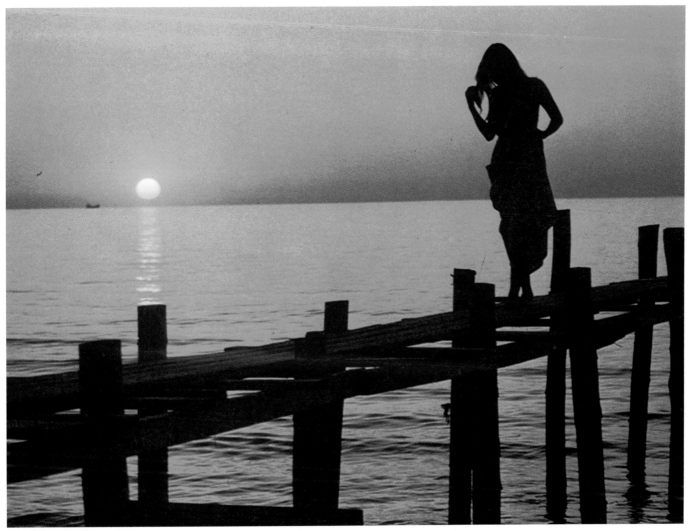

THE HINT OF A STORY
▲ The romance of a picture is
heightened if it contains some clue to
a wistful story. As it shows no
detail of the silhouetted figure, this
picture depends entirely on creating an
atmosphere. The sunset sets the
mood, and the distant boat on the
horizon suggests the reason for the
girl's vigil on the shore.

COLOUR AND MOOD
◄ Bright, contrasting colours make a
picture seem more forceful and
energetic. For the gentle, languid
mood of romantic glamour pictures,
keep the colours within the same
range. Avoid strong sunlight too,
which brightens the colours as well as
throwing hard-edged shadows. Here
the muted colour allows the dark
outline of the girl's figure to dominate
the picture. The small, sunlit area
burns out to a colourless glow.

the right atmosphere. Where the background includes tiny highlights, like the sparkle on water or the soft shine on silver jewellery, use a cross-screen filter which gives them a soft glittery effect as well as slightly diffusing the rest of the image. Soft-focus filters of all types will help soften the image. But they will not do the whole job of creating atmosphere for you. They are only part of the complete picture.

Some romantic photographers make their own soft-focus effects by simply breathing on the lens before they take the picture, but the results are unpredictable. Vaseline smeared on a UV or skylight filter may give a better effect. You can produce a variety of textures by smearing it diagonally or in circles, with less in the centre to give a centre-spot. You can also experiment with using gauze, black stockings or even opaque paper in front of the lens to soften the image or to give an even grainier impression.

The advantage of manufactured soft-focus filters—fog, pastel or diffusion filters—is that they are predictable. Combine them with graduated filters which will darken the sky or introduce a subtle tint over part of the scene.

Film

Grainy films and romantic images go together. Generally, faster films tend to produce grainier images which appear less sharp. Ektachrome 200, pushed two stops, gives a grainy result with a slight yellow cast which may add to the effect. Experiment with fast films and with pushed film (many commercial laboratories will push process slide films at no extra cost). For really exaggerated grain, you can also follow Sarah Moon's example by enlarging part of a slide.

But no matter which film you use it will not supply the right feeling to a picture if the idea is not there in the first place. There are no romantic pictures without romantic feelings behind them.

The secrets of model makeup

Few photographers realise how much makeup can improve their portraits. If they think of it at all, they are content to photograph their subject in her ordinary, everyday makeup, and are often surprised that the portrait is less attractive than they had hoped.

Photographic makeup does more than normal makeup. Under the revealing light of studio flash and the searching eye of the camera, it helps to cover the tiny imperfections on the skin which are hardly seen with the naked eye. It will make the most of your model's bone structure and help to hide faults — such as a large nose or too wide a jaw.

Next time you have a portrait session get your subject to apply photographic makeup following the simple steps shown on these pages. All the products used are normal everyday cosmetics, available in local stores.

A makeup table with a mirror, good light and a comfortable chair are essential. A ceiling light above the model's head is useless, as it will cast shadows on the face and make highlighting and shading difficult to judge. The ideal set-up is even illumination surrounding the mirror and shining straight on to the face. Otherwise, two unshaded 100 watt bulbs either side of the mirror will do.

Before she applies her makeup, the model should cleanse her face thoroughly, removing all previous makeup, tone her skin with tonic and apply a thin layer of moisturizer.

WHAT YOU WILL NEED
The picture above was taken just as the model walked into the studio, with no makeup on. The shot on the right shows her after she had been given a full photographic makeup. To perform this transformation we used ordinary cosmetics, available from any good chemist shop.

Foundation
Liquid foundation makeup, bronze cream blusher, pale highlight cream, cover cream, translucent face powder, powder blusher, shader, highlighter.

Eyes
Eyebrow pencil, eye makeup pencil, powder eyeshadows, dark powder liner, mascara.

Lips
Lipstick, lip gloss

Accessories
A powder puff, a fine cosmetic sponge, a selection of sable makeup brushes, a rouge mop, cotton wool buds, cotton wool, tissues.

1 FOUNDATION
Select a liquid or cream foundation that matches the skin tone. With a fine cosmetic sponge blend a light, even film over the face, including the eyelids, back to the hairline and over the jaw onto the neck and throat. Once the face is covered, continue to blend with a patting, stippling action until the surface is as flawless as possible, adding extra foundation where the surface may still be uneven.

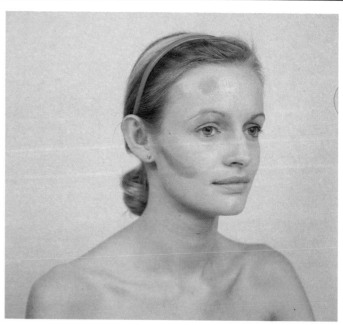

2 SHADING
Shading—along with highlighting—will add depth to your portrait and prevent the face from having a flat appearance. Here you can see the application of shading cream before it was blended in. Note the upward curve of the shadow under the cheekbone and the touches of colour on the browbone and the forehead.

3 BLENDING THE SHADER
Blend the shader carefully away with the cosmetic sponge—or with the tip of your middle finger. Your aim should be to soften the edges of the shaded area until the graduation from dark to light is scarcely visible.

4 HIGHLIGHTING
Highlights do the reverse of the shaded areas, bringing prominence to the bone structure. Here you can see the highlight cream applied to the cheekbone before it was blended in. The golden rule of highlighting and shading is: anything you wish to look smaller you should make darker and anything you wish to look larger you should make lighter.

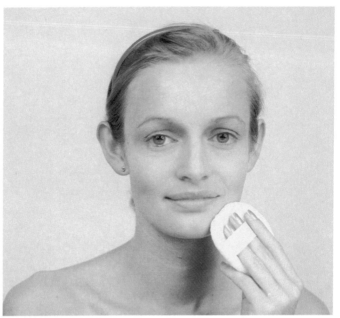

5 COVERING UNDER-EYE SHADOWS

You can also use pale highlighting cream to hide any unwanted shadows under the eyes. Apply the highlight with a brush directly into the heart of the shadow and softly pat away the edges with the tip of your finger until it blends into the foundation. At this stage you might also want to use a beige cover cream to cover any spots or other obvious blemishes such as scars.

6 POWDERING

Pick up a generous amount of powder on a flat velour puff, fold it in half and rub the surfaces together until the powder is pressed back into the texture of the puff. Now pat the powder over the face until it is completely matt. Just before you powder around the eyes make sure that the makeup has not squeezed into creases. If so, pat them smooth with a finger and powder to prevent them reforming.

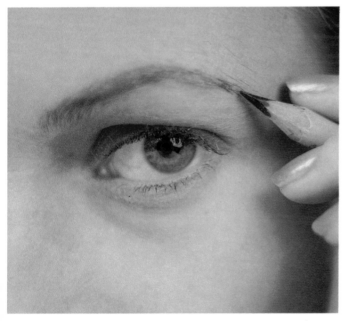

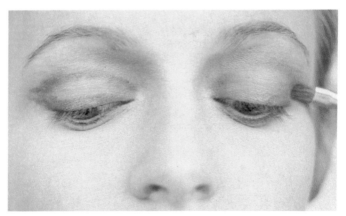

7 EYEBROWS

Brush the brows with a clean mascara brush, grooming them into the best possible shape. Then with your eyebrow pencil sketch in the brows with short strokes—like hairs themselves —starting immediately above the inner corner of the eye and following the natural arch of the brow to a point just past the outer corner, lifting the shape very slightly as you get to the outer end.

8 EYE PENCIL

With a well-sharpened eyepencil draw a wide line of colour along the top lid, close to the roots of the lashes. Draw another line along the socket crease, and where they meet at the outer corner, thicken the line and wing it up over the outer end of the brow bone (see the eye on the left). With a square-ended ¼in (5mm) sable brush blend these lines into the shape you can see on the right. Then add a line of colour with the eye pencil underneath the lashes on the lower eyelid and blend it away with the brush to meet the blended colour on the top lid. The colour of the subject's clothes will influence what colour you choose for the eye makeup. Generally, you should stick to neutral browns or blue/grey for a portrait, since strong fashion colours quickly date and can look rather startling or overpowering in a portrait.

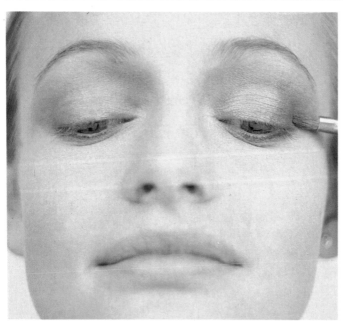

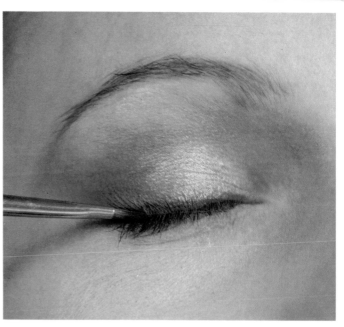

9 EYE SHADOW
Brush over the pencilled, blended pattern on the top lid with irridescent powder eye shadow of a colour that tones in with the pencil. Use a ¼in (5mm) brush for this, concentrating most of the colour on the lid itself (see the eye on the right). Deepen the socket line and the outer corner with a darker tone of matt powder shadow, using the same colour to intensify the line under the lower lashes.

10 EYE LINER
With a fine pointed brush draw a line of very dark powder shadow—or eyeliner—along the edge of the top lid, as close as possible to the roots of the lashes. Extend the line just beyond the outer corner of the eye and soften it slightly with a clean brush.

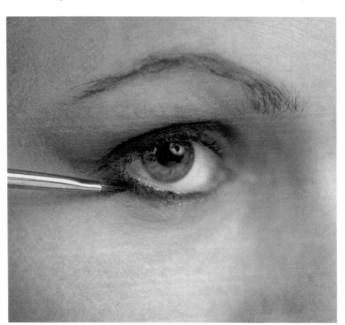

11 LINING THE LOWER LID
With the same colour eye liner, draw a very fine line along the edge of the lower lid, extending it at the outer corner to join the line on the top lid. Add a little extra colour where the lines meet to deepen the shadow at the very outer edge of the eye.

12 HIGHLIGHTING THE EYES
Apply a highlight to the central area of the top lid with a very light irridescent powder eyeshadow. With the same powder highlight, brush lightly along the centre of the browbone immediately below the eyebrow to give it a very slight shine.

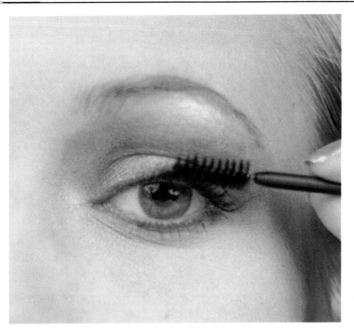

14 LIPS

Using a lip brush (here we used a No 6 Filbert sable brush), outline the lips with your chosen colour of lipstick or gloss, widening a narrow mouth or making full lips narrower as you feel necessary. (Note that the model's lips were very slightly *under*painted here since they might be a little too generous in proportion to the rest of her face.) Then fill in the centre of the lips with the same colour. If the lips are very narrow, paint the outline again with a deeper shade of lipstick and fill in the centre with a lighter shade. This makes the lips appear to be very much fuller.

13 MASCARA

Apply your mascara generously, first to the bottom lashes and then to the top so that there is no risk of smudging the top lashes as you do the lower ones. Make sure that the colour is carried right down to the roots of the lashes, giving them a couple of coats if necessary. Also, make sure that the lashes are separated as much as possible.

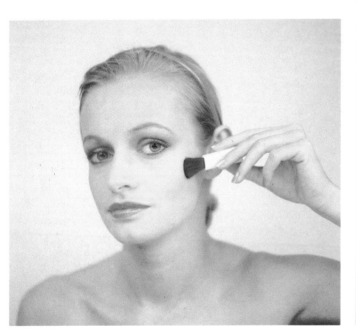

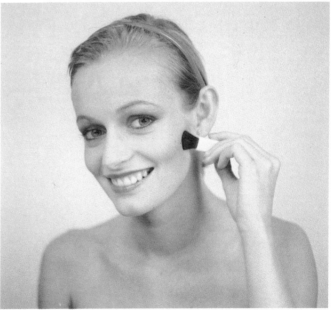

15 BLUSHER

Using a 'rouge mop', dust a soft application of blusher, chosen to tone in with the lip colour, over the cheekbones. If you are photographing in black and white you should omit this stage since the red tones will register as grey and the blusher will tend to flatten the cheekbones. Instead add a touch of powder highlighter to the cheeks.

16 STRENGTHENING THE SHADING

With the rouge mop and powder shader, strengthen the shadow under the cheekbones. If your subject has a double chin, you can also use this shader to make it less obvious. Apply it lightly under the jawbone and down the throat, making sure there are no obvious lines of dark colour on the basic foundation colour.

Taking fashion pictures

Clothes are central to a portrait of anyone dressed up for an occasion or wearing a uniform for the first time. They may be the most important part of a picture if someone has bought or made a new outfit.

Clothing is also a subject that allows the photographer to break all the rules in the search for novelty.

Even if you do not want to take any 'fashion' shots, look at the pictures in fashion magazines anyway. Notice how they create mood and movement. The pictures will help you to see in new ways and to take more interesting shots. Fashion can be taken outdoors, on location or in the studio. The combination of clothes, location or background, and lighting sets the mood or it may be suggested by the clothes themselves.

Fashions change, and so do the settings which evoke them. A 'fifties look might suggest milkshakes, cola, rock and roll, and custom cars. A Japanese style might want flat colour, fans, exotic flowers, bamboo and water gardens.

Fashion outdoors

Choose a location that will contrast with or complement the clothes. Try to find a place that will provide a variety of backgrounds and props. A park or a patch of countryside is ideal. An empty stretch of beach or street are other possibilities.

Avoid well-populated places unless you intend to have other figures in the picture. People will stare, which will inhibit both photographer and model. Remember that locations are real places made up of wet grass and mud. Warn your model of the risks and watch out for these when shooting.

In general, choose to shoot in the morning or afternoon with the sun at an angle and diffused by cloud. The extreme contrast of midday sun is harder to control, but can also make interesting images. A face in the deep shadow of a large hat will not detract from the garment.

Back lighting adds life to semi-translucent fabrics and makes a rim light around heads and figures. Use fill-in flash if necessary but not at full power as this would produce a dark background.

Shooting indoors

Fashion need not be shot in a studio. A window can provide all the light that is needed. Add a few props such as a chair, a table and some flowers to create a scene.

Try exposing and processing black and

THE RIGHT BACKGROUND
▶ The elements of this picture work together to show off the cool, cotton outfits. The flowers match the fabric colours, and the models look relaxed in the setting. *Andreas Heumann*

▼ Stone and tweed contrast in tone and texture, they harmonize in colour and the stitching and mortar lines echo each other. Add the angular pose, and the overall impression is of a very smart and formal jacket. *Julian Calder*

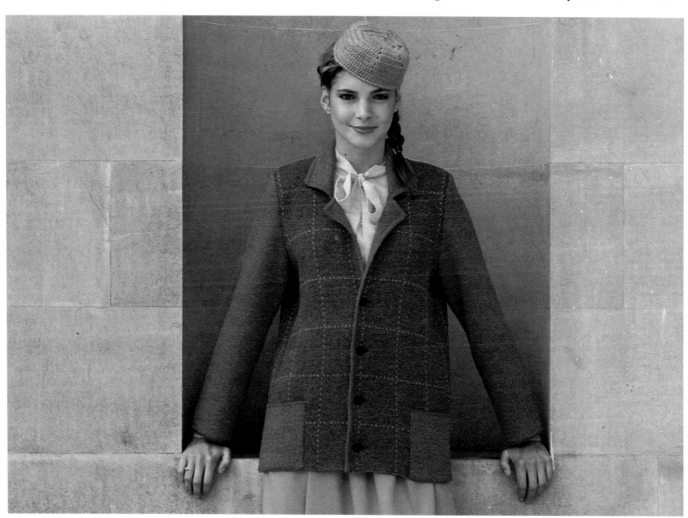

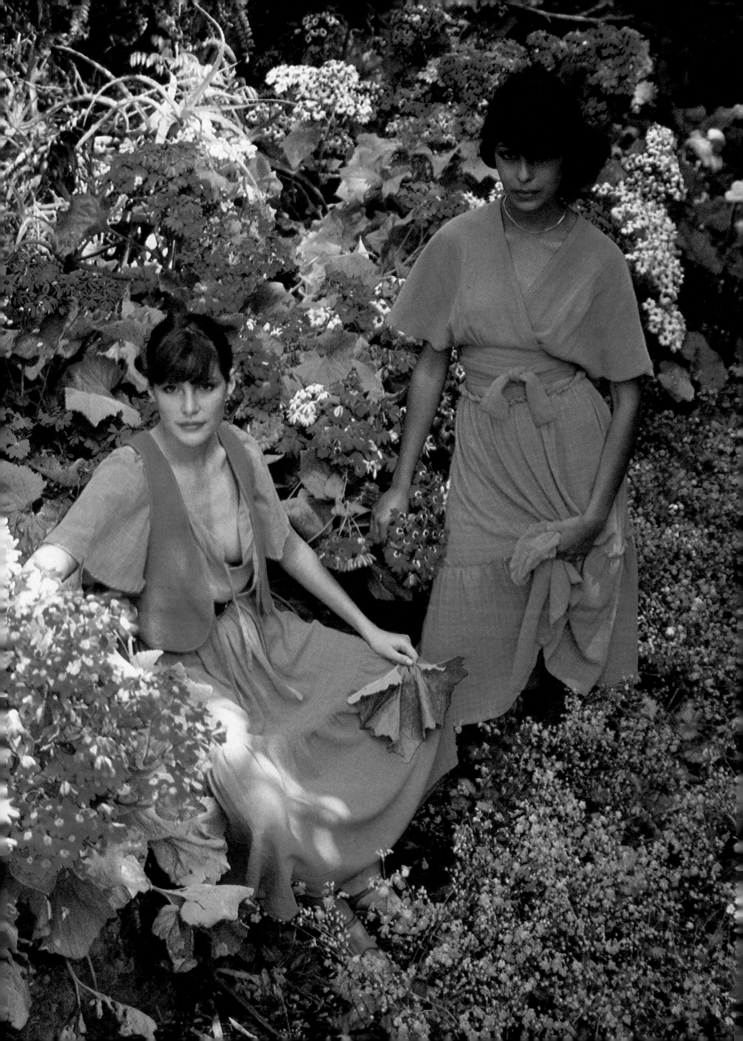

white film in print developer to give maximum grain. Then print on contrasty paper.

Again, fill-in flash or a reflector can be used to reduce lighting contrast. Flash at full strength will make the world outside the window appear as if at night. An umbrella flash will light a full-length figure plus background and foreground. Shooting against a plain background is the hardest way to use this type of light. The whole mood must be created by lighting, movement and expression.

There is no scenery to help the picture. Start with a high, frontal light. Then play around with the position to make different moods. Try the light soft or contrasty, as a spot or coloured by gels, filters or sheets of plastic placed over the flash.

A second flash can be used to back light hair, eliminate background shadows or to produce more shadows. Shadows can be strengthened by moving the model closer to the background. A ring flash (a circular flash head that is mounted around the lens) makes an apparently shadowless picture.

Models and makeup

Choose someone tall and slim. Most professional female models are at least 5ft 7in (170cm) tall. Male models are usually about 6ft (182cm) tall with a 38in (96cm) chest.

Models with statistics like these will help your photographs. The camera has a tendency to make people look heavier than they are.

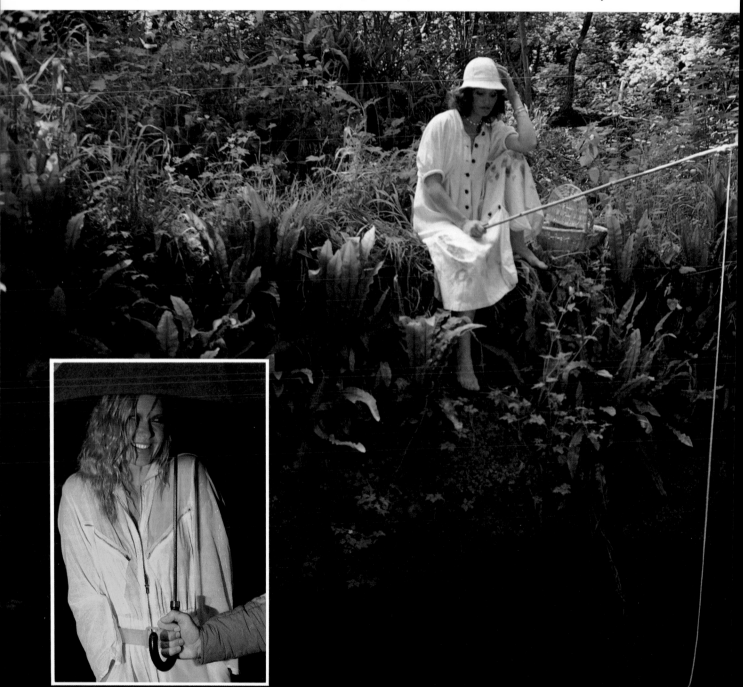

The model's makeup and hair also contribute to the mood of a picture. Makeup may be soft and natural or bright and brazen. Look at magazines for inspiration. If the model is not an expert, try for a simple, natural look. Just use a covering foundation, a little eye shadow, mascara and lipstick. Avoid shiny lipsticks and eye gloss unless you particularly want this effect. They can look ugly on film.

Hair can be worn up, down, plaited, crimped: suit the style to the clothes.

MAKE USE OF PROPS

◄ The fishing line is impossibly thick, but it is a believable prop that gives the model something to do. The basket is a nice touch that helps to complete the scene. The picture is posed and contrived, but it makes the dress the most important element which justifies the photograph. *George Wright*

◄ Inset: a look, a little water and a simple prop suggest a whole story. The picture is made to come alive without detracting from the jump suit. The lighting is from a single flash head with an 85B orange filter. *Tino Tedaldi*

▲ The red tee shirt is vibrant against the black background. The whites do not detract from the red and the model uses the towel to project a sense of healthy sportiness for the camera.

A studio can be a very difficult place to take fashion photographs. The mood of every picture may have to be created with lighting, the minimum of props and the model's ability in front of the camera. This picture might not have been so successful if the lighting was more complex. One studio flash lights the model from the front with a flat, even light. Another flash from behind adds a few highlights. *Tino Tedaldi*

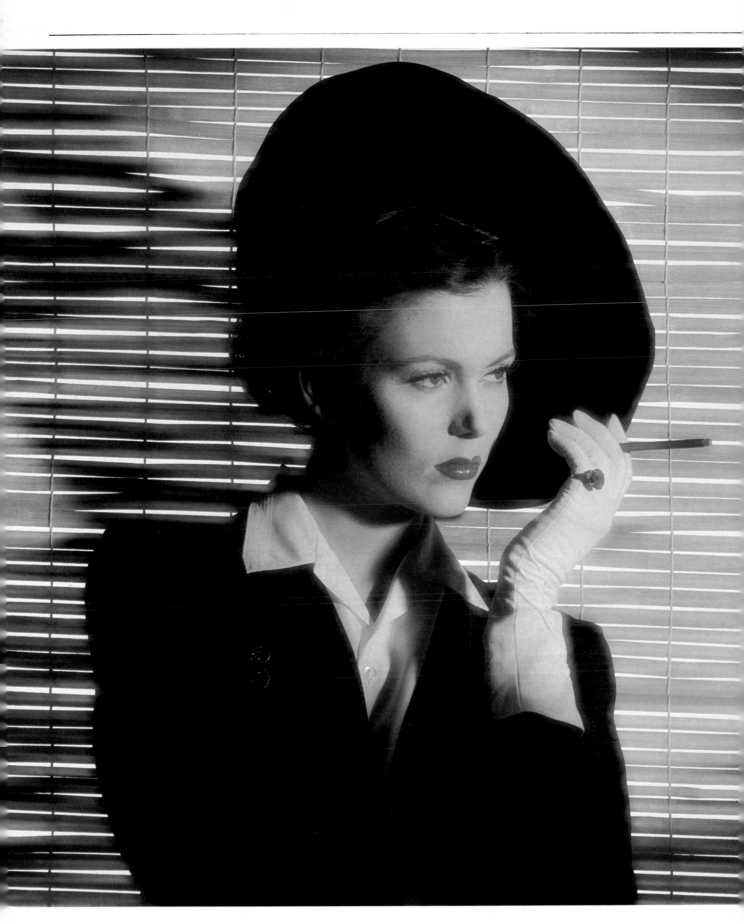

Picture ideas

Hopefully, the combination of clothes and location will create ideas. First, get your subject to move about so that you can both get the 'feel' of the outfit. Does it look best with the model standing, sitting, lying, running, jumping, laughing, being sexy or aloof?

The photographer should start the session with some ideas to suggest to the model. A good model will be able to feel the part and project it. But don't be persuaded by good modelling if you think the image looks wrong.

Look for details of the outfit that can be used. A hood, say, can be left to hang or worn up to frame the face. If it is worn up, the hood can be held away from or tight up to the face.

Sleeves may look best with an arm or arms raised or with the hand on the hip. Pockets can also be used. A position that feels awkward to the model may look right, so these poses are always worth trying.

On location, decide whether to use the scenery or to lose it in an out-of-focus blur. Interesting images have been made by using the figure as only a small part of the picture. Alternatively, crop in close and fill the frame with all or part of the figure.

Try blurring the moving model slightly by choosing a slow shutter speed. Use available benches, trees and steps for the model to sit on or lean against. Shoot from a high or low viewpoint, keeping in one position and getting the model to move.

Indoors, by available light, the model may have to be carefully posed. But with studio lighting, success is entirely dependent on how you make the model move and the shapes you create.

it is easiest to have the camera on a tripod. You can then concentrate on facial expressions and be on the alert to capture the right moment.

The important point is to create a mood both in the session and in the final picture. Don't be scared to break the rules. If a sedate evening dress looks best with the model jumping up and down on a building site, then do it.

◀ **Little (if any) detail can be seen in either the hat or the jacket, but there is no mistaking the dramatic cut or style of the outfit.** *Sanders*

▶ **A long lens has made good use of a simple background. The steps have been reduced to a series of regular lines that contrast with, and emphasize, the model's relaxed pose.** *John Garrett*

A basic posing guide

A photograph of a person freezes a fraction of a second of their life: it shows only a tiny instant of reality, but fixes it forever, in great detail. This is why it is often necessary to pose the subject of your photograph.

When you are with someone, their gestures and movements over a period of time give a *cumulative* impression of the way they look. In a photograph, all this has to be conveyed instantaneously. In addition, when you are with someone you tend to focus attention on one particular part of them—most probably their eyes—and ignore much of the rest. In a photograph you are at leisure to inspect all those forgotten outposts—the awkward position of the legs, or the tightly clenched hands.

A professional model is experienced in maintaining a relaxed appearance for the benefit of the camera. You could ask her to throw her head back and laugh for a pose and she should be able to return to very much the same position for the next shot as well. With inexperienced sitters, though, you should make the pose as straightforward as possible. In this section we deal with solving the problems you might come across with simple, seated poses.

To begin a picture session, first provide a comfortable chair—not too high, or low or with unwieldy arms—and ask your subject to sit quite naturally. Then study the image in the viewfinder and suggest ways to improve it.

Poses for photography are infinitely variable. The secret of being able to tell a good pose from a bad one is to concentrate on the image in the viewfinder *as a picture*—or even as a piece of design. A wide smile that captivates your attention when you take the shot will not make up for the fact that the model's neck looks unnaturally twisted and awkward in the final picture. But remember, this critical scrutiny is your job, not your subject's. Nothing makes an inexperienced subject so nervous as having the various parts of their body shoved around as objects. So let the model feel, move and act as freely as possible and make up your own mind about what is the most suitable pose.

▼ **Dancers and models are trained to move gracefully: they know how to look good. Inexperienced subjects may need the photographer's help.** *Sanders*

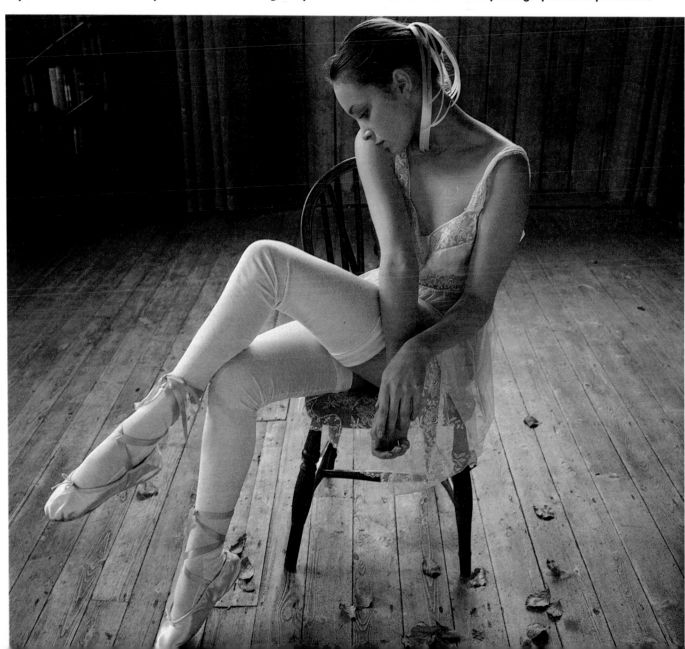

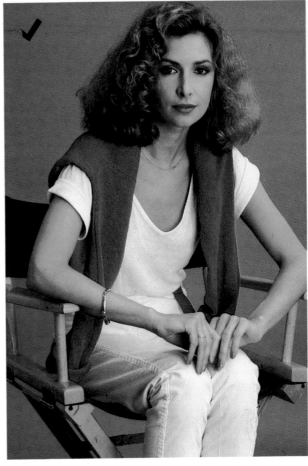

▲ Widespread legs—even in trousers—and spread fingers make this pose look rather disjointed.

▲ The knees together slims the pose; linking the hands makes a harmonious circle of the arms.

▼ Folded arms look dull and lack grace and the clearly visible sole of the foot is not very attractive.

▼ By crossing the other leg the sole disappears. The angled arms and hands now add life to the pose.

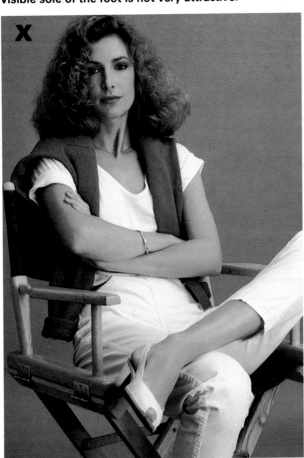

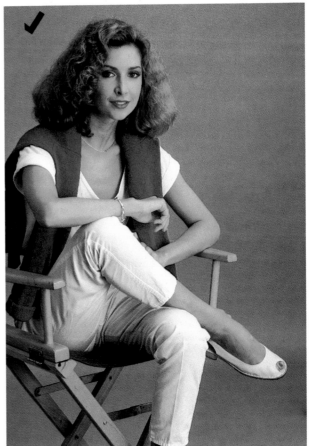

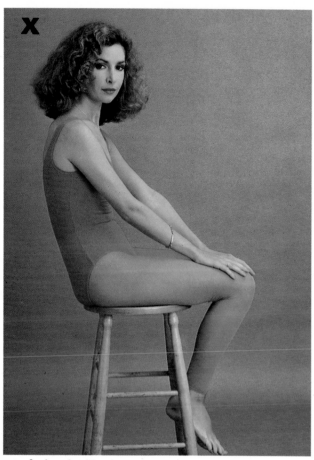

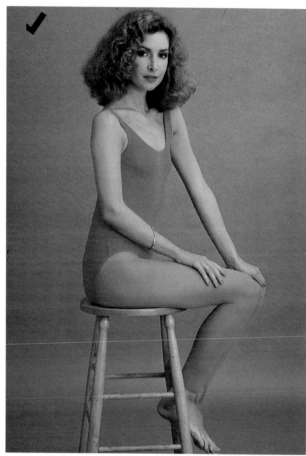

▲ A slouched back makes the subject look rather weary and accentuates the bulge of her stomach.

▲ Straightening up solves all this, and slightly turning the shoulders gives the arms a better line.

▼ Even the shapeliest legs look better if they are in pairs: like this, the subject's slim legs look gawky.

▼ By keeping her knees together at a slight angle, in this shot she shows off her sleek calves.

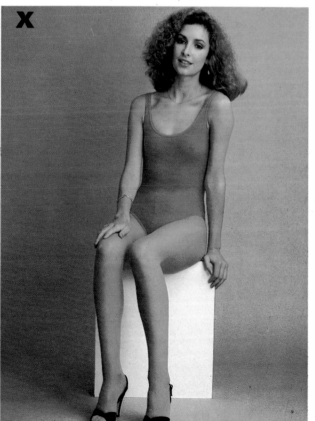

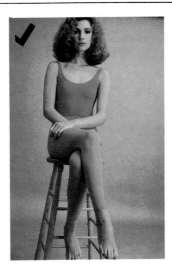

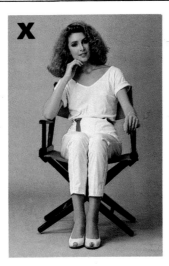

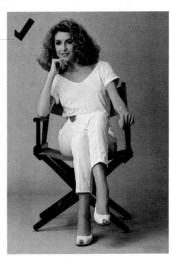

▲ From the front, the foreshortening makes the subject's thighs and toes look much too big.

▲ Masking the left thigh with her knee and pointing her toes gives the pose a far tidier line.

▲ Though the pose is good, the subject is not relaxed: note that her head is not really resting on her hand.

▲ A word of encouragement can give the subject the confidence to relax into a comfortable position.

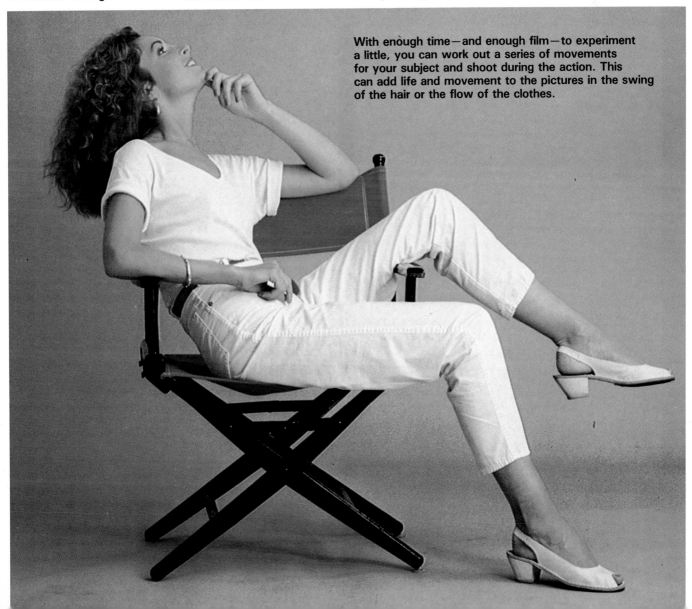

With enough time—and enough film—to experiment a little, you can work out a series of movements for your subject and shoot during the action. This can add life and movement to the pictures in the swing of the hair or the flow of the clothes.

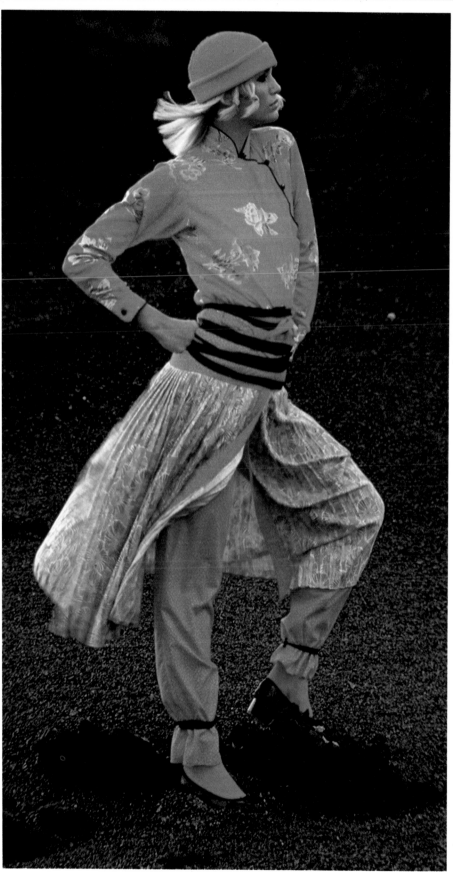

Whenever you take a posed picture it is best to discuss the kind of pose you want with your subject beforehand. If they know what you are after they will usually be more co-operative, and together you should be able to find the right pose fairly quickly.

It is also important to consider the clothes your subject is wearing. For our illustrations we have chosen a leotard, so you can see the position of the limbs clearly, but the clothes will make a considerable difference. You would not ask a girl in a flowing evening dress to lie full length on the floor, for instance, but you might if she were wearing jeans or a swim suit.

The most important factor in posing is to get your subject looking relaxed and natural. If you try a couple of poses and these look awkward, allow your subject to move around freely until you see, in the viewfinder, a pose that makes a good composition. Then you must check each element of the pose, to see how it fits into the overall picture. In other words, check the position of fingers and hands, elbows, legs and feet, to ensure that all are shown to their best advantage. Make sure each limb looks 'connected', with no parts of the body disturbing the flow of the figure.

This posing guide gives some concrete examples of the type of problem to look out for—and how to correct it for the sake of the overall composition.

To a nervous subject, it might be worth explaining that some of these alterations are necessary because of the optical effects of the lens, not because the subject looks peculiar in real life!

For example, with a standard lens, you have to approach quite close to the subject to fill the frame, and you run the risk of exaggerating the size of the parts of the body closest to the camera. This is why you should ask your subject to modify the pose so that all their limbs are at roughly the same distance. Problems like this don't occur in real life, when we see people 'in the round', in three dimensions. They are particular to photography, which represents reality in only two dimensions and therefore requires a rather more careful approach. Often subjects will feel nervous if you give posing instructions, rather than leaving them to their own devices. But *you* are the one who can see the final result, and so you are the one who must make sure the pose is correct.

◀ **Posing cannot always be left to the model: the photographer must decide what works for the camera.** *Hans Feurer*

▲ Turning the body at an angle to the camera while the face looks directly into the lens tends to slim the body—but it can then bring other problems. Here the subject's shoulder is too hunched, giving her back a rather sloppy curve. At the same time her neck appears to have totally disappeared, which spoils the picture.

▲ In this picture the subject has corrected the hunched shoulder, stretching out her neck to give a far better shape. Unfortunately, however, the angle of the body is too great for this to work well since—in order to face the camera directly—she has had to twist her neck to much that she creates deep creases.

▲ Turning the body further towards the camera solves the problem of the creases in the subject's neck. Here it is the angle at which she is holding her head that spoils the picture. Lifting the back of her head, she has then also tucked in her chin and, though she is by no means prone to double chins, she appears to have one here!

▲ In this picture the model altered the tilt of her head so that the double chin disappeared and the shadows around the jaw line helped to flatter her bone structure rather than spoiling it. The pose appears completely easy and natural, though at the time the subject was conscious of stretching up to give a livelier, more flattering line.

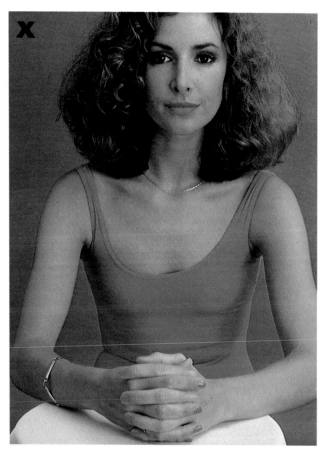

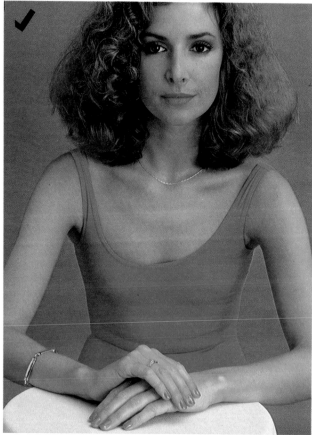

▲ 'What should I do with my hands?' is a question that many subjects ask. This shows one way *not* to hold them! Close to the camera, the fingers look far too big.

▲ Holding the hands edge-on to the camera looks neater. Keep them together, and keep the best hand—or the hand with a decorative ring—on the top.

▼ It can be attractive for the subject to put the hands to the face—but not like this; here they obscure the jawline and the fingers are ugly and obtrusive.

▼ Side-on to the camera, the hands here are much less overpowering, allowing all the attention to go to the face. The chin rests only lightly on the hands.

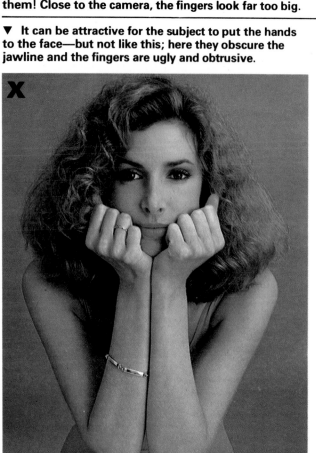

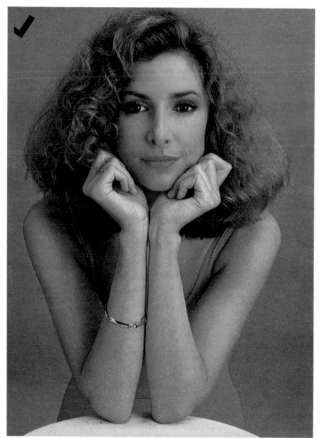

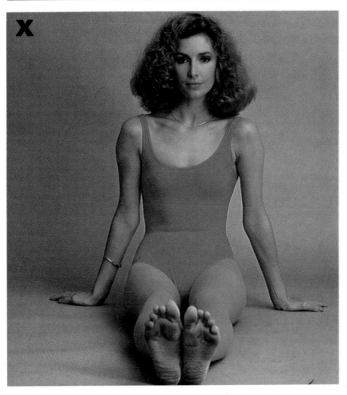

▲ Sitting on the floor can cause problems. This pose, as well as fattening the legs because of foreshortening, is completely dominated by a pair of apparently huge feet.

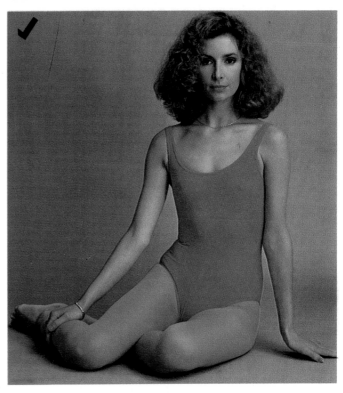

▲ By simply bending her knees away to the side, the subject gets her feet in proportion. This pose also makes a far more graceful composition in the viewfinder.

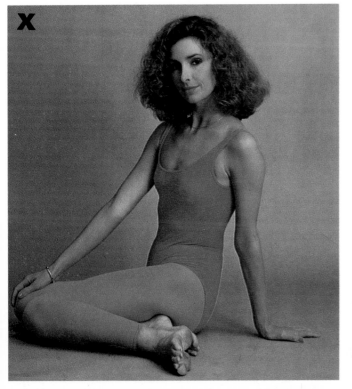

▲ When your subject is sitting with her legs to one side, make sure they do not point at the camera. From this angle the feet look untidy and the shape of the thigh is distorted.

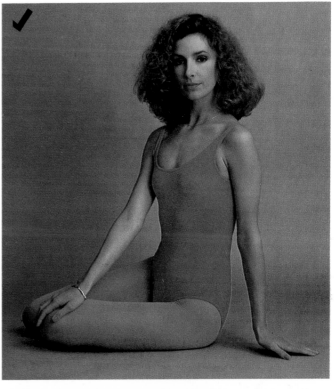

▲ This angle is far better, with clean lines and a strong shape. It improves on the picture above by masking the feet so that they do not attract too much attention.

▲ Another answer to 'Whatever shall I do with my hands?' is to flick them casually through the hair to give a feeling of movement. But here the arms are foreshortened.

▲ Spreading the elbows outwards puts the arms in better proportion as they are now on the same plane as the body. They also form a V-shape which frames the face.

▼ Hands-on-hips often improves a picture—but you must be careful how you do this. Pictured like this, the subject appears to be suffering from backache.

▼ By turning the hand the other way, the model seems no longer to be nursing her back. Turning the body towards the camera conceals the sharp curve of the back.

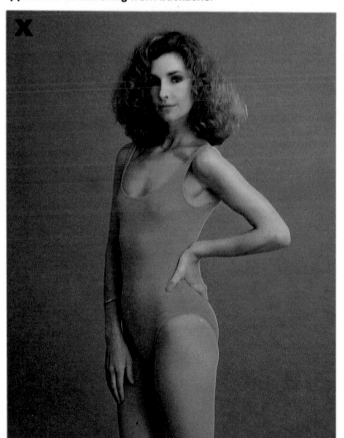

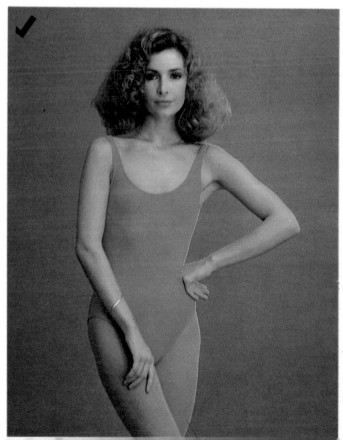

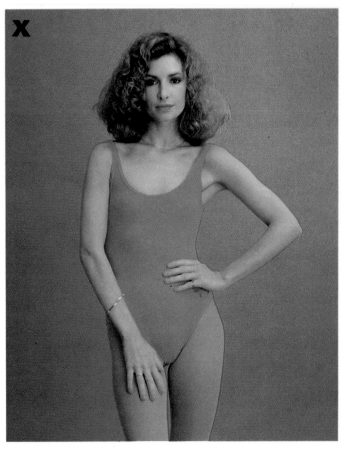

X

▲ Spreading the fingers along the front of the waist is better than clutching at the small of the back. But with both hands spread, it is another case of 'too many fingers'.

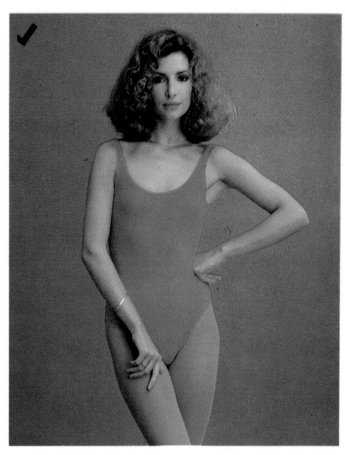

✓

▲ This pose is neater, not only because the hands are less obvious, but also because the subject has crossed one thigh over the other to improve the curve of her hips.

▲ The clothes your subject is wearing, or any 'props' that come to hand, can improve a picture by suggesting ways to vary the pose. Something as simple as a jersey can help. Nervous subjects are only too glad to have something familiar to 'play with' while you are busy looking for a suitable pose.

▲ Different props suggest different poses. To begin with, leave it to your subject to decide what to do with a handbag, for example. Watch through the viewfinder until the pose makes a good composition and ask her to hold the pose. Then scrutinize the image for awkward details and suggest changes.

▲ Props can often give you ideas for a theme. Slung on her back to look like a rucksack, this bag suggested hiking to *Tino Tedaldi's* model and she assumed a pose that suited that idea. Your subject may not be quite as versatile as this professional model, so help by letting her know when a pose works well.

The successful planned group

For many photographers, the invitation to any social event—a wedding, a christening, even a family outing—may be accompanied by the request: 'And, please, bring your camera.' The advantage of photographing people who are all fully aware of the camera is that you can expect their co-operation: the problem is that you can't always depend on it. With planned groups, self-consciousness is your chief enemy. By the time you have the group you want, you may find that those cheerful faces have turned to stone and the results are far from the friendly gathering you set out to portray.

The successful planned group photograph shows every member to advantage yet forms a pleasing arrangement when viewed as a whole. Your chief difficulty will be in remembering the composition while dealing tactfully with the personalities involved. Plan as much as possible in advance. If your subject is a sports team, for example, think out your colour scheme beforehand, working out what background to use. Or, if the group includes children and adults, plan how to deal with their varying heights. Planning can save time—and tempers too—on the day. If you can arrange the group quickly, the results are less likely to show tell-tale signs of boredom and restlessness. When the session begins, establish your authority right away, at the same time persuading your subjects to participate—to think about what you are trying to do. Identify everybody by name, and use their names when giving your directions. Make these directions clear and to the point: you will lose their attention if you are indecisive.

Lighting

The ideal lighting for groups is bright but even. Check before you start shooting that each face is similarly lit. In direct sunlight you may find the shadow of one member of a group falling across the person next to him. And there is sure to be someone who

▲ An Edwardian family posed against a painted backdrop: (right) alternating black and white areas are balanced and the babies' legs are arranged to lead the eye towards the centre.

▼ At a royal wedding the photographer has little control over the situation. Wherever possible, keep bright colours to the middle and look for details to break a monotonous line. *Howell Conant*

can't help squinting all the time. But the light does need to be bright so that you can shoot with a small aperture to maintain a large depth of field and good definition throughout the picture.

Arranging the group

How do you go about arranging a group in anything but a straight line? Consider a group of three to start with. You only have to turn the two outer figures slightly towards the centre, and you already have an improvement on a straight line-up. Try to decide before-hand what your subjects should do with their hands, and make that one of your first directions. This will not only improve the final picture but will also help the group to relax: people who are self-conscious in front of a camera find this one of the most agonizing pro-blems. If you are moving in close—shooting from the waist up—it is best to keep it fairly uniform with arms folded or hands clasped in front as a sort of frame for the bottom of your picture. If you have got more space, try varying the positions more—one person with arms folded, one with hands in pockets or behind his back.

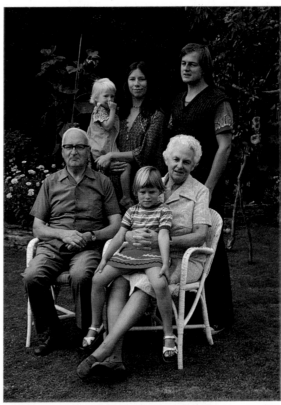

◄ Here the three bright heads, all against dark backgrounds, form a central pattern. Below them, white chair legs slope in to contain the group. *Richard Greenhill*

▼ Planned groups need not be formal. The position of the three faces on the right and the leaning figures are carefully composed, yet seem relaxed. *Clay Perry*

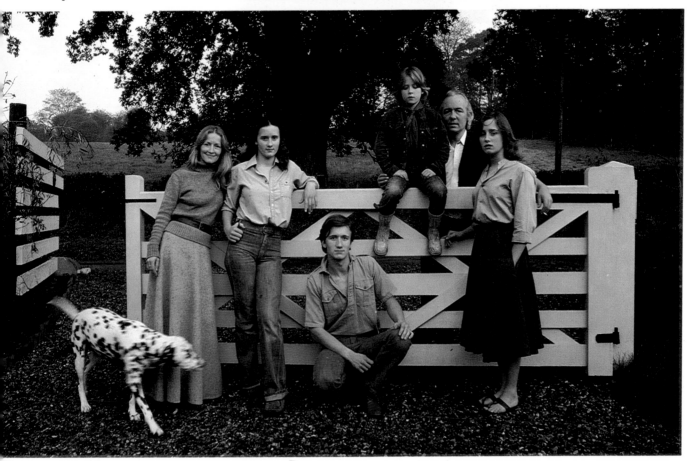

Props and location

You can tell the viewer a great deal about any group of people simply by adding props or choosing an appropriate location. The most obvious 'prop' of course is a uniform. A group of solicitors might each be holding a bundle of papers tied with that tell-tale ribbon; the local fishing club would have rods and nets.

Try varying the direction in which you get your subjects to look. Include one shot with them all looking into the camera but experiment with their eyes looking just above and either side of the camera. And don't always insist on a smile: in the wrong situation smiles can look very forced and unnatural.

Composition will be a lot easier if there is something to form the group around. Take a single arm-chair, for example, and that same group of three. With the chair at an angle of about 45° to the camera, ask one to stand at the back, the second to sit and the third to perch on the arm of the chair. They turn their heads to the camera, but the angles of their bodies

▲ As these children are perched on a wall, a straight line-up is unavoidable: lively colour emphasizes their mood. *Richard Greenhill*

► Backlighting makes this group stand out from its surroundings and also helps with detail by reducing contrast on the faces.

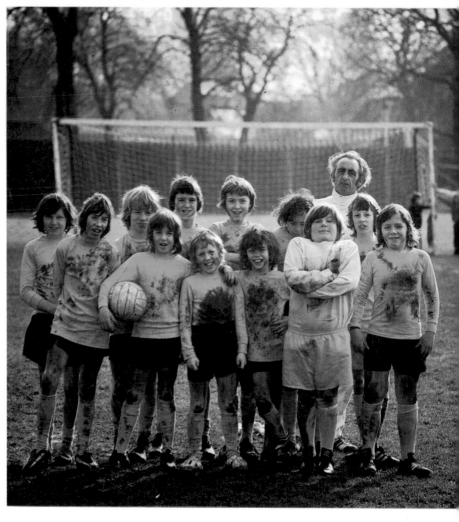

give the group cohesion.

The same principles apply when you add two or three more to a group. You may need two chairs or a sofa; outside you could use a bench, a fallen tree trunk or a flight of steps. But vary the heights as before, and have the outer members of the group turned inwards slightly towards the centre. You can add to the informality of the picture by getting some members of the group to look into the group while others look towards the camera. If there are children in the group, a book or a toy on their knees will keep them occupied between shots and add to the picture's relaxed atmosphere.

◄ Photographing Generation X in his studio on Ektachrome 64, *Gered Mankowitz* used backlighting and low frontlighting to cast menacing shadows on their faces.

▼ What begins as a candid shot may be improved if the subjects become aware of the camera and will co-operate. You need not ask them to pose: shift your own position to get the best grouping. *John Bulmer*

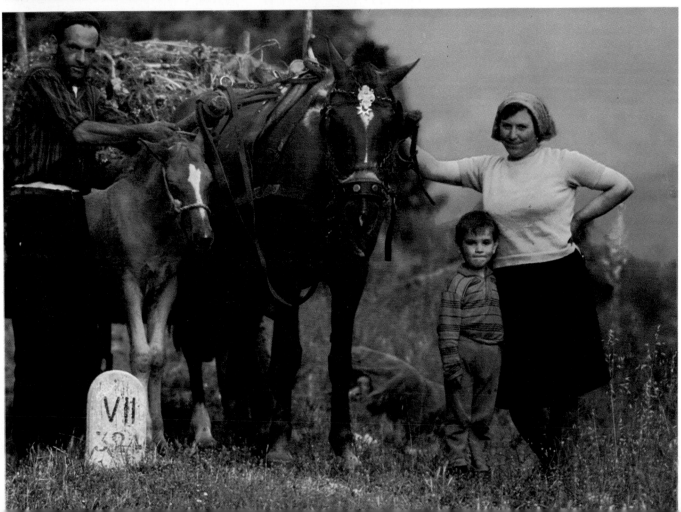

Lens and viewpoint

A wide angle lens can give your groupings a third dimension by bringing some members closer to the camera than others. By focusing on the central figure and using a small aperture you will keep everyone in focus. This can be a particularly effective way of underlining the hierarchy in a group—the chairman with his board; an airline captain and his crew; the local headmaster with his staff, and so on.

As a general rule, the larger your group the more formal your approach. Three guests chatting at a wedding party suggests a loose informal grouping. The full line-up of bride, groom, bridesmaids and both families needs more organization—partly to give the group cohesion and partly so that you can include everyone without sacrificing detail. As groups like these get bigger you may need to take your picture from an elevated position. This gives you greater depth and the chance to see every face clearly without spreading the group too widely. A wide angle lens will help again here, but watch carefully that the distortion which comes when you tilt the camera downwards does not become too obvious especially towards the side of the picture. As before, get everyone to turn inwards towards a point about half way between you and the front of the group. If you are shooting in colour and some of the clothes are very much brighter than all the rest, keep those towards the centre of the group.

Using a tripod

It is often an advantage to operate the camera with a cable release. With the camera on a tripod you are free to watch the expression of each member of your group more easily. And by moving away from the camera you will diffuse some of the tension that is invariably created by your hovering behind the camera ready to pounce.

If you do use a tripod you must check through the viewfinder first that every face is clearly visible, that no one's feet have been cut off and that there are no distracting elements in the background, all of which are too easily forgotten amid the other problems of group photographs.

It would be the result of good luck rather than good judgement if your first exposure caught exactly the right expressions on every face, and if ever there was a case for using a lot of film, group photography is it. There will come a time when enthusiasm wanes and your subjects start to get bored. Equally, everyone will tend to be a little stiff at first. It is somewhere in the middle that you are likely to get your winning shot.

▶ A low viewpoint, combined with the distortion of his 24mm lens gave *Patrick Thurston* an original shot of the Vienna Boys' Choir.

▼ Planning a group is one thing: getting co-operation is another. *Cartier-Bresson* did not help by stealing the ladies' attention.

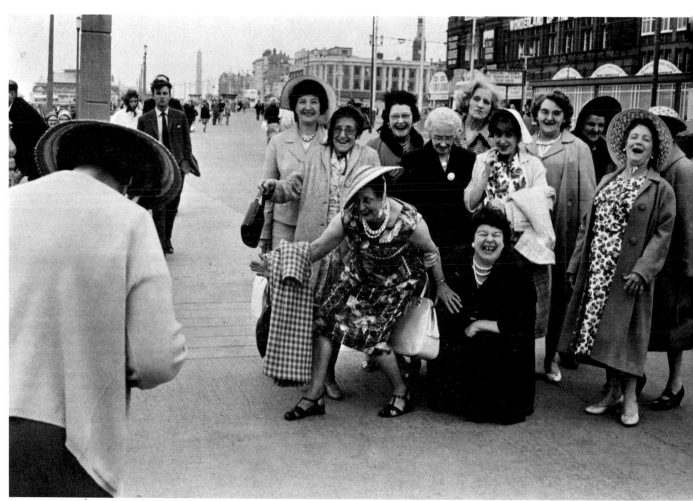

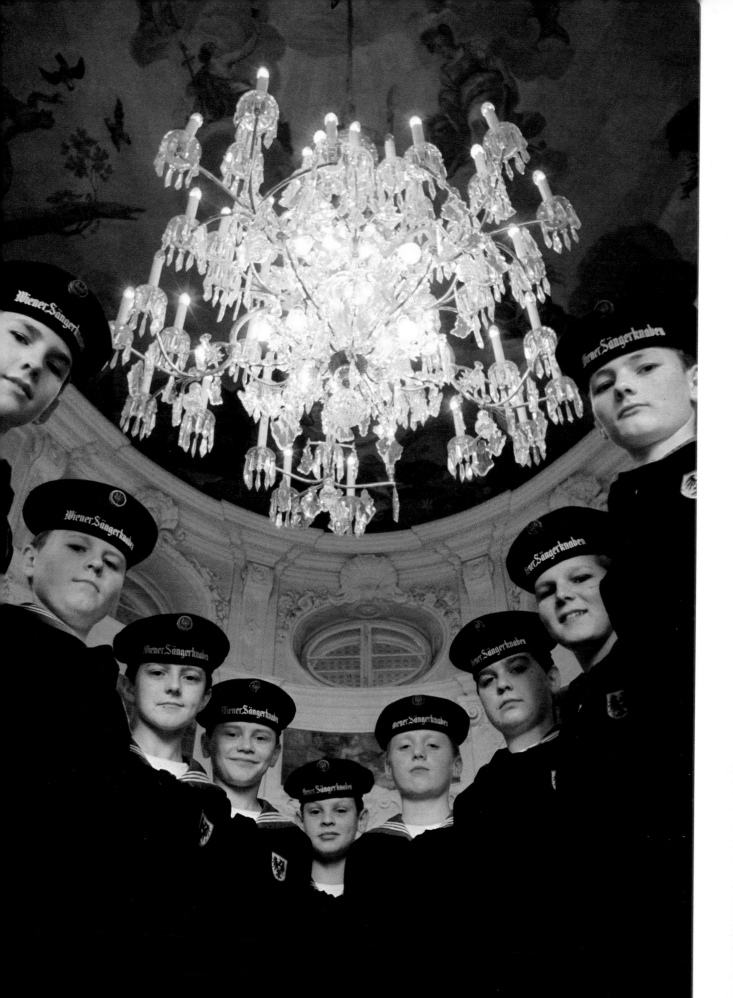

Photographing candid groups

Watching, waiting and then seizing the moment—these are the vital elements of candid group photography. Unaware of the camera, your subjects are caught up in their own affairs and it is up to you to find the best way to capture the event.

Concentrate on the overall composition of the picture rather than on one or two details. Henri Cartier-Bresson went to extraordinary lengths to compose his pictures—sometimes going so far as to look at them upside down.

Desperately camera-shy himself, this enigmatic Frenchman has become the leading figure in 20th century reportage, revered by professionals and amateurs alike. Photography, he once said, is the simultaneous recognition—in a fraction of a second—of the significance of an event. It is also the recognition of a precise organisation of forms which brings that event to life. Detail—individual expressions or movements—sometimes distracted his eye from the overall composition, so from time to time he would fit a reversing prism to the top of his Leica while he watched the form of the picture take shape. You can recognize 'the precise organization of forms' whichever way you look at it.

Composing the picture

Good composition is a principle vital to all aspects of photography. And it is a principle most easily forgotten when it comes to taking candid pictures of

▼ The arrangement of this group happened naturally: it was up to the photographer to see the shapes, select the right viewpoint and the right moment to take the picture. Here *Cartier-Bresson* chose to include the boat which balances the family group.

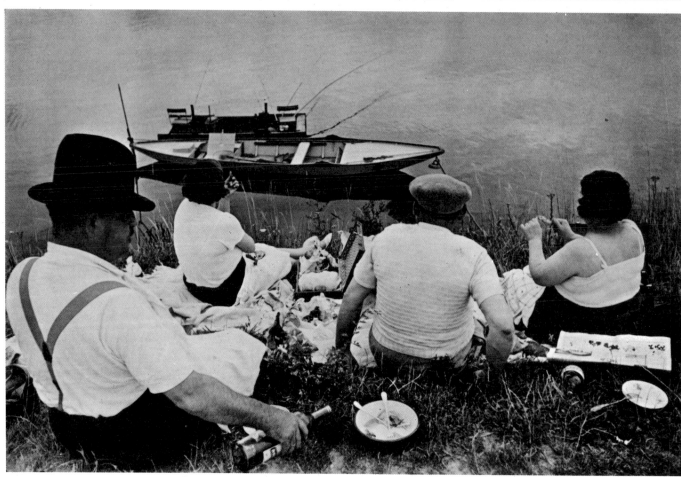

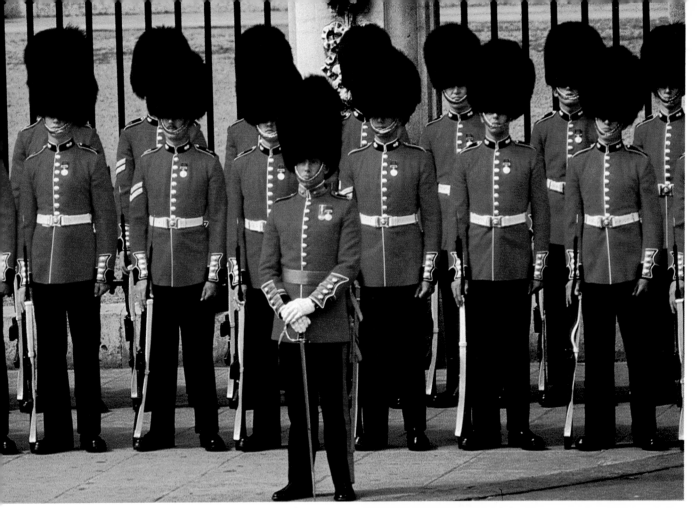

The candid photographer may find patterns organized for him.
▲ Composed of verticals, this picture's strong feature is nevertheless the horizontal band of red, barely broken by a lone, off-centre figure. *Homer Sykes* used an 80–200mm zoom.
► Viewpoint alters shape. This regular column of Yemeni boy soldiers has a strong V-shape— picked out by the uniform waistbands—viewed from high up and to the side. Keeping a distance, *John Bulmer* used a 180mm lens.

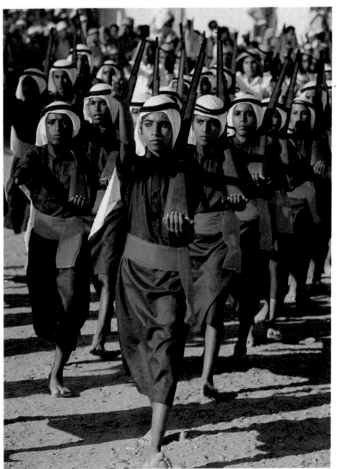

people—especially when there is a group of people. With planned groups there is more time to look critically at what's going on. Candid group photography requires the simultaneous recognition, in that fraction of a second. Cartier-Bresson did not learn his skills overnight. The eye of a photographer needs training. You can start by looking at the photographs of other experienced photographers, and at paintings. Where you find the photographer or artist has created a good overall composition, analyse for yourself what elements of the picture make the composition strong—converging lines, repeated shapes, juxtaposition of elements, and things of this kind.

One of the first things you will notice is the way a composition changes radically as you raise or lower your angle of view. By going above eye level you gain a viewpoint on people at the back of the group and a greater scope for composition. Conversely, a low angle can be especially useful if you want to emphasize the dominance of figures in the foreground.

The best angle

If the people in the group have some clear relationship to one another, find the angle that shows it best. And keep thinking ahead so that you are ready

▼ *John Bulmer* photographed this moment of intense concentration from within the group: his 24mm lens exaggerates the diagonals which all converge on the board.

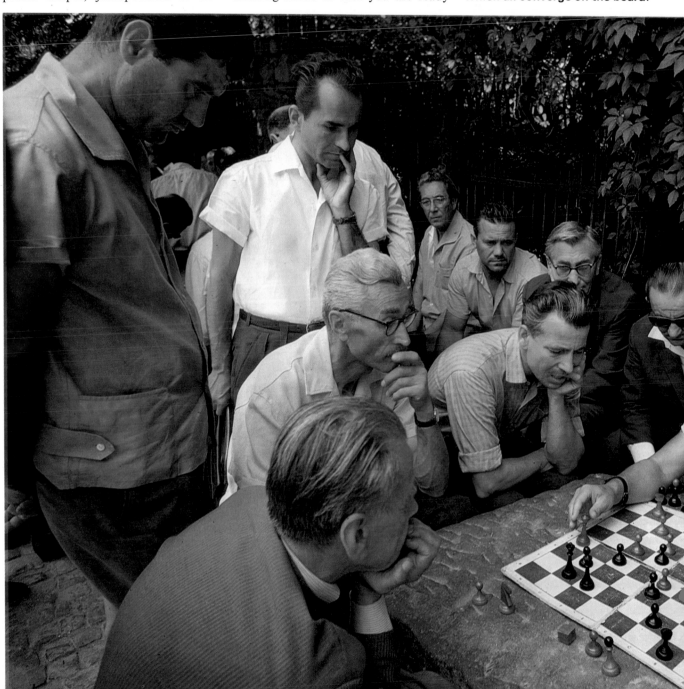

▶ Only with a combination of luck, patience and a well-trained eye can the candid photographer hope to capture bizarre juxtapositions like *Martin Parr's* divided congregation. Cutting the picture in half, though this breaks a rule of composition, gives the two groups equal prominence.

▼ A horizontal format gives the vertical spears more emphasis, drawing attention to the height of these Masai warriors, and the patches of bright colour help to pick out the group from its surroundings. *Peter Carmichael*

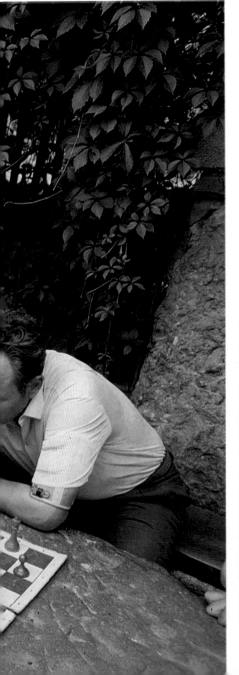

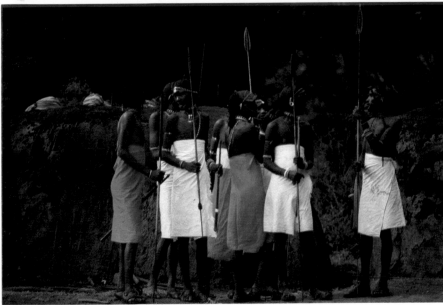

for that precise moment when a certain juxtaposition or interaction gives the picture added interest. Be on the look-out too for unconscious humour in the groups you choose—a bikini-clad girl talking to a group of well-covered nuns, a bald-headed man amongst a crowd of long-haired youngsters, or any odd, poignant juxtaposition.

Equipment

A telephoto lens with its concertina effect will emphasize crowding—commuters at a bus stop or on the station platform, or demonstrators on the march—and at the other extreme a wide angle lens can be used to give the viewer the feeling of being right there, in the middle of the crowd.

With smaller groups be selective about the number of people you include in the picture. Choose your distance and your lens to exclude people who don't contribute to the picture. For instance, if there are three people talking and one slightly separated from the group, it will be up to you to decide—by the way you frame the picture—whether

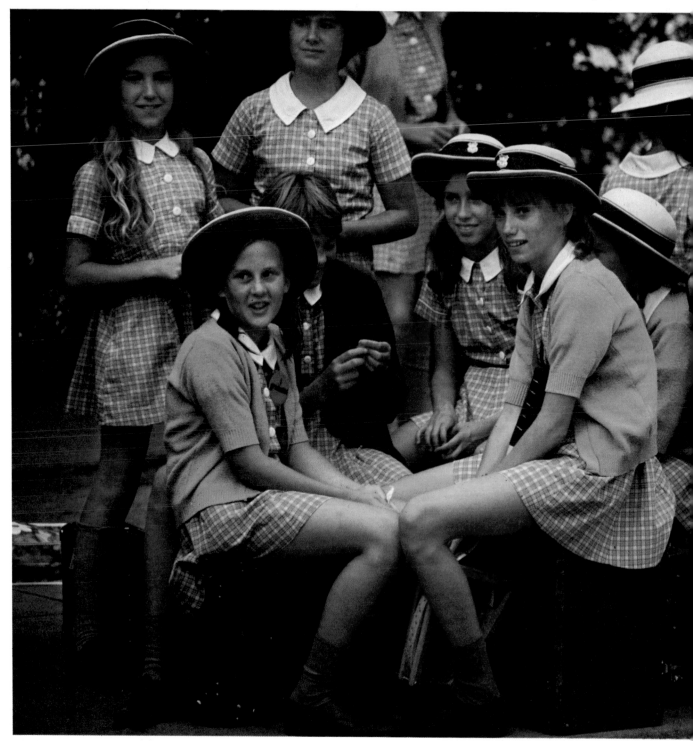

to photograph three friends or three friends and an outsider.
Remember that the perfect grouping, once missed, seldom repeats itself. All the more reason to prepare all you can in advance. Load your camera with a comparatively fast film which will give you plenty of exposure latitude. Take account of the light before you start

shooting—you will have your time cut out concentrating on what you see in the viewfinder so set your aperture at the start and wind on your film after each shot, ready for the next.
Last, but not least, be bold. There is no law against taking photographs of people as you find them. Some people will object, of course, and you will

probably feel content to respect their wishes. But in the majority of cases, either your subjects will not be aware of your presence or they will be flattered to be chosen. More often than not, they will start playing to the camera and that can spoil the spontaneity of the situation. So try to get in one or two shots before you are noticed.

◀ People tend to form cohesive groups naturally. The schoolgirls on the edge of this group are all turned in towards the central oval formed by the seated girls. The uniform colours throw the angles of arms and legs into relief.
Thomas Hopker

▲ With his depth of field limited by a 180mm lens, the photographer focused on the figures facing him and used the foreground as a frame.

▼ Taking cover from a downpour, this random group is unified by a strong red background. *John Garrett*

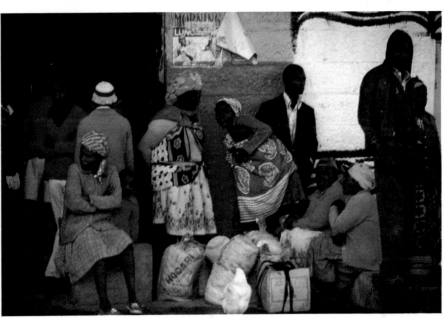

Parades and processions

Parades combine the pleasures of photographing people, movement and colour with the problems of working in a crowd.

They vary from the pomp and formality of a state or royal procession to the free confusion of a local carnival. A parade's formality will determine how close the photographer can get to it. But large crowds are always a problem. You need to be quick thinking, adaptable and aware of everything that is going on to make the most of a parade. Be well organized to select moments and details from the whole, moving procession. Prefocus where possible and set the exposure in advance.

Planning a viewpoint

Unfortunately, most processions and parades are formal. The crowd is restricted to the roadside along the route. This means the photographer will be some distance from the subject, fixed to one viewpoint and pinned in a crowd. In these cases it is best to pre-plan a view point by obtaining a map of the route from the organisers, or from newspapers. Arrive early to obtain the position; it will be difficult to reach later. Ideally, several vantage points are needed to cover a parade. One to photograph the whole subject, another to take separate floats and participants, plus the freedom to move around.

The chance to change viewpoints is rarely possible except, perhaps, with local carnivals. If you have to choose a single viewpoint, choose one that will provide a variety of photographs.

High up in a building or on a bridge overlooking the route has the advantage of being above the crowd. It should be easy to photograph the whole or parts of the approaching parade from this bird's-eye view.

It is also possible to use a tripod away from the crowd. This will allow longer lenses to be chosen. Shoot before the parade becomes too close and people's heads get in the way.

Among the crowd the best viewpoint is

▼ Crowds make it hard to shoot parades. They jostle the camera and get in the way. Choose a position to work from and get to it before the parade starts. High viewpoints make it possible to leave crowds out of the picture. *Patrick Thurston* emphasized the formality of Trooping the Colour by showing only the ranks of guardsmen.

▲ Shoot from the outside of a bend in the road to see what is coming and so anticipate reactions. Work quickly. Use a 135mm or 85mm lens for portraits to throw confusing backgrounds out of focus. *Graeme Harris*

▼ Some carnivals are so informal that it is possible to join in, but use a wide angle lens if you do. This will enable you to work at close distances, with enough depth of field to avoid focusing problems. *Anthony Blake*

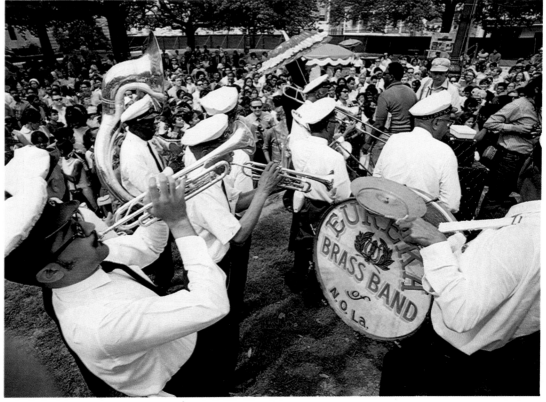

on an outside curve of the road. This spot will offer several directions in which to shoot. An added bonus is that the parade has to slow down on a bend. Some formal processions, especially State occasions, return along the same route. It is often worth waiting for this. The crowd will have thinned out leaving the photographer some room to move. Hold the camera above your head if it is impossible to see over the crowd. If the camera has a waist-level viewfinder, hold it upside down and compose the picture on the screen. However, most SLR cameras will just have to be pointed downwards slightly and the shutter released when something interesting passes.

Guess the focus. Use a standard or wide angle lens at an aperture of f8 or smaller. At best this is a hit and miss method. It may save an otherwise missed opportunity but more likely it will waste film. If you have a really strong camera case, stand on it instead.

An unhampered view can be had at the finish of a parade when the floats and participants have to wait around. Use the freedom to move among them. Do not be too shy to approach someone who looks interesting. People are usually flattered to pose if asked.

A lens of 15mm is ideal for this kind of portraiture. Its shallow depth of field will separate a face from a distracting background. A medium focal length lens is also useful for candid shots.

Take advantage of stationary floats to take pictures of details not visible, or impossible to photograph, when the parade is moving.

Technique

Focus on a point (it may be a crack in the road) which the parade must pass. Take an exposure reading and you are ready and waiting for something really interesting to appear.

Parades move faster than they appear to. Don't take repetitive pictures in an attempt not to miss anything. Look at the people and their transport as well as the parade as a whole.

Take every opportunity to vary composition and subject. Impact can be added by kneeling down (if there is room) and shooting when the subject is nearly on top of the camera. Always be ready for the unexpected. A clown greeting the crowd, for example, can

▲ Look at the people on each float as well as at the whole display. Vary your approach when the parade moves too fast to do this. Look for faces on the first six floats, look for colour or detail on a few more and then take in the next half dozen. *David Simson*

▶ Use simple backgrounds. The trees here make the girls stand out and seem to suit their costumes. *David Simson*

provide a much needed close-up. Exposures as slow as 1/60 are not a problem. When the parade is moving towards the camera very little movement will record as blur. As it passes at right angles more movement will be blurred. Pan the camera as the subject passes and the background will be blurred instead. Beware being jostled; this will cause camera shake.

Having spent a great deal of effort avoiding the crowd don't forget to take pictures of it. The excitement of the occasion will show in people's faces.

Equipment and film

A 35mm SLR is ideal, preferably with through-the-lens (TTL) metering.

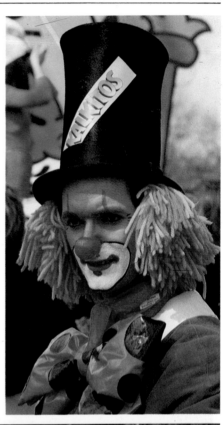

▲ Pictures taken away from the centre of the crowd's attention add variety. Look around for excited expressions or colourful groups, like these Chelsea Pensioners, when there is a gap or lull in the procession. *Brian Seed*

▶ Ask interesting people to pose if it is impossible to get the candid pictures you want. Anyone prepared to dress up and take part in a parade is most unlikely to refuse to have their picture taken. *Alison Foster*

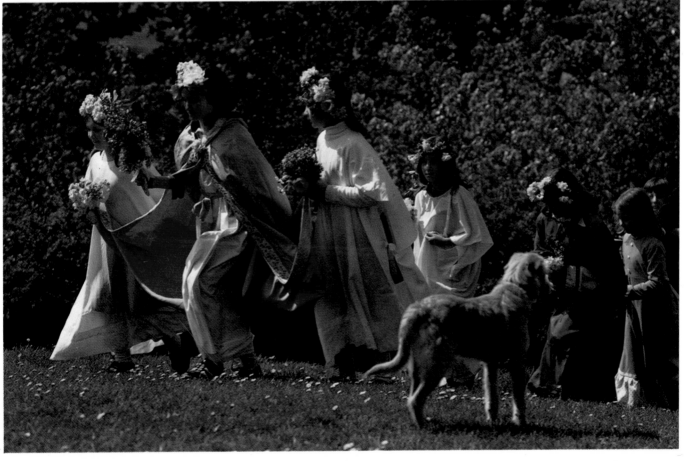

A standard lens and a medium tele-photo will cover most situations. A 70-200mm zoom could replace both.

A wide-angle lens might be more use than a standard lens at a local carnival. The photographer can become very involved in these informal events.

If the weather is fine, 64 ASA film is suitable. But parades are held in all weathers and at all times of day. Choose a 200 ASA or 400 ASA film when photographing at dusk or by the parade's lights. Be prepared to push a film to 800 ASA or 1600 ASA at night.

In dull weather a fast film has two uses. It allows exposures to be kept short and it gives the choice of using a smaller aperture for greater depth of field. In black and white, choose a medium speed film. This gives the biggest choice of apertures and allows high speeds to freeze the action.

Equipment safety

Keep equipment to the bare essentials to avoid losing bits and pieces in the crowd. This can happen accidentally—it may be impossible to retrieve a dropped lens cap, for example. Also, the crowds at parades and carnivals are attractive to pick-pockets and other thieves.

Therefore, do not carry your equipment in a shoulder bag, which is vulnerable when you need both hands to operate the camera. Keep your camera round your neck on a secure strap. Keep any extra lenses and spare films inside fastened pockets. For this reason 'combat' style jackets are to be much preferred to tailored or suit jackets. Do not carry more money or other valu-ables than you absolutely need. Also, it is wise to have all your camera equip-ment insured.

In the vast majority of cases these pre-cautions will not be needed,but it is better to be safe than sorry. Nothing takes the fun out of a carnival as quickly as discovering that your favourite lens has been 'liberated'.

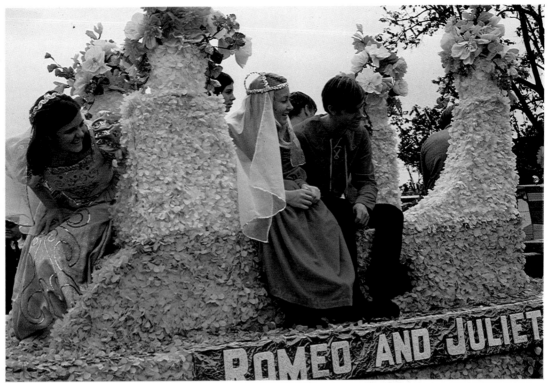

▲ People on floats tend to pass by with a glazed smile. Always keep the correct exposure set and make it easier to capture a natural expression. It will also help to pre-focus on a spot the parade must pass over. *Brian Seed*

▼ A camera with a waist level finder can be held above your head to raise the viewpoint. Windows, multi-storey car parks, steps or even a sturdy gadget case can be used to increase your height. *K D Fröhlich*

▲ Exposures as slow as 1/60 should not show blur in a parade moving steadily towards the camera. A panning motion at 1/60 as the parade passes will blur the background and keep the subject sharp. The small boys were taken at 1/15. The mixture of blur and camera shake looks exciting if used sparingly. *Douglas and Lena Villiers*

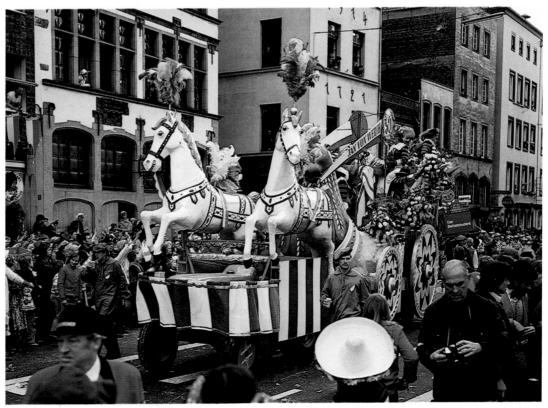

Parties and celebrations

'Always have your camera handy, ready for the moment when a hot-air balloon has to make a landing in the shoppers' car-park or an eccentric on a penny-farthing joins in the rush hour scramble.' Good advice—often repeated in books and magazines about photography—but sometimes difficult for the amateur to follow. The weekly shopping basket is heavy enough without adding an SLR camera with a long telephoto to the burden, and few commuters want to think about focus and exposures on their journey to work. Holidays are often the only time when the enthusiastic amateur and his camera can become inseparable, particularly holidays at home where all the equipment—cumbersome tripods and flash units—is readily to hand and there is no risk that a camera left lying

▲ *John Garrett* hung black velvet behind the Christmas tree to separate it from the party clutter about it. He shone some tungsten light on the tree and bracketed his exposures.

▲ Next *John Garrett* experimented with a star filter, again bracketing his exposures. With 400 ASA film, an exposure of 1/8 at f5·6 would show the lights but little foliage detail.

◀ A panning movement at 1/15 blurred the kitchen and flames from the pudding. Bounced flash froze the woman and her expression while lighting the right of the picture which was in the dark. Both flash and window light were under-exposed by one stop. A 35mm lens was used for its wide view and depth of field. *Richard and Sally Greenhill*

Time to experiment

Even for those photographers experienced enough to be able to handle their camera with speed and efficiency, it is still worth looking through last year's family pictures to see how to improve on competent shots. Most pictures can have their content or composition improved with a little thought.

▼ Jokes like this are not usually spontaneous, they have to be seen and posed. *Charles Harbutt* lit the scene with electronic flash using daylight film. The film is compatible with the flash but not with the candlelight. The lower colour temperature of the candlelight enhances the warm colour of the pumpkin.

open on a table might suddenly disappear. But even then it is possible to miss the high points of an event.

Take a look at last year's Christmas pictures, for example: did you have your camera upstairs on Christmas morning ready to catch the expressions on your children's faces when they opened their stockings? Have you got a shot of the carol singers who suddenly arrived at your door? Was your camera ready in time to record the moment of joy when the new bicycle was unveiled or did you have to make do with a more self-conscious 'thank you' a moment later? And even if you did manage to release the shutter at the right moment, are you entirely happy with the focus and exposures that had to be worked out in haste?

Keep your camera ready

For candid shots, you can save precious moments of fiddling with equipment by setting the camera beforehand. Many of your photographs of family festivities will be indoors, so load the camera with a fast film for available light photography (400 ASA colour negative or transparency film) and keep your flash gun fixed to the camera for when you need to boost available light. By day you can work out a likely exposure for the available light, and when it gets dark, set your controls for flash. If you have an automatic flash unit, keep it preset for the most probable range of distances you will be shooting at—indoors about 2 to 3 metres—and set your lens to the appropriate stop. You can even keep your lens focused at roughly the right distance to save a couple of seconds when you take your picture. Then with the film wound on, ready for the next picture, leave the camera in an accessible place where it will be safe but easy to get at in a hurry.

The best lens to choose for photographing parties at home is a slightly wide angle lens—35mm or 28mm on a 35mm SLR camera. The wider field of vision is useful when you are unable to stand far back from your subjects. The depth of field aids quick focusing.

Indoor shots with flash—where you control the lighting—give a great deal of room for variety and experiment. With an extension lead you can use your flash off the camera and eliminate the mask-like faces that result from direct frontal lighting which throws no visible shadows, and also avoid the risk of unnatural red eyes staring from the picture. Even with the flash fixed to the camera, you can still vary the lighting by bouncing the light from a side wall or the ceiling, or failing that from a special reflector—a large piece of white paper, or even a white sheet. This gives softer shadows and a more flattering light for pictures of people.

You may prefer to photograph by available light wherever possible, but don't forget the opportunities that flash gives you subtly to improve on the lighting. Weak fill-in flash used well need not detract from the more 'documentary' effect of available light shots: for a shot of a group of faces with a window behind, for example, use the camera setting suggested by your TTL meter, and supplement this with a flash calculated to under-expose the subjects by two stops. This gives you detail on the faces without killing the effect of natural light.

As well as experimenting with the direction and strength of your flash, you can also try altering the colour of the light with filters, or by bouncing it off a cream or pale pink reflector for a warmer effect, but remember to take into account that a coloured surface will not reflect as much light, so unless you have an automatic flash gun, set it to over-expose the subject slightly. Try a few exposures for these shots, as it is difficult to predict how much light will reflect from any particular surface.

Special lighting

Photographing a festive table by candlelight or a Christmas tree with fairy lights reflected in tinsel decorations are challenging lighting problems. On daylight film, candlelight and artificial light have a warm orange appearance, and throw a warm light on the faces they illuminate. Much of the time this is perfectly satisfactory and merely adds to the atmosphere, but it can look strange when mixed with colder lighting such as daylight or flash. For photography by low available light you will probably need a tripod unless you can afford to sacrifice depth of field and open the lens very wide. Do not be afraid of working with your lens at its full aperture, but

focus carefully. With 400 ASA film a typical exposure for fairy lights on a tree—showing the lights, but little detail of the tree—would be 1/8 at f5·6. A face lit solely by a candle, about half a metre away, gives an exposure of about 1/30 at f4, but it is always worth bracketing your shots to allow for any other reflected or ambient light.

Resorting to direct flash for candlelit

scenes will 'kill' the candlelight, though if you can reduce the power of the flash to an absolute minimum—by pointing an automatic flash gun directly at a white ceiling at close range, for example—you may strike a lucky balance between the candles and the fill-in flash.

The highlight of a celebration dinner is often the moment when all the lights are switched off and the flaming plum

▲ **Exposing for the snow, 1/30 at f5.6 on 400 ASA film, will let the tree light register and leave the sparkler glowing.** *Monique Jacot*

◄ **Fast films like Ektachrome 400 are essential for working in low light. Expose for the skin tones in the face The background exposure, which gives atmosphere, is less important.** *Adam Woolfit*

▶ *John Garrett* **took a reading off the cakes with candles before exposing tungsten film. The warm candle glow surrounded by the cold blue of window light adds to the intimate sense of the occasion.**

pudding is brought in or the host does his party piece with crêpes Suzettes. Burning alcohol gives off a weak blue flame which appears naturally as blue on daylight colour film. With the artificial lights switched off and perhaps a few candles burning to light the table, an exposure of 1/15 at f2 will show the ghostly blue flames.

Grouping your subjects

A dinner table is an excellent place to photograph family and friends, particularly if it has been carefully decor-
ated for a special festive occasion. It helps the photographer by keeping all the subjects together in roughly the same positions so that he can experiment with various camera angles and lighting effects, and it also helps the subjects who are too well occupied with the meal to become bored or self-conscious. A wide angle lens allows you to include the whole table at a manageable distance and by climbing on to a chair you may be able to raise your viewpoint so that none of the group is masked by another, or by a
large centrepiece. If you have a tripod, choose a good camera angle and use the delayed action release so that you can include yourself in the picture while you rejoin the festivities.

As well as the highlights of an occasion the portrait photographer can use the time when the family is relaxing to experiment with more thought-out, less instantaneous shots. Engrossed in their new toys, the children are less likely to notice you as you watch the way they have grouped themselves in your view-finder. An armchair or a sofa make ideal focal points around which a group forms quite naturally. Even without looking through the view-finder, you may like to spend some time just seeing your family in terms of interesting groups. Simply by record-ing the moment when two figures are leaning slightly apart your picture can suggest a relationship between the two instead of merely showing two separate individuals.

One way the family photographer can get completely unaware pictures of the household relaxing after a day of festivities is to draw open the curtains and take himself and his camera out-side for some shots through the window. If, at Christmas time, there is snow on the window-ledge the warm effect of the artificial light indoors will make a chilly contrast with the cold outside—and perhaps provide the ideal picture for next year's personalized Christmas card.

Pictures of a wedding

For the amateur photographer, an invitation to a wedding is a perfect opportunity to practise taking pictures of people. There are the candid shots of anxious faces before the event; the ceremonial views of the procession; formal portraits of bride and groom, family and guests all looking their best; and group pictures which become more and more informal as festivities continue. And what better wedding present for the bride and groom to supplement the professional's pictures.

For many couples, their wedding is the occasion of a lifetime, so an amateur should never attempt to take the official photographic record unless he is absolutely certain that he can cope with ease and that his pictures will come out well. However strongly the couple may try to persuade you, resist them unless you are completely confident of your results: it is always better to play safe for such an unrepeatable occasion, and employ a professional photographer—at least for the wedding ceremony itself. Relieved of the full responsibility, you can take along your camera and go for the less formal shots he may not have time for, or the pictures that may only happen amongst family and friends. But never get in the way of the professional: you may ruin both his and your own photographs and the bride will not thank you for that.

While it is sensible to keep your camera handy at all times, ready for the unexpected opportunity, there are particular moments during the ceremony and the reception that lend themselves to specific types of photography.

Bride at home
Before the bride leaves for the church ask her to give you 10 minutes for informal portraits and full-length shots at home or in the garden. The backgrounds will be far more personal than at the church or hall. She might also have her bridesmaids with her and be able to pose with father, mother and other relations. Only attempt this if you are already quick and efficient at handling your camera and flash. There will not be time for endless meter readings and fumbling.

In the church
As a guest you will probably go into the church before the bride arrives. Try to station yourself on the centre aisle, near the back. Strictly, you should ask the vicar's permission to take pictures in the church but most vicars do not mind a discreet picture taken from the back, without flash and during a hymn, to cover the noise of the shutter. With fast colour film, it is usually possible to get good results at about 1/30 at f2 on a dull day in a dark church, and up to about 1/30 at f5·6 in a bright church. If the ceremony is taking place in a registry office, you will probably be unable to use your camera unless the official photographer has posed some shots and allows you to photograph his set-ups.

After the ceremony
The professional photographer will usually set up and shoot his groups at or near the church door. For the amateur it is best to slip out of the church while the couple are signing the register. Place yourself well to one side of the professional and shoot the groups he arranges at an angle. While he is working, you can turn your lens on to the guests coming out of the church and be watching the proceedings. This will give you some ready-made, informal groups of the guests, close together and all looking the same way. When there is a long path to the cars, take the opportunity for some action shots using a fast shutter speed.

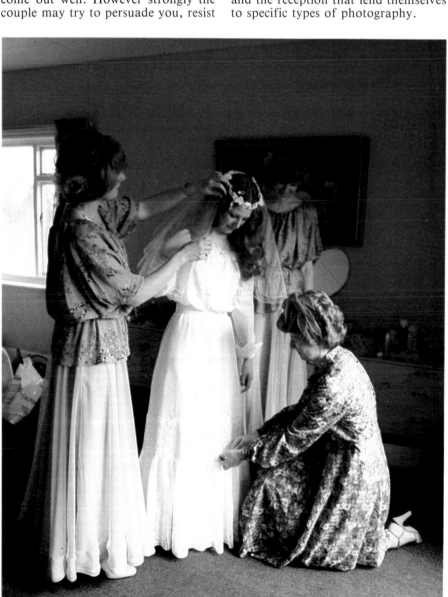

◄ Before a wedding, the photographer must remain in the background, quietly on the look-out for candid shots of the hectic preparations. *Derek Bayes* chose light from a low window rather than obtrusive flash, exposing for 1/60 at f2·8.

◀ Photographing inside the church by available light can be tricky, but may give some interesting effects. Though the lighting here comes from behind the children, enough is reflected from their white clothes to light the middle bridesmaid's face. With a combination of good framing and good luck—her awed expression as she glanced at the camera— *Tom Hustler* catches the mood of the occasion.

▼ Mixed light in a church gives daylight film a warm, orange cast but this is more acceptable than the cold blue of window light on tungsten balanced film. *Derek Bayes* used Ektachrome 200 at 1/30 and f2·5, shooting from the organist's gallery with a 105mm lens.

▼ Keep an eye on what the official photographer is doing: the amateur can both take advantage of the formal groups he arranges and include him in less formal, atmosphere shots. *Adam Woolfitt* watched over the photographer's shoulder as he set up the shot with a fill-in flash, choosing the moment before the flash for his own exposure. With Kodachrome 25 film, he set an aperture of f5·6 at 1/125.

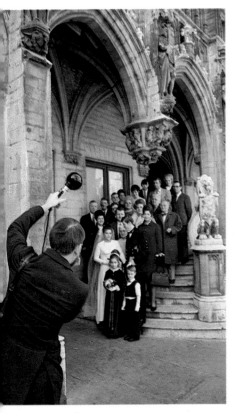

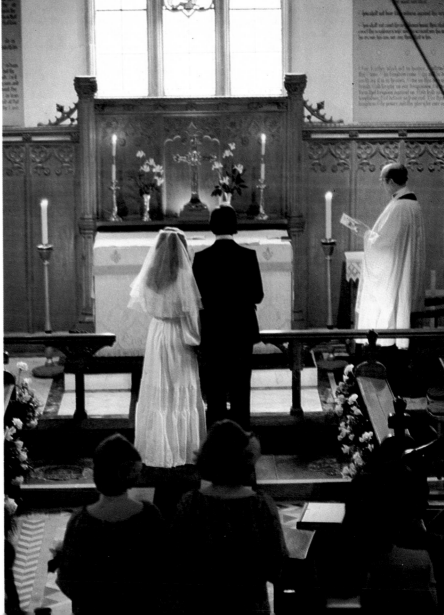

At the reception

Get back to the reception quickly to be first in and to avoid the queue. Keep an eye open for good candid pictures of the couple receiving their guests, but this period can also be used to take the bridesmaids and pages aside (photograph brothers and sisters together, even if one is not an attendant) and find a plain background indoors or a green hedge or bush outdoors to shoot some semi-posed full-lengths and close-ups. Next, try to organize some more candid pictures of the younger ones eating, playing hide-and-seek round a tree, or just holding hands. On sunny days, shoot into the sun, taking a reading on the shadow side, and always use a lens hood. Only use flash fill-in if absolutely necessary when the contrast is very high. Set an automatic flash gun for a film twice as fast as the one you are using. There is usually a pause after the couple have received their guests and before the meal or main reception. This is the time to ask the bride to pose for a few special pictures, with and (if you have not previously taken pictures at her home) without her husband.

You should have chosen your locations, whether in or out of doors, and already worked out the ideas and poses you are going to try and the exposures and equipment you want to use so that you can lead them straight to the spot and start shooting without wasting time. Try for some romantic shots—kissing, touching champagne glasses, looking at the bouquet, or at each other, profiles in semi-silhouette. You will get maximum co-operation if you are quick and efficient.

Cake cutting and speeches

If the professional is to cover the reception he will probably have done a mock cake cutting as soon as the couple returned from the ceremony, so the way will be clear for you when it actually takes place. You might be able to ask the toastmaster or best man to pose them for a picture holding the knife and looking at you before they actually cut the cake when their faces may be hidden. Speech makers are worth a few pictures, and keep an eye open for the reactions of the couple to the traditionally suggestive remarks of the proposer or the best man. During the speeches, position yourself behind and to one side of the couple and try to photograph as many of the guests as you can. You might find it useful to change to a wide angle lens for this. If

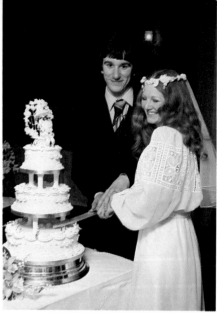

▶ Flash-on-camera gives a bland, overall light which flattens detail especially on white dresses and on cakes. Either hold the flash away from the camera or bounce it from a reflecting surface. Here the photographer used electronic flash bounced from an umbrella.

▼ Look for original shots to liven up conventional wedding pictures. *Michael Boys* blocked reflections from outside with his own shadow for a clear view of the bridesmaid.

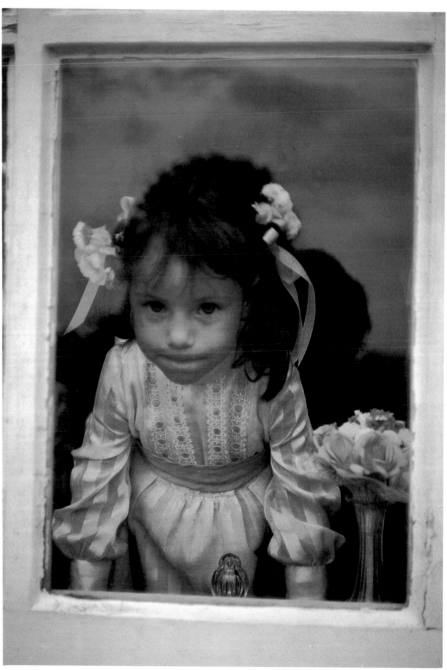

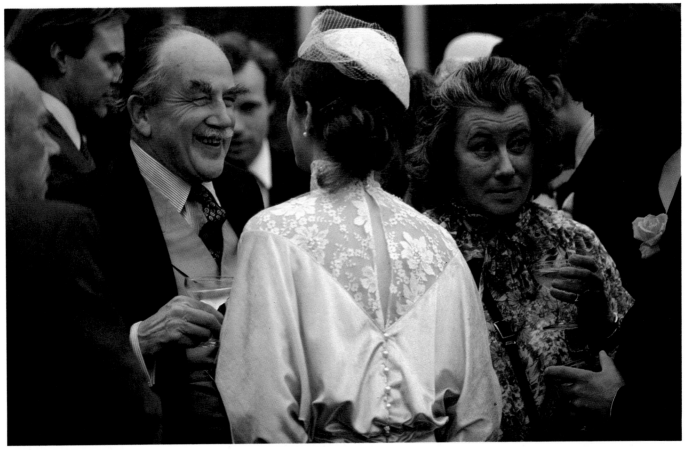

▲ Reception shots become more candid as guests relax. For a bride's eye view, *John Sims* used a long lens to fill the frame with faces.

▼ As hilarity takes over, be ready for the unexpected. *Archie Miles* set his shutter at 1/250 and released it with the groom in mid-air.

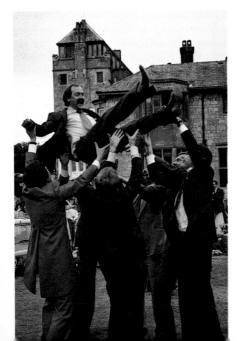

you cannot get enough in from eye level, try holding the camera and flash above your head and pointing it down slightly. This will give you many more faces at the back.

The going-away

This is a great time for candid pictures: the run down the line of guests, confetti, rice, kisses all round, the decorated car, the kiss in the back seat, throwing the bouquet, tears, and everybody waving goodbye. The professional rarely waits for it so make sure you are there.

Camera and equipment

It is essential to have a camera which you know how to use quickly and efficiently. Never buy a new camera to shoot pictures at a special event without taking several experimental reels of film and seeing the results first. It is also fatal to borrow someone else's camera for this sort of occasion.

Colour negative or slide film of medium speed is the best all-round film (64-100 ASA). 400 ASA film is very useful for low light shots in a church or out of doors on a dark or rainy day, but it is too contrasty to use in bright

sunlight. It is also useful with an accurate electronic flash for far-away groups indoors and out.

You should always buy the best flash gun you can afford: automatic exposure models with a thyristor for quick recycling times are the best. They should be fitted on a bracket to the side of the camera rather than in the hot shoe. This helps to avoid the 'red eye' effect and gives slightly better modelling to faces. Many flash guns can be attached to the camera with an extra 1-metre extension, so the head can be held away from the camera to drop the shadow behind the subject and give even better lighting—but this technique needs lots of practice to avoid the flash pointing one way and the camera another!

Along with equipment, the photographer needs a fair amount of experience and technique to cover a wedding thoroughly. He will also need to expose a lot of film but, for an important family event, that is money well spent. You will probably want to give a set of pictures to the couple as a present, but don't be afraid to charge others a fair price per print to offset your heavy expenses and your time.

The official record

If you have to think twice about taking responsibility for the official wedding photographs, don't do it. If you *are* to take the official pictures, however, remember that they should have priority over any others. Here is a guide to the shots that the bride will expect you to include.

Arrivals

● You should catch the groom arriving with the best man and take another shot or two of the groom on his own, fairly close up.
● Then wait for the bride to arrive with her father.

Bride alone

● A few pictures of the bride posed quietly on her own are an important record. They should be close-up, three-quarter and full length and the veil should not be over her face. Her body should turn away from the camera slightly and her head towards it, with the bouquet 'cheated round' as well, and her arms slightly bent at the elbows. The train, if there is one, should be brought round from the back, but not so far that it looks unnatural. These shots are often taken with soft focus; never confuse soft focus with out-of-focus. Soft focus is the diffusion of an image with a lens set sharp and altered by filters.
● These pictures are best taken before the ceremony, at home or at the church, or afterwards during a quiet period at the reception.

Signing the register

● Vestries can be small and cramped, and relations very emotional, but a quick, posed shot is usually required by the family.
● In a registry office photography may not be allowed during the brief ceremony, but the registrar's clerk is usually willing to help pose a special shot afterwards.
● Depending on the lighting, you should attempt at least one shot of the procession down the aisle.

Groups

● These are best taken at the church (or registry office) door. This is one occasion when you might find a tripod useful. You will have been able to work out the best position beforehand, and it is sometimes necessary at a very crowded wedding for the official photographer to stake his claim for the best viewpoint.
● Several shots of the couple full length and three-quarter length should be included, looking at the camera.

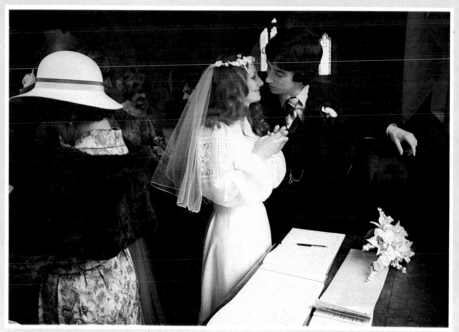

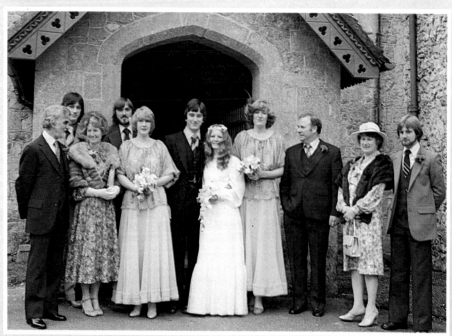

- As the bridesmaids and families begin to appear, take control of the situation straight away. Try to entertain them: you will hold their attention, and produce more natural expressions.
- After the pictures of the bride and groom, ask the best man to stand with the couple next to the bride, then add the bridesmaids and pages, placing them equally each side. A tiny child can go in front of the bride, but be careful not to hide her dress.
- Next bring in the two sets of

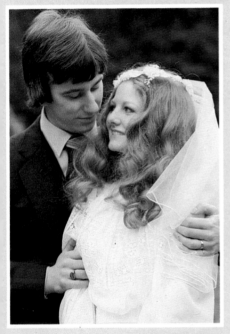

parents, standing next to the couple, with the bride's on her side and the groom's on his, repositioning grown-up bridesmaids on the edges of the group and the children spread out in front to cover the adults' legs, leaving the bride and groom clear in the middle.
- Near relations can be added, but if there are too many it will make a very unwieldy line. You may want to change to a wide angle lens at this point, or organize separate groups of the couple with different sets of relations.

Leaving the ceremony

- Position yourself for some shots of the couple walking to the car together, and getting into it.
- Try for a close-up shot of the couple inside the car. Flash may be very useful here.
- Finally, you should be able to get some good pictures of the guests waving the couple off.

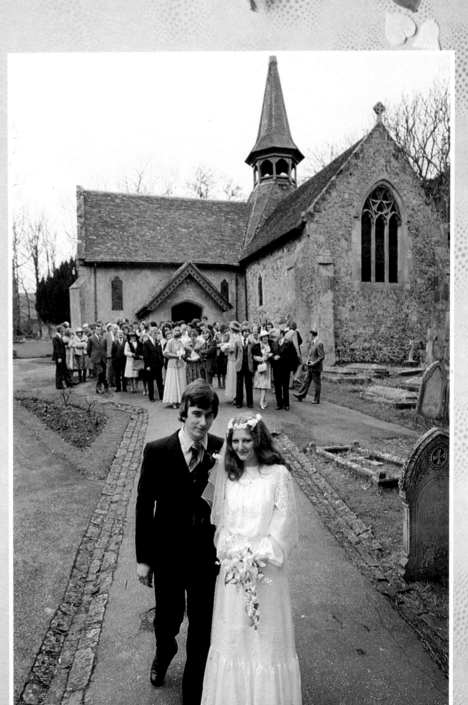

Taking your camera on holiday

A camera has become as essential a part of holiday equipment as suntan oil and paperbacks. Everyone wants to come back with a record of it all on film. But the danger is that the holiday-maker tends to press the button frantically at whatever comes along with no thought for the best way to capture the scene.

Yet holidays are the ideal time to plan pictures. Away from normal daily routine, the photographer has all the time he could want to look, think and record his holiday. The key to turning holiday snaps into good pictures is discipline—in the way you look at, and place your subjects in, your surroundings; in composition, viewpoint and lighting.

Introducing people

Pretty though some narrow village street may be, you will find that your pictures come to life if you include people. Don't be shy about it. Ask the local fishermen or the women talking in a doorway if you can photograph them. They can only say no and may be flattered.

In addition to local colour, you will probably want to take pictures of the people you are on holiday with. As most of us become self-conscious in front of a camera, try to catch them unawares. If that does not work, at least give them something to do, like sipping a drink or biting into a chunk of melon. Children will be at their best building sandcastles or splashing about in the water. Make your pictures tell a story and aim for a complete collection of place and family. Don't forget to include yourself: get someone else to take the occasional shot with you in it.

Viewpoint and lighting

Before you take a photograph, ask yourself two questions. Am I working from the best viewpoint? Is it the best light? Bright sunlight casts heavy shadows, which can be dramatic on buildings, but not on people. Try to avoid harsh midday sun in Mediterranean countries, the result will be pictures with too much contrast and unflattering shadows. Early morning or evening light brings out more delicate colours and long, gentle shadows. Don't be put off by bad weather. Medium-speed film can cope with most bad lighting conditions and the even, diffused light can be most flattering for portraiture.

Composing your picture

Having decided on viewpoint and lighting, give some thought to composing your picture. As your picture frame is not all that big you must make sure that every part is contributing to the whole. Skies can take up more space than anything else, so unless you are making a feature of them—a dramatic sunset, perhaps, or using them to emphasize a feeling of space—keep the amount of sky down to a minimum.

Sometimes your angle of view will leave you with an area of sky you cannot get rid of, resulting in a small image of a person overwhelmed by a large expanse of sky. Try to find some foreground to fill the space such as the bough of a tree. It may be out of focus, but that doesn't matter. Look out, too, for other frames —an arch or a gap between rocks are all useful. Not only do they give a picture shape, they also add depth.

▶ **Right: look for ways to photograph people so they aren't staring into the sun. Here, water reflects light on to the face and required an off-the-face meter reading.** *Michael Boys*

▶ **Far right: here the bright light breaking through storm clouds throws up the shapes of the people clearly.** *Adam Woolfitt*

▼ **Below left: look for ways to combine colour and silhouette.**

▼ **Below right: this is a simple and very effective picture of a market stall-holder. The piles of fruit make a strong foreground.**

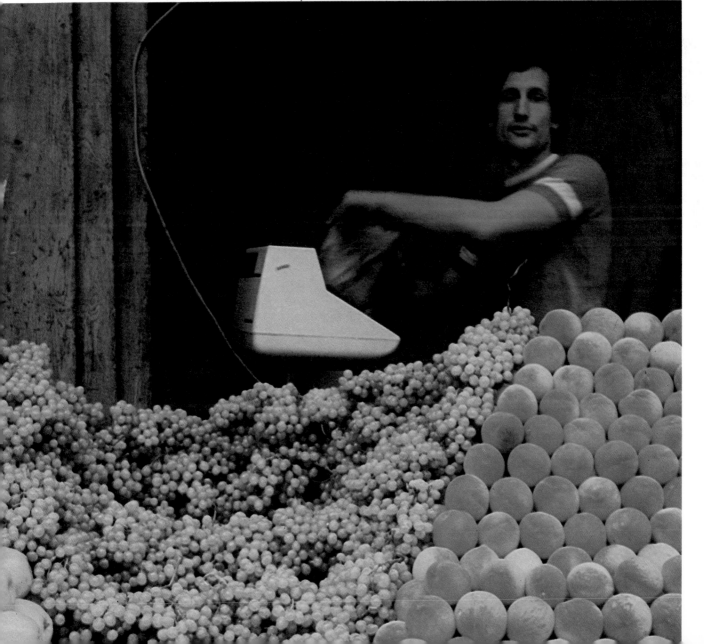

Equipment
Travel light. It will be less restricting in the end. Keep equipment in a tatty holdall rather than a shiny new gadget bag.

Filters. Many photographers keep a skylight filter on the lens all the time. If you are shooting colour, it will reduce haze and the filter will protect your lens. It also helps to keep a lens hood on the camera. There is always the risk that the lens will pick up flare and spoil your picture.

Metering. Harsh lighting can be a very difficult problem in hot countries. If the picture includes both highlights and dense shade choose which is the most important and get as close as possible to take an exposure reading. A hand-held meter is more accurate than a through-the-lens meter in these extreme conditions.

Film. If you are going to a sunny climate, you can afford to take slow-speed film—64 ASA for colour slides, up to 100 ASA for colour prints and up to 125 ASA for black and white. If sunny weather isn't likely or you simply want greater latitude, Ektachrome 200 is a good medium-speed film for colour slides, Kodacolour 400 for prints (it's also balanced for both daylight and artificial light) and any 400 ASA film for black and white.

If you are taking candid shots of people it is unlikely that they will stay still for long and you will need to work quickly. Choose a film of at least 100 ASA to allow a shutter speed of 1/125 or faster. This will avoid camera shake and subject blur.

Lenses. If you are photographing in crowds it is easy to blend into the crowd and remain unnoticed. Details of expression or hand movements can be picked out with a long lens. A 200mm lens is about the longest that can be used in these cramped and crowded conditions. With a 35mm–105mm or 140mm zoom you will be equipped for a wide variety of shots.

Flash. It helps to have a small flash when working indoors or when there is mixed lighting. Use it as a fill in.

Precautions
Before beginning a holiday photographic session, there are a few things to remember. Keep the camera and lens clean and take plenty of film. Keep an extra

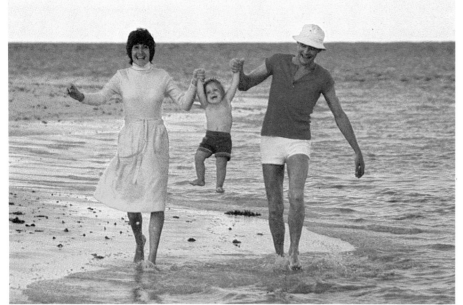

▲ Look for spontaneous moments that capture the spirit of a holiday. Keep your camera set at a fast shutter speed, such as 1/250, so you can be ready for when you need to stop movement. *John Garrett*

◄ Look for unusual viewpoints such as the top of a sea wall or a bridge. Here, the high camera position excludes unwanted detail while the wide-angle lens gives a feeling of immense space. *Roger Jones*

► Look for ways to emphasize the feeling of sun and brilliant light. A simple starburst filter here highlights the glitter of the sun and water. *Michael Busselle*

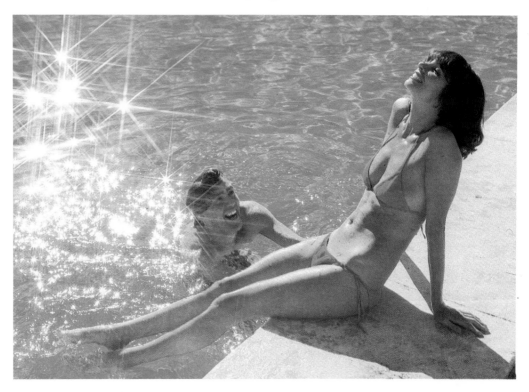

roll of film with you, either in a pouch on your camera strap or in your pocket (not in the glove box of the car). If you are at the beach, protect your camera from sand with a plastic bag sealed at the top with an elastic band and keep well away from sand and salt water which will jam up the mechanisms. If you do drop your camera in sand or salt water, take it to the nearest photographic shop straight away to be looked at. Rain water will not damage your camera so long as you wipe it dry as soon as you can.

Planning ahead

Taking your camera and equipment with you on holiday—particularly if you are going abroad—requires a certain amount of planning. Use the check-list below to remind you of all the things you should do before leaving home.

● **Insurance:** make sure your cameras and equipment are covered by holiday insurance.

● **Customs:** take receipts for your equipment with you in case you need to prove to customs on the way back that you did not buy anything abroad. Keep the receipts separately so that if your equipment is lost or stolen you will have a record of the camera body numbers and lens numbers. If you no longer have your receipts, take a copy of the insurance valuation and check with customs before you leave that this will be sufficient proof that you owned all photographic equipment prior to going away.

● **Security scanners:** some X-ray equipment used for security reasons at airports can damage film. Keep all your film together in your hand luggage and submit it for a visual check.

● **Film:** decide before you go what sort of film to take—and take plenty of it. Film can be expensive abroad, particularly in holiday resorts.

● **Insulated film bags:** heat breaks down film emulsion, so it is important to keep film cool. Take a cooler bag—Kodak makes one especially for the purpose—or take care to keep film in a cool place, such as a refrigerator, both before and after using it.

● **Lens cleaners:** take a blower brush or lens cleaning cloth to make sure your lenses are always clean. Take lens tissues and lens cleaning fluid to clean off fresh-water stains.

● **Notebook:** if you need a reminder of what you have taken photographs of, take a notebook and jot down captions as you go. You can also number each roll of film with self-adhesive freezer labels to help you to keep track.

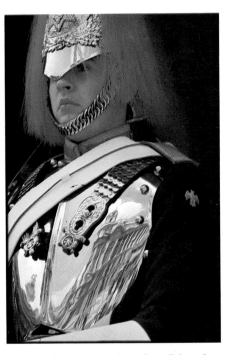

▲ Look for new angles of traditional sights. Here, the photographer catches the reflections of a red double-decker bus in the breastplate of this guardsman.

◀ Look for ways to catch the magic of a place; *John Bulmer* waited until the water was perfectly still to take this mirrored reflection of man, camels and buildings. A 105mm lens keeps the proportions right.

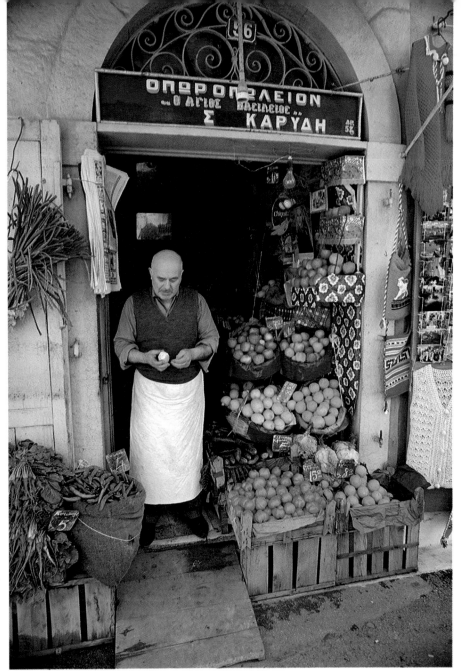

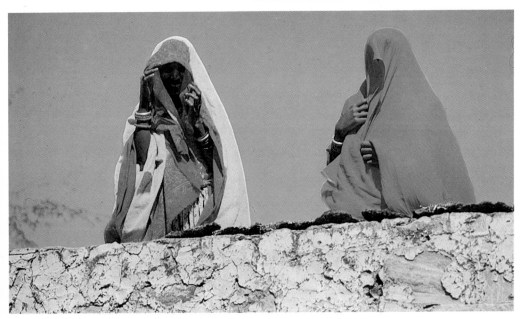

▲ Look for local colour to bring back holiday memories. Here, the combination of the diffused lighting and the slow speed of Kodachrome produces fine detail and rich colouring.
Michael St. Maur Sheil

◀ Look for strong shapes and colours, effects that a simple 110 camera can capture as well as an SLR. A hard blue sky provides a vivid background for the brilliant reds and yellows of the Indian women's clothes. *S. G. Hill*

On the beach

The fun of a sunny day on the beach is more than just a subject for the camera. The relaxed atmosphere is also a source of ideas and better pictures. A sense of well-being makes it easier to find new subjects and different ways of seeing the familiar.

The most basic equipment—from an SLR with one lens to a simple 110 camera—and a little thought, is enough to capture most events on the beach. A standard lens is quite suitable, even for candid pictures. People expect to have their pictures taken on the beach. A short telephoto or a standard lens with a converter is a good alternative choice. The beach will be so brightly lit that a loss of maximum aperture, which happens with a converter, will not be a problem. The ultimate in relaxed photography is a 70-210mm zoom used from a deck chair. Just let the subjects come to you.

Extra lenses and accessories are useful, but keep equipment to a minimum. You are on holiday and do not want to carry a heavy bag around. There is also a danger that sand may scratch lenses or get into equipment. Sea spray can also cause corrosion. Simple precautions will protect against damage like this, but the less equipment there is, the easier it is to protect.

People

People will certainly appear in any series of pictures taken on the beach. They are not likely to be aware of the photographer if they are dozing in the sun or playing energetic games. Crowds are also good places to take candid shots as well as being an easy subject in their own right.

Games or sudden action need fast reactions or a pre-set camera. Set a standard lens at f16 and focused on 3m. Everything from 2m to 7m in front of the camera will be acceptably sharp. Most groups or games should remain within this distance. In bright sunshine on the beach 64 ASA film needs an exposure of 1/125 at f16.

Children's games are easier to follow than adult games because they are more predictable. Grown ups play over a larger area. Children are more active but their games tend to be about one or two points.

Portraits of the lifeguards, ice-cream salesmen, sea-food vendors and local characters who come onto the beach are there for the taking. They provide an ideal opportunity to build confidence in asking strangers to pose. You will be feeling relaxed which will encourage

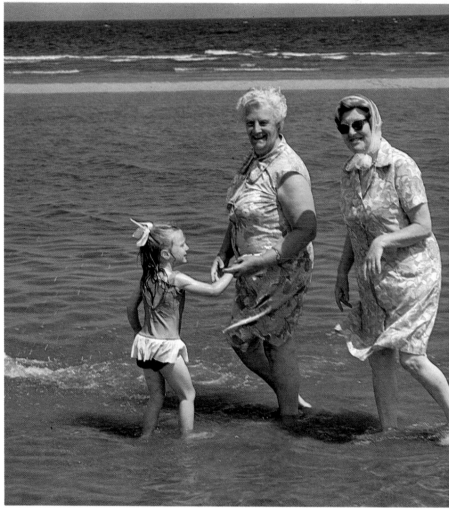

◀ **Take advantage of the time available on the beach to look for new ways to photograph a holiday.** *Alfred Gregory*

▶ **Sand reflects so much that it is easy to over-expose. Incident readings are the most reliable way to measure exposures. Expect readings to be perhaps a stop less than inland. Reflected light also fills in shadows—helpful on a sunny day but subject modelling may be poor if the sky is overcast.** *Robin Bath*

▼ **Exclude backgrounds of sea or sand from exposure readings. Point the meter at your own skin if the subject is too far away.** *Patrick Thurston*

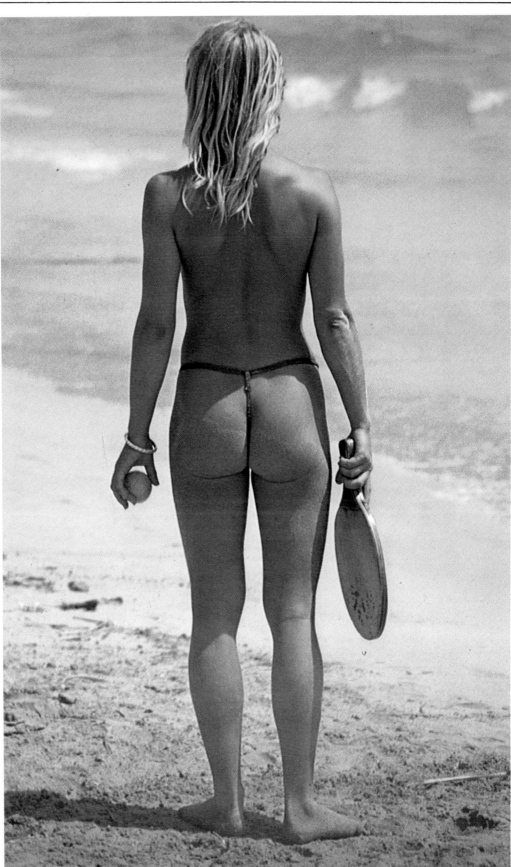

the subject. And it is in the local people's interest to keep the holiday maker happy. Just off the beach there are fairground attendants, stall keepers, bingo callers and many others to approach.

Viewpoint needs more careful choice than under many other conditions. The bright conditions on and around sand means that small apertures will have to be used. This makes it difficult to throw backgrounds out of focus. Choose uncluttered backgrounds like sand, or even the sea or sky, when possible.

Other subjects

While you potter about the beach look around for subjects you might not usually take—elements that you can combine with your pictures of people. **Abstracts** are easy to find on the beach.

They are good subjects to stretch the imagination. Deckchairs and umbrellas have bright colours which contrast with the sea and sand. They also have strong shapes which are visually appealing in small parts. There will also be brightly coloured plastics like life belts, nets, fishing floats and baskets.

If one abstract idea catches your fancy, say shadows, try to develop it. Make people and beach furniture throw shadows in the shapes you want. Take a series of shots through the day as the sun moves and the shadows change.

Sunsets (and sunrises) change fast. Take frequent exposure readings to keep pace with fluctuating light levels. Readings taken from the sun or its strongest reflections will make the sea and sky look darker. Take readings to one side of the sun for a lighter picture.

Rocks are a virtually inexhaustible source of pictures. The stone will be worn by the sea into all manner of shapes. These forms will look very different from slightly different angles or if the camera is moved further away or closer.

Seaweed will festoon the rocks (and any wrecks or flotsam). Its colour and sparkle will change as the sun dries it out. The pools among the rocks contain green and brown weeds, red sea anem-

▼ **People expect to see cameras and to have their picture taken beside the sea. Take the opportunity to gain confidence in asking strangers to pose. They do not have to be holidaymakers, nor even on the beach. Look for the people who run fairgrounds, stalls and bingo halls nearby.** *Mike Portelly*

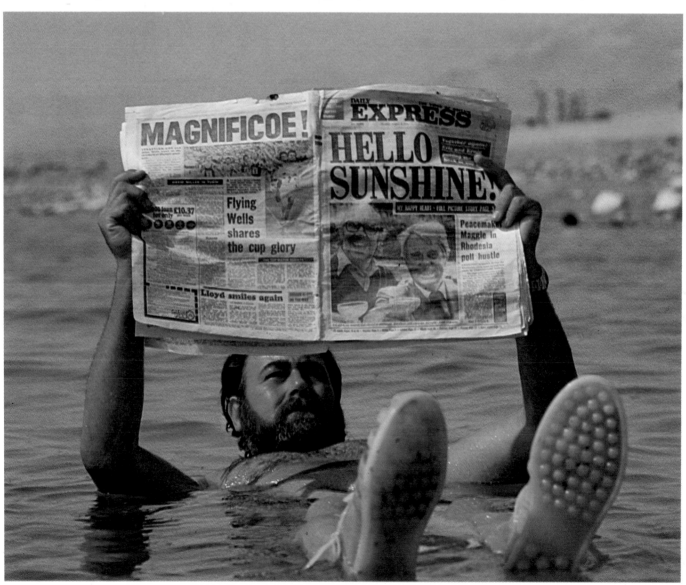

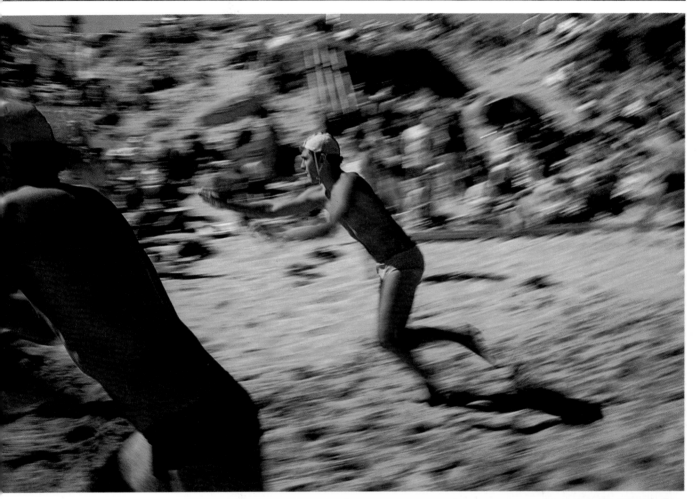

▲ Pre-set the camera to photograph fast sports and games. Set an exposure at a small aperture. Set the focus at a likely distance. Read off the depth of field on the lens. Keep within this distance and shoot as the action happens. Re-focus and re-set the camera for a second shot—if there is time. The results will not always be perfect but you are less likely to miss anything with this method. *Tom Nebbia*

▶ Light changes rapidly early and late in the day. Keep referring to the meter at these times. Evening light has a warm, relaxed quality suitable for pictures of people. Morning light is colder and better for pictures of the beach. *John Garrett*

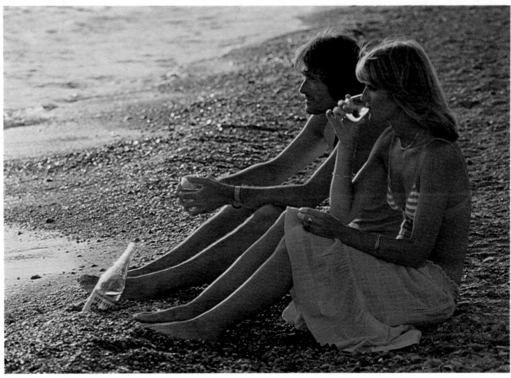

ones and coloured fishes. Fit a polarizing filter on the lens to take pictures of life in the water. It will help to remove unwanted reflections.

Shells and small stones along the water's edge should be sought facing the sun. The light reflecting off tiny, wet subjects make them easier to see. A subject like this will usually depend on its colours and textures for visual impact, so move in close. A great expanse of sea or sand behind will just swamp it.

Lighting and exposure

Lighting conditions are always extreme on the beach. The sky and sea reflect so much light that it is easy to over-expose pictures. Exposures will be shorter than for pictures taken inland in the same weather conditions. Use a lens hood and a UV or polarizing filter at all times.

The most reliable way to measure exposure is to take an incident light reading with a hand-held meter. If only the camera meter is available, take the reading close to the most important area of the subject. Exclude areas of sky, sea and sand unimportant to the picture. This is absolutely essential in direct sunlight.

If people are the main interest of the picture take a reading directly from their skin or, if you can't get close enough, from your hand. Choose a highlight rather than a shadow or mid-tone for the measurement. It is easier to over-expose than to under-expose in these conditions. If you really feel unsure of the exposure, refer to the instructions that come with your film. These are more accurate than guessing.

Silhouettes are best taken in the evening or late afternoon. There is too much light reflected into a subject's shadow to make silhouettes easy to do during the day.

There will be little or no subject modelling when the sky is overcast. Sea and sand reflect the soft light back onto the subject making the highlights and shadows merge. These are good conditions in which to shoot portraits, and colour for its own sake. The even light means that the lightest and darkest colours need the same exposure. They will appear equally intense on a correctly exposed film.

Time of day affects modelling as well as colour and atmosphere. Early morning, when the sun is low, is a good time to photograph the beach or along the sea shore. The light is not so red as in the evening and there is plenty of modelling in the sand, stones or shells.

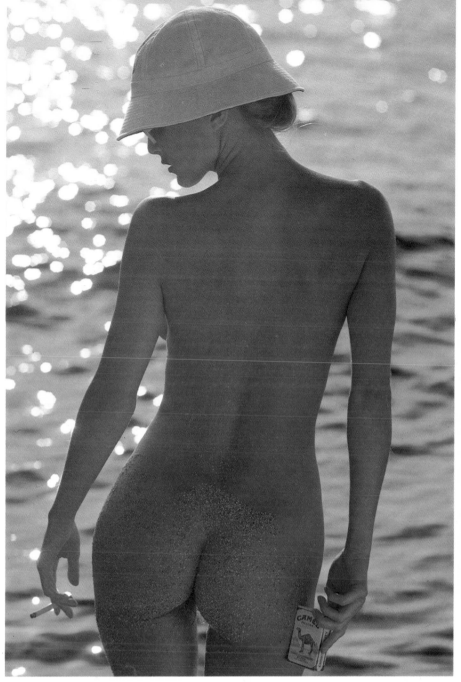

Few people are about at this time of day so the shore will be empty and the sand undisturbed.

By late morning shadows and highlights approach their maximum brightness range. Light reflected off the sand, although it creates exposure problems, helps to keep the subject within the contrast capabilities of slide film. To help reduce the contrast in sunlit portraits, fill in the shadows by using a white garment as a reflector.

Evening light, which is warm and red, has a relaxed feel. People will not only be tired at this time, they will also look as if they have spent a day on the beach. If the sun is placed a little behind someone, they will be surrounded by a rim of light.

Hints and tips

● UV filters cut out 'blue haze' which appears on colour film. Yellow filters cut it from black and white.

● A polarizing filter is an alternative to both yellow and UV filters. It will need increased exposure (up to ½ stop) but can also be used to darken blue skies.

● Filters protect lenses against sand.

● Domestic cling film is as effective as a plastic bag against fine sea spray.

● Load film in the shade. Even if it is just the shadow of your body.

● Get out of the wind and spray when removing equipment from a protecting plastic bag.

● Keep equipment in a bag on its own, in the shade away from the activity on the sand.

◀ This picture was taken on a beach in Ibiza for a Camel cigarettes calendar. Although *John Kelly* was shooting half into the sun, the model's back is lit by the evening sun reflected from the beach.

▶ This was actually taken by the side of a swimming pool in the Canaries. *Chris Thomson* used a 135mm lens on an Olympus OM-1 with 64 ASA Kodachrome.

▼ Polarizing filters darken the sky. UV and skylight filters reduce haze. UV (unlike skylight) filters do not affect colour or exposure. Filters are also useful because they protect lenses from the sand. *Patrick Gauvin*

Winter holidays

There is no need to be an expert skier to enjoy a mountain winter holiday—especially if you are a photographer. Opportunities for photography are endless, and whatever your favourite type of photography—portraits, landscapes or action shots—the bright snow and clear air will throw a new light on your subjects.

Special precautions

Photographing at high altitudes does present some minor problems as well, however. Though it is invisible to the eye, the large amount of ultra-violet light in the mountains comes out very blue on film. The solution to this is to leave a pale pink skylight B or a UV filter permanently on your lens.

When carrying several lenses of varying diameters be sure to have a filter for each size. A lens hood is also

essential to prevent flare. One thing you will seldom need in snow is a flash fill-in so don't bother to take a flash-gun on to the slopes: you should carry the minimum of equipment when walking—or sliding—around on the mountains.

It is more convenient to discard bulky camera cases for the same reason, despite the fact that cold, wet weather can harm your equipment. It is generally quite safe to carry your camera round your neck inside a loose-fitting anorak. If you are reasonably competent you can even ski with it there because, if you fall, it is usually sideways or backwards. It is easy to unzip the jacket and lift the camera out for a quick shot, and your body heat helps to keep the camera in good order.

Your camera should always be serviced thoroughly by a reputable dealer

▼ Very cold weather can affect the efficiency of both your camera and your film. In sub-zero temperatures keep the camera under your coat when not in use: if you are using an instant camera, keep it warm while the film develops.

▶ For this shot *Alfred Gregory* took a cable car very early one morning, when the long shadows added depth and form to mountain ridges. He used a 200mm lens and shot at f8 and 1/125 on Kodachrome 64.

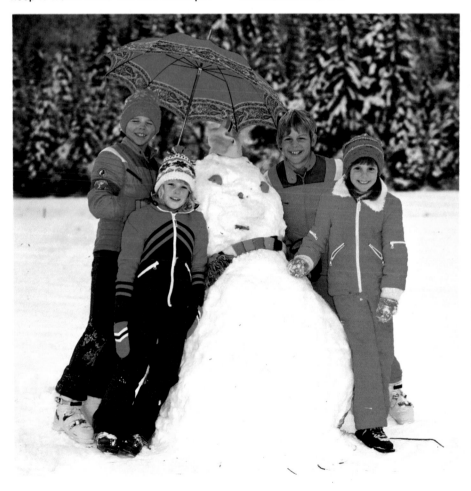

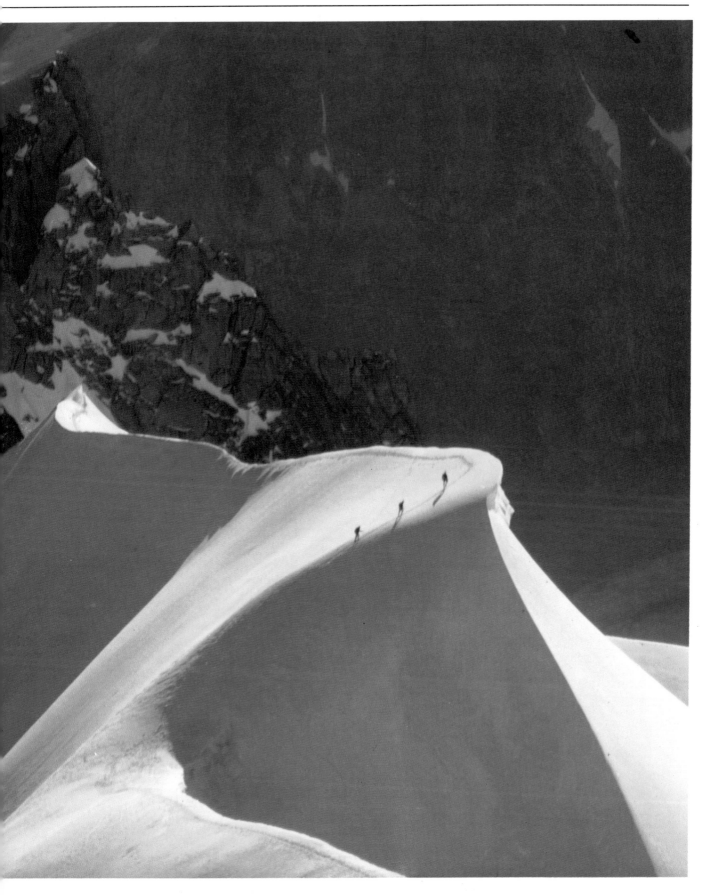

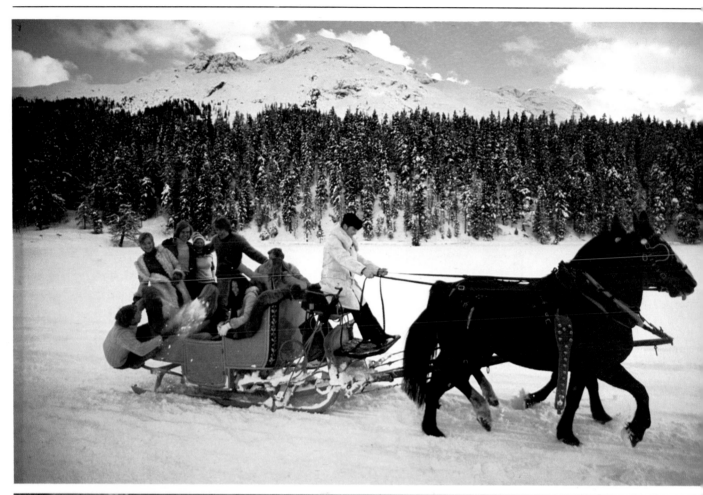

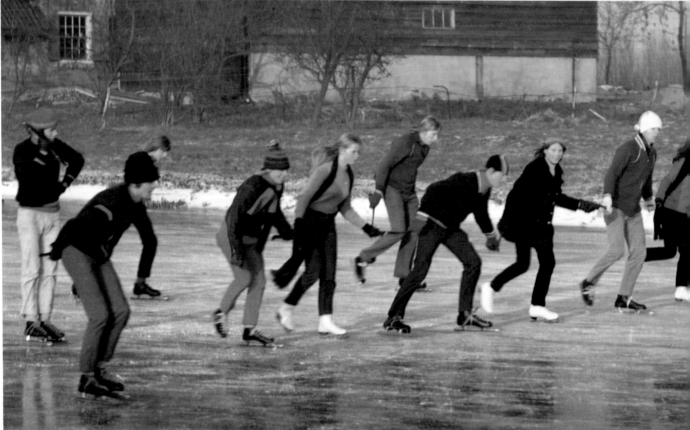

◀ Snow will reflect the colour of the sky, particularly in the areas of shadow. Here the cloudy sky gives a soft light and the clear white snow throws the subjects into silhouette. *Horst Munzig*

▶ A clear blue sky will give very blue shadows and crisp snow against which to contrast brightly coloured subjects.

▶ Below: using a Nikon FE for the first time, *John Walmsley* found that the automatic, aperture priority TTL meter worked well with reflective snow and backlighting. An aperture of f3·5 allowed him a fast enough shutter speed to freeze the action.

▼ Sidelighting from a low winter sun gives this picture its depth, and increases the effect of the reflections in the ice, giving an exposure of 1/125 and f4 on Kodachrome 64. *Alfred Gregory*

before you go on holiday, and you should tell the dealer who services it that the equipment might be used in sub-zero temperatures. In extreme cold the normal lens grease turns hard and sticky, which makes between the lens shutters slow and inaccurate—focal plane shutters are usually unaffected. You can use all normal films in cold weather: because of the amount of light from the snow, you can afford to go for high quality and stick to 64-100 ASA films.

A photographer's hands get very cold in freezing conditions, and they need as much consideration as his camera if they are to do their job well. As well as the heavily padded skiing gloves, take with you a lightweight pair which are supple enough for you to feel the controls of your camera. Ski boots or snow boots and ski trousers that fit tightly into them are very useful for clambering about in deep snow when you are intent upon finding that unusual angle.

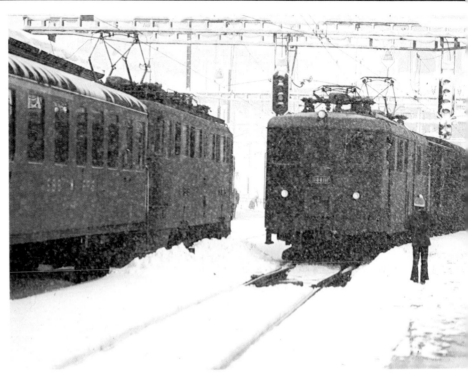

Sunshine and shadow

The weather makes a great difference to snow pictures: in cloudy conditions the snowy landscapes can look flat and uninteresting. It would be optimistic to expect full sunshine for more than a third of the days you spend in the mountains, though the weather tends to be brighter in spring than in mid-winter. Use the dull days for finding interesting detail shots, for portraiture or other subjects that respond to soft, even lighting. Spend some time exploring all the different locations, surveying the scenery from mountain cable cars and lifts, so that when the sun does appear you can go straight to the promising places without wasting time. It is also a good idea to work out soon after you arrive where the sun rises and sets—which areas are in sunshine or shadow at different times of day. Early morning and late afternoon often provide the best lighting for photographs, with sloping shadows showing more detail on the sparkling snow.

Exposures

Judging exposures can be tricky at first because of the glare from the sunlit snow. To prevent white snow being reduced to mid-grey tones, the override on an automatic exposure camera should be set at plus two stops. To begin with it is a good idea to use two different methods for each exposure reading. Don't neglect the exposure advice included in the leaflet that

comes with every roll of film: for Kodachrome 64, for instance, the instructions say 'Bright or hazy sun on light sand or snow—1/125 at f16' and most of the time they are right. A meter pointed straight at your subject —say, a group of people against a bright snowy background—might easily read f22 (or even f32) if the sun is being reflected into the lens from the snow, while an incident reading with a hand-held meter might say f11. Take a reading of the sunlight reflected from your hand and you can be sure that the faces will be correctly exposed. The Kodachrome 64 instruction that suggests 'Bright or hazy sun (distinct shadows)—1/125 at f11' is often correct for close-ups, particularly if they are side or backlit.

For backlit subjects where the face is illuminated by the light reflected from the snow, check this against a meter reading taken very close to the face, making sure that you shade the meter from direct sunlight with your hand. If you are photographing your group against—or sideways on to—the sun you should again take the advice offered in the Kodachrome leaflet and give at least one stop more.

For evening and sunset pictures a TTL meter will be fairly reliable, but remember to take the reading from the important part of the picture—the sunlit mountain peak, for example, or the chalet in the shadows below.

Subjects in the snow

For landscape photographers, the mountains are obviously a rich source of dramatic pictures and exaggerated viewpoints. But even for those more interested in photographing people, the lighting conditions in snow—which is an ever present 'fill-in reflector'—provide new opportunities to experiment. And for action photographers there is everything from the graceful experts on the higher slopes to the stumbling beginners' antics on the nursery slopes below. Even if you do not ski well, you can take the ski-lift to photograph the experts, or position yourself at a bend of a slalom course—particularly when there is a competition—where a number of skiers will be taking the same route. Find out if there is a bobsleigh run in the area, and don't miss an opportunity to photograph any ski-jumping competition (see the section on winter sports which discusses this aspect in more detail).

Action shots

Anyone who can safely get down a simple run on skis has a bigger choice of locations, but it is seldom worthwhile to find a good background and hope that someone will ski conveniently into your frame. It is better to arrange your action pictures with a friend who can ski well—bribing him, if necessary, with the promise of free pictures. Pick a place where the sun is

◄ Not all snowscapes are clear and bright. To warm the bleak white of falling snow, *Henry Low* used an A2 amber filter: the train lights and little boy's hat add contrast to the monochrome effect.

► When the sky clears there is plenty of light for action shots. *Tom Hustler* found a good camera position below a ridge and arranged for an expert skier to ski over it, signalling as he started off so that the camera would be ready at the right moment.

▼ Australian born *John Garrett* took this picture of his family's first encounter with snow at 1/30, slow enough to show the flakes as they fall.

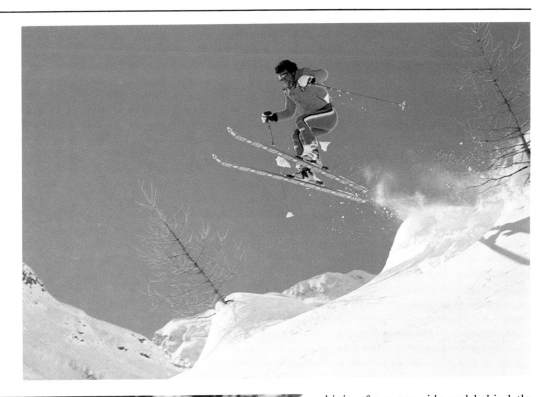

shining from one side and behind the subject as he turns at a chosen spot: if you spread a white handkerchief where you want him to turn, the skier will be able to see it but it will not show up in your pictures. Then position yourself 5 or 6 metres away and signal him to start when you are ready.

When you are sure of getting reliable results from your action shots, try to persuade a ski instructor to be your subject. He may be good enough to do spectacular jumps for you over snowy mounds while you lie low to catch him in the air. Get him to shout as he sets off if you can't see his approach.

Panning is very effective for action pictures: keep the skier in the centre of your frame all the time as you take the shot and even afterwards on the follow-through. The action will seldom be completely frozen even so, and the movement will also show in the fact that the skier is flying through the air, or that snow is spurting from beneath his skis.

Twin lens reflex cameras, though more cumbersome, are very useful for important action shots because they allow you to watch the action at the moment of firing the shutter. With all very fast action shots try to squeeze the shutter release about 1/25 of a second before the point you want to catch—this is 'think time' to compensate for the delay between the brain giving the signal and the shutter firing.

Photographing peoples of the world

A callow young photographer was once browsing in a London street market. Catching sight of an interesting stall and a more interesting stallholder, he hoisted his unobtrusive little Leica to his eye.

'What do you think you are doing? I didn't say you could take my picture.'

'Well actually this is a public thoroughfare and there is no law against my taking photographs here.'

'Yes there is: I'm the law on this stall, and if you want my picture you'll have to ask first, see?'

'Very well then. I'd like to photograph you and your stall please. May I?'

'No you can't. Clear off.'

The photographer was lucky enough to come away with a shot of the irate stallholder. But he was in danger of coming away with bruises as a memento of his tactless approach to the problem of photographing strangers.

▶ A picture worth the risk of bruises, it was taken some years ago by the now-established *John Goldblatt.*

Camera shyness and social taboos do not begin across the frontier. They are right there on your doorstep—perhaps even in your own frozen attitude when you find yourself at the other end of a lens. And when the person pointing the camera at you is a complete stranger on the street, even the most hardened photographer might be a little suspicious and annoyed.

In most parts of the world people feel just this way about having their privacy invaded. There are places in Africa and the Middle East where people believe that your black and chrome box is a trap to capture their soul. If a photographer simply appears out of the blue, what right has he to take away their most valuable possession in a camera?

Taboos

Even though they may have got used to cameras, some Muslims still observe the Koranic prohibition against portraying any living thing—animal or vegetable. It is never wise for the casual photographer to take pictures of veiled Muslim women.

People in Hong Kong—especially the women—also react quite aggressively to being photographed unawares. While freelance photographer Lesley Nelson was scanning a Hong Kong building site through her viewfinder she saw a woman labourer approaching her at a trot with a pointed bamboo pole and every intention of using it.

There are even taboos against looking: in some African markets you may come

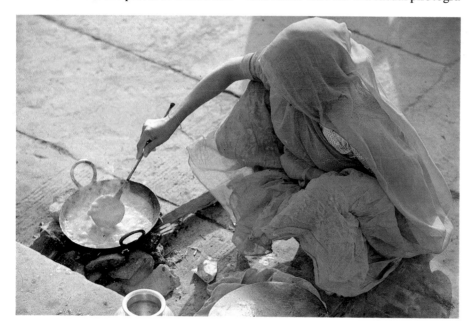

◀ *Alfred Gregory* takes most of his photographs abroad. Here he was an onlooker at the celebrations for the deity Rama's birthday in Benares, India. He took this shot of a woman preparing breakfast for her family after their ritual bathe in the Ganges in the very early morning, while she was totally unaware of his presence. Practised in moving about discreetly in the crowd, he was able to come up quite close with a 105mm lens. His film was Kodachrome 25, which makes the most of the strong colour; his exposure was 1/125 at f8.

▶ To photograph this Indian follower of Shiva in a state of trance, *Roland Michaud* had to be as unobtrusive as possible. Flash would have been out of the question, and the low light and consequent wide aperture made it critical to focus on the eyes.

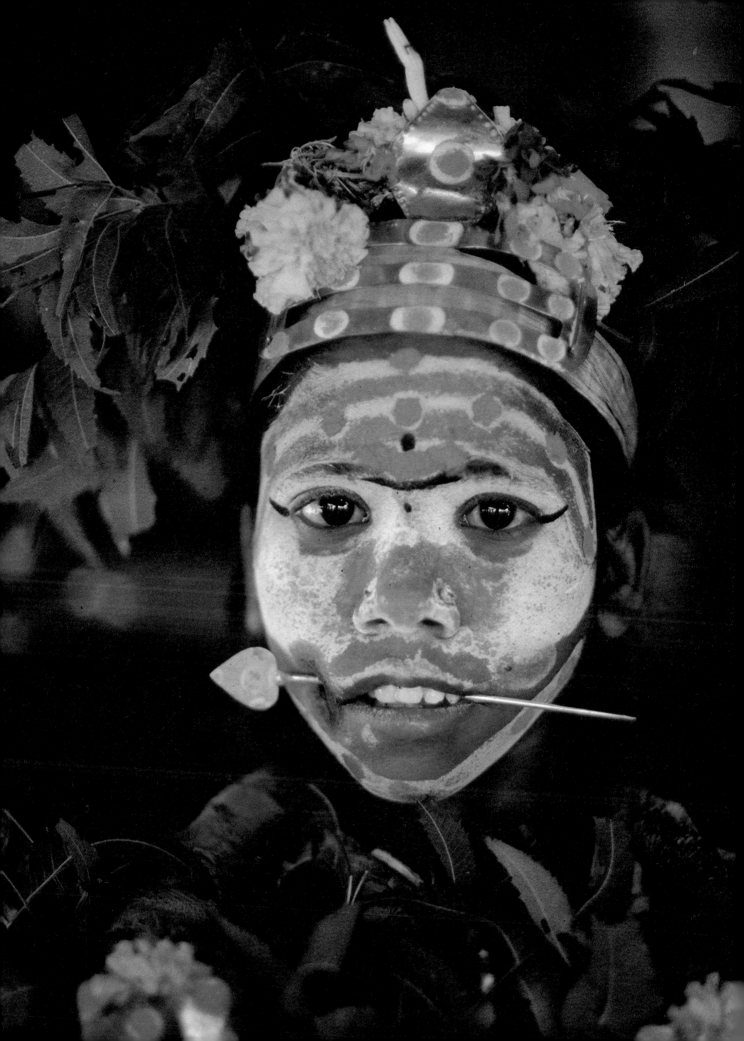

across blacksmiths making spearheads some distance from the main throng. An interesting shot—but beware. The smelting and forging of iron is often a secret, magic craft, for the eyes of initiates only. Without detailed research, taboos like this are completely unpredictable and can be sprung on the unsuspecting photographer in every country of the world. When you travel abroad with a camera it is worth finding out a little about the local life and customs before starting to take pictures.

The right approach

Wherever you travel and whatever the taboos, there are two basic approaches to photographing strangers. One is with a long telephoto lens, standing well back and hoping your subjects will not notice you. But far more rewarding is the gradual and friendly approach: if this is successful you can use any lens you like and come as close as you choose. Taken to its limit, this friendly approach can mean spending half a day, or even the first couple of days if you have time, wandering about and making friends with the people you want to photograph. If you can resist the temptation, leave your camera behind on your first time out. It may mean you worry about the shots you are missing, but there will be more and better shots once you've made your contacts—drunk mint tea or shared food to seal your friendship—and stored up goodwill for the time you do eventually bring your camera out.

▲ **Asking people to pose for the camera sometimes gives more interesting results than catching them unawares.** *John Garrett* was able to compose this group of Americans abroad with care, and they had the chance to present themselves as they would like to look.

▼ **This family group in Accra, West Africa, formed itself quite naturally.** *John Bulmer's* technique is to work very quickly: though some of his subjects here are aware that they are being photographed, they have not yet had time to react to the camera.

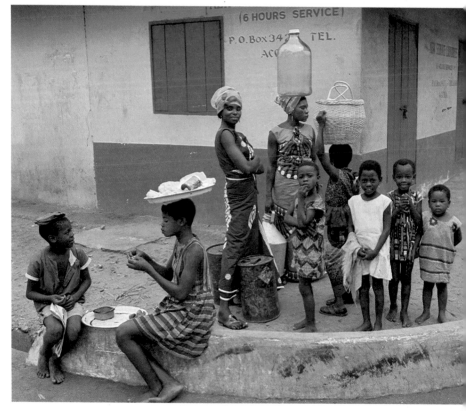

Candid photography

Sometimes the photographer can get away without preparing the ground. Sometimes there is no time: a shot comes into view suddenly and that's the one you want. This is where you need cheerful diplomacy and perhaps even courage. Unless you are photographing a busy scene like a festival or a market, the best way to get natural shots of people is to go by yourself. Imagine what it feels like to be an Omdurman silversmith or a Spanish lacemaker in a striking costume sitting quietly outside your house. You look up from your work to find six or seven tourists advancing on you with photographic intent—and must resent the invasion of privacy.

The roving photographer should always carry his equipment in a bag. A telltale camera bag will do, but a nondescript shoulder bag is better. Some photographers use a fishing bag with its convenient pockets and pouches for keeping camera bodies, lenses and films separate. At all costs don't be hung all over with equip-ment, glittering like a Christmas tree and the focus of everyone's attention. Photographers who get the best candid shots of people engrossed in their own business are the ones who can make themselves invisible and blend into the background.

Dealing with enthusiasts

Camera shyness and taboos are not the only problems that the travelling photographer has to face. In some places the local youths will come right up, nose-to-nose with the camera, often in an exaggerated boxing pose. Oblige them with a shot even if you don't really want it. They'll be happy, you will have wasted only one frame of film, and they will soon relax so that you can take the pictures you really want.

Then there are the children, eager to crowd round you, inquisitive and pestering. They gaze right into the lens from only centimetres away, they push and pull, want to try your camera and won't leave you alone. Have patience with them: they will soon be distracted by a new fascination. You might even be

▼ *Timothy Beddow* captured this candid shot while he was photographing at a Mexican festival. One way of avoiding your subject's attention is to use a right angle attachment: by means of a mirror fitted to the end of your lens (right) you can point your camera at 90° to your subjects and still keep them in your viewfinder: they may be aware of you, but have no idea they are being photographed.

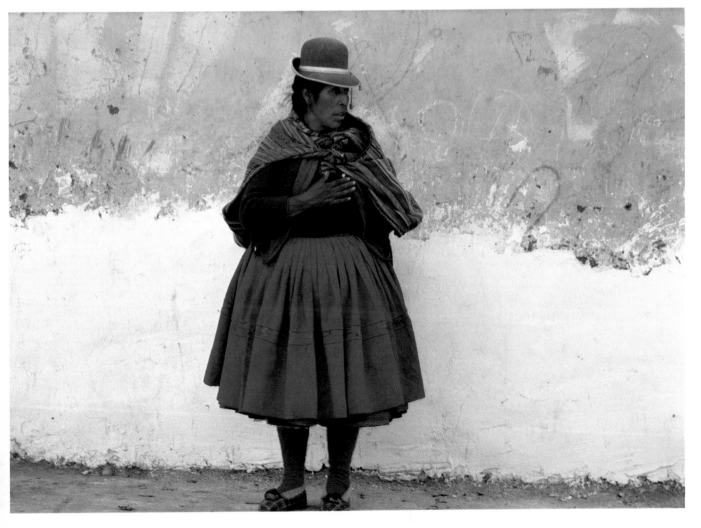

able to point them in the direction of another tourist, perhaps, and then get a few good photographs.

You should never give money as an inducement for someone to pose unless you are really desperate for a shot. In poorer countries you are almost sure to be asked, but you should stand your ground and refuse, otherwise you will be inviting a clamour of pleading and a forest of outstretched hands. And to oblige the new benefactor, everyone will want to pose.

The quickest way to get on good terms with people is to learn a few words of their language. 'Hello' and 'thank you' will take you a surprisingly long way across the chasm that divides you.

▶ **Perhaps the most satisfactory way to take photographs of strangers is to win their complete co-operation.** *John Garrett's* **portrait of this Greek elder shows the rapport he established.**

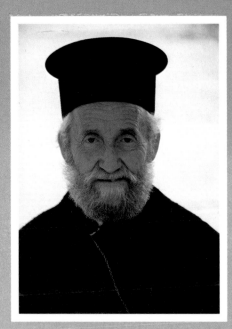

▼ **The Bedouin Arabs are wary of photographers—believing that they may make off with their souls in the camera. But** *Robin Constable* **was able to overcome this fear in spite of the language barrier. He spent two days as their guest in the desert and found that the best technique was simply to keep smiling and shaking them by the hand. He took this shot in the early morning with a 35mm lens, just as the camel train was about to mount up.**

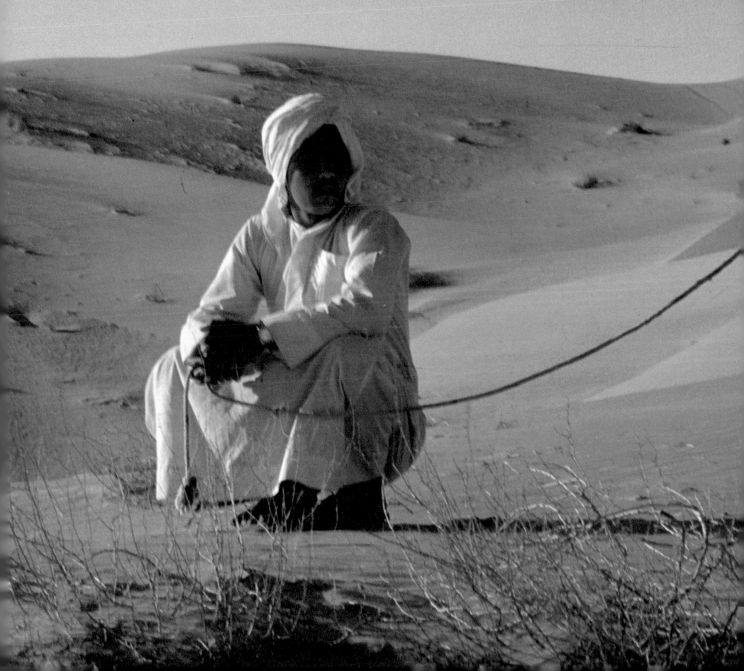

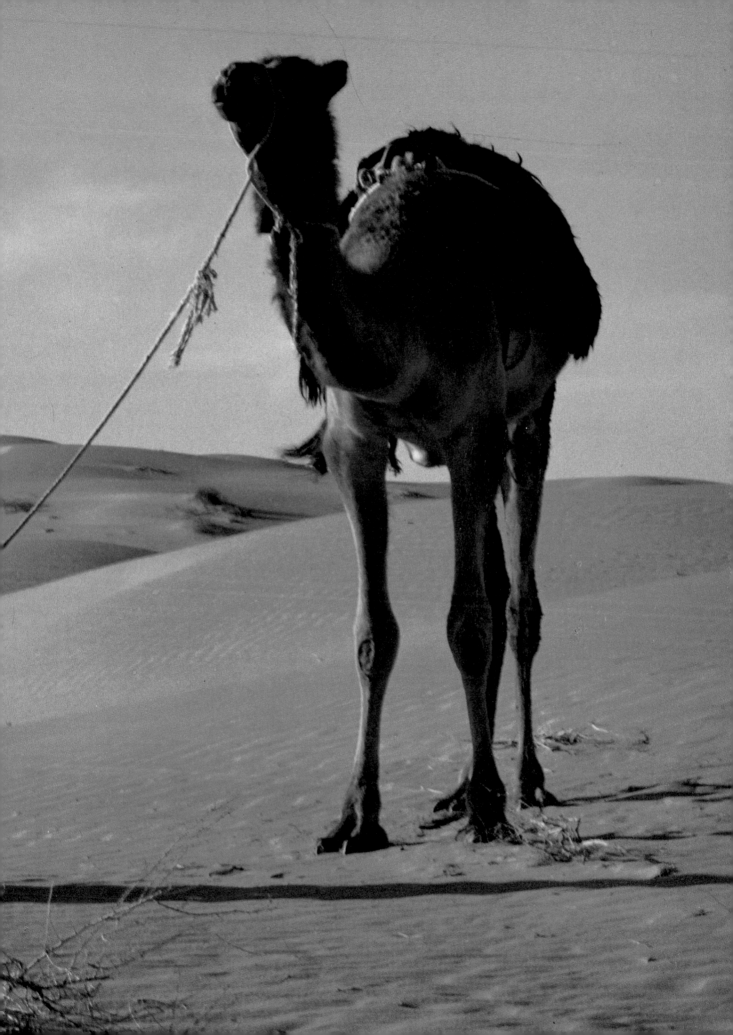

Dance in pictures

If actions can speak louder than words, dance shows people at their most eloquent. For any photographer interested in photographing people, it offers the opportunity to portray the subtlest forms of physical expression.

The challenge is to the photographer's ability to isolate still pictures from the moving spectacle presented on the stage. And the conditions under which he has to work range from the difficult to the—seemingly—impossible.

Dealing with stage lighting

Anyone who has visited a theatre knows the limitations of stage lighting. These light levels are even more of a problem when your target is constantly on the move. Point your camera at a brightly lit stage and—even with 400 ASA film—you may not get a shutter speed faster than 1/60 with the lens wide open. But

don't be put off, photographing dance is not impossible.

Film can seldom be slower than 400 ASA and it is usually best to uprate it to 1600 ASA. This will give workable shutter speeds of 1/125 at f4 in typical lighting. Even so, the required shutter speed might be as slow at 1/15.

With wide apertures, depth of field will be at a premium. Focusing will, therefore, become very critical, especially if you have more than one dancer in the frame. If the stage is crowded it is vital to isolate important parts of the action.

The right equipment

Keep your outfit plain and simple. An SLR is the obvious choice, since it is easy to use and offers interchangeable lenses, TTL metering and complete mobility. A 50mm lens will suffice for most situations as you will usually be

PEAK OF THE ACTION
▲ **Low theatre lighting can mean slow shutter speeds, however fast your film. For sharp pictures of fast-moving dancers, catch the 'hiatus' (like the top of this leap) when the subject is momentarily still.** *Jean-Claude Lazouet*

THEATRE LIGHTS
▲ A realistic rendering of colour when photographing under theatre light is virtually impossible. Make the most of the dramatic colours and experiment with filters. This shot of the Santa Barbara Ballet in rehearsal was taken with a starburst filter. *Marvin Lyons*

◄ Photographs of dance do not always have to be sharp. Here *Luis Vilotta* used a slow shutter speed to blur and soften the movement of the dancers for effect.

able to work close up to the stage. A medium or long telephoto (135mm or 200mm) is useful for those times when you cannot get so close, and will allow you to take tightly cropped images of small areas of the stage from close up.

An 80-200mm zoom lens is an ideal focal length to have, but for the beginner the slow shutter speeds required by maximum apertures of around f4 may prove more of a hinderance than a help.

A tripod, the usual solution in low light photography, can limit your mobility. Practise bracing yourself against a seat or some other fixed object instead, and get into the habit of making panned exposures. Focus and frame your shot at the start of the movement. Fire the shutter as the dancers reach the point in the action that you want on film, following it through, much like a golfer. Most, if not all, dance photographs are shot during dress rehearsals. The same movement may be repeated several times as the performers try to get it just right. Use this time to study the piece. Check when the movement is at

its peak, or when leaps and lifts occur: these are the most difficult shots to make. Watch the whole stage. Decide which pieces of the action you want, and then make your exposures on the second, or succeeding run.

If you think that you may only get one chance at a particularly pleasing movement, focus and frame as accurately as possible. Check your light reading, and working as smoothly as you can, shoot as much of the sequence as your fingers will allow.

A power winder is a useful item to have, but not essential, at best it may give you half a dozen more frames than you might have got. At worst it can waste a great deal of film and add to the possibility of camera shake. Far better to practise fast firing the camera at eye level, with no film in the camera. Two frames per second are possible with this technique, as fast as some power winders, and half as noisy. Remember you will be a guest at a photo-session, and the less distracting you can be to the performers the better. Flash photography, even at dress rehearsals, is forbidden, so leave this item at home.

Film

Choose your film with care—and take plenty of it. Unless you are going to be really selective with your shots, you will need half a dozen rolls to cover the average rehearsal.

Whether you choose to shoot black and white or colour will depend on what you want from your photographs. High speed black and white emulsions will tend to give you very contrasty and grainy results. They can be very dramatic, but call for accurate developing and printing to yield satisfying results.

Pushing a 400 ASA slide film up to 1600 ASA tends to shift the colour balance towards the warmer tones. Shadow areas will reproduce as browns rather than blacks, and because of this it is often possible to retain subtle details in the shadow areas which would be lost in black and white.

With uprated films, grain is inevitable, but much of the excitement of the dance lies in the atmosphere created by the stage and lighting directors. Grain, contrast, and unreal colours, used thoughtfully, will help to retain that atmosphere in your shots.

Interpreting the dance

Capturing a sense of movement can also give your shots something more, especially if the grace and line of the piece are combined with that sense of

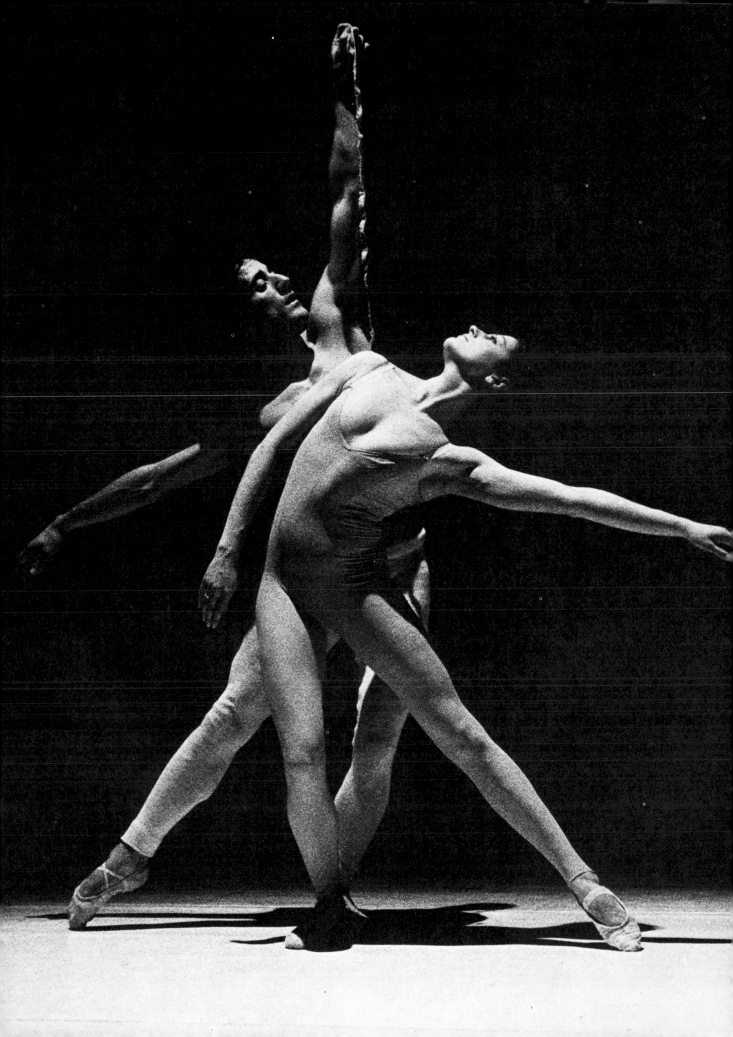

▶ Though you can take pictures of the full company of dancers on a well-lit stage, it is often better to isolate one or two figures. Use a long lens or move in—if possible—for a close-up. *Peter O'Rourke* framed this pair using a 75-205mm zoom lens. He shot on 400 ASA Ektachrome, uprated to 1600 ASA and 'push processed'. Exposure was 1/60 at f5·6, based on a reading which avoided the influence of the black background. The precise framing makes the picture.

◀ Try to learn enough about dance to know the right moment to release the shutter. In this picture, the top lighting helps by outlining the limbs. *Paul Forrester*

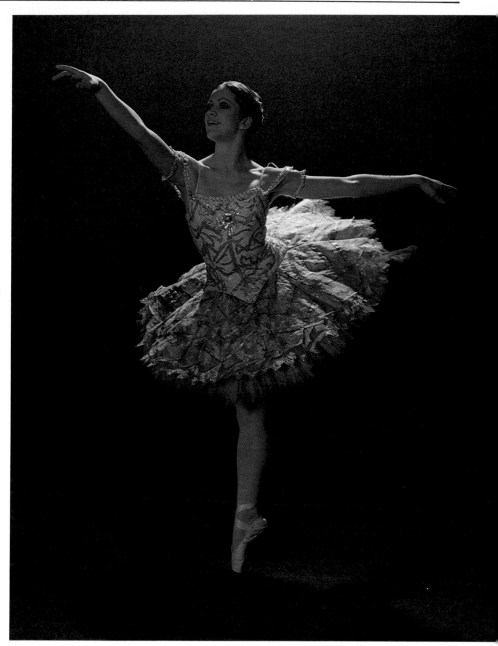

motion. You can take really abstract shots which show blurred blocks of colour—though some recognisable outline should be included in the picture.

There is no foolproof technique for taking successful photographs of dancing, as the results will depend entirely on the photographer. However, if you intend to sell or exhibit your dance photographs there is one very stringent rule. Your photographs must show the dancers with their limbs in the correct ballet positions. Facial expressions are an important part of each piece, and these, too, should be correct. You must, therefore, show all of your shots to the public relations department of the company involved before you show them in public. They will tell you which photographs you can show, and those you cannot. You must respect this decision, and you would be wise to accept any criticisms made of your photographs.

Failure to produce the right shots on your first attempts should be seen as an incentive to try harder. Anyone who is involved with dance is well aware of the pitfalls which beset the beginner, and is unlikely to miss any promise you have as a dance photographer.

How to begin

The most difficult thing about photographing dance is getting into the auditorium in the first place. It is not unusual to have thirty photographers at one rehearsal. All will have been invited, and spare places are at a premium.

If you have never tackled dance photography before, find a company in your area and write to the Public Relations Officer. A polite phone call to the company should secure the name of

that person, and will make your introductory letter less formal.

Explain that you are interested in the idea of photographing dance, and enquire whether you might be allowed to take some shots of a practice session, offering the company first choice of any photographs. If they say yes, make sure you keep your appointment and make yourself known to your contact on arrival. He or she will introduce you to the instructor who will explain what limitations may be placed on your shooting.

Work quietly and conscientiously. Leave if you are asked to, or when you have exhausted your capabilities.

Get your films processed and present the results to the publicity officer as promptly as possible. Supply the company with any prints which they may ask for, either free, (as a token of your goodwill towards the company) or for an agreed price per print. A request for a credit on any photographs which the company may use will usually be granted.

Having surmounted this hurdle, and assuming that you have shown some competence in your work, invitations to photo-calls may well follow, and you will have every opportunity to put your photographic abilities to the real test of dance photography.

Photographing winter sports

Winter sports, with their speed and excitement, make an excellent subject for winter holiday photography. You can take dramatic action shots of downhill ski-racing and ski-jumping, or combined snowscapes and skiing photographs at cross-country events.

Ski-racing

Ski-racing falls into two broad categories—Alpine and Nordic—and these styles are fundamentally the same whether you are taking photographs of the Winter Olympics or a package ski holiday fun race.

Alpine ski-racing consists of three main tests of a skier's courage and skill: the Downhill Race, the fastest and most exciting ski event, during which skiers reach speeds of around 120 kph; the Special Slalom, a short, often steep course with alternate red and blue gates close together, each of which the skiers have to pass through to remain in the race; and the Giant Slalom, which combines features of both the others. The flags (or gates) in the two slalom events are positioned on the morning of the race and the skiers

are not allowed to run the course beforehand, as they can on the downhill course. This is to test their skill in picking the fastest line between the gates on the spur of the moment.

Nordic ski-racing is quite different. It is held cross-country and designed to test endurance and the specialized half-walking, half-running technique needed to ski on relatively flat terrain. The Biathlon involves carrying a rifle and shooting at targets during the race, particularly difficult when skiers are exhausted and out of breath.

Finally, there is ski-jumping from both the 70m and 90m towers. This is probably the most dramatic ski event.

▶ A low early-morning sun, emphasized by a cross-screen filter, backlights the subject and also reflects enough light from the snow to show detail. *Tony Duffy's* exposure was 1/500 at f8.

▼ The choice of a telephoto lens allowed *Helmut Gritscher* to frame very tightly on the subject. He panned the shot, predicting the skier's course from previous runs.

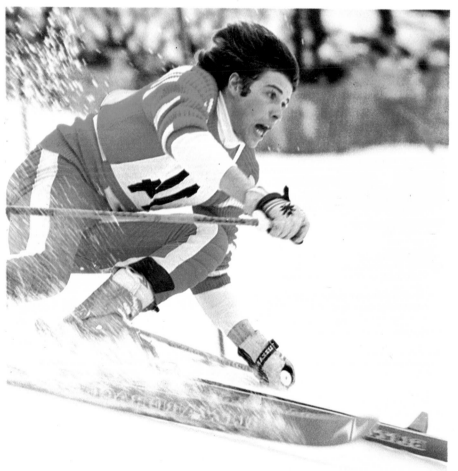

Care of your camera

Photographing ski-racing involves using your camera at sub-zero temperatures, and any lenses longer than 180mm should be specially greased with a product that does not harden at low-temperatures. Most lens manufacturers can advise you where to have this done and the cost is reasonable. Remember to take spare batteries as the cold shortens their normal life. If you are using a motor-drive camera with nickel cadmium batteries, don't forget to take your recharger. Never put cameras or lenses down on the snow, keep them under your coat when possible, and each evening check and clean your equipment carefully.

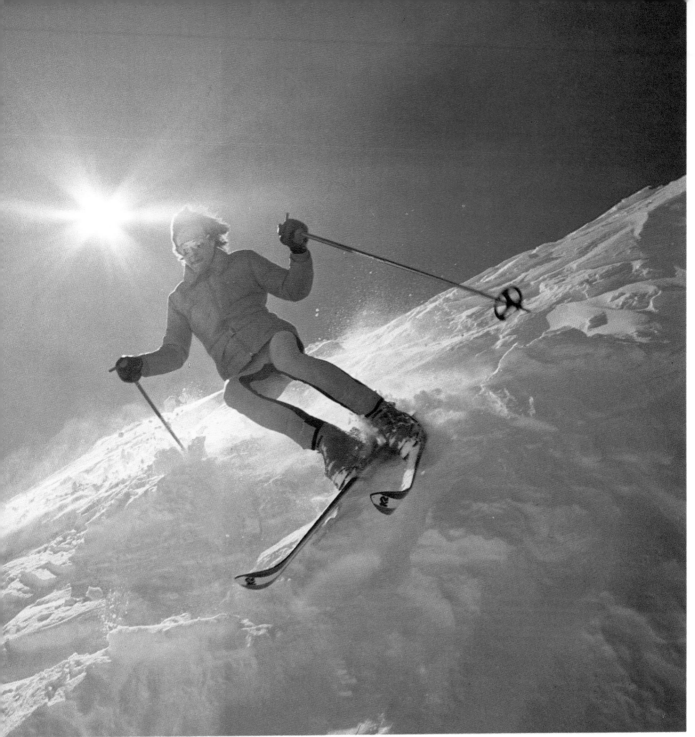

Working in snow

Don't bother to take a tripod to a ski-race: it's cumbersome to carry and difficult to use on a steep, icy or snow-covered mountainside. A monopod will serve you far better. Take the longest lens you have, preferably at least a 400mm as you are not allowed to get too close to the gates through which the skiers negotiate their course. If you don't have a 400mm lens, a tele-converter will do quite well as you normally have plenty of light to work with.

If you are using black and white film, fit a yellow filter to your lenses. If you are using colour a normal sky-light filter is fine. Keep the filters on the whole time as you will inevitably have snow or ice thrown up on your lens when you are on a mountainside. Use the maximum depth of field (the highest aperture number) consistent with a shutter speed of 1/500. Unless you are taking panning shots you will need this speed to stop the action and the depth of field to give you latitude in focus on a subject coming towards you at nearly 120 kph.

A few extra items are absolutely essential: thin nylon undergloves for changing film and in case your fingers are too numb to feel through ordinary thick gloves; sturdy, waterproof boots, preferably with crimpons or a solid edge with which you can kick footholes into ice or packed snow; and some head covering. A hip-flask can be very useful too, and a bar of chocolate is comforting as you may be on the freezing mountainside for four to five hours at a time.

Alpine racing

If you are a good skier you can save time and energy by taking the tow rope to the top of the course and slowly side-slipping down, studying the corners, bumps and backdrops to select your best position. Otherwise you should walk the course or seek advice of someone who knows it. Once the racing starts it is virtually impossible to find another position without

missing everything.

Obtain a start list before you set out. The top 15 skiers usually come in the first group—which is a pity as you need all the practice you can get to work out your timing—but they are always preceded by three or four forerunners.

When you have found your spot, take five minutes to stamp out a flat ledge in the snow—it is very easy to drop something and then have to watch it speeding away down a mountain slope. Hang your camera and lenses under your coat when not in use and keep them off the snow at all costs.

Because of the possible danger, especially in downhill racing, you are kept well back from the gates—often behind a fence—and on each major corner there are huge catch-nets which you cannot shoot through.

If you choose a position under a bump in the course you will not see the skier until he is airborne, so keep a check on the running time: usually in downhill racing, one skier sets off every minute, and in slalom every 30 seconds. Check the second hand on your watch: they will come through within a couple of seconds of their allotted time and this saves you holding a camera to your eye for up to a minute. The skier's speed will give you very little reaction time, so ask a course marshall above you to shout when the skier approaches (they often do this in any case).

For slalom races it is often possible to get closer to the flags than for downhill racing. Try to use the brightly-coloured flags to add to your composition. Remember that the skiers often throw up snow and 'edge' violently as they round the flags. More important, you can use the flags to pre-focus and know that you will have the skier in sharp focus as he rounds them. Follow-focusing a high-speed skier is always risky—and often a waste of film.

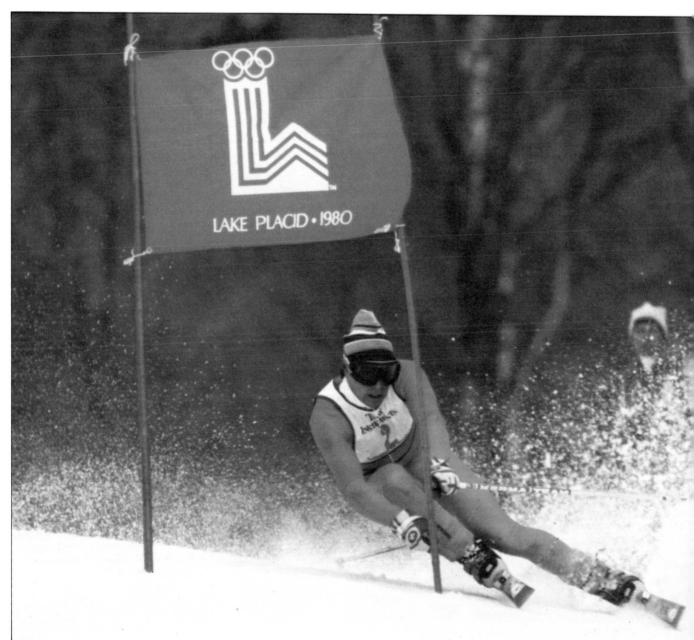

▶ Low sidelighting casts long shadows which mark out the pattern of slalom runs: for details of snow, take care not to over-expose. *Adam Woolfitt*

Below: a shiny 'fish' suit shows the aerodynamic shape of a downhill racer. The panned camera indicates her speed, though a patterned background would have more impact. *Tony Duffy*

▼ From 20 metres, at the side of the giant slalom run, *Tony Duffy* focused on the gate with a 400mm lens, waiting for the moment when the skier threw up a spray of snow against a dark background.

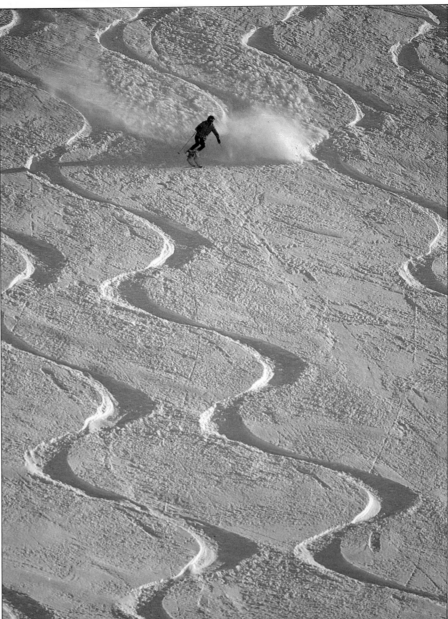

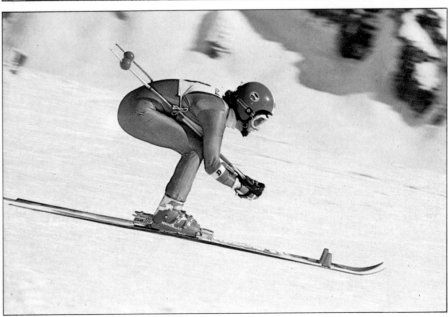

Ski-jumping

Of the three major positions for photographing ski-jumping—side-on, head-on and under the jump—the first is by far the most popular. At the apex of the jump, often above the tree line, you can use a fast shutter to freeze the action or a slow one to blur the crowds and trees. Try to keep the tops of the trees in the bottom of the frame as this lends height and scale. Wait for the moment when the skier's nose appears to be about to touch the end of his skis as he leans forward in a seemingly impossible aero-dynamic position.

If you can get access to a position under the lip of the jump or at the top you will be able to take some great photographs. At big events, however, these positions may be out of bounds to photographers.

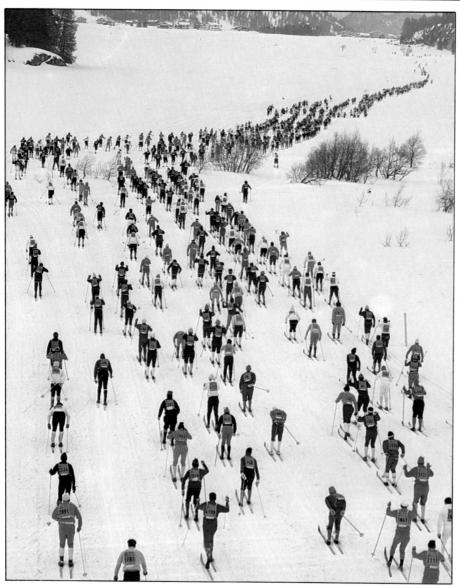

Nordic events

Cross-country races are a lot easier to cover as the courses are usually flat and there are not the problems of access and working position that you find in Alpine events. This is the opportunity to incorporate snowscapes and winter photography to advantage: usually the skiers follow the same track and photographers can use these tram-line tracks across a virgin snowfield to give depth and perspective and a harmonious composition. When the skiers enter woods with branches laden with snow, the scenic photographer can be creative and still capture the excitement of the sport. In addition, the competitors are travelling at only a jogging pace and this makes focusing much easier. One particularly good shot of the Biathlon event is to be had by shooting along the

▲ The mass start at a cross-country ski race is a rare opportunity to photograph hundreds of skiers together. In dull weather, the lack of shadows makes the skiers appear to float on the snowy landscape. *Adam Woolfitt*

line of skiers standing side by side, steadying themselves and aiming their rifles at the targets, often with clouds of breath condensing in the cold air. Skiing is one of the few sports where starts and finishes do not provide the best pictures. At the start, the skiers are almost concealed by the starting hut and it is difficult to get a position to shoot from. At the end, the competitors often don't know who has won when they finish the race and so show no excitement and jubilation—or disappointment.

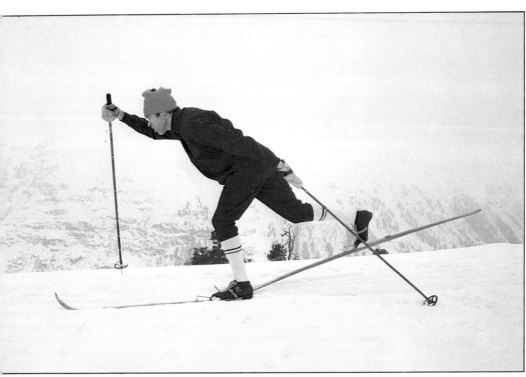

◀ The comparatively slow pace of cross-country ski-racing allows the photographer to concentrate on composition. The stark white landscape places all the emphasis on the actions of the skier.
Horst Munzig

▼ Against a clear sky or snow, this ski-jumper would have appeared quite motionless: against this colourful crowd he would have disappeared were it not for the fact that the shot was panned. As well as showing speed, panning the camera places extra emphasis on the subject.

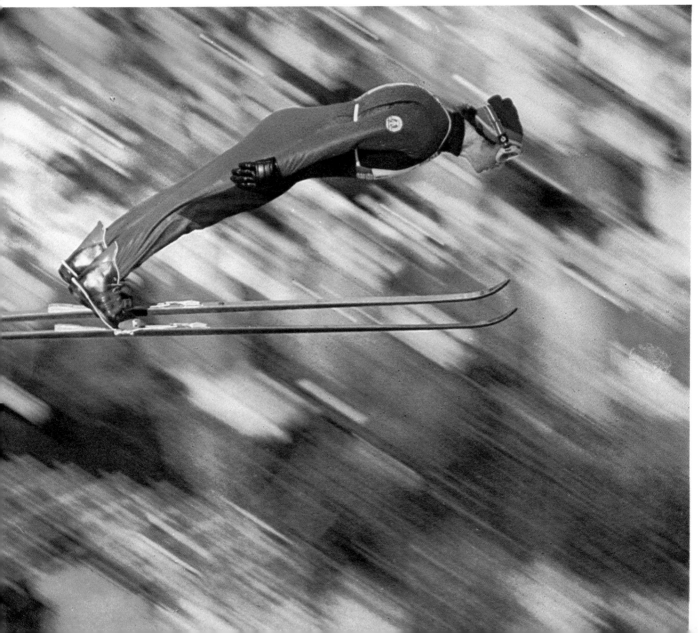

Ice skating

Ice skaters travel very fast indeed over the ice, especially during their most spectacular jumps and set pieces. Fast shutter speeds are essential to freeze the flying figures, and so the best place to photograph skating is at an outdoor rink where there is plenty of light. At a winter resort, for example, you may also have a breathtaking mountain backdrop for your pictures.

Ice reflects a great deal of light and will mislead a light meter into giving too little exposure—by one stop at least—unless you take care to expose for your subject rather than the surroundings. The best way to do this is to take a reading off the skater's face while he or she is standing on the ice so that the skin tones will be right. As you work out the correct exposure, use a shutter speed of 1/500 to make sure of stopping the action during even the fastest jump or spin.

Solo skaters

Curiously, it is the simplest of jumps that make the best pictures. Unless you yourself are an expert skater and anticipate these, it is best to ask someone to pose for your pictures. One very effective jump to ask for is the 'stag', where the skater has one leg bent under him and one outstretched; another is the 'splits' performed in mid–air. The 'butterfly' jump also looks very impressive to the camera, as the skater throws his legs back in a kind of cartwheel and faces the camera in a position horizontal to the ice. One jump which is often performed by female soloists is the 'bunny' jump which involves a mid–air back kick. All these relatively simple jumps will give your picture a clear and graceful line.

Paradoxically, the most difficult jumps, performed often for competitions, tend to make the worst pictures. 'Double–axles' and 'triple–toe–loops' may bring an audience to its feet but they are quite disastrous for the photographer, and there are very few good shots of either of these jumps which entail fast, mid–air rotations. To get a dramatic effect, photograph jumps from a low viewpoint—a kneeling or crouching position—which shows the height of the jump and separates a skater from the ice.

Shooting outdoors in sunny conditions, try using the skater's shadow on the ice for additional effect. For these shots you will need to be standing, or even to take a higher vantage point on a chair or bench. Experienced skaters also do the most impressive spins which, for the photographer, have the advantage of being performed in one spot so that there is no problem with focus.

Pairs skaters

Some of the most dynamic skating pictures are of couples skating together. These fall into two categories: pairs skaters and ice dancers. Of the two, the pairs skaters are the more acrobatic, as the man is allowed to lift his partner over his head in a handstand, or to throw her, whereas ice dancers may not lift their partner above waist level and can never lose touch with one another. Watch out especially for the famous 'death spiral' when photographing pairs skating.

At an indoor ice–rink

Skating competitions usually take place at indoor skating rinks, where the photographer will almost inevitably come across the problem of low light. There are two ways to cope with poor lighting: the first is to photograph the skaters during a practice period when you will be allowed to use a flash gun. This is only possible if you can get close enough to the skaters, or better still if you can get them to pose for you by the edge of the rink, since a normal flash gun will not carry across the width of an ice rink. If you are using flash, try using it off the camera to avoid the 'red eye' which can spoil an excellent shot.

The second way to deal with poor light

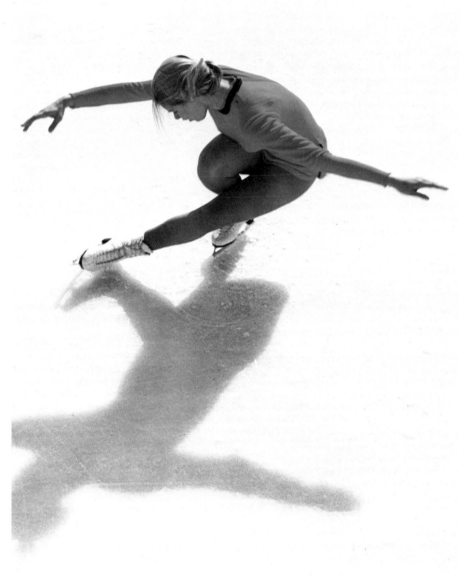

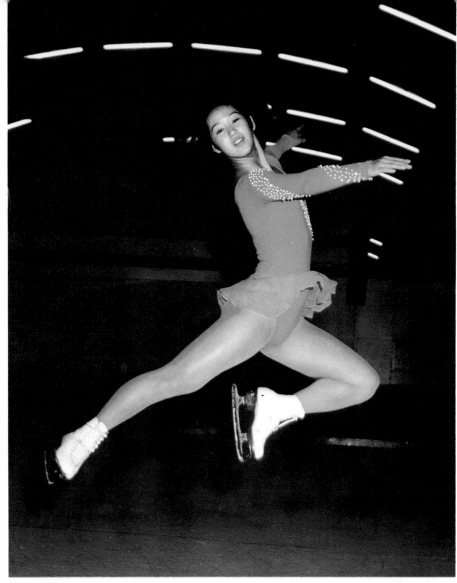

is to turn it to advantage and use a very slow shutter speed—as slow as 1/15 or 1/8—and go for an impressionistic shot with plenty of colour and movement. If you have a zoom lens, you could try zooming during the exposure. Rather than looking for pin–sharp results, accept the fact that your film will need to be pushed two stops and go for a very grainy texture. With a little trial and error you could end up with a shot that can take pride of place in a collection as a Degas–like 'impression' of skaters on the ice.

During exhibition performances spotlights are often used, though they are not allowed during competitions. These can be a great help to the photographer: don't close in too tight on the image of the skater or you will lose the dramatic shadows in the pool of light behind on the ice.

Photographing competitions

Photographing an indoor championship is a tricky task, but for the determined amateur here are some useful pointers:

● The lighting at an indoor rink will almost certainly require you to use a tungsten balanced film (unless the event is being televised, in which case the lights may be balanced for daylight film). Ektachrome 160 tungsten balanced film can be uprated to an effective speed of 640 ASA, pushing it two stops, which in most cases will allow you to use a lens in the range of 180–300mm with correspondingly limited apertures.

● If you are using a camera with an automatic exposure metering system, bear in mind that the reading you will get from the ice will be at least one stop (and possibly more) under–exposed, so always expose for the skaters themselves and not the ice.

● The amateur will probably have to shoot from the public seats, but this position—looking down on the rink—is not necessarily a disadvantage. It will give a clear, uncluttered background for your shots, whereas professionals working at ice level have advertising billboards to cope with, and a line running through the skaters' waists where the fence gives place to the dark backdrop of the crowd. In fact, many professionals can also be found working from the higher public seats.

● A position halfway along the side of the rink is best, as you will have the whole area covered if you use a medium telephoto lens (135–180mm).

● When the skaters come on to the ice

◀ Photographing at an outdoor rink, *Erich Baumann* used the skater's long shadow in his composition. He under–exposed the shot, at 1/500 and f11 on 200 ASA Ektachrome, so that the figure is almost in silhouette, while the texture of the ice is quite detailed.

▲ *Tony Duffy* photographed Reiko Kubayashi performing a stag jump with flash–on–camera during a warm–up.

▼ He shot the 1979 World Champions in a death spiral on tungsten balanced Ektachrome pushed two stops.

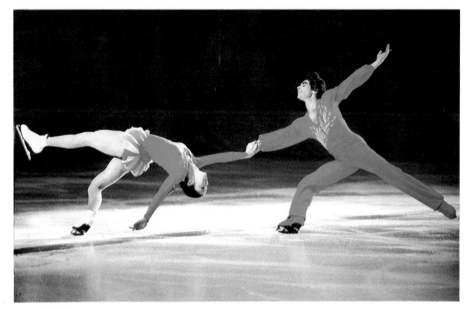

for their warm–up period, watch them very carefully and note when and where they do their best set pieces, so that you can be prepared for them during the competition itself.

Ice hockey

Many of the techniques—and many of the problems—associated with photographing ice skating also apply to ice hockey. The game is one of the fastest in the world, and is hard to photograph unless you accept that you cannot effectively cover every inch of the rink. The most dramatic action takes place around the goal area, with the goal keeper—with his surrealistic protective face mask and heavy padding—contributing a peculiar interest to the shots. A good position to photograph from is parallel to the goal line and a few metres to the side. This tends to foreshorten the action in the goal area and add punch to your shots.

At some ice hockey matches at indoor arenas it is possible to work from a high position and shoot down on the players in the goal mouth. A low angle is more difficult because of the screen around the playing area, designed to protect the spectators from the flying puck.

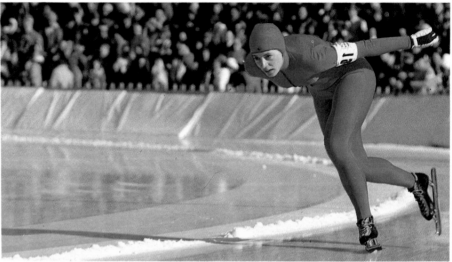

The game begins with the referee dropping the puck between the opposing players and this is always a good opportunity to take pictures: you can convey the element of competition between the teams though they are for the moment relatively static. For once you will be able to escape the restrictions placed upon the photographer by the need for fast shutter speeds to freeze the lightning action.

▲ Lende van de Sitjtje in a 3000m speed race: outdoors, *Tony Duffy* had enough light to freeze the fast motion.

▶ With his shutter set at 1/15, *Erich Baumann* went for an impressionistic shot of the dizzyingly fast sit–spin.

▼ With a 300mm lens, *Tony Duffy* covered the goal mouth as Russia's goal keeper came out against Germany.

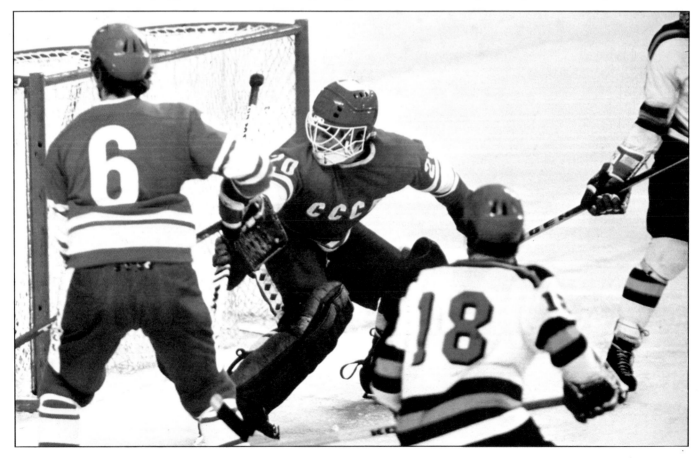

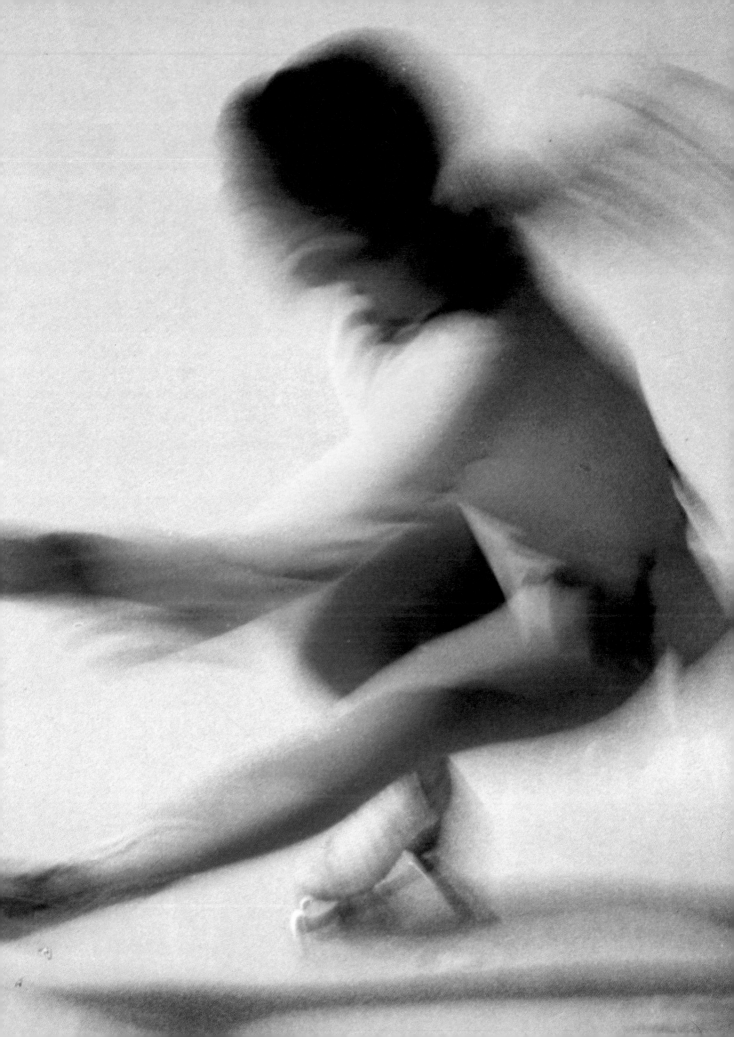

Pitch sports

Whether your interest in photographing pitch sports is primarily that of a supporter or a photographer, a well-timed shot of a winning goal or a crucial save can justly take its place amongst your most treasured possessions. To be able to settle those endless arguments about whether the ball would really have gone in the net with a definitive photograph gives the football fanatic a glorious satisfaction: for the amateur photographer it is a mark of a job well done, and may even herald the beginning of a lucrative hobby photographing sport.

Equipment

Anyone who owns a 35mm SLR is already equipped with the best camera system for the job. Larger format cameras are bulky and limited as to the telephoto lenses available. Fixed focus cameras are less agile at coping with awkward lighting and distance problems. The amount of equipment you need to carry will be dictated by the position you are photographing from

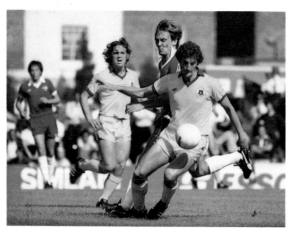

► One of a series of motor-drive shots taken on a 300mm lens at the British Lions v New Zealand Maoris game. *Adrian Murrell*

◄ Typical mid-field play between Chelsea and Everton. *Leo Mason* set a 400mm lens to f5·6 at 1/500 on 64 ASA film.

▼ Following focus on the ball from the touchline *Mason* released the shutter as the forward made his break.

but, wherever you shoot from, you may need to photograph action on the other side of the pitch and a telephoto lens is a necessity. If you have a long telephoto, you also need a tripod, or preferably a monopod which is easier to handle in crowds. A medium focal length zoom is useful if you are closer to the action because it will allow you to frame the shot in the viewfinder.

Motor-drives (or autowinders, which are now supplied as standard items with many modern SLRs) can be a great help to the sports photographer. They not only enable you to keep your eye to the viewfinder when the action is at its peak, but also allow you to catch sequences of pictures of events which occur within fractions of seconds of one another during a game.

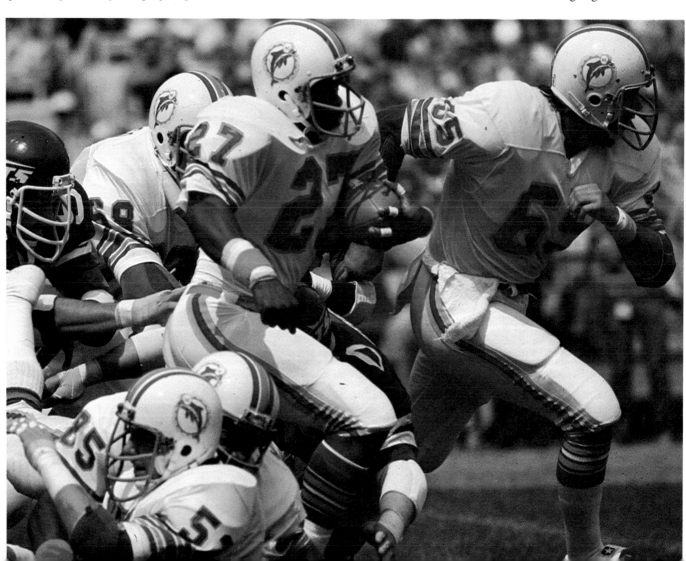

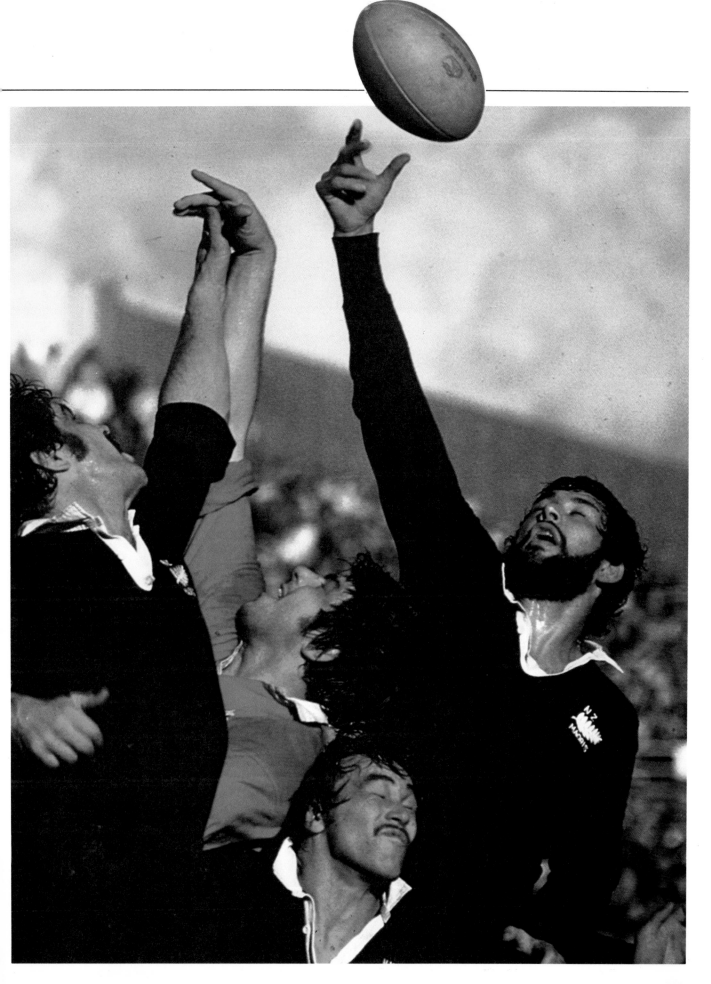

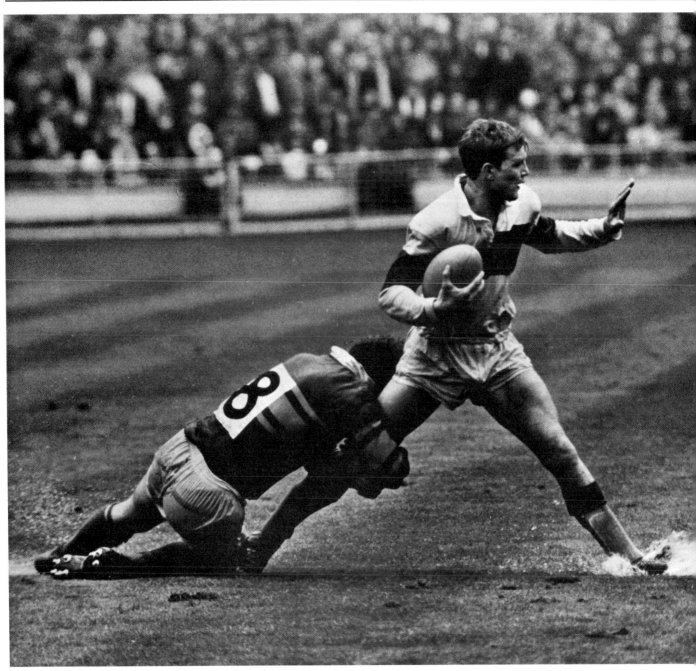

The serious sports photographer with an eye to publication may also feel it worthwhile to take along two camera bodies, one loaded with monochrome and one with colour film.

Film and exposure

The use of long lenses with their relatively small maximum apertures—plus the fast shutter speeds that are necessary to freeze the action—mean that you need a fast film. The most popular type, 400 ASA, has the additional advantage of allowing you to push, or uprate, the basic ASA rating to +2 stops (1600 ASA).

and beyond. This is particularly useful with pitch sports which are generally played in poor winter light. For very bad lighting it is worth noting that Kodak make a 35mm film called 2475 Recording which has a rating of 1600 ASA and can quite satisfactorily be pushed to 3200 or even 6400 ASA.

The best way to take a light reading for the players is off the grass, which approximates to average skin tones. One major exposure problem will probably be the shadow cast by large grandstands at professional games. On a sunny day this shadow can blot out

half the pitch and result in a light loss of as much as two stops. Whereas most black and white films have the latitude to cope with this, colour film is a more difficult problem. The best solution is to determine periodically where you think most of the action is likely to occur and photograph selectively in that area, be it shadow or direct sunlight. As your technique improves you will find it becomes second nature to compensate with shutter speed or aperture without taking your eye from the viewfinder as the players drift in and out of the shadow area.

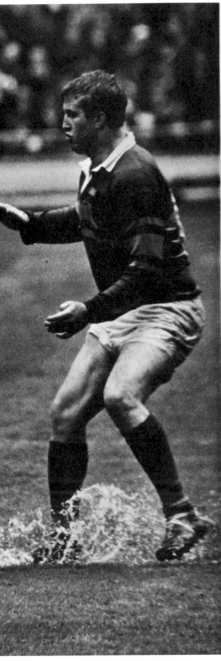

◄ For the crowd, moments like this are too fleeting to be clearly recalled and merge into the electric atmosphere. But an adept photographer can capture such crucial encounters as they happen for analysis later on. *Bryn Campbell*

▼ At a cup final, supporters have their own game to play—a battle of 100,000 wills. With a 300mm lens turned briefly on the terraces, *Don Morley* could show only a fraction of their numbers though foreshortening emphasizes the crush.

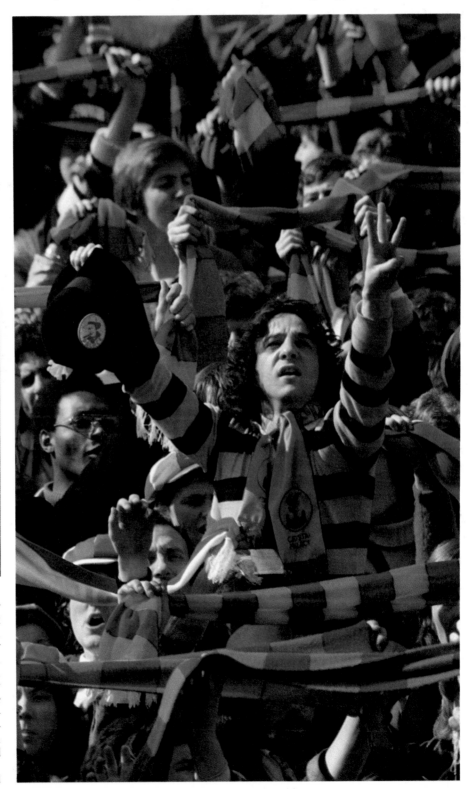

Locations

At top matches played in the larger stadiums, the key positions—such as at the touchline in American and British football and in rugby—are reserved for the professional photographer. With lower divisions and amateur games, however, a letter to the club secretary requesting a field pass will generally be successful. A good way to make yourself known is to offer your photographs to the club for publication in their programme or the local newspaper.

But don't despair of getting any good

pictures if you cannot get right up to the pitch for an important match: with rugby football, in fact, a position at ground level is not necessarily the best place to photograph from, as it may not give a comprehensive view of the pattern of play. Professional sports photographers have photographed pitch sports with very acceptable results from as far as thirty rows back in the spectators' seats.

Photographing from the crowd will require a telephoto lens—preferably 300mm or 400mm—with a tripod or monopod. Find a position as close to the centre of the field as possible: with a 400mm lens you will then be able to cover both goals and all the action midfield. Photographing from behind or alongside the goal remains the traditional spot for pitch sport photography, however. Whether or not you have a field pass, this position will allow you to shorten your focal length to 50–135mm in order to cover the goal area nearest you.

Techniques

Touchline photographers at rugby matches usually prefer to move up and down the pitch with the play and for this a zoom lens can be particularly useful. The peak of the action in field sports usually happens in mid-field, in front of the goal, in scrums or touch downs—and during isolated incidents off the ball. Knowing when these are likely to occur is half the battle, and comes with experience of the sport concerned. However, there are several techniques that will help to speed up your reactions and teach you that anticipation.

The first of these is to isolate the key players who will dictate the pattern of play and around whom the match revolves. When you have identified them, learn to 'follow focus': with this technique, you pan the camera to follow your principal subject in the viewfinder until a suitable moment arrives—when the player is shooting for goal, for instance, or an opposing defender is coming up to tackle, or during the excited moments after a goal has been scored.

The next most important aid to photographing a particular sport well is to get the feel of the game: if you are photographing a sport with which you are unfamiliar you should at least understand the implications of the various movements. Line-outs and tries, penalties and corners each have their own natural build-ups, and pos-

sible consequences. The reaction of the crowd will tell you when a vital run or pass is happening, but you must make sure you know where to look, and if possible have the relevant player in your viewfinder before it happens.

Floodlights

In winter, many of the pitch sports you attend will be partially or wholly flood-lit. The majority of stadiums have adequate lighting for photography, but you will still probably need to push your film to get fast enough shutter speeds to capture the action. If you intend to shoot in colour, check beforehand whether the stadium lights are balanced for daylight film.

Practical tips

● Carry your equipment in a metal box as this not only protects your cameras from bad weather but also doubles as a seat if you are on the touchline.

● Continually check light levels as these can drop very quickly during the winter: getting into the habit of

monitoring light levels is also good photographic discipline.

● Always use the highest possible shutter speed and work down the range as the light drops, rather than compensating with your aperture and sacrificing depth of field.

● When shooting in wet weather, protect your camera in a household plastic bag. Choose a big enough bag so that you can freely wind on your film inside it and cut a hole for the lens, securing it with a rubber band.

● Make sure no rain gets into the camera when you change film as this will show up on your negatives. Always clean your camera thoroughly inside and out after exposure to water.

● Take your film out of its carton and mark the top of the plastic can with a felt tip pen, noting its contents. This makes it quicker and easier to change film and cuts down on baggage.

● Maintain your concentration in the viewfinder and don't get distracted by people around you. Remember that the most spectacular sporting feats often occur when you least expect them.

▲ During long, often wintery and sometimes uneventful moments, the pitch sports photographer can find time to experiment with shots and techniques. This portrait of Joe Namath of the Los Angeles Rams could be carefully planned. About to make a throw, his action is predictable, giving a comparatively long time for framing and focusing at close range. *Tony Duffy* used a Nikon F2 and a 300mm lens: at 64 ASA exposure was 1/500 at f5·6.

▲ Top: to exaggerate the force with which rugby players go down for a scrum, *Leo Mason* added movement with a zoom lens, zooming from 80 to 200mm at 1/60.

▶ Lucky shots cannot be planned for, but good timing can help. At the 1978 League Cup final, *Leo Mason* had just focused on the ball when Denis Tuart kicked the winning goal and he released the shutter by reflex. With a motor-drive this shot may have been lost.

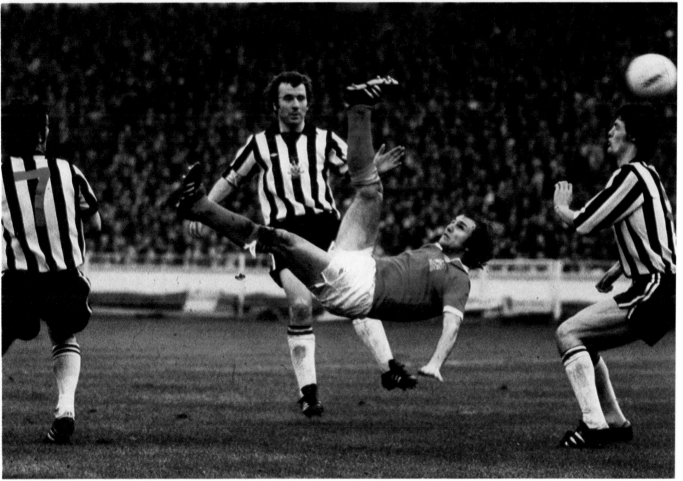

Athletics meetings

Track and field athletics offer the photographer more variety than almost any other sport.

Athletics is about total commitment and competition. This shows on the faces of competitors, whether they are club athletes or internationals. The joy of victory, the agony of defeat and the moment that competitive effort peaks are common to all athletes. In addition, ·track events have dramatic starts. Each of these predictable events is a source of pictures.

The full flavour of athletics can be photographed at local club meetings. These are held most weekends during the summer. It is usually possible to obtain an in-field position at local events. A few complementary prints to the athletes, club secretary and/or local newspaper will ensure a welcome on any return visit.

Addresses of local clubs can be obtained through the local paper or athletics association.

Many schools have their own sports days, and would be grateful for some photographic coverage.

If you plan to cover a big meeting, perhaps at a major stadium, you will have to shoot from the stands. Decide which events to concentrate on and buy a seat near them. A lens of 300mm or longer is essential to fill the frame from the public seats.

Sprinting

It is possible to photograph the start, the middle or the finish of a sprint, but not all three in the same race.

Sprints have an extra competitiveness. Most times all the runners will be in the frame. This does not happen often in long distance races.

Starts in 100m races show the contest well, especially when photographed from the side and slightly to the front. Stop right down to get all eight runners sharp. If the light is too low to do this, keep one or two sprinters really sharp. Let the others go out of focus.

The 200m has a staggered start. Stand outside lane eight and the runners will form a semi-circle back to lane one with the starter behind.

Do not fire the shutter before the starting gun goes off. Runners on the blocks are so keyed up that the shutter noise may set them off. They will not thank you for causing a false start.

Mid-race will see all the runners bunched together. A panned shot can suggest the effort that every sprinter puts in. Shoot at 1/125. This is fast enough to freeze some leg and arm movements and slow enough to blur the crowd in the background.

Finishes can be photographed from two angles: the side and facing the tape. In either case you can pre-focus on the finishing line and wait for the runners to come into shot. Most top sprinters dip at the tape. It is easy to lose sight of their faces, so choose a lower rather than a higher viewpoint.

Middle distance races

The 400m is run in lanes, so perhaps should be considered as a sprint. Certainly everything said about photographing the 200m applies to the 400m, with one important difference: the start and finish of one 400m race can both be photographed.

The 800m and 1500m will be shot at the finish in most cases. Often the race is decided between two or three runners fighting it out on the finishing straight. Moments of real drama often take place on the final bend, where runners cut loose in a sprint for home. However, it can be very difficult to capture this in a still picture.

Ten years ago runners used to just break the tape. Now they are more publicity conscious. They wave their arms, clench their fists, shout for joy and even jump in the air as they cross the line. All this can make for good pictures.

Long distance races

Marathon and cross-country races give the photographer tremendous scope in the use of background, viewpoint and camera technique.

Marathon runners become increasingly spread out as the race continues. A high viewpoint will show them stretching in a long line into the distance. They grab a drink or a sponge at feeding stations as they plod past. Choose a viewpoint that will show the runners' faces as they approach such a station.

Cross-country races are held all round the country during the winter. Study the course beforehand and choose the best places along it to take photographs. These may be on hills, by fences or looking down on a stream. Shoot the start when the field surges off as a mass, then move ahead to each chosen spot.

◄ Photograph the start of a 100m sprint from low down and slightly in front of the line. Focus on one runner and stop down to keep the others as sharp as possible. Set a fast shutter speed, say 1/500, if you want to be sure of stopping the action. Release the shutter as you hear the starting gun, and not before. *Tony Duffy*

▲ Middle distance races may be decided in a fight between two or three runners in the final straight. Pre-focus on a spot where you know they must pass. *Tony Duffy*

▼ Winners often react dramatically. Focus on the tape and shoot from a low angle (the winner may dip his head). *Tony Duffy*

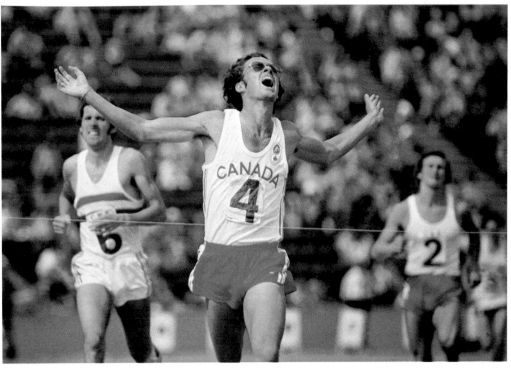

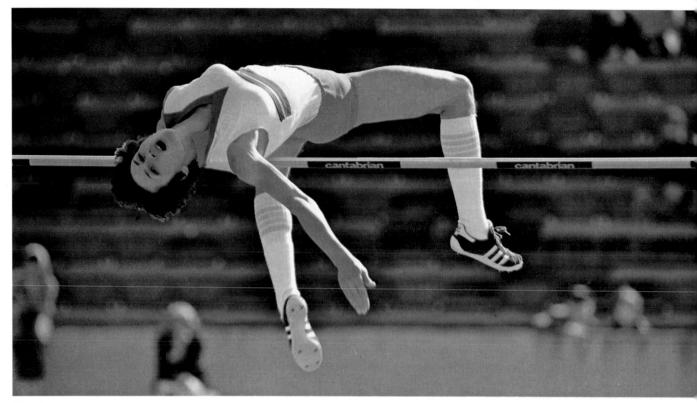

Track events over long distances include the 5000m, 10,000m and the 5000m steeplechase. Try to remember who is in the lead as this is not always clear once the leaders lap the back markers. Watch the competitors' faces towards the end of these races. The runners will be in pain and the agony shows in their expressions.

The prime position in the steeplechase is by the water jump. A low viewpoint, close to the hurdle, will put both the runners and the splashing water within the angle of view of a standard lens. If you can get close enough, a wide angle lens can be used for special effects.

Jumping events

High jumpers use the Fosbury Flop and the conventional straddle in about equal numbers.

'Floppers' clear the bar backwards. A viewpoint slightly behind the bar is best for this style. Jumpers' heads may disappear from view when seen from the front of the bar. Some 'floppers' have an additional tendency to turn their heads to one side. It pays to watch their practice jumps to see which way they face.

Straddle jumpers are best photographed from the front of the bar. They can be photographed on top of the bar or coming down. They will face the camera as they land.

▲ Take a Fosbury Flop from behind the bar. Every 'flopper' jumps in a different way. Watch them in practice. Note how the bar is approached and which way they turn their heads. Straddle jumpers should be photographed from the front. Focus on the bar and wait for the jump. *Tony Duffy*

▼ Shoot a long jumper's landing from the lowest possible angle to catch the flying sand. Use a wide aperture to throw the background out of focus. If it is difficult to guess where the landing will be, shoot from one side of the pit. As you become more expert move round to face the jumper. *Tony Duffy*

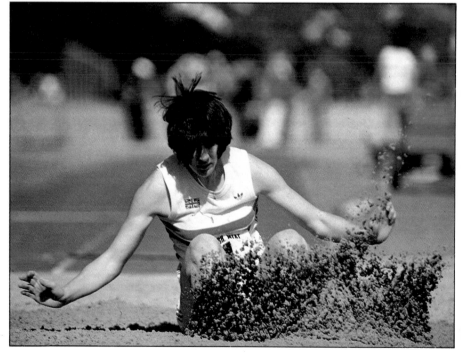

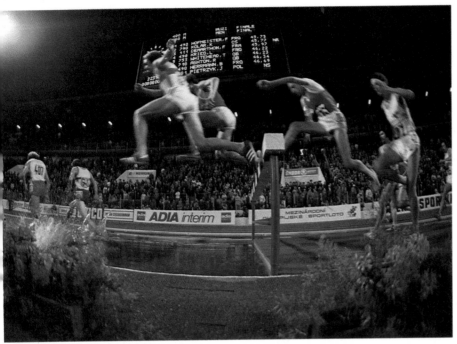

▲ Floodlit athletics meetings can be taken using 400 ASA slide film pushed one or two stops. If the event is being televised then the lighting will approximate to daylight in colour temperature. The water jump is the most interesting hurdle in the steeplechase. A wide angle lens will add variety in a series of long shots. *Tony Duffy*

Long jumpers look dramatic in mid-air at the top of their leap. Equally exciting is the landing when the sand explodes outwards. Shoot the landing from the lowest possible angle.

Pole vaulters look like monkeys on sticks as they reach the top of their ascent. The sport is about the most rewarding of all athletic events. There is the moment when the vaulter thrusts upwards hands pushing the pole away before crossing the bar. And there is the clearance as he sails over. If it is possible to shoot head-on without distracting the vaulter, aim for the moment when he plants the pole and begins the ascent. Glass fibre poles bend through almost 90° at this point.

Throwing events

Hammer and discus throws are made from a wire cage for spectator safety. This presents a problem for photographers. If possible, shoot from low down through the opening of the net. The first turn of the wind-up and the release of both throws are the best time to shoot.

Shot putting is easier to photograph. Viewpoints can be varied easily. Shoot almost head-on for the moment of release, or from the side or behind as the putter glides across the circle.

Javelin has no wire cages to contend with. Shoot just prior to the release. Watch for both left and right hand competitors in the throwing events. Place yourself so that they face the camera when you shoot.

Equipment choice

Being small and quick to use, a 36mm SLR camera is the best choice. A motordrive or autowinder can be useful for shooting sequences, but is not needed for most athletics photography.

Lenses: a 30mm is the best all-round lens for track and field events. Shorter lenses of 100 to 135mm can be used for finishes or for shots between events. To save having to change lenses all the time—which can result in missed shots—it is useful to have two camera bodies. A zoom lens is an alternative. The ideal range is 100–300mm, but such zooms are rare. The more common 70–210 or 80–220mm zooms may not be long enough at their maximum telephoto settings.

Mirror lenses of 500 or 1000mm may be needed for some pictures. Mirror lenses are more compact than long focus or telephoto lenses of the same focal length. **Film:** where possible in bright light use slower films such as 64 ASA Kodachrome for maximum sharpness and colour rendering. However, with long lenses you will need fast shutter speeds to avoid camera shake. Except in bright sunlight, therefore, fast films may be needed.

In poor light, 400 ASA films can be 'pushed' one or two stops to 800 or 1600 ASA if the processing is changed to compensate. Many laboratories will do this for a small extra charge.

Supports: when using long lenses it is preferable to use the camera on a tripod. This will not be possible if you are taking pictures from the stands, and in the field a tripod can be cumbersome and get in the way. A good compromise is to use a monopod, (on one leg), which provides steadying support but is easy to carry around and to set up.

Backgrounds and viewpoint

When there are stands and spectators, the athletes you are photographing can be lost in the background confusion. To avoid this, use your telephoto at, or close to, full aperture. This will throw the background out of focus and make the subject stand out.

With jumping events, choose a low viewpoint to place the subject against the sky. If you are photographing from the stands, the height will often let you position athletes against the simpler background of the grass inside the track.

Pre-focusing technique

It is difficult to keep fast-moving athletes in focus, so don't try. Instead, *prefocus* on a fixed point where the athlete is going to pass. For example, focus on the finishing line, on the bar for high jumping or pole-vaulting, or on a particular fence in the steeplechase. Follow your subject in the viewfinder, but without changing the focus setting. When he or she reaches your predetermined point, press the shutter release. That way you are sure to get sharp pictures.

Summary

● Choose 35mm equipment for versatility and ease of focusing

● Use a 300mm or 400mm lens for field or track events, but keep a short telephoto or a standard lens handy for use between events.

● Use wide apertures to throw the background out of focus.

● Vary your viewpoint to obtain simple backgrounds and add interest.

● Practise focusing quickly (on pedestrians or moving traffic, for example) before going to an athletics meeting.

● Learn as much as you can about the sports you wish to photograph. If you understand what is happening you stand more chance of success.

Indoor sports

The first visit to an indoor sports arena with a camera can bring a few surprises. Low light combined with fast action tends to send the TTL meter way into the minus sector, and there are other problems that it is difficult to anticipate. 'Be prepared' is a motto that can save a wasted trip or rolls of unsatisfactory pictures. Here are some tips on what to anticipate before you set off.

The sports considered are those which offer no particular advantage to the professional with his press card. Among them are wrestling, amateur snooker, judo and the martial arts, basketball, squash, showjumping, boxing, table tennis and floodlit football, which—though not an indoor sport—involves similar techniques.

Anticipating lighting problems

It is worth telephoning the venue before you go to find out from the manager what type of lights are to be used. Most stadiums which regularly hold televised events will have installed lights which are corrected at 3200 Kelvin for tungsten colour slide film.

If you cannot find out what type of lighting is used carry both daylight and artificial light balanced films. Take both medium and high speed daylight films to cope with all eventualities. You may be able to find out on the night what type of lighting is used from a technician at the venue. Or simply ask yourself if the lighting looks yellower than normal daylight. If so there may be sodium lamps in the arena. Does it look rather green? There may be mercury discharge lamps.

To avoid a warm colour cast thrown by light which is warmer than daylight, use tungsten balanced film—if you are able to get reasonable exposure settings at the 160 ASA speed at which it is available. If not, use daylight film with correction filters. However, remember that if light is at a premium, the correction filter itself will cut out much of the light reaching the film and limit your exposure.

Often the only solution is to give in and accept the colour cast given by artificial light on daylight film, in order to retain fast shutter speeds. Uprating the film beyond the manufacturer's specifications may be another solution. If you uprate tungsten film, the colour may be more accurate than if you were using fast daylight film, but the image quality will suffer.

Uprating film is a good expedient in an emergency, but in general you should never use a faster film than absolutely

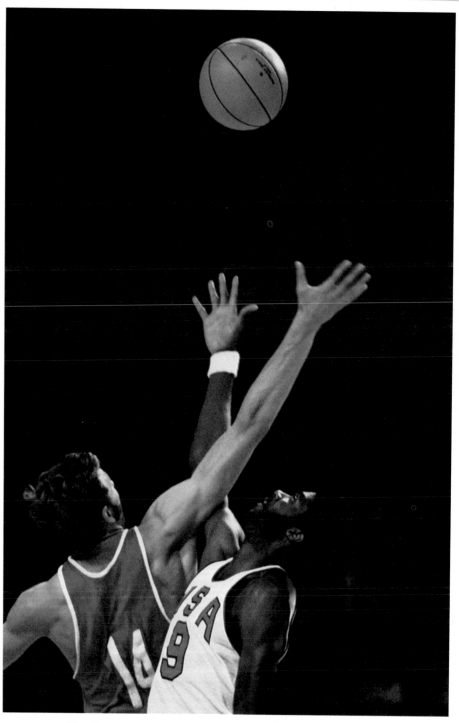

necessary. The best way to make sure of this is to go to the arena in advance and try out various exposures and ASA speeds.

One pitfall to be aware of is the mixed light you may encounter in modern sports halls which have artificial lighting plus glass roofs and large windows. This will give an inevitably patchy result. You can minimise it by framing your shots with this colour difference—

almost invisible to the eye but evident on film—strongly in mind. Early in the day, when daylight predominates, use daylight film. Later on the different light sources will be in a confusing balance, so wait until after dark and change to tungsten balanced film.

Of course, situations like this are no problem to the black and white photographer. The extra daylight will simply boost the overall light level, allowing

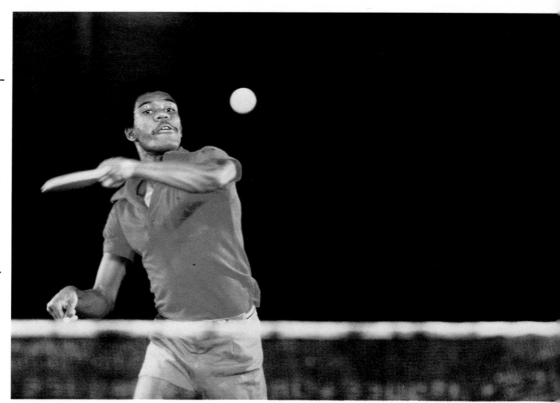

◀ Low light indoors needs longer shutter speeds than normal for action shots. *Tony Duffy* got away with 1/125 here because he shot as both the players and the ball had momentarily stopped moving upwards and before they began to drop down again.

▶ A fast 300mm lens gave *Don Morley* an exposure of 1/250 at f2·8 with 160 ASA tungsten film pushed one stop. With a maximum aperture of f4·5, the film would have been pushed to 640 ASA.

▼ In sports like wrestling some moments are almost static. Here *Don Morley* used 1/60 at f2·8 on 125 ASA for the strained expressions.

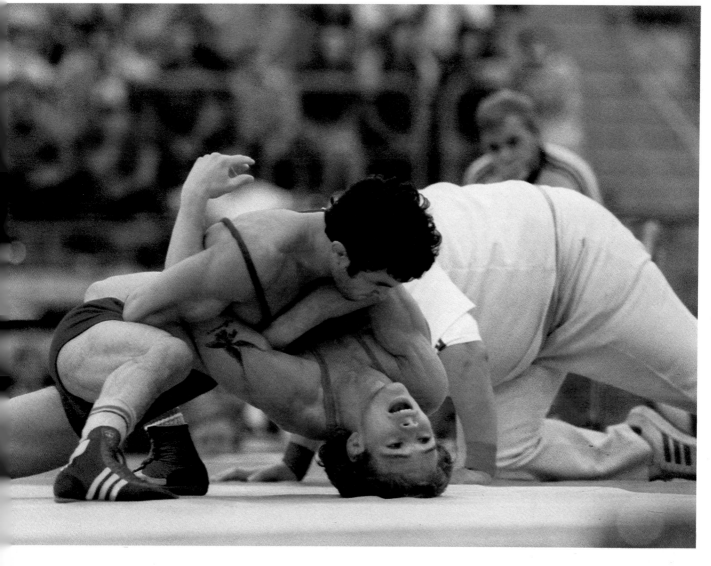

more latitude in exposures—or even allowing the use of a slower film with better quality results.

Viewpoint and lenses

Light levels are bound up with the lenses you use. A wide angle or a standard lens may have a maximum aperture as wide as f1·4, so you can work in lower light levels than with telephoto lenses. These have smaller maximum apertures, like f4 and f5·6. The lenses you use will in turn depend on where you are in relation to the action. The best viewpoint depends on the sport you are wanting to shoot, but in general, the best preparation is to decide on the kind of shots you want, and the shots you will be able to get with the lighting and the lenses you have available. Then book your seat well in advance.

Most venues are fairly flexible, and will not mind you moving around in the aisles. But remember that others have also paid to watch the game, and don't obstruct their view. If in doubt, play safe and pay for a 'ringside' seat.

Few amateurs—and few professionals—are in the happy position of being able to use any focal length lens that seems appropriate. Do not waste time trying for shots which you have not the equipment to achieve.

For example, if you were lucky enough to be photographing a table tennis match with a 300mm f2·8 lens, you would be able to get shots of the player at the opposite end of the table from a front row seat. Under the normal minimum lighting conditions at a table tennis tournament, this would mean uprating your film from 400 to 1600 ASA—even with the wide aperture available. With this you would be able to get a fast enough shutter speed of 1/125 at f2·8.

But you won't have a 300mm f2·8 lens, only a 135mm or 200mm so wait for the doubles tournament, when you will be able to fill the frame with a pair of players. If your longest fast lens is an 85mm or 50mm f2, you will have no hope of filling the frame even in doubles events, so choose a seat at the centre of the side of the table. You can then get shots of either end of the table at around 1/500 at f2, or decide on better quality and leave the film speed at 400 ASA. This example serves to demonstrate the number of complex variables to be considered when you set out to photograph under these conditions. Some of these can be simplified if you can take along two camera bodies. Do not uprate the film in both bodies to

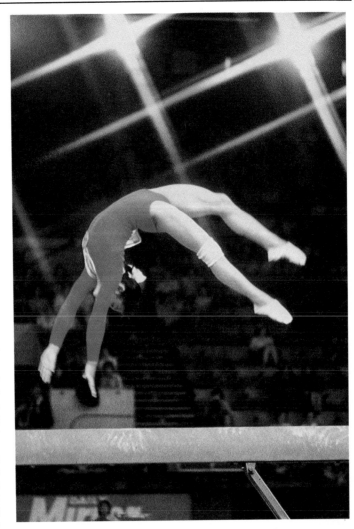

▲ If you catch sight of an action happening in the viewfinder then you have missed it on the film in your camera! *Tony Duffy* has enough experience to anticipate shots like this. He has a motordrive fitted to the camera but uses it only to avoid having to take his eye from the camera to wind on the film. He finds it more accurate to time each shot separately than to keep his finger on the shutter release for several motordrive shots.

▶ Study your subjects so that you can predict the best shots. Riders often tend to lean the same way over jumps *another* rider and the shot would have failed. *Don Morley.*

the maximum. Save on quality by using the slower rated film with your faster lenses.

Exposing for action

Most sports involve rapid movements which will require minimum shutter speeds of 1/250 to stop peak action. It is easy to misread what is really happening. For instance, in tennis, squash, badminton, or table tennis it is important to have the ball in the shot. This means that you are able to use a slower

shutter speed to take the shot either before or after the player has made his stroke—either *before* or *after* the fastest, peak action.

Don't overlook moments of concentration, during the service or waiting to receive the ball. Such moments call for shutter speeds of only 1/125. Even when players are in motion, your shutter speeds will depend on the type of motion involved. It would take a much faster shutter speed to freeze a player diving sideways across the frame to reach the

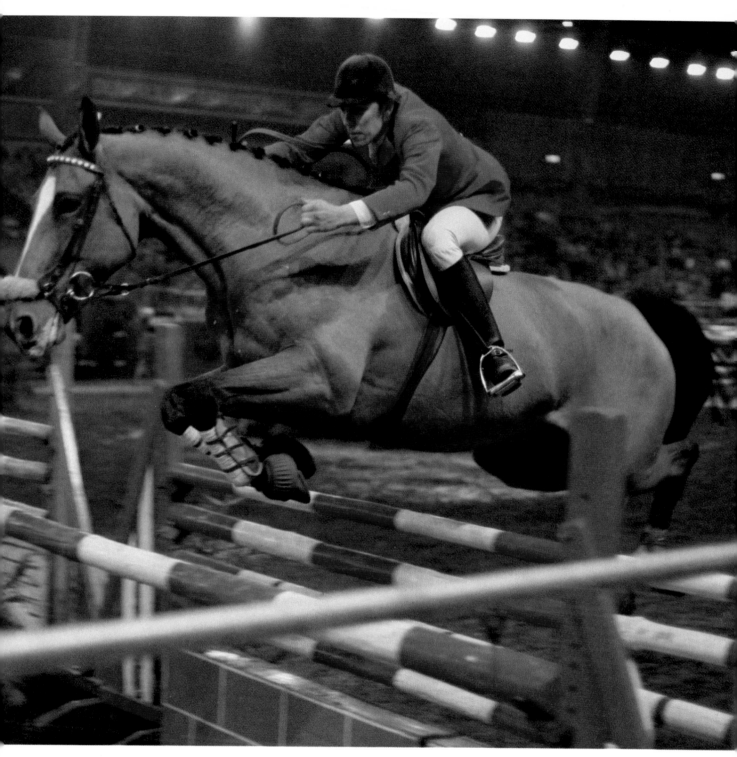

ball than if he were diving forwards or away from the camera.

Movement in several directions—an arm out one way and a leg to balance it the other way—needs a faster shutter speed. Compare this to a shot of several basketball players leaping upwards to the basket. All the movement is at a similar pace in the same direction and, moreover, there will be a moment of relative stillness at the top of the leap. With a little experience you can spot these moments when, even under the poorest lighting conditions you can use slow shutter speeds, take pictures at smaller apertures with greater depth of field, or use slower film for better quality. Your skill with the camera depends partly on knowing the sport. Experience of individual teams or players can also help. For example, in show-jumping, riders tend to hang over the horse's neck on one side or the other. If you are on the wrong side, you will not get the rider's face in the shot and the picture will fail.

Keep a record

The key lesson with problems concerned with lighting, exposure or the game itself is *keep a record*. Note down what light levels you found at a particular venue with a particular sport. Record the lenses and shutter speeds you used, whether you used a filter, whether you uprated the film, even who plays left-handed. Records like this will eventually prove invaluable in predicting what you will need for good pictures in difficult conditions.

Glossary

Words in *italics* appear as separate entries.

A

Angle of view This is the maximum angle seen by a lens. Most so-called standard lenses (for example 50mm on a 35mm camera) have an angle of view of about 50°. Lenses of long focal length (200mm for example) have narrower angles and lenses of short focal length (eg 28mm) have wider angles of view.

Aperture The circular opening within a camera lens system that controls the brightness of the image striking the film. Most apertures are variable—the size of the film opening being indicated by the f number. (See *Relative aperture*).

Artificial light This term usually refers to light that has specifically been set-up by the photographer. This commonly consists of floodlights, photographic lamps, or flash lights (electronic or bulb).

ASA American Standards Association. The sensitivity (speed with which it reacts to light) of a film can be measured by the ASA standard or by other standards systems, such as DIN. The ASA film speed scale is arithmetical—a film of 200 ASA is twice as fast as a 100 ASA film and half the speed of a 400 ASA film. See also *ISO*.

Automatic exposure A system within a camera which automatically sets the correct exposure for the film being used and the scene being photographed. There are three main types:
1 Aperture priority—the photographer selects the aperture and the camera automatically selects the correct shutter speed
2 Shutter priority—the photographer selects the shutter speed and the camera sets the correct aperture.
3 Programmed—the camera sets an appropriate shutter speed/aperture combination according to a pre-programmed selection.

Available light A general term describing the existing light on the subject. It usually refers to low levels of illumination—for example, at night or indoors.

B

Back light A light directed on to the subject from behind so the subject is between the back light and the camera. This gives a silhouetted subject with a tracing of light around the outer edge of the subject, and is sometimes referred to as rim lighting.

Boom light A light (electronic, flash or tungsten) that is suspended at the end of a long horizontal pole and counter-balanced by a weight on the other end of the pole. A boom light is used where a light on a conventional stand would show in the picture area, for example, where a top light is needed to illuminate the hair in a portrait.

Bounce light Light (electronic flash or tungsten) that is bounced off a reflecting surface. It gives softer (more diffuse) illumination than a direct light and produces a more even lighting of the subject. There is a loss of light power because of absorption at the reflecting surface and the increased light-to-subject distance. It is best to use white surfaces since these absorb only a small amount of light and do not colour the illumination.

Bracketing To make a series of different exposures so that one correct exposure results. This technique is useful for non-average subjects and where film latitude is small (colour slides). Expose the film using the most likely camera setting, found with a light meter or by guessing. Then use different camera settings to give more and then less exposure than the nominally correct setting. A bracketing series might be: 1/60th sec f8, 1/60th sec f5·6, 1/60th sec f11, *or* 1/60th sec f8, 1/30th sec f8, 1/125th sec f8.

C

Cable release A flexible cable which is attached (usually screwed-in) to the shutter release and used for relatively long exposure times (1/8 and more). The operator depresses the plunger on the cable to release the shutter, remotely. This prevents the camera from moving during the exposure.

CC filters These are 'colour correcting' or 'colour compensating' filters which may be used either in front of the camera or when printing colour film, to modify the final overall colour of the photograph. Their various strengths are indicated by numbers usually ranging from 05 to 50. Filters may by combined to give a complete range of correction.

Colour balance The overall colour cast of the film or print. Normally a film or print is balanced to give grey neutrals (such as a road or pavement) and pleasing skin tones. The colour balance preferred by the viewer is a subjective choice, and this is the reason for the variety of colour films available.

Colour cast A local or overall bias in the colour of a print or transparency. Colour casts are caused mainly by poor processing and printing, the use of light sources which do not match the film sensitivity, inappropriate film storage (high temperature and humidity), and long exposure times.

Colour negative A type of film which is used primarily to give colour prints, although colour transparencies and black and white prints may also be produced. The colours of a colour negative are complementary in colour and hue to the original subject colours. The characteristic orange appearance of all colour negatives comes from the built-in corrector which improves overall colour fidelity.

Colour reversal A colour film or paper which produces a positive image directly from a positive original. Thus a colour reversal film gives a colour transparency directly from the original scene and a colour reversal paper (for example, Cibachrome or Ektachrome paper) gives a positive print directly from a transparency.

Colour temperature Different white light sources emit a different mixture of colours. Often, the colour quality of a light source is measured in terms of colour temperature. Sources rich in red light have a low colour temperature—for example, photofloods at 3400 (Kelvin)—and sources rich in blue light have a high colour temperature—for example, daylight at 5500K. Colour films have to be balanced to match the light source in use, and films are made to suit tungsten lamps (3200K) and daylight (5500K).

Contrast The variation of image tones from the shadows of the scene, through its mid-tones, to the highlights. Contrast depends on the type of subject, scene brightness range, film, development and printing.

Conversion filter Any filter which converts one standard light source to another standard light source. For example, a Wratten 85B filter converts daylight to photoflood type illumination. This filter, when placed in front of the camera lens, enables a camera loaded with tungsten colour film to give correct colour photographs in daylight. To compensate for the light absorbed by the filter, you need extra exposure (determined by the filter factor).

Cropping The selection of a portion of the original format of a negative or print so as to modify the composition. Cropping can be done during enlarging or later when the print is trimmed.

D

Daylight colour film A colour film which is designed to be used in daylight without or with electronic flash or blue flash-bulbs. This film type can also be used in tungsten or fluorescent lighting if a suitable filter is put in front of the lens or light source.

Depth of field The distance between the nearest and furthest points of the subject which are acceptably sharp. Depth of field can be increased by using small apertures (large f numbers), and/or short focal-length lenses and/or by taking the photograph from further away. Use of large apertures (small f numbers), long focal-length lenses, and near subjects reduces depth of field.

Depth of field preview A facility available on many SLR cameras which stops down the lens to the shooting aperture so that the depth of field can be seen.

Diffuse light source Any light source which produces indistinct and relatively light shadows with a soft outline. The larger and more even the light source is the more diffuse will be the resulting illumination.

Diffused image An image which has indistinct edges and appears 'soft'. Overall- or partially-diffused images can be produced in the camera by using special lenses and filters, or by shooting through various 'filmy' substances such as vaseline and sellotape.

DIN Deutsche Industrie Normen. A film speed system used by Germany and some other European countries. An increase/decrease of 3 DIN units indicates a doubling/halving of film speed, that is a film of 21 DIN (100 ASA) is half the speed of a 24 DIN (200 ASA) film, and double the speed of an 18 DIN (50 ASA) film. See also *ISO*.

E

Electronic flash A unit which produces a very bright flash of light which lasts only for a short time (usually between 1/500-1/4000 second). This electronic flash is caused by a high voltage discharge between two electrodes enclosed in a glass cylindrical bulb containing an inert gas such as argon or krypton.

Exposure The result of allowing light to act on a photosensitive material. The amount of exposure depends on both the intensity of the light and the time it is allowed to fall on the sensitive material.

Exposure factor The increase in exposure, normally expressed as a multiplication factor, which is needed when using accessories such as filters, extension tubes, and bellows. For example, when using a filter with a x2 exposure factor the exposure time must be doubled or the aperture opened by one stop.

Exposure meter An instrument which measures the intensity of light falling on (incident reading) or reflected by (reflected reading) the subject. Exposure meters can be separate or built into a camera; the latter type usually gives a readout in the viewfinder and may also automatically adjust the camera settings.

F

Fast films Films that are very sensitive to light and require only a small exposure. They are ideal for photography in dimly lit places, or where fast shutter speeds (for example; 1/500) and/or small apertures (for example, f16) are desired. These fast films are more grainy than slower films.

Fill light Any light which adds to the main (key) illumination without altering the overall character of the lighting. Usually fill lights are positioned near the camera, thereby avoiding extra shadows, and are used to increase detail in the shadows. They are ideal for back-lit portraits and studio work.

Film speed See *ASA*, *DIN* and *ISO*.

Filter Any material which, when placed in front of a light source or lens, absorbs some of the light coming through it. Filters are usually made of glass, plastic or gelatin-coated plastic and in photography are mainly used to modify the light reaching the film, or in colour printing to change the colour of the light reaching the paper.

Flash See *Electronic flash*, *Flashbulb* and *Flashcube*.

Flashbulb A glass bulb filled with a flammable material (such as magnesium or zirconium) and oxygen, which when ignited burns with an intense flash of light. Flashbulbs are usually triggered by a small electrical current and are synchronized to be near their peak output when the shutter is open.

Flashcube An arrangement of four flashbulbs that are positioned on four sides of a cube—the cube being automatically rotated to the next bulb after one is fired. The bulbs are fired either by a small electrical current or by a simple percussion mechanism.

Floodlight A tungsten light (usually 250 or 500 watts) which is within a relatively

large dish reflector.

f numbers The series of internationally agreed numbers which are marked on lenses and indicate the brightness of the image on the film plane—so all lenses set to f8 produce the same image brightness when they are focused on infinity. The f number series is 1·4, 2, 2·8, 4, 5·6, 8, 11, 16, 22, 32 etc—changing to the next largest number decreases the image brightness to ½, and moving to the next smallest number doubles the image brightness.

Focal length The distance between the optical centre of the lens (not necessarily within the lens itself) and the film when the lens is focused on infinity. Focal length is related to the angle of view of the lens—wide-angle lenses have short focal lengths (e.g. 28mm) and narrow-angle lenses have long focal lengths (e.g. 200mm).

G

Grain The random pattern within the photographic emulsion that is made up of the final (processed) metallic silver image. The grain pattern depends on the film emulsion, plus the type and degree of development.

H

High key A photograph that consists of mainly light tones, a few middle tones, and possibly small areas of dark tones. A high key photograph is achieved by using diffused lighting and a subject that is predominantly light in tone.

Highlight Those parts of the subject or photograph that are just darker than pure white eg lights shining off reflecting surfaces (sun on water, light shining through or on leaves).

I

Incident light The light that falls on the subject rather than that which is reflected from it. Light meter readings that measure incident light (incident readings) are not influenced by the subject and are better for non-average subjects, such as objects against black or white backgrounds.

ISO International Standards Organisation. The ISO number indicates the film speed and aims to replace the dual ASA and DIN systems. For example, a film rating of ASA 100, 21 DIN becomes ISO 100/21°.

K

Kelvin A temperature scale which is used to indicate the colour of a light source. Kelvin scale equals Celsius plus 273, thus 100 degrees C equals 373K. See *Colour temperature.*

Key light The main light source in a lighting set-up which is usually supplemented by other less powerful lights and possibly reflectors. The key light sets the overall character of the lighting.

L

Lens hood (shade) A conical piece of metal, plastic or rubber which is clamped or screwed on to the front of a lens. Its purpose is to prevent bright light sources, such as the sun which are outside the lens field of view from striking the lens directly and degrading the image by reducing contrast (flare).

Light meter See *Exposure meter.*

Lighting ratios This refers to the comparative intensities of the main (key) light source and the fill-in light(s). For example, a studio portrait may be lit by a main light that is four times the intensity of a fill-in light (which lightens the shadows); this represents a lighting ratio of 4:1. Outdoors the lighting ratio depends on the weather—a cloudless day representing a high ratio, and an overcast day (where the clouds act as reflectors) a low lighting ratio.

Long focus lens Commonly used slang for 'long focal length lens', which means any lens with a greater focal length than a standard lens, for example, 85mm, 135mm and 300mm lenses on a 35mm camera. These long focal length lenses are ideal for portraiture and sports.

Low key This describes any image which consists mainly of dark tones with occasional mid and light tones.

M

Motor-drive see *Power winder.*

Multiple exposure The process of making more than one exposure on the same piece of film, thus allowing one image to be built on top of another. Multiple exposure is easy to achieve with large studio and most medium format cameras, but can be difficult with miniature cameras (35mm), 110 etc.) because most have a double exposure prevention system—the film must be advanced to tension the shutter.

N

Normal lens A phrase sometimes used to describe a 'standard' lens—the lens most often used, and considered by most photographers and camera manufacturers as the one which gives an image most closely resembling normal eye vision. The normal lens for 35mm cameras has a focal length of around 50mm.

O

Over-exposure Exposure which is much more than the 'normal' 'correct' exposure for the film or paper being used. It cause loss of highlight detail and reduction of image quality.

P

Pentaprism An optical device, used on most 35mm SLR cameras, to present the focusing screen image right way round and upright.

Photoflood An overrun tungsten bulb (subjected to a higher voltage than the bulb is designed for) which gives a bright light having a colour temperature of 3400K.

Polarizing filter (or pola) filter A filter which, depending on its orientation, absorbs polarized light. It can reduce reflections from surfaces such as water and glass and also darken skies in colour shots.

Power winder A camera attachment (or built-in unit) which automatically advances the film from one frame to the next. It enables the photographer to make about three exposures every second. Motor drives are more sophisticated power winders, designed to produce more frames per second.

Push processing The overdevelopment of films or papers which have been under-exposed. See *Uprating a film.*

Q

Quartz tungsten lamp See *Tungsten halogen lamp.*

R

Red eye This 'bloodshot' appearance of eyes can occur when taking portraits with a flashgun attached to the camera. It is avoided by moving the flashgun away from the camera.

Reflector Any surface which is used to reflect light towards the subject. They can range from a curved metal bowl surrounding the light source to simply a matt white board.

Relative aperture This is the fractional number found by dividing the lens focal length by the diameter of the light beam entering the lens. The more commonly used f-number is the reciprocal of the relative aperture.

Rim light Light placed behind the subject to give a pencil of light around the subject's outline. Rim lighting is often used to highlight hair.

S

Saturation The purity of a colour. The purest colours are spectrum colours (100% saturation and the least pure are greys (0% saturation).

Single lens reflex (SLR) A camera which views the subject through the 'taking' lens via a mirror. Many SLRs also incorporate a *pentaprism.*

Skylight filter A filter which absorbs UV light, reducing excessive blueness in colour films and removing some distant haze. Use of the filter does not alter exposure settings.

Slide See *Transparency.*

Slow film see *Film speed; Fast film.*

Snoot Cone-shaped lamp attachment which concentrates the light into a small circular area.

Soft-focus lens A lens designed to give slightly unsharp images. This type of lens is used primarily for portraiture.

Spotlight A light source which produces a concentrated beam. They give hard-edged shadows and are used as a main light or to accentuate texture.

Standard lens See *Normal lens.*

Stop Another term for aperture or exposure control. For example, to reduce exposure by two stops means to either reduce the aperture (for example, f8 to f16) or increase the shutter speed (1/60 sec to 1/250 sec) by two settings.

Stopping down The act of reducing the lens aperture size ie increasing the f-number. Stopping down increases the depth of field.

Strobe light American slang for 'electronic flash'. More precisely, a strobe light is a pulsating electronic flash unit which repeats its flash at regular intervals. The rate of flashing can often be varied.

Synchronization The precise timing of flash light with the camera shutter. When using electronic flash the camera should be set on X sync and a shutter speed of 1/125 sec or longer (see camera instructions) for focal plane shutters and any speed with leaf shutters. With flashbulbs use M sync and 1/60 sec or longer (see camera instructions). If only X sync is available use flashbulbs at 1/8 sec or longer.

T

Telephoto lens A long focal-length lens of special design to minimize its physical length. Most narrow-angle lenses are of telephoto design.

Through-the-lens (TTL) metering Any exposure metering system built into a camera which reads the light after it has passed through the lens. TTL metering takes into account filters, extension tubes and any other lens attachments. It gives only reflected light readings.

TLR See *Twin lens reflex.*

Transparency A colour or black-and-white positive image on film designed for projection. Also known as a slide.

Tripod A three-legged camera support. Various tripod heads are available with various adjustments, and some tripods also have a centre column for easy height control.

TTL metering See *Through-the-lens metering.*

Tungsten film Any film balanced for 3200K lighting. Most studio tungsten lighting is of 3200K colour quality.

Tungsten-halogen lamp A special design of tungsten lamp which burns very brightly and has a stable colour throughout its relatively long life. Its main disadvantages are the extreme heat generated and the difficulty of obtaining precise control of lighting quality.

Tungsten light A light source which produces light by passing electricity through a tungsten wire. Most domestic and much studio lighting uses tungsten.

Twin lens reflex (TLR) A camera which has two lenses of the same focal length —one for viewing the subject and one for exposing the film. The viewing lens is mounted above the taking lens.

U

Uprating a film The technique of setting the film at a higher ASA setting so it acts as if it were a faster film but is consequently underexposed. This is usually followed by overdevelopment of the film to obtain satisfactory results.

V

Variable focus lens Slang term for lens having a range of focal lengths.

W

Wide-angle lens A short focal-length lens which records a wide angle of view. It is used for landscape studies and when working in confined spaces.

Z

Zoom lens Alternative name for a lens having a range of focal lengths. One zoom lens can replace several fixed focal-length lenses

Index

A

Abstracts:
 nudes, 124–5, 126, 128
 on the beach, 192, 195
Action pictures, 178, 193, 208–35
 children, 84, 87, 88, 90–95
 indoor sports, 234–5
 winter sports, 200–201, 212–15
Adventure playgrounds, 92
Alpine ski-racing, 212, 213–14, 215
Aperture, 16, 17, 47, 54, 66, 70, 116
Athletics meetings, 228–31
 backgrounds and viewpoint, 230
 equipment and preparation, 230–31
 floodlit, 231
 races, 228, 229

B

Babies, photographing, 70, 74–9
 candid pictures, 75
 close-ups, 76
 keeping a record, 76–9
 lighting and background, 76
 planned pictures, 75–6
 see also Children
Backgrounds:
 athletic meetings, 230, 231
 baby photographs, 76
 children at play, 94
 contrasting and complementary, 30
 double portraits, 40–41
 fashion pictures, 141
 for atmosphere and composition, 31
 light, 36
 nude photographs, 104
 parades, 171
 portraits, 22, 30, 32, 34
 romantic glamour pictures, 130
 semi-aware pictures, 16–17
 wedding photographs, 178
Back lighting, 20, 40, 50, 158
Beach photographs, 190–95
 children in, 190
 games and sports, 190, 193
 lighting and exposure, 194
 nudes, 103, 120–21, 191
 people, 190–92
 portraits, 190, 192
 rocks, seaweed and shells, 192, 194
Black and white film, 55, 57, 87, 88
Blur, 95, 145, 172–3, 208–9
Bonfire photographs, 68
Bounce brackets, 60, 61
Brightness range metering, 57
Burning-in, 114

C

Cable release, 22, 32, 42, 160
Camera angles, 126, 128
Camera clubs, nude photography
 sessions with, 102, 121
Camera shake, 32, 60, 66, 172–3
Cameron, Julia Margaret, 32
Candid photographs, 13, 38, 44–9
 aperture, 47
 babies, 75
 children, 70–72, 73, 83, 84, 85, 88
 close-ups, 83
 groups, 162–7
 lenses, 44, 45
 parties and celebrations, 175
 strangers, 205
 weddings, 178, 180, 181
Candlelight pictures, 66–9, 175, 176, 177
 creative effects, 68
 exposure, 67–8
 photographs by daylight and, 89, 115
 shutter speeds and film speed, 66–7
Cartier-Bresson, Henri, 45, 49, 162, 164
Check light or confidence light, 60, 62
Children, photographing, 70–95
 at play, 83, 84, 89, 90–95
 babies, 70, 74–9
 camera-shyness, 70
 candid pictures, 70–72, 73, 83, 84, 85

Children, photographing cont.
 close-up shots, 72
 compiling an album, 72–3
 equipment, 94–5
 flash, 70, 71, 94–5
 lenses, 94
 on the beach, 190
 on holiday, 184
 and pets, 87
 schoolchildren, 86–9
 set-up situations, 73
 snow pictures, 196
 techniques, 70–72, 94–5
 toddlers, 80–85
Christmas tree photographs, 174, 176, 177
Close-framing, 124, 128
Close-ups, children, 72, 76, 82, 83–4
Clothes, models', 96, 130, 140, 145, 150, 155
Colour casts, 66–7, 122, 123, 232
Colour negative film, 55, 57, 62
Colour slides (transparencies), 55, 57, 60, 62, 122
Combination prints, 73
Composition:
 background for, 31
 groups, 156, 157, 158–9, 162–4, 165
 holiday pictures, 184
 nudes, 123
 portraits, 38, 86–7
Cropping, 124–5, 128

D

Dance in pictures, 208–11
 equipment, 208–9
 how to begin, 211
 interpreting the dance, 209–11
 peak of the action, 208
 stage lighting, 208, 209
Daylight see Natural daylight
Delayed action time release, 42
Depth of field, 17, 32, 47
Diffusers, 106–7, 126
Diffusing screens, 31
Dinner party photographs, 177
Distortions, 23, 123
 reflected self-portraits, 42, 43
 using wide-angle lenses, 23, 32, 33
Dodging, 114
Double portraits, 38–41
 composition, 38
 conveying a relationship, 40
 lighting, 40

E

Equipment, 32, 123
 athletics meetings, 230
 beach pictures, 190
 children at play, 94–5
 dance photographs, 208–9
 group pictures, 166–7
 parades and processions, 170–72
 pitch sports, 222, 224, 226
 safety, 172
 snow pictures, 213
 wedding pictures, 181
 winter mountain holidays, 196, 200
Exposure(s), 54, 112, 114, 116, 172, 173
 beach pictures, 194
 candlelight, 66, 67–8
 flash, 60, 62, 63, 116, 175
 indoor sports action pictures, 218, 234–5
 multiple, 42, 62, 64, 73
 nudes, 112, 114, 116, 121–2, 126
 parties and celebrations, 175
 pitch sports, 224
 snow pictures, 200
Exposure metering, 50–59, 112, 114, 115, 191
 brightness range metering, 57
 candlelight, 67–8
 contrasty scenes, 56
 difficult subjects, 56–9
 hand-held, 54, 56, 67, 115
 high and low key subjects, 59

Exposure metering cont.
 incident light meters, 50, 52, 53, 56
 key tone method, 57, 59
 limitations, 55
 metering tones, 52, 59, 219
 reflected light meters, 50, 52, 56
 tone values, 52, 55
 TTL, 50, 51, 52, 53, 54, 55, 56, 67, 112, 208
Extension leads/cable, 60, 87, 116, 176
Eyes, importance in portraits of, 10, 13

F

f stops, 52, 54, 55, 56, 57
Fashion pictures, 140–45
 background, 141
 indoors, 140, 142, 145
 lighting, 142
 models and makeup, 142–3
 outdoors, 140
 picture ideas, 145
 props, 143
Film, film speeds, 54, 123, 172, 181, 187, 200, 224, 230
 candlelight pictures, 66–7
 flash, 60, 62, 63, 64
 400 ASA, 66–7, 94, 172, 175, 176, 181, 187, 208, 224, 230
 grainy, 131, 133
 high speed, 81–2, 87
 tungsten balanced, 28, 219
 uprated, 66, 81, 95, 133, 172, 208, 209, 210, 224, 230
Filters, 176
 CC (colour correcting), 122
 cross-screen, 68, 133, 212–13
 diffusion or pastel, 133
 flash and, 60
 fog, 117, 119, 133
 graduated, 100–101, 133
 opaque vignette, 21
 polarizing, 42, 194, 195, 196
 skylight, 60, 133, 187, 196, 213
 soft focus, 117, 119, 133
 star-burst, 68
 UV, 119, 133, 194, 195, 196
 Wratten 81 series, 122, 126
Firelight pictures, 66, 67, 68
Fireworks photographs, 68
Fish-eye lenses, 42
Flare, 17, 24, 196
Flash, flash guns, 28, 34, 60–65
 automatic thyristor control, 60
 bounce, 28, 60, 61, 62, 64, 70, 71, 82, 86, 87, 114, 116, 117, 124, 130, 176, 180
 check light, 60, 62
 computer, 116–17
 dedicated flash guns, 60
 direct, 60, 61
 exposure, 60, 62, 63
 fashion pictures, 142, 143
 fill-in, 62, 63, 64, 71, 115, 142, 176, 179
 film and filters, 60, 62
 firelight pictures, 68
 four-light set-up, 36–7
 hair/rim flash, 65
 indirect, 61
 main light flash guns, 62, 63
 multi-exposure, 62, 64
 multiple adaptor for, 63–4
 nude photography, 115–17, 122, 125
 one-gun multi-exposures, 64
 parties and celebrations, 175, 176
 photocell sensors, 60
 reducing strength of, 116–117
 ring, 142
 romantic glamour pictures, 130
 slave unit, 62
 strobe, 125
 studio flash unit, 117
 synchronized, 62–4
 two- and three-flash portraits, 64
 using daylight with, 115–17
 using more than one flash gun, 62–5

Flash cont.
 using one flash gun, 60–61
 wedding pictures, 178, 179, 180, 181
Flash bracket, 95, 181
Flash sync socket, 60, 62, 64
Floodlights, 226, 231
Follow focus technique, 226
Formal portraits, 30–37, 38
 background, 30, 36–7
 composition, 86–7
 directing your subjects, 32
 equipment, 32
 lens distortion and, 23
 lighting, 30–31, 34–7, 86
 on location, 33
 organizing a studio, 34
 schoolchildren, 86–7
Fully aware pictures, 10, 12, 13

G

Girls (models), photographing, 96–101
 choosing your model, 96
 clothes, 96, 130, 140, 145, 150, 155
 directing a model, 101, 146–55
 equipment, 101
 fashion pictures, 140–45
 make-up, 96, 99, 134–9
 where to shoot, 99
 see also Nude and glamour photography
Glass, self-portraits in, 42, 43
Group photographs, 31
 the best angle, 164, 166
 candid, 162–7
 composition, 156, 157, 158–9, 162–4, 165
 equipment, 166–7
 fully-aware, 13
 lens and viewpoint, 160, 161
 lighting, 156–7
 parties and celebrations, 177
 planned, 156–61
 props and location, 158–9
 using a tripod, 160
 wedding pictures, 178–81, 182

H

Hair light, 36, 86
Hair/rim flash, 65
Hamilton, David, 130
Highlights, 36, 57, 59, 74–5, 115, 194
Holiday pictures, 184–9
 composition, 184
 film, 187, 188
 including people in, 184
 travelling with equipment, 187–8
 viewpoint and lighting, 184, 186
 winter mountain, 196–201
 see also Beach photographs
Hot shoe, 60, 62, 63

I

Ice hockey, 220
Ice skating, 218–21
 competitions, 219–20
 indoor ice-rink, 218, 220
 outdoors, 198–9, 218
Incident light meters, 50, 52, 53, 56, 191, 194
Indoor sports, 232–5
 anticipating lighting problems, 232, 234
 exposing for action, 232–5
 keeping a record, 235
 viewpoint and lenses, 234
Insulated film bags, 188
Insurance, 188

K

Karsh portraits, 20
Kodak Grey Scale, 55
Kodak Neutral Test Card, 50, 53, 56

L

Lens cleaners, 188
Lens distortion, 23
Lens hoods, 16, 24, 180, 194, 196

238

Lenses:
athletics meetings, 230
abstract nudes, 128
candid pictures, 44, 45
candlelight pictures, 66
close-up, 76
dance pictures, 208–9
fish-eye, 42
indoor sports arenas, 234
mirror, 230
portrait, 23, 25, 31, 32
standard, 23, 76, 94
see also Telephotos: Wide-angles
Light, lighting:
backlighting, 20, 40, 50, 158
beach pictures, 194
bounced, 106
candlelight, 66–9, 89, 115, 175, 176, 177
children, 76, 80, 81–2, 86
diffused, 80, 82, 106, 107, 110, 111, 117, 124, 130
double portraits, 40
fashion pictures, 142, 143
fill-in, 31, 36, 40, 86, 115–17, 122
floodlights, 226, 231
hair, 36, 86
holiday pictures, 184
indoor sports, 232, 234
location, 117
modelling, 86, 106, 110, 115, 194
natural daylight, 20, 24–9
nudes, 105, 106–7, 108, 109, 110, 112, 115, 117, 121–2, 125–6
parties and celebrations, 176–7
planned groups, 156–7, 158
planned portrait, 20
portraits on location, 30–31
reflected, 24, 28
Rembrandt, 36
rim light, 36–7
romantic glamour photographs, 130
semi-aware pictures, 16
shooting into the, 16
sidelighting, 82, 116, 215
spot, 126
stage, 208
studio, 20, 34–7
sunlight, 24, 110, 122, 156, 184, 194
theatre, 209
tungsten photofloods, 28, 34, 115
wedding pictures, 178, 179, 180
window light, 28, 31, 82, 106, 108, 109, 110, 112, 115, 140
see also Flash; Studio lighting
Light metering see Exposure metering
Lighting ratio, 62, 115–16
Light-trails, 68

M
Makeup, models, 96, 99, 134–9, 143
Matchlight photographs, 67, 68
Mirror lenses, 230
Mirrors, self-portraits in, 42, 43
Model agencies, 103
Modelling light, 86, 106, 110, 115, 194
Models, photographic:
basic posing guide, 146–55
choosing, 96
clothes, 96, 122, 130, 140, 145, 150, 155
directing, 10, 103–4, 123
fashion, 142–5
hairstyle, 130, 143
makeup, 96, 99, 130, 134–9, 143
nudes, 102–4, 122–3
romantic glamour pictures, 130
Monopods, 213, 226
Motor-drives or autowinders, 222, 230, 234
Multi-exposures, 42, 62, 64, 73
Multiple image prisms, 68
Multiple printing, 73

N
Natural daylight portraits, 24–9, 31
improvised studio indoors, 28

Natural daylight portraits cont.
reflected light outdoors, 24
shadows, 25–7
sunlight problems, 24
see also Sunlight; Window light
Nordic cross-country ski-racing, 212, 216, 217
Nude and glamour photography, 102–33
abstracts, 124–5, 126, 128
attention to detail, 128
background and props, 104, 105
camera angles, 126, 128
camera techniques, 126
choosing the room, 108
close-framing and cropping, 124–5
contrast control, 115
directing the model, 103–4, 123
exposure, 112, 114, 115, 121–2, 126
film and equipment, 123, 125, 128
flashes and floods, 115–17
indoors, 108–19
lighting, 105, 106, 108, 109, 110, 112, 115, 121–2, 125–6
location lighting, 117
outdoors, 120–23
photographing a friend, 102
posing and composition, 122–3
professional models, 102–4, 122
reflectors, 112, 114, 115
romantic glamour photography, 130–33
window light, 110, 112, 115
windows in the picture, 112, 113, 114

O
Over exposure, 57, 113, 122, 130

P
'Painting' with light, 64
Panning, 172–3, 201, 215, 216–17
Parades and processions, 168–73
equipment and film, 170–72
technique, 170
viewpoint, 168, 170
Parties and celebrations, 174–7
flash, 175, 176
grouping your subjects, 177
setting camera beforehand, 175
special lighting, 176–7
Peoples of the world, photographing, 202–5
candid pictures, 205
social taboos, 202, 204, 205
Photoflood lamps/lighting, 28, 34, 86, 115, 117
Photograph albums, family, 72–3, 76–9, 88
Pitch sports, 222–7
equipment, 222, 224, 226
film and exposure, 224
floodlights, 226
locations, 225–6
techniques, 226
Planned group photographs, 156–61
lens and viewpoint, 160
lighting, 156–7
props and location, 158–9
using a tripod, 160
Planned portraits, 20–23
distortions, 23
informal poses, 22
putting subject at ease, 20
Playgroups, 83, 92
Portraits:
beach, 190
close-up, 82
double, 38–41
flash, 60, 64–5
formal, 23, 30–37, 86–7
group, 13, 31
informal poses, 22
improvised studio, 28
on location, 30–33
at parties and celebrations, 177
planned, 20–23

Portraits cont.
schoolchildren, 86–7
self-portraits, 34, 42–3
studio, 34–7
using natural daylight, 24–9
Posing guide, 146–55
Printing, multiple and combination, 73
Props, 104, 105, 130, 155, 158
Public parks, children at play in, 92
Push processing, 81, 87–8, 95, 119, 133, 172, 209, 210

R
Red eye effect, 60, 64, 176, 181
Reflected light, 24, 28, 185, 191
Reflected light meters, 50, 52, 56
Reflections, self-portraits as, 42, 43
Reflectors, 31, 34, 36, 40, 60, 61, 80, 101, 105, 106, 107, 112, 114, 115, 122, 124, 125, 130, 142, 176
Rembrandt lighting, 36
Rim light, 36–7, 65
Rocks, pictures of, 192
Romantic glamour photographs, 130–33
background, 130
film, 133
filters, 130, 133
lighting, 130
the model, 130
props, 130
see also Nude photography

S
Schoolchildren, photographing, 86–9
formal portraits, 86–7
group of, 166–7
home activities, 87
lighting, 86
outdoor action pictures, 87
special events, 87–8
see also Children
School playgrounds, 92
Seaweed, photographs of, 192
Security scanners, 188
Self-portraits, 34, 42–3
in the darkroom, 42
delayed-action time release, 42
holding camera at arm's length, 42
long cable release, 42
multi-exposures, 42
reflections, 42, 43
in silhouette, 42
Semi-aware photographs, 10, 13, 14–19
Shadows, 74–5, 142
brightness range metering, 57
crossed, 62
flash and, 60, 62, 64
nude pictures, 115
on the beach, 194
portraits, 24, 25–7, 36, 37
self-portrait in silhouette, 42, 43
snow pictures, 196–7, 200
Shells, photographs of, 194
Shutter speeds, 17, 54, 66, 82, 87, 95
Silhouettes, 42, 43, 49, 108, 133, 194
Ski-jumping, 212, 216, 217
Ski-racing, 212, 213–15, 216, 217
Skin texture, 126, 128
Skin tones, 51, 52, 59, 103, 122, 126, 176, 218
Slave unit, 62
SLR cameras, 44, 56, 75, 76, 94, 170, 208
flash, 60, 63–4
Snow photography, 177, 196–201, 213
action shots, 200–201
exposures, 200
sunshine and shadow, 200
winter sports pictures, 212–17
Soft focus, 117, 119, 133
Sport photography:
athletics, 228–31
beach, 190–193
ice sports, 198–9, 218–21
indoor, 232–5
pitch sports, 222–7
winter skiing, 200–201, 212–17

Spot light, 126
Stage lighting, 208
Standard neutral grey test card, 50, 51
Studio flash units, 117
Studio lighting, 15, 20, 34–7
background, 36
basic, 36
fill-in, 31, 36
four-light set-up, 36–7
hair light only, 36
key light only, 36
more than one light, 36
nudes, 106–7
rim light, 36–7
Studio portraits, 28, 30, 36
Strobe flash, 125
Sun, shooting into the, 17, 24, 180
Sunlight, 24, 110, 122, 156, 184, 200
Sunsets, 133, 192
Synchronization, 62

T
Table lamps, 68
Tele-converters, 190, 213
Telephoto (long-focus) lenses, 12, 14, 17, 18, 44, 45, 83, 114, 123, 128, 166, 172, 190, 204, 209, 222, 226, 234
85mm, 32, 76, 94, 101
90mm, 25, 70
105mm, 44, 76, 101, 105, 114
135mm, 23, 32, 44, 94, 209, 234
300mm, 223, 226, 230, 233, 234
400mm, 213, 226
mirror lenses, 230
Theatre lights, 209
35mm SLR cameras, 44, 60, 76, 94, 170, 175, 222
Toddlers, photographing, 80–85
see also Children
Tonal values, 52, 55, 56, 57, 59
Tripods, 22, 32, 42, 66, 67, 101, 106, 116, 126, 160, 209, 230
TTL metering, 50, 51, 52, 53, 54, 55, 56, 67, 112, 208
Tungsten balanced film, 28, 219
Tungsten lighting, 69, 117, 174
photofloods, 28, 34, 115, 117
Twin lens reflex cameras, 201

U
Unaware subjects, 10, 11, 12, 13
Under-exposure, 57, 58, 76, 113, 114, 119, 122

V
Viewpoint, 32, 184
athletics meetings, 230, 234
for groups, 160, 161, 163, 164, 177
holiday pictures, 184, 186
on the beach, 192
parades and processions, 168–70

W
Water, 42, 92, 94, 123
Wedding pictures, 156, 160, 178–83
at the reception, 180
in the church, 178, 179
official pictures, 182–3
Weston light meter, 55
Wide-angle lenses, 13, 15, 19, 23, 31, 32, 42, 44, 123, 128, 160, 166, 172, 175, 177, 234
distorting features with, 23, 32, 33
Window lighting, 28, 31, 82, 106, 108, 109, 110, 112, 140
using flashes and floods with, 115–17
Winter mountain holidays, 196–201
action shots, 200–201
exposure, 200
Winter sports, 198–9, 200–201, 212–17
Alpine racing, 212, 213–14
care of your camera, 212
ski-jumping and racing, 212, 216, 217

Z
Zoom lenses, 124, 172, 190, 209, 210, 227, 230

Photographic Credits

John Garrett 1, 4–5; Adrian Murrell/All Sport 6; Uwe Ommer 8; Kim Sayer 2–3.

Taking Successful Portraits
Malcolm Aird 16 (top), 17; Steve Bicknell/Eaglemoss 23, 28, 29; Michael Boys/Susan Griggs Agency 12, 13 (top); John Bulmer 11, 14, 25 (top), 31 (top left and right), 45 (bottom left and right); Michael Busselle/Eaglemoss 12 (bottom right), 36, 37, (bottom); Bryn Campbell/John Hillelson 18 (bottom left); James H. Carmichael/The Image Bank 22 (right); Henri Cartier-Bresson/John Hillelson 45 (top); Anne Conway 43; Elliott Erwitt/John Hillelson 46 (bottom); Financial Times 30 (bottom); John Garrett 38 (bottom), 40, 41; Handsworth Self Portraits 42; Robert Harding 44; Chris Hill 34 (bottom); Thurston Hopkins 47; Karsh/Camera Press 20; Dorothy Lange/Oaklands Museum 10; Robin Laurance 12 (top left and centre left), 18 (left, right, and top), 19 (top), 48 (left), 49; Laurence Lawry 32 (centre and bottom), 33 (top left and right); Patrick Lichfield/David Lynch 21; Roland and Sabrina Michaud/John Hillelson 16 (bottom); Clay Perry 31 (bottom), 34, 35, 38 (top); Roger Perry 30 (top); Spike Powell 22 (left); Chris Schwarz/Mudra 24; Anthea Sieveking 15 (bottom); Homer Sykes/Eaglemoss 18, 19 (bottom), 26, 27 (top), 39; Patrick Thurston 13 (bottom); John Walmsley 15 (top), 25 (bottom); John Walmsley/Eaglemoss 26–7 (bottom); Herbie Yamaguchi 46 (top), 48 (right).

Lighting for Better Pictures
Jonathan Bayer 55; Per Eide 59; John Evans/Eaglemoss 61, 64, 65; Hideki Fujii/The Image Bank 69; John Garrett 56, 57 (bottom); John Goldblatt 67; Walter Iooss/The Image Bank 57 (top); John Kelly 68 (right); Laurence Lawry 66, 67; J. Pfaff/ZEFA 62; Sanders 58, 63; Tino Tedaldi/Eaglemoss 50, 51, 52, 53

Babies, toddlers and schoolchildren
Malcolm Aird 77 (bottom right), 80, 86, 87; Tony Boase 85 (bottom left); Michael Boys/Susan Griggs Agency 82 (top right); Colour Library International 82 (bottom left); Michael Busselle 89 (bottom left); Gary Ede 82 (bottom right); Elliott Erwitt/John Hillelson 74, 75; John Garrett 72, 73, 84 (bottom right); P. Goycolea/Alan Huchison 91 (bottom); Richard and Sally Greenhill 77 (bottom left); Helmut Gritscher/Aspect Picture Library 70, 71; Michael Hardy/John Hillelson 89 (bottom right); A. Howland 92; Pierre Jaunet/Aspect Picture Library 90; Jacques-Henri Lartigue/John Hillelson 74 (left); Constantine Manos/John Hillelson 88 (top left); Tom Nebbia/Aspect Picture Library 93 (top); Fiona Nicholls/Aspect

Picture Library 84 (bottom left); Clay Perry 89 (top right) Ken Schiff/Aspect Picture Library 95 (bottom); C. Shakespeare Lane 77 (top left, top right), 93 (bottom and right); Anthea Sieveking 78 (top and bottom right), 79 (top centre and top right); Anthea Sieveking/ZEFA 81, 83, 84 (top), 88 (bottom); Anthea Sieveking/Vision International 91 (top); Homer Sykes 79 (bottom); Patrick Thurston 94–5; Tony Stone Associates 76, 78 (bottom left); Richard Tucker 95 (top); John Walmsley 85 (top); John Watney 85 (bottom right)

Nude and Glamour Photography
Caroline Arber/David Lynch 114 (bottom), 128 (bottom); H. Blume/ZEFA 120, 123 (top); Michael Boys/Susan Griggs Agency 104 (right), 105 (top), 109, 112, 113, 115, 116 (left); Bill Brandt 127; Stuart Brown 117; Michael Busselle 99 (top), 110, 111, 126 (bottom); Michael Busselle/Eaglemoss 106–7; Raul Constancio 108 (right); Colour Library International 97, 98, 99 (bottom), 100, 102, 105 (bottom); Per Eide 114 (top), 129; John Garrett 103 (bottom), 108 (left), 119, 124, 125, 126 (top), 128; Ashvin Gatha 116 (right); Lorentz Gullachsen 121 (bottom); David Hamilton/The Image Bank 130, 131, 132, 133; Andreas Heumann 121 (top); John Kelly 103 (top), 104 (left), 122; Howard Kingsnorth 100 (top); Donald Milne/ZEFA 123 (bottom); David Pratt 96 (bottom); Martin Riedl/Eaglemoss 96 (top); Sanders 118; Tino Tedaldi 101 (top centre and top right); James Wedge 101 (top left)

Makeup, posing and fashion
Julian Calder 140; Colin Craig/Eaglemoss 134, 135, 136–9; Hans Feurer/The Image Bank 150; John Garrett 145; Andreas Heumann 141; Sanders, 144, 146; Tino Tedaldi 142 (left), 143; Tino Tedaldi/Eaglemoss 147, 148, 149, 151, 152–155; George Wright 142, 143

Groups and occasions
Derek Bayes/Aspect Picture Library 178, 179 (bottom right), 180 (top), 182–3; Anthony Blake/The Picture Library 169 (bottom); Michael Boys/Susan Griggs Agency 180 (bottom); John Bulmer 159 (bottom), 163 (bottom), 164–5, 167 (top); Peter Carmichael/Aspect Picture Library 165; Henri Cartier-Bresson/John Hillelson 160, 162 (bottom); Howell Conant/John Hillelson 156 (bottom); Alison Foster 171 (top right); K.D. Fröhlich/ZEFA 173 (bottom); John Garrett 167 (bottom), 174 (bottom left and bottom right), 177; Richard Greenhill 157 (top), 158 (top); Richard and Sally Greenhill 174 (top); Charles Harbutt/John Hillelson 175; Graeme Harris 169 (top); John Hillelson Collection 156 (top); Thomas

Hopker 166–7; Tom Hustler 179 (top); Monique Jacot/Susan Griggs Agency 177 (top); Gered Mankowitz 159 (top); Archie Miles 181 (bottom); Martin Parr 165 (top); Clay Perry 157 (bottom); The Picture Library 158 (bottom); Brian Seed/Aspect Picture Library 171 (top left), 173 (top); John Sims 181 (top); David Simson 170, 171 (bottom); Homer Sykes 162–3; Patrick Thurston 161, 168–9; Douglas and Lena Villiers 172–3; Adam Woolfitt/Susan Griggs Agency 176, 179 (bottom left)

The Travelling Camera
Robin Bath 191; Timothy Beddow 205; Marc and Evelyne Berheim/Woodfin Camp 184; Michael Boys/Susan Griggs Agency 185 (top left); John Bulmer 188, 204 (bottom); Michael Busselle 187 (bottom); Robin Constable/Susan Griggs Agency 206–7; Colour Library International 196, 199 (top); John Garrett 185, 187 (top), 193 (bottom), 201 (bottom), 204 (top), 206 (top); Patrick Gauvin/Aspect Picture Library 195 (bottom); John Goldblatt 202 (top); Alfred Gregory 190 (top), 196–7, 198–9, 202 (bottom); Robert Harding 189 (top left); S.G Hill 189 (bottom); Tom Hustler 201 (top); Roger Jones/England Scene 186; John Kelly 194; Henry Low/Elisabeth Photo Library 200; Roland Michaud/John Hillelson 203; Horst Munzig/Susan Griggs Agency 198 (top); Tom Nebbia/Aspect Picture Library 193; Mike Portelly 192; Michael St. Maur Sheil/Susan Griggs Agency 189; Chris Thomson 195 (top); Patrick Thurston 190–1 (bottom); John Walmsley 199 (bottom); Adam Woolfitt/Susan Griggs Agency 185 (top right)

Capturing Movement
All-Sport 216–7 (bottom); Erich Baumann/All-Sport 218, 221; Bryn Campbell 224–5; Tony Duffy/All-Sport 212–3 (top), 214–5 (bottom), 215 (bottom right), 219 (top and bottom), 220 (top and bottom), 226, 228, 229, 230, 231, 232, 234; Paul Forrester/ZEFA 211; Helmut Gritscher/Aspect Picture Library 212 (bottom left); Jean-Claude Lazouet/The Image Bank 208 (top); Marvin Lyons/The Image Bank 209 (top); Leo Mason 222, 227; Don Morley/All-Sport 225, 233 (top and bottom), 234–5; Horst Munzig/Susan Griggs Agency 217 (top left); Adrian Murrell/All-Sport 223; Peter O'Rourke 210; Luis Vilotta/The Image Bank 208–9 (bottom); Adam Woolfitt/Susan Griggs Agency 215 (top right), 216 (top left).

Artwork Credits
Drury Lane Studios 37, 53, 64, 65, 110, 156, 157, 162, 163